MW00561938

for Carl / David
Welcome back from all that
sunshine —
Looking forward to seeing you at

KILLING VINCENT

THE MAN, THE MYTH, AND THE MURDER

B'HHS-59 — 60th Reunion —
and a Book signing?

I. KAUFMAN ARENBERG MD

All the Best for 2019

I. Kaufman Arenberg MD

N3M
Productions

Nostradamus
and the Three Maestros
Productions, LLC

iii

"Killing Vincent: The Man, the Myth, and the Murder disproves a common myth about the 'mad artist,' Vincent van Gogh, and his 'suicide,' making a case for a far different scenario surrounding his death. It's a combination of true crime and an unsolved romantic murder mystery. It is a psychological probe into history that is a 'must' for any reader interested in Vincent's life and death.

Dr. Arenberg maintains that Vincent wasn't a depressed and insane individual who shot himself in a wheat field. Instead, he was not 'mad.' Yet, Vincent stumbled to his accommodations, bleeding from an abdominal wound that killed him. Who created that fatal injury? Did Vincent shoot himself? A modern forensic analysis confirms that the wound was not self-inflicted; therefore, not suicide, but murder.

From an in-depth probe into the artist's psyche, a new diagnosis of Asperger's Syndrome emerged. In addition to progressive, investigative steps into physical evidence, such as the murder weapon, Dr. Arenberg leaves no stone unturned; whether it be forensic reenactments of the murder and discussions of the crime scene or examinations of motives and likely perps.

The result is simply an unparalleled 'must,' recommended not just for art enthusiasts, but for true crime and history readers interested in the process of re-examining a homicide cold case and its impact on modern-day audiences."

~ Diane Donovan, Senior Reviewer, Midwest Book Review

"Dr. Arenberg puts the 128-year old 'suicide' narrative to the ultimate test. With a dearth of hard evidence, Dr. Arenberg employs known testimony, apocryphal stories, and conflicting interviews to stitch together what is the most persuasive explanation of what actually happened to Vincent Van Gogh....What is so fascinating to me is the narrative...which has been spoon-fed to the public and academia alike: Van Gogh was mad, cut off his ear, then shot himself. Dr. Arenberg destroys this dogma with modern forensics and develops a very likely motive for a scenario that makes suicide mathematically unlikely.

Overall this is an amazing book about a truly underappreciated and tantalizing story and has 'major motion picture' written all over it."

~James Atlas, Amazon, 5 stars

"[Dr. Arenberg] explores the why, where, and how of the murder of this revered icon. He uses both the available historical evidence and the tools provided by modern forensic technology. Then he proposes a who? If you love art, know van Gogh, or enjoy forensics, this book will keep you hugely entertained."

"I got to know the people contemporaneous to Vincent well, as if I were there watching them as they interacted. Vincent and beloved brother Theo, friend Paul Gauguin, doctor Paul Gachet and son Paul Jr., and model Adeline all come alive in the pages. Heaps of evidence debunking the suicide theory are in the book. The author definitely convinced me. I was almost moved to curse those scheming hypocrites who killed Vincent!"

"I support Dr. Arenberg's dogged pursuit of the truth surrounding Vincent's demise. He perseveres in clearing Vincent's name of the stigma of suicide, although many in the art world think it 'blasphemous' to say Vincent did not kill himself"

~ Miriam Molina, www.onlinebookclub.om

"When I studied the life of Vincent, all literature of the time pointed to Vincent as a creative madman who took his own life. When I was offered the book, Killing Vincent, to review, I immediately said yes. Hearing that Vincent may have not taken his own life was an interesting concept to me.

Killing Vincent takes you into the last part of Vincent's life and explores the evidence that suggests the murder of the talented artist. If you are an art history buff or find cold murder cases fascinating, check out this book today."

~ Carol Heppner, blogger

Dr. I. Kaufman Arenberg takes on a part of art history that has been accepted as truth for well over a century and totally debunks it. In what is probably one of the most provocative books today, Killing Vincent: The Man, the Myth, and the Murder, Dr. Arenberg refutes history and instead offers forensic proof that one of the world's greatest artists, Vincent van Gogh, did not die by his own hand but was, in fact, murdered! The author challenges history with today's forensic science and unrepentant analysis and hard evidence to present a far more believable scenario of van Gogh's death than what history had us believe—one that should make a riveting, blockbuster movie!

~Rebecca Simms, Ascot Group

"...using 21st-century forensic simulations and reenactments with the same antique revolver that might have been used in the murder, vintage black powder bullets and FBI ballistic gel..."

"...Everyone is fascinated and intrigued by the iconic Vincent...But when you substitute premeditated murder [for suicide] and an elaborate cover-up, then add to that an intriguing romantic twist that could provide a motive for his murder—you will really have everyone's attention!"

~ www.Officer.com

"...to reconsider the circumstances of the artist's death. Was it the result of a premeditated murder and extensive cover up, a self-inflicted injury, or somehow the result of foul play by villagers who taunted and accidentally wounded the excitable artist? The plausibility of his narrative will certainly encourage further discussion on the death of the world's most famous artist."

"...Suspicions of foul play now abound in Arenberg's historical investigation of van Gogh's last 70 days in Auvers-sur-Oise, France. Anyone interested in truth, accuracy, history, justice, romance, and art rather than blasphemy should know all the details in this provocative controversy and draw their own conclusions."

~ Timothy J. Standring, Curator, Denver Art Museum

Vincent's Thoughts

"at the end of my life, I hope to pass away, looking back with love and tender regret, and thinking, 'Oh the pictures I might have made'"

~ Letter #338 To Theo, Drenthe, November 19, 1883

"through my work I'd like to show what there is in the heart of such an oddity, such a nobody"

~ Letter #249 To Theo, The Hague, July 21, 1882

"I'm ... absolutely and utterly convinced that I am, after all, on the right path — when I want to paint what I feel and feel what I paint — to worry too much about what people say of me."

~ Letter #528 To Anthon van Rappard, Nuenen, August 18, 1885

"During these attacks ... I feel a coward before the pain and suffering ... I also feel frightened faced with the suffering of these attacks. It is the work that keeps me well balanced. I cannot live since I have this dizziness [vertigo] so often."

~ Letter #605 To Theo, Saint-Rémy-de-Provence, Sept. 10, 1889

"Ah, if I'd been able to work without this bloody [disease]! How many things I could have done, isolated from the others, according to what the land would tell me. But yes – this journey is well and truly finished"

~ Letter #630 To Theo, Saint-Remy-de-Provence, May 1, 1890

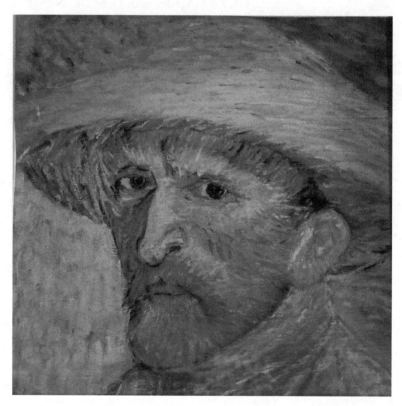

*Sheldon David Stern, an **integration of Vincent's self-portraits**, 1984. Pastels on bonded paper, 10 x 10 in, Private Collection.*

In Memory Of

my beloved "favorite" sister

Jessie Joy Kaufman Stern
May 8, 1931 – March 7, 2018

*This book is dedicated to my BIG sister Jessie, who was my mentor in
all the arts: literature, music, art, and dance. She was always there
encouraging me in all endeavors. She was my muse and sadly
passed away while I was in the midst of writing Killing Vincent.*

2nd Printing Update!

Is a Recently Surfaced Photo from 1887 Truly the Only Frontal Photo of the Now Iconic Painter?

While Vincent van Gogh's self-portraits were a significant part of his painting career, no confirmed photographs of the artist as an adult are known to exist. However, a very rare photographic type, an 1887 melanotype by Jules Antoine (1863-1948), recently came to light and reportedly "shows van Gogh smoking a pipe while having a drink with friends, including Paul Gauguin and Emile Bernard." This rare photo shows a man—allegedly Vincent van Gogh—in a relaxed position smoking a pipe held in his left hand.

> *"The image first came to the attention of French photo expert Serge Plantureux when two individuals acquired the photo at an estate sale and thought they recognized a few of the faces, among them, artists Paul Gauguin and Emile Bernard—a significant discovery in and of itself. Analyzing the photographic process, and pinpointing when and possibly where the photo was taken, raised the chances significantly that a bearded figure who appears amongst the gathering of stoic men might be Van Gogh. The photo went to auction, June 19, 2015 at 2PM, at Romantic Agony in Brussels and was expected to fetch between $136,000 to $170,000."*
> — *L'Oeil de la Photographie* (The Eye of Photography)

A final sale price has never been made public (as of February 2019), nor are the whereabouts of this intriguing photo known today.

According to *DutchNews.nl*, the photograph expert at the Van Gogh Museum in Amsterdam is not convinced that this photo depicts the painter *"because it simply does not look like him."* I would have to concur with the photo experts at the Van Gogh Museum on this one. I believe that the most realistic images of Vincent were painted in Paris around 1886 by John Peter Russell (Figure 5, Chapter 1) and by Vincent himself (Figure 6, Chapter 1).

Unfortunately, I am unable to provide a copy of the photo as it is still copyrighted. The photographer's death was less than 75 years ago, which is too recent to fit the duration of required years for the photo to be in the public domain. However, the image can be easily found online through a search engine or by following the link provided on **Page 290**, which also provides additional information regarding this new-found photo.

NOTES
2nd Printing

There were some obvious missed glitches in the editing process of the first printing for which apologies are offered and corrections have been made for this second printing. A special thank you to all those who submitted needed corrections, which have all been addressed. This second printing also adds some new material and images that will help transition this book smoothly into a screenplay. Additionally, the book is laid out in an expanded format to make it easier to follow some more complicated chapters—particularly Chapter 23, What Really Happened, and Chapters 22 and 27 on forensics. My sincere apologies again, and I hope that you will enjoy this enhanced version with its additional material and improved clarity.

I have tried to maintain my open narrative and informal, non-academic style as if we were just talking together about Vincent, his art, his loves and his death, over dinner, or just a coffee or a glass of wine.

There has already been some notable, positive buzz about this project in the earliest responses from art historians, academics, and interested readers across the spectrum. These readers have encouraged that this book be made into a movie. Thus, transitional elements and other minor changes have been added to the KV book to make the second printing (2019) a strategic stepping stone to film scripting. You should lose nothing from reading the story and research in the original, first edition, which is the underlying basis and research for the movie, but not articulated as such. It is hoped and expected that these revisions will still maintain the thrust of the original KV, and yet optimally utilize and expand the majority of the accumulated research to make a better book to movie script transition. This will ultimately reflect a better basis for a very different KV movie than you would otherwise have expected. The KV movie is the cornerstone of KVP (Killing Vincent Project); with maybe a few more twists and surprises forthcoming.

Hopefully, these changes in focus will help those of you who are into the silver screen format more than just into written words, to be better prepared and enthralled by your cinematic experience. You will see Vincent and Marguerite's love unfold, evolve, and blossom before your eyes from the perspective of our surprise *"fly on the wall."* Hopefully, it will mesh with the tragic, almost Shakespearean story of a love just out of reach and then taken away by murder.

On the other hand, if you are more intrigued by solving this 128-year-old cold case crime to your satisfaction and want to answer the question of suicide or murder for

yourself, pursuing all those rabbit holes, "*facts*," and connecting all the meaningful "*dots*," than you do not need the movie version of the book. It is really two separate endeavors, almost two separate books combined under the overall KVP research project and introduced as one book.

Solving the mystery and coming to the answer of suicide or murder allows us the ability to fully explore the unspoken relationship that was the basis for Vincent's honor killing. Hopefully you might even enjoy the movie more because you have already solved the mystery. Now, enjoy the real love and death story of Vincent van Gogh…

Contents

FOREWORD

Dr. Arenberg is a physician turned gumshoe who recounts an alternative narrative of Vincent van Gogh's last 70 days of his artistic journey, since the gingered artist got off the train from Paris on May 20, 1890. He asks readers to reconsider the circumstances of the artist's death. Was it the result of a premeditated murder and extensive cover-up, a self-inflicted injury, or somehow the result of foul play by villagers who taunted and accidentally wounded the excitable artist? The plausibility of his narrative will certainly encourage further discussion on the death of the world's most famous artist.

An extensive examination of forensics led Arenberg—a retired ear surgeon, author, editor of several medical books, and an innovator with multiple patents—to conclude that it is unlikely that Vincent shot himself. Without mention of a black powder burn to the artist's flesh or clothing, it is possible that the wound may have been caused by a gunshot fired from an undetermined distance, or that the wound was caused by a knife. Further, he suggests that there may have been a clandestine romance that led to a possible honor killing. Hollywood should be ready to purchase the screen rights of such a narrative.

In 1990, Arenberg entered the art history world when the *Journal of the American Medical Association* (*JAMA*) published his article that posthumously diagnosed van Gogh with Meniere's disease, an inner ear disorder. This article led many to question the accepted perception that van Gogh had epilepsy, as his malady of Meniere's disease more correctly explained his misdiagnosed "*attacks.*" Most people assume the great Dutch post-Impressionist painter suffered a serious mental disorder that would eventually drive him to madness and suicide. Instead, Arenberg never believed that Vincent took his own life, which led him to research further what may have been the cause of his death.

Killing Vincent seeks not to create another biography about van Gogh's life but rather to explore in depth the possible scenarios related to his poorly documented and suspicious death. This book explores the idea that van Gogh's death—long thought to be a straightforward case of a self-inflicted gunshot wound—is shrouded in mysterious circumstances that simply do not add up to suicide. If the artist did not commit suicide but died of a bullet wound, then who shot him?

Suspicions of foul play now abound in Arenberg's historical investigation of van Gogh's last seventy days in Auvers-sur-Oise, France. Anyone interested in truth, accuracy, history, justice, romance, and art rather than blasphemy should know all the details in this provocative controversy and draw their own conclusions.

Timothy J. Standring
Gates Family Foundation Curator, Denver Art Museum

2

Introduction

Gary D. Vander Ark, M.D.

Distinguished Clinical Professor,
Department of Neurosurgery,
University of Colorado School of Medicine, Denver

My association with Irv Arenberg extends back about fifty years, to when I was the Chief Resident in Neurosurgery at the University of Michigan and he was a medical student. In the ensuing years, our career paths often intertwined as I continued working in neurosurgery and he embarked on a specialty in neuro-otology (neurological disorders and surgery of the inner ear).

Given our decades as friends and colleagues, I can vouch for the fact that Irv has had a burning interest in Vincent van Gogh's life for the last thirty years. He became an expert on the artist's medical condition, publishing several articles on the subject that were well received by the international medical community. His distinguished medical career and lifelong study of van Gogh have given him a unique expertise on the artist's physical and mental health, which led him to make an initial diagnosis, in 1990, that van Gogh had not epilepsy (as was commonly proposed) but Meniere's disease, an inner-ear problem that causes bouts of vertigo, hallucinations of motion, and ringing in the ears.

Irv never believed that van Gogh committed suicide. In this book, he goes back to the beginning of the tale of the artist's death—which has long been littered with misinformation and suspicions of foul play—to tell his own version based not in conjecture but in facts and science. He sheds new light on the narrative with his personal diagnosis, combined with the benefits of modern forensic reconstruction.

It is with great collegial respect and admiration for Irv's work that I introduce *Killing Vincent*, where he can finally lay out the stories, evidence, and hypotheses that have long preoccupied him. I find this ongoing exploration of van Gogh's life, his medical issues, and now his death to be thoroughly fascinating. Although this book raises many more questions about the death of van Gogh than it answers, it provides a wonderful service by once and forever killing the idea that van Gogh committed suicide and offering a much more logical possibility for the end of Vincent's life.

THE GOALS OF THIS BOOK

Killing Vincent is meant as a historical analysis and exposé that continues to explore and seek answers to the key questions that *TIME* magazine posed in its October 31, 2011 cover story: *"Who killed Vincent van Gogh?"* and, *"Was van Gogh's death really a suicide?"*

This work is not meant as an academic treatise or dissertation, with every observation, thought, and detail requiring documentation. It is only an attempt to seek the truth of what really happened on the day Vincent van Gogh was mortally wounded, and to best connect all the missing "*dots.*" In the process, I will piece together the few facts that are known to try to recreate potential murder scenarios and uncover the real reason Vincent van Gogh was murdered, significantly changing the perception about the death of art history's most iconic figure.

At the outset, I would like to clarify my background and my role in this cold-case investigation. I am not an art historian, an artist, a curator, or an art critic. I am not involved with any museum or anyone who owns a Vincent van Gogh painting. I have "*no skin in the game,*" as they say. I do not want to look at Vincent's art to try to diagnose his medical problems, determine his mental state, or try to guess and speculate about what was going on in his brilliant mind at the time. Trying to understand the mindset of a fascinating historical figure and genius such as Vincent van Gogh is impossible. The extant van Gogh literature is filled with many such attempts made over the years, and no one has yet succeeded. I am not trying to improve on the numerous biographies and treatises on his extremely well-documented life. Rather, I want to unravel the mystery of his death.

When I started this project, I never believed that Vincent committed suicide, but I dedicated my new research to exploring all the possibilities from every angle. I tried to present all this research objectively, without any bias. However, as I progressed into all the research surrounding Vincent's mysterious death, my theory as to who most likely killed Vincent evolved and why. I became even more certain it was very unlikely that he committed suicide. I will demonstrate why it was not likely or possible for him to have done so. I will then elaborate on my theory about the murder of Vincent, *"who-dun-it"* and why, and its brilliant cover-up.

This book has three major goals: first, to determine whether Vincent van Gogh's death was really a suicide as legend would have you believe, possibly an accident, or a likely murder and a clever, misdirected cover-up. So very little is indisputably known today about his mythical death, yet so much is well known, by comparison, about his life.

If I can convince you that Vincent did not commit suicide, then the second major goal becomes to critically evaluate all the persons of interest in this epic cold case and to search for the possible motive of the killer(s).

The third and final major goal is to further solidify the case against suicide, utilizing modern forensic evidence. This includes simulations of the day Vincent was injured using the same antique model gun, reenactments of firing that gun with vintage black powder bullets, and a detailed forensic analysis of the signature powder burn that the gun would have left behind on clear, FBI ballistic gel, that is 100 percent consistent with human tissue. All the new forensic studies are documented in photos and videos.

This book attempts to explore all possible scenarios and motives, no matter how likely or unlikely, or how relevant or irrelevant they may appear to be to this cold case at first glance. Which of several scenarios best puts all the facts, stories, and legends together and connects all these odd "*dots*" now in a persuasive manner? Sometimes the truth is more unbelievable than the reality it discloses.

Sherlock Holmes was often noted to say, "*When you have eliminated the impossible, whatever remains, however improbable, must be the truth.*" - Sir Arthur Conan Doyle

I present all the alternative possibilities for you to consider in the hope that I can convince you that at least one of them is a realistic alternative to the old, legendary assumption that Vincent shot himself. My goal is to exonerate poor Vincent from the stigma—going against his person, his beliefs, and his religion—that accompanies his supposed suicide.

So, let me lead you to the world court of public opinion and the wealth of information, theories, and, unfortunately, unsubstantiated rumors surrounding Vincent's death, which someone might have deliberately spread for whatever misunderstood or nefarious reasons. There are so many unanswered questions that are begging for resolution. I will try to put all these questions in some meaningful order that remain in the mysterious, yet legendary demise of our most beloved and recognized artist, Vincent van Gogh. I will attempt to shed new light on the epic, historical, romantic murder mystery surrounding the unexpected death of this icon.

Maybe it was a suicide as we have been told, maybe it was an accident, and maybe it was really a murder and a cover-up. We do not know for sure—and nobody does—but now we have some new information and several different potential scenarios and motives to explore to try to take a more modern look at the mysterious death of this beloved painter. Let us question everything we know or think we know, as well as all of our sources, in order to drill down on all the different possible scenarios, no matter how odd they may seem, with a completely open mind.

I will look at Vincent's medical, mental, and physical health, his state of mind, the people he associated with, and the motivations that those people might have had to kill Vincent—or that Vincent might have had to kill himself. Ideally, we can eliminate all of the old information and revisit the big picture with our pre-existing bias left outside the covers of this book. A reexamination of all the pertinent evidence will allow you, the reader and jury, to make your

own judgment in this case. We can explore all aspects of this infamous cold case together and then you can, with a more expansive and comprehensive perspective, decide for yourself who is responsible for the mortal wound and ultimate death of Vincent van Gogh.

If this false suicide theory is finally put to rest—as is my intent—then a serious look at his death as an unsolved homicide must now be vigorously pursued. "*Blasphemy*" it may be to some, but truth ultimately must prevail: Vincent van Gogh did not commit suicide as the legendary myth would have you believe with a self-inflicted gunshot wound to his abdomen ... **he was murdered!**

Part I

Background on Vincent van Gogh: What Happened to van Gogh BEFORE he was mortally injured?

Chapter One

Vincent's Life Until His Discharge from the Asylum at St. Rémy-de-Provence

To best understand the circumstances surrounding Vincent van Gogh's death, it is important to first understand what his turbulent life was like, in the broadest strokes, before and after his year in the asylum (May 1889 to May 1890). His early life was emotional and complicated. His brief life of only 37 years was marked by a sad childhood and a distinct and never-ending lack of parental acceptance and affection. His early adult life was replete with various failures in both his professional and romantic endeavors. These problems were most likely exacerbated by difficulties socializing, a tendency to argue, and issues relating to his peers and colleagues. These social and interpersonal difficulties did not help him when he finally made the major, abrupt change from a zealous pursuit of religion to an even more zealous pursuit of art. His main artistic time periods were: his tortured and volatile Dutch period; his Impressionist awakening in Paris, characterized by a notable lightening up of his palette and meeting his peers; his Arles period, with Gauguin in the Yellow House and the ear mutilation; the hospital recovery; and then leaving Arles for the solitude of the asylum in Saint- Rémy-de-Provence, where he admitted himself and had nothing to do but paint, meditate, reflect, and heal body, mind, and soul.

Most everyone can accept that Vincent van Gogh was a brilliant, innovative artist who was known for breaking away from Impressionism and leading the movement toward modern art, even though during his career only one of his oil paintings was ever sold. Vincent died not knowing that his vibrant landscapes, beautiful still lifes, and compelling portraits would eventually become some of the most sought-after, valued, and expensive works of art in the modern world. His brilliant, creative, and original works of art have been credited with the tumultuous, chaotic breakthrough to modern and abstract art today.

His legendary life is extremely well known, intimately and thoroughly documented, and represented in an extensive roster of novels, biographies, investigative reports, academic books, magazine articles, academic treatises, movies, popular songs, and even a one-man

11

theater production. Van Gogh's rise to posthumous fame accelerated in the early 20th century when his letters to his brother were published by his sister-in-law, Johanna van Gogh-Bonger. A book published by Irving Stone in 1934, *Lust for Life*, and its Academy Award-winning 1956 film and biopic adaptation of the same name propelled Vincent's story even further into the international spotlight. Since then, the multitude of writings on the subject have ensured that Vincent van Gogh become a household name, a cultural icon, and one of the most beloved artists in history. His life story—most notably the infamous episode in which he allegedly cut off his ear and gave it to a prostitute after an argument with his peer, the now renowned painter Paul Gauguin—has become an important part of our western culture and is considered common knowledge.

Soon after his death, a familiar, albeit dramatic, unsubstantiated story and suicide narrative was accepted and entrenched in the public mind: the tragic, "*mad*" painter was doomed from the start. Having failed at several other professions, Vincent felt the call to follow his passion for art. In less than 10 years, he was transformed from a novice to a prolific genius. He knew many of the greats in the Paris art world, yet he enjoyed none of their successes. He was a tortured soul, a victim of his own dark thoughts and a seemingly incurable case of intermittent "*attacks*" of what was then misdiagnosed as epilepsy. His storied mental instability truly embodied the "*tortured artist*" persona. His genius and unwavering focus made his frenetic behavior seem strange and hard for the people around him to accept him for who he truly was. Just as he was gaining positive critiques and showing well in France, Belgium, and Holland, he met his untimely and somewhat mysterious demise, often considered by experts and laypeople alike to have been a purposeful act of suicide. However, this history that many so readily accept may not necessarily be the truth. In order to understand Vincent's unfortunate and untimely end, it is first important to understand his sad life in general and the circumstances that led him to the small countryside town in which he was ultimately buried.

Early Life

Vincent Willem van Gogh was born March 30, 1853 in the small town of Groot-Zundert in the Catholic part of western Holland. He was a very different and somewhat difficult child, born into a strict Dutch Reform family. Vincent's father, Dorus, was the reverend in Zundert. Vincent's mother, Anna, acted as the social arm of the parsonage and was very rigid and difficult to love. Vincent craved his parents' attention and love but did not ever receive the affection he so desperately craved. When his brother, Theo, was born four years later, Vincent was happy to finally have a companion. Even into adulthood, the brothers shared a close bond. Despite his enthusiasm and desire for love, Vincent's social skills and ability to interact with others was dismal at best, so he became an avid reader. Vincent was a very solitary child, often deep in thought or out spending time alone in nature. He became quite a prolific naturalist, collecting all kinds of insects,

particularly beetles. He collected them, pinned them, and learned their botanical names in Latin. He also collected birds' nests and other unusual items. Nature fascinated him and the wonder of it all allowed him to thrive in solitary activities.

Vincent had two brothers and three sisters, and the family was very close-knit out of necessity. As a Dutch Reform family in the midst of a predominantly Catholic town, they were somewhat isolated. Many family activities, such as reading, storytelling, and holiday celebrations, were important events in the van Gogh family. These were the memories that anchored Vincent to his old home and to the family closeness that defined his childhood. Yet the entire family was somewhat rigid and outwardly unloving; they did not offer the support that Vincent really needed and desperately craved to blossom as a child. Vincent's unusual behavior was often most troubling for Vincent's mother, Anna, who was never quite sure what her eldest son might do or say when parishioners came calling to the house. At one point in Vincent's adult life Anna wrote to Theo that she wished Vincent dead. This was the underlying maternal feeling Vincent faced his entire life, despite his efforts to win over his mother through gifts of affection and hand-drawn art. Theo was clearly her favorite son.

Although he was extremely bright, Vincent's social behavior made him a problem child, so he was sent away from the family to his first boarding school when he was only 11 years old. By the age of 16, after sporadic stints in multiple boarding schools, Vincent left his childhood home, his siblings, and his parents to take a clerk job with the art dealers Goupil and Co. in The Hague; he got that job through family connections. After several years of learning the business and doing well, he transferred to the London branch in 1873.

According to family legend, he fell in love with the daughter of his boarding-house owner, Eugenie Loyer, but he soon found out that the infatuation was not returned—she was secretly engaged to someone else, and Vincent had his first broken heart, as was suggested by Johanna van Gogh-Bongers in her later writings. Vincent felt betrayed and returned home to his family for several weeks of mourning an unrequited love. He took this rejection hard and changed much of his business-like behavior, his demeanor, his dress, and his hygiene, developing an uncaring and unprofessional attitude. He became even more withdrawn and introverted. We have very few recorded details about this heartbreak and its effects given that Vincent did not write any explanation for his unexpected departure from the boarding house, but the obvious long-term outcome speaks volumes. From this point onward, he could never maintain a job, friendships, or a normal, self-sufficient life.

He was then very unhappy and transferred to the Paris branch of Goupil and Co. He bounced around—back to London, then back to Paris. He was eventually discharged from the company. No longer in the family art business, he took a job on the east coast of England in 1876 as a teacher of French and German to English schoolchildren. This effort, too, was unsuccessful.

Vincent then turned to religion and, in a transparent attempt to gain his father's approval, attempted to become a reverend. He failed the preparatory classes for theology in Amsterdam while staying with an uncle and ultimately abandoned his formal theological studies. He headed for Brussels to learn to be an evangelist, but after several months, he failed again and went home to his family who now resided in Etten. After spending a tempestuous Christmas holiday with his family, he attempted to do missionary work in the very poor, destitute coal-mining region of Belgium called the Borinage. After half a year as a missionary preacher, he was dismissed for being overzealous and instead continued his missionary course on his own with some financial help from his family. This pattern of solitary study while being financially supported by his family would continue for the rest of his life. Theo supported Vincent by giving him a monthly stipend of 150 francs from the time he decided to become an artist, after giving up his desire for a career in the ministry, until his death. This amount was generous; for comparison, Vincent's friend Joseph Roulin, who was the postmaster in Arles and had a family of three at the time, received a monthly pay of 50 francs.

The Dutch Period

In the summer of 1880, Vincent abandoned his evangelical efforts and began to draw. He declared to his family that he wanted to become an artist, but again he would face numerous difficulties. He was convinced he had found his calling, though he had no formal training in art. He demonstrated remarkable progression and goal-oriented focus. Always one for self-study, he learned from drawing manuals, from exhibits, and a great deal from his experiences from his apprenticeship with the art dealers. He headed to Brussels again and made the acquaintance of an artist, Anthon von Rappard. The two exchanged many letters over a relatively short period, but Vincent ended their relationship, like so many others, on a distinctly sour note after multiple intense arguments about a variety of subjects. He was always seeking friends in the artists' community but, due to his recurring difficulties with social interactions, he was very proficient at destroying any meaningful connections and basic friendships. From Etten in the summer of 1881, he met his recently widowed cousin, Cornelia "Kee" Voss, and her son, in Amsterdam. Without any regard for her recent loss or social convention, Vincent declared his profound love and his one-sided intent to marry her, but she dramatically turned him down. The humiliating rejection was swift and severe, but not well accepted by Vincent, thus marking the second notable rejection and failure in his adult romantic endeavors.

He tried to set up a studio in The Hague and got some instruction and encouragement from his cousin, Anton Mauve, a well-known artist. He often went to the beach at Scheveningen to paint (Figure 1).

Despite Mauve's best intentions to help him get started as an artist, Vincent predictably destroyed their relationship. In 1882, he moved into a studio and asked a pregnant prostitute,

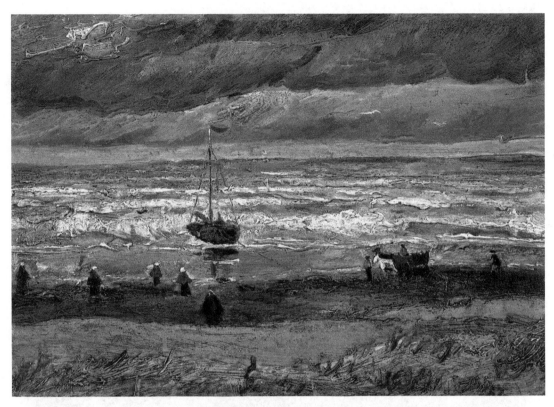

*Fig. 1. Vincent van Gogh, **Beach at Scheveningen in Stormy Weather**, 1882.*
Oil on paper on canvas, 34.5 x 51 cm, Stedelijk Museum, Amsterdam.

Sien, to move in with him along with her young daughter. Vincent often used prostitutes as his models, and eventually he acquired syphilis and gonorrhea for which he endured many treatments. After Sien had her second child, they moved into a larger studio. Vincent began to get commissions from his uncle, Cornelius, and began to use oil paints.

By the fall of 1883, he had a final break with Sien after much pressure from his family members, who were concerned about the moral, social, and financial implications of their relationship. After this third notable failure to create a loving family of his own, Vincent moved to the dreary bogs of northeastern Holland. At the end of that year, he returned to his family again after another set of social and professional failures. He remained there, eventually with his own studio rented from the Catholic sexton. He had a love affair with an older neighbor, Ms. Bergamon, which ended in a scandal so damaging and ostracizing in the small village that the poor woman attempted suicide by strychnine poison. This horrible incident marked Vincent's fourth significant romantic failure.

Four days shy of Vincent's thirty-second birthday in 1885, his father died, marking the end of their tumultuous and confrontational relationship, which had been a point of stress for the entire family. At the end of 1885, Vincent moved yet again—now to Antwerp, where he first saw and became enamored by Japanese woodblock prints, whose use of color became important influences on his work during his later efforts in Paris.

During this beginning period of his artist's career, he was fascinated with portraying working-class people. He drew and painted peasants in a very dark and somber palette. The most famous paintings from this period are *The Potato Eaters*, *Head of a Peasant with a Pipe*, and *Head of Peasant Woman with White Cap* (Figures 2-4).

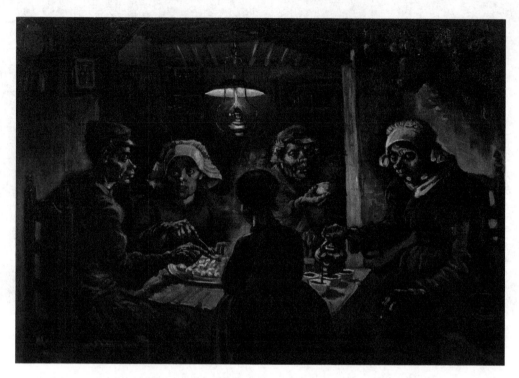

*Fig. 2. Vincent van Gogh, **The Potato Eaters**, 1885.*
Oil on canvas, 72 x 93 cm, Van Gogh Museum, Amsterdam.

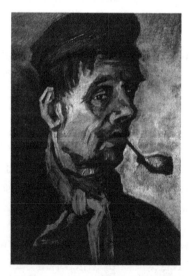

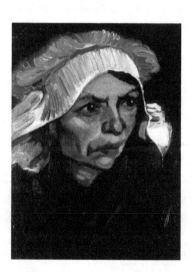

*Fig. 3. Vincent van Gogh, **Head of a Peasantwith a Pipe**, 1885. Oil on canvas, 44 x 32 cm, Kroller-Muller Museum, Otterlo.*

*Fig. 4. Vincent van Gogh, **Portrait of a Farmer's Wife with a White Cap**, 1885. Oil on canvas, 41 x 31.5 cm, EG Buhrle Collection, Zurich, Switzerland.*

In January 1886, Vincent began taking classes at the Academy of Fine Arts in Antwerp. Though this period was marked with a great deal of artistic growth, Vincent had many major disagreements and arguments with his teachers and peers over style, color, form, and just about everything in traditional art. To say that Vincent and his instructors at the Antwerp Academy disagreed about all aspects of conventional art would be an understatement.

The Paris Period

Vincent left Antwerp abruptly and moved to Paris to live with his younger brother in the summer of 1886. Theo—who was now a well-established art dealer for the successor firm to Goupil and Co.—became his mentor and only patron, taking care of all of Vincent's expenses. It should be noted that Vincent never routinely earned any money as an artist, nor worked at anything else after declaring himself an artist. He enrolled in a famous Parisian studio and met Henri de Toulouse-Lautrec, Louis Anquetin, and John Russell, who painted one of the most famous portraits of Vincent (Figure 5). This image in particular is notable because it is perhaps the most realistic likeness of Vincent when compared side by side with what may be Vincent's most realistic self-portrait image (Figure 6). Vincent was known to have abhorred photography and no frontal photographs of him exist today.

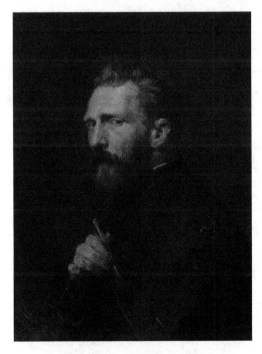

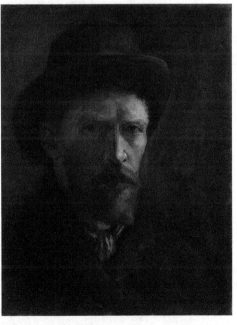

*Fig. 5. This portrait may be the most realistic image of Vincent van Gogh. John Peter Russell, **Portrait of Vincent van Gogh**, 1886. Oil on canvas, 60.1 x 45.6 cm, Van Gogh Museum, Amsterdam.*

*Fig. 6. This self-portrait of Vincent van Gogh appears to be the most realistic and similar to Russell's portrait of Vincent. Vincent van Gogh, **Self-Portrait with Dark Felt Hat**, 1886. 41.5 x 32.5 cm, Van Gogh Museum, Amsterdam.*

With his exposure to other Impressionist artists, Vincent gave up his somber, dark palette for a much lighter one and became an experimental colorist. Examples of his lighter Paris period pallette are presented for comparison (Figures 7-11).

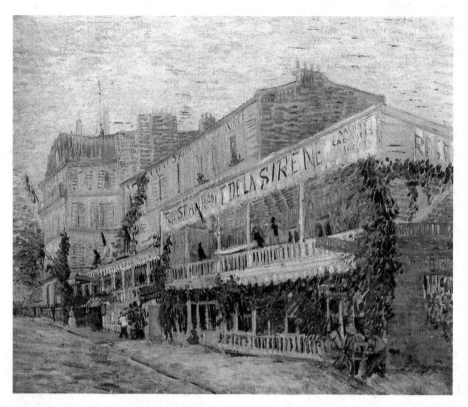

*Fig. 7. Vincent van Gogh, **The Restaurant de la Sirene at Asnieres**, 1887. Oil on canvas, 51.5 x 64 cm, Musee d'Orsay Collection, Paris, France.*

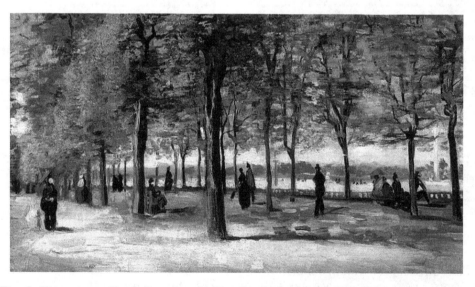

*Fig. 8. Vincent van Gogh, **Lane at the Jardin du Luxembourg**, 1886. Oil on canvas, 27.5 x 46 cm, Sterling and Francine Clark Art Institute, Williamstown, Massachusetts.*

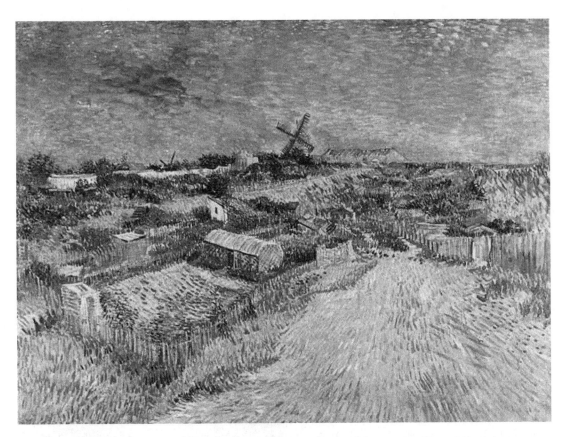

Fig. 9. Vincent van Gogh, **Vegetable Gardens in Montmartre: La Butte Montmartre***,*
1887, Oil on canvas, 96 x 120 cm, Stedelijk Museum, Amsterdam.

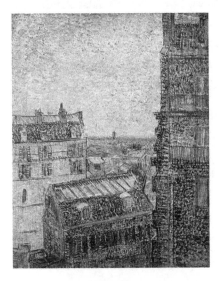

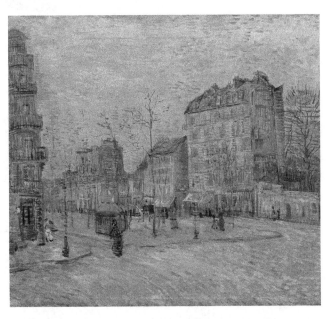

Fig. 10. Vincent van Gogh,
View from Theo's Apartment*,*
1887. Oil on canvas,
45.9 x 38.1 cm, Van Gogh
Museum, Amsterdam.

Fig. 11. Vincent van Gogh, **Boulevard de Clichy***,*
1887, Oil on canvas, 46 x 55.5 cm,
Van Gogh Museum, Amsterdam.

Theo became ill at the end of 1886 with an undisclosed illness; however he apparently recovered from it. Meanwhile, Vincent became even more enamored with the Japanese woodblocks and their use of color, and he spent time studying and emulating their style (Figure 12). Vincent's fascination with Japanese woodblock art and their intensity of colors was carried forward into his ongoing experimenting in Arles.

He met more contemporary artists of note over the course of his stay in Paris: Armand Guillaumin, Camille Pissarro, Emile Bernard, Paul Gauguin, Paul Signac, Georges Seurat, and others. Despite seemingly enjoying success in Paris and literally *"hanging his art"* with his peers at various venues, Vincent unexpectedly left for the south of France to be able to paint in that special light seen *"only in the Midi."*

There is really no reasonable or accepted explanation for his abrupt departure. What may have happened between the brothers was not really put into writing. It is important to

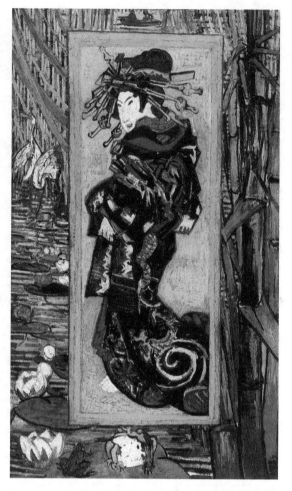

Fig. 12. Vincent van Gogh,
Japonaiserie Oiran (After Kesai Eisen),
1887. Oil on canvas, 105.5 x 60.5 cm,
Van Gogh Museum, Amsterdam.

note that Vincent never painted a portrait of his beloved brother and benefactor, Theo, despite being roommates. This is significant since Vincent was always looking for models or intriguing characters to have them sit for their portrait. He had often paid prostitutes to sit for him, instead of ever asking Theo…(and as you will see later, Paul Gachet Jr. in Auvers-sur-Oise).

The Arles Period

He arrived in Arles in the winter of 1888. Vincent loved the light there, as he had hoped he would, and painted some spectacular pieces. He took a long weekend to visit and explore the Mediterranean beaches at Saintes-Maries in the south of France and painted a lovely seascape (Figure 13).

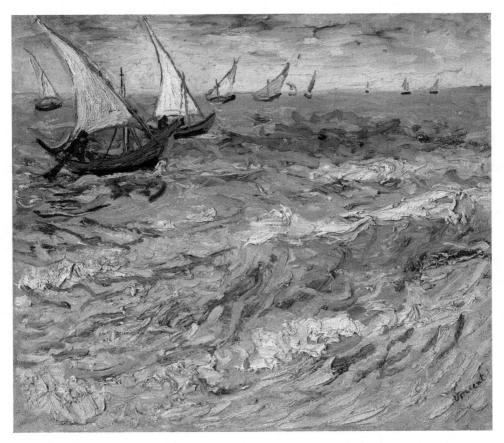

Fig. 13. Vincent van Gogh, **Seascape at Saintes-Maries**, *1888.*
Oil on canvas, 44 x 53 cm, Pushkin Museum, Moscow.

Fig. 14. Vincent van Gogh, **The Little**
Arlesienne, *1888. Oil on canvas, 51 x 49*
cm, Rijksmuseum Kroller-Müller, Otterlo.

He was also fascinated with the beauty of the women of Arles and was happy if he had a female model (Figure 14).

However, his health was starting to become a concern, as Vincent suffered several violent "*attacks*" and hallucinations in Arles that were initially attributed to epilepsy. In between these intermittent attacks, he had completely symptom-free periods and was able to focus on his art and paint extensively.

Vincent had first stayed in a hotel after his arrival in Arles, but unsurprisingly, ended up in a dispute with the owner. He was able to leave and rent an entire house, the now famous "*Yellow House*" (Figure 15)

with his well recognized bedroom (Figure 16). Soon after moving to the Yellow House, Vincent launched a campaign to have Paul Gauguin join him. He was very excited about the arrival of Gauguin, as he thought this would be the beginning of his dream of a utopian artist colony in the south of France. In anticipation of Gauguin's arrival, Vincent painted several versions of sunflowers to decorate Gauguin's bedroom (Figure 17).

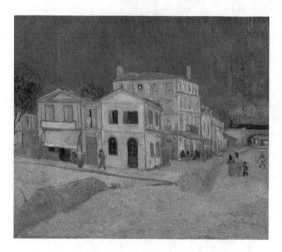

*Fig. 15. Vincent van Gogh, **The Yellow House**, 1888. Oil on canvas, 76 x 94 cm, Van Gogh Museum, Amsterdam.*

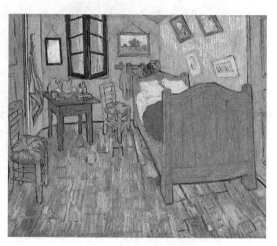

*Fig. 16. Vincent van Gogh, **The Bedroom**, 1888. Oil on canvas, 72.5 x 91.3 cm, Van Gogh Museum, Amsterdam.*

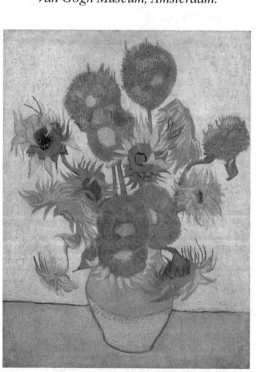

*Fig. 17. Vincent van Gogh, **Sunflowers**, 1888. Oil on canvas, 92 x 73 cm, National Gallery, London.*

Vincent and Gauguin shared the four-room studio for a somewhat brief period, until the infamous ear episode. Theirs was a complicated relationship. They started as friends, painting portraits of each other (Figures 18-19).

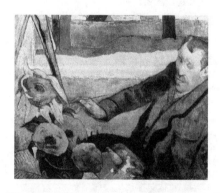

*Fig. 18. "The Painter of Sunflowers," **Portrait of Vincent van Gogh**, Paul Gauguin, 1888. 73 x 91 cm, Oil on canvas on "jute", Rijksmuseum, Amsterdam, Netherlands*

Fig. 19. Vincent van Gogh,
Portrait of Paul Gauguin,*1888,*
Oil on burlap, 38.2 x 33.8cm,
Van Gogh Museum, Amsterdam.
Vincent painted his roommate and
fellow artist in the Yellow House.

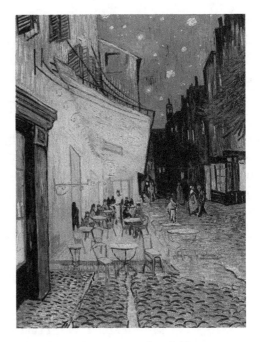

Fig. 20. "Eating together." Vincent van
Gogh, **Café Terrace at Night**, *1888. Oil*
on canvas, 80.7 x 65.3cm, Kroller-Muller
Museum, Otterlo

They seemed at first to enjoy painting and working together and discussing art at length. However, predictably, Vincent had this talent for losing friendships, and his relationship with Gauguin was no exception. Though they spent a significant amount of time painting, eating (Figure 20), drinking (Figure 21) and whoring together (Figure 22), their friendship and compatibility eventually reached a dramatic end. Why?

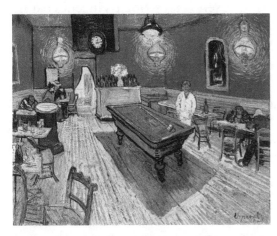

Fig. 21. "Drinking together." Vincent van
Gogh, **The Night Café**, *1888. Oil on canvas,*
72.4 x 92 cm. Yale University Art Gallery,
New Haven, Conn.

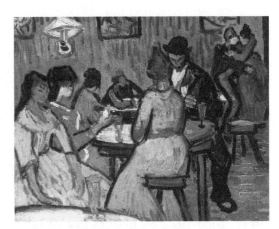

Fig. 22. "Whoring together." Vincent van
Gogh, **The Brothel**, *1888. Oil on canvas,*
33x41 cm. The Barnes Foundation,
Merion, Pa.

Weeks of frustration between the two roommates led up to Vincent's infamous alleged self-ear mutilation. In mid-December, Gauguin—who was also getting a stipend from Theo to live with Vincent—had grown frustrated with Vincent's intrusive and unpleasant behavior and expressed a plan to get away from Vincent, whom he often claimed later was "*mad.*" Vincent was both needy and argumentative; he would never back down from any verbal confrontation, which he most often precipitated. They argued more and more, until finally on December 23, Gauguin told Vincent that he was leaving him and the Yellow House. Vincent apparently exploded and threatened Gauguin, or so the story goes—at least Gauguin's version. After Gauguin walked out the door, Vincent, now in a rage, cut off much of his own ear and delivered it to a prostitute named Rachel. Or so the story goes. An interesting book studying all aspects of the ear episode and what was actually amputated was written by Bernadette Murphy, *Van Gogh's Ear* (2016).

Gauguin And Vincent Duel To Defend The Prostitute Rachel's Honor

An alternative, brilliant, and in depth view of Paul Gauguin and Vincent's ear mutilation can be studied in Nick Van Der Leek's *The Murder of Vincent Van Gogh* (Shakedown, 2018). Van Der Leek bravely suggests that it was Gauguin who cut off Vincent's ear prior to his announced departure back to Paris (*ibid.*). Possibly both were consorting with Rachel and had a fight on who was her rightful lover? Vincent would have been more vulnerable and needy in this scenario. Probably, Vincent claimed she loved him too, they argued, inebriated, as Gauguin emphasized reality to him as his parting "*fatherly advice*". Maybe Vincent foolishly challenged Gauguin to a duel to settle their differences, and protect Rachel's honor. Gauguin was a known fighter and expert swordsman and (purposely) sideswiped Vincent's ear in this version. Gauguin's story is the one the police, doctors, and townspeople heard, and became the accepted legend. When Paul Gauguin was sent back his swords from Arles, after his speedy departure, were there still remnants of Vincent's blood remnants on it? This would explain why Vincent took his ear remnant to Rachel to show her his "*love*" for her and his willingness to defend her honor.

The police took Vincent, bleeding, to the hospital on the day before Christmas. Johanna Bonger had just agreed to marry Theo and was planning to take him to her family in Holland for Christmas when Theo received a telegram from Gauguin to come immediately to Arles. He claimed Vincent had fallen "*gravely ill*" (Naifeh, p. 705-706, 2011). Theo stopped his holiday plans and rushed to Vincent's bedside. After Theo was assured by the doctor, Felix Rey, an intern (Figure 23), that Vincent would survive and was in good hands, he immediately departed to join his wife and her family in Holland. Dr. Rey told Theo that Vincent was suffering from "*over excitement*" and an "*extremely hypersensitive personality*," but was not "*mad*" (*ibid.*, p. 707). During his

hospital stay, Vincent had problems with the doctors and the staff in general but liked the intern, Dr. Rey. Though it was not directly stated, Theo's quick departure could have been indicative of a strained relationship between the two brothers, or just the need to be with his beloved, Johanna, rather than babysit his older and difficult brother.

Vincent's self-portraits with bandaged left ear are intriguing, and demonstrate his focus on his art and himself as they seemed inextricably bound. He was always looking in the mirror to study himself—a form of introspection and therapeutic meditation that may have contributed to his eventual recovery in the asylum (Figures 24, 25).

Since he was considered "*crazy*," Vincent was put in isolation. During this time, 30 of his neighbors—except his only loyal friend, the postmaster, Joseph Roulin (Figure 26)—signed a petition to the mayor and the police

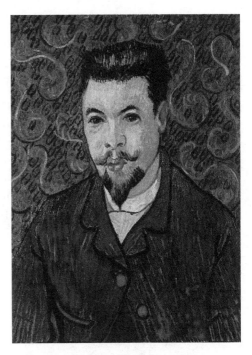

*Fig. 23. Doctor Rey treated Vincent after his self-mutilation, Vincent van Gogh, **Portrait of Doctor Rey**, 1889, Oil on canvas, 64 x 53 cm, The Pushkin State Museum of Fine Arts, Moscow*

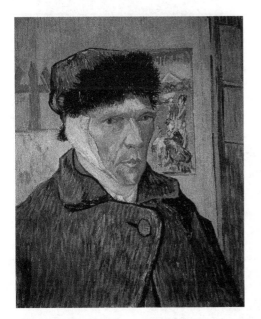

*Fig. 24. Vincent van Gogh, **Self-Portrait with Bandaged Ear**, 1889, Oil on canvas, 60 x 49 cm. Courtauld Gallery, London*

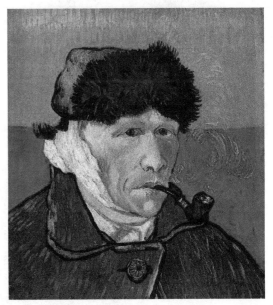

*Fig. 25. Vincent van Gogh, **Self-Portrait with Bandaged Ear and Pipe**, 1889. Oil on canvas, 51 x 45 cm, Kunsthaus, Zurich (on loan)*

to have him removed from the Yellow House and put in an asylum. Roulin's son, Armand (Figure 27), also sat for his portrait and was the "*star*" in *Loving Vincent*. The long and difficult hospital recovery combined with the strongly negative reaction of his neighbors is what ultimately led Vincent to decide, himself, to escape the threats, taunts, and ongoing torments and admit himself to the asylum. He apparently believed this was his only escape to peace and quiet and the ability to think, meditate, refocus, and paint whenever he could. When he was discharged from the Arles hospital, safe to travel, he left for the asylum in Saint Rémy where he admitted himself to a room provided by Theo. Theo paid the bills, yet interestingly never came to visit his brother. He was too focused on his wife and his new life, or just happy to not have to deal with his difficult brother, but rather keep paying the bills for his own peace and quiet.

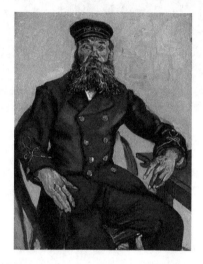

*Fig. 26. A portrait of Vincent's best friend in Arles. Vincent van Gogh, **Postman Joseph Roulin**, 1888. Oil on canvas, 81.3 x 65.4 cm. Museum of Fine Arts, Boston, Mass.*

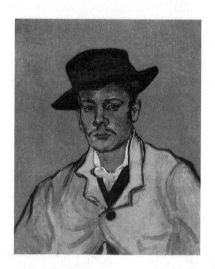

*Fig. 27. The Postman's Son, Vincent van Gogh, **Portrait d'Armand Roulin**, 1888, Oil on canvas, 54.1 x 65 cm. Museum Folkwang, Essen, Germany*

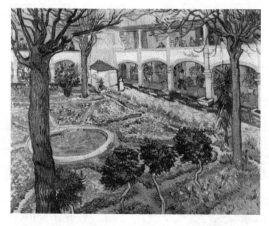

*Fig. 28. Vincent van Gogh, **Garden of the Hospital in Arles**, 1889, Oil on canvas, 73 x 92 cm. Oskar Reinhart Collection, Winterthur, Switzerland*

The Asylum Period in Saint Rémy

After much arguing with everyone but his friend, the postman, Vincent agreed to admit himself to the Asylum for Epileptics and Lunatics in Saint Rémy, near Arles. Once there, except for his letters and his art, he remained somewhat mute and used this year of quiet to re-explore his life, his innermost thoughts, and expunge his inner demons. A year later, he emerged calm and "*cured.*" Apparently the solitude, introspection, basic diet, and forced sobriety were an effective therapy that helped Vincent to achieve a new, more comfortable, calm, serene, and accepting self.

The view from the large window at the asylum at Saint Rémy was a pleasant escape from his neighbors in Arles and the loss of his painting "*friend*" Gauguin.

A recent, well-documented study titled "*Starry Night—Van Gogh at the Asylum*" details the year from May 1889 to May 1890 that Vincent spent in the town of Saint-Rémy-de-Provence at the Saint-Paul-de-Mausole asylum (M. Bailey, Starry Night, 2018). Vincent remained inside the walls of the asylum, though was occasionally allowed outside to paint. Importantly, this study presents an amazing account of what Vincent's life was really like for that year of self-imprisonment. His movement was limited and he lost many freedoms, but despite all of these self-imposed and asylum restrictions, he was brilliant and prolific in his output as usual (*ibid.*) and as evidenced by the masterpiece, *Starry Night* (Figure 29).

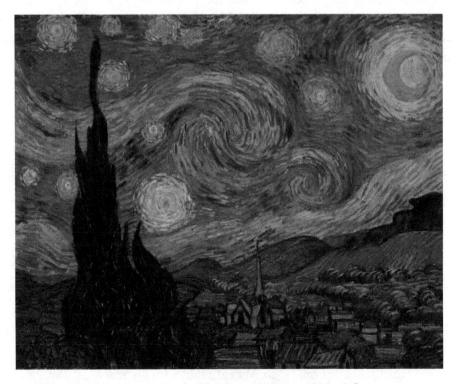

*Fig. 29. Vincent van Gogh, **The Starry Night**, 1889. Oil on canvas,*
73.7 x 92.1 cm. Museum of Modern Art, New York

I believe that his year in the asylum, under these restrictive conditions, allowed Vincent the time to really think everything through and leave the asylum a new man. I believe he really was "*cured*" of his "*madness*" and other assorted mental, social and behavioral issues that he entered with. At least he was significantly improved (if not "*cured*") and much better able to cope with life's travails in a more finely focused capacity. After all, he had nothing else to do for a year except eat, sleep, take "*the cold baths,*" reflect with deep introspection, get out into nature to find a place to put his easel and paints...and paint, and paint even more. And of course, write letters. His self-portraits at the asylum were less frequent and less intense than his prior periods. I accept that there was a decrease in his past need for deep introspection, which he had often achieved while viewing himself for hours in the mirror. This very necessary and significant deep look into himself while he created his self-portraits also reflected his mental state. This can be clinically considered a relevant indicator of his mental improvement, the "*cure*" if you will, which is intriguingly confirmed by the lack of any self-portraits in Auvers—his most calm and prolific period.

Many of his canvases from Arles and Saint Rémy are iconic images and are now hugely sought-after, but at that time he had trouble giving them away as gifts. Unfortunately many were destroyed—some were even used as archery targets. Masterpieces of this period, like *Wheat Fields with Cypresses* (Figure 30) and *Starry Night* (Figure 29) have gained international fame and fortune for those fortunate enough to have the vision of their artistic merit early on, before Vincent's acceptance and fame had spread. The latter was even the subject of a song in honor of Vincent that suggests he wasn't crazy, but maybe commited suicide as "*lovers often do*" after a love affair gone awry ("*Vincent,*" also known as "*Starry, Starry Night,*" by Don McLean).

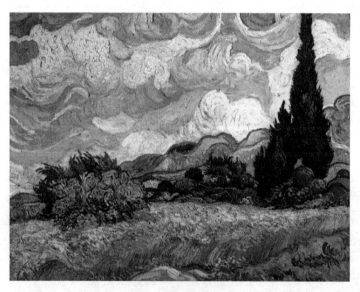

Fig. 30. Vincent van Gogh, **Wheat Field with Cypresses at the Haute Galline Near Eygalieres***, 1889. Oil on canvas, 73 x 93.4 cm, Metropolitan Museum of Art, New York City*

The Departure From The Asylum In Saint Rémy

As the year in the asylum, looking out his window (Figure 31), was ending with fewer and milder attacks, Vincent felt better and was calmer. He desperately wanted to go to Paris to meet his sister-in-law, Johanna, and his new nephew, Vincent, who had been named after him. He also wanted to catch up on what was happening in the Parisian art world. Because Vincent was in Saint Rémy on a voluntary basis, Dr. Peyron agreed to discharge him from the asylum and wrote "*cured*" in the register after his discharge on May 16, 1890.

Vincent traveled by himself overnight on the train to Paris on May 17 where Theo met him and took him home. He very much enjoyed meeting Jo and little Vincent in their small apartment, which was filled with Vincent's paintings everywhere. Johanna enjoyed finally meeting Vincent and later remarked on how much healthier he looked than her frail husband. However, Vincent perceived an

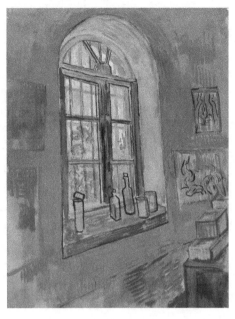

Fig. 31. Vincent van Gogh,
Window in the Studio, *1889.*
Chalk, brush and oil paint,
and watercolor on paper, 62 x
47.6 cm. Van Gogh Museum,
Amsterdam

undercurrent of tension, mostly financial, and felt uncomfortable with his ongoing dependency on his brother's good will. Despite this long awaited family reunion, his discomfort apparently prompted Vincent to leave Paris earlier than expected, for his new home in Auvers-sur-Oise, only an easy hour by train from Paris.

Despite his successful career as an art dealer, Theo could not sell his brother's paintings, which were notably out of the mainstream of commercially accepted artworks. There was only one major oil painting, *The Red Vineyard* (Figure 32), that

Fig.32. Vincent van Gogh, ***The Red Vineyard****,*
1888, 75cm x 93cm, Pushkin Museum
of Fine Arts, Moscow

was sold while Vincent was alive. This painting was purchased by a fellow artist, Anna Boch, for 400 Belgian francs—roughly $400 USD in 1890 or at least $4,000 today. It was the only major oil painting sold, not traded or gifted, while he lived.

This recognition of a real sale and the positive published critiques he had received of his art should have been exciting for any *"starving"* artist. You would think Vincent should have been ecstatic at any awareness of the beginning of his successful start in the art world as a commercially successful artist, but it was not to be. This lack of enthusiasm was despite a very positive review by the newly recognized art critic, Albert Aurier. After a few days in Paris taking in as many galleries and exhibits as he could, visiting Pere Tanguy painter's supply store where some of his prolific output was stored, Vincent felt compelled to pack it all up to go to Auvers-sur-Oise. Vincent was disappointed that his old friends Emile Bernard and Paul Gauguin were in Paris, but there was no communication, interest, or any opportunity to get together.

On May 20, Vincent departed for an hour's train ride to the sleepy little village of Auvers-sur-Oise, to meet his new friend and doctor. This was to be the start of a new life, which he had prepared for after a year of rest, solitude, painting, and planning his new life. There is no documented reason why Vincent left Paris so quickly, but we can speculate that there was perhaps an argument, not written about but alluded to. Theo's finances were becoming challenging for everyone dependent on him, and Vincent appeared to be much more capable and in control of himself. He was less overwhelmed by stresses now and more accepting of his situation after his year in the asylum, but very much looking forward to his first meeting his sister-in-law, Johanna and his name sake nephew.

Why Was Vincent's Reunion With Theo And His New Family So Brief, And What Was The Reason For His Rapid Departure?

No one knows for sure what happened. Jo never really described anything negative about that visit in her diary or her memoir (Johanna van Gogh-Bonger, 1913, 2015). She always kept to proper French society and Dutch Reform upbringing in the age of Victorian mores, and made an extra effort to maintain a *"family friendly"* story for the lives and interactions of her family, particularly the brothers. The only unusual comments from that visit were how surprised Jo was to finally see Vincent in such good health compared to his younger, sickly brother, when they were standing side by side. When she first glimpsed Vincent, she said *"I had expected a sick person"* (Naifeh, p. 821, 2011). Later, she wrote *"but here was a sturdy, broad shouldered man, with healthy color, a smile on his face, and a very resolute appearance"* (*ibid.*). It all must have seemed strange for her, since these two brothers had not seen each other for almost two years,

since the ear episode. Theo, then, only made a short visit to the Arles hospital from Paris to see his brother and meet his ear doctor, after which he abruptly left to meet Jo's family for the Christmas holiday and wedding planning.

One possible theory to explain why the two brothers, once so close, drifted apart over those last years is Jo's excessive fascination and constant awareness of Vincent in her life. Perhaps there was an attraction to her brother-in-law that came from his constant presence in her life and the ongoing conversations between her husband and his brother in voluminous correspondences. Perhaps it came from the ever-present Vincent art surrounding her in her home, a presence that came to define all aspects of her new life and family. It would have been a difficult distraction for her to deal with, all while she was getting used to life with a new baby. Jo initially may have been ambivalent about Vincent, torn between her fascination with his art, an appreciation for his genius, and the significant impact of his financial drain on her household activities. Maybe she appreciated Vincent's art at an emotional, gut level that she found attractive and compelling. Certainly his intellect was appealing. It's possible that Jo fell in love with Vincent's art and creativity, being continually surrounded by it all the time, everywhere she looked. It is also conceivable that after meeting Vincent face-to-face and finding him surprisingly "*attractive*"—and probably even more attractive than Vincent's sickly brother and her husband—there may have been some challenging brotherly competition and confrontational unspoken body language that Vincent sensed. After all, Jo had said she was surprised how much healthier and "*broad shouldered*" Vincent was than her pale, weak-appearing husband. Maybe when she actually met Vincent there was an unexpected, reciprocal attraction, "*love at first sight*," that was readily apparent to all.

Maybe Jo's unexpected feelings for Vincent predisposed her to take on the lifelong mantle of the defender of everything Vincent after the brothers' deaths? Maybe Jo really ended up falling for the other brother? It would explain why Jo dedicated her life to Vincent's memory, recognition, and fame, and not Theo's. After all, everything in her life—her husband's work, the family's finances, the art on her walls, even her son's name—was devoted to Vincent...a devotion to which she may finally have succumbed. These unexpected feelings could also explain why Vincent felt so uncomfortable with Paris, and departed so rapidly without any explanation.

Vincent made only one comment about his departure: "*I felt very strongly that all the noise there was not for me.*" He said, "*Paris had such a bad effect on me that I thought it wise for my head's sake to fly to the country.*" Maybe it was not the "*noise,*" but the transparent, mutual feelings of attraction for Jo that made him so uncomfortable around his brother and his new wife. We cannot know for sure what was really happening when Vincent left Paris. Was he actually experiencing the beginnings of another vertigo attack? Was it a situational stress reaction with a possible panic attack, or was he just feeling guilty for his financial dependence on his younger brother? Was he deeply jealous of his brother's good fortune to find his life partner, Jo? Or was he truly frightened by the

consequences of an apparent mutual attraction between Jo and himself? The van Goghs were a dysfunctional family at several levels to say the least, but they paled in comparison to the truly dysfunctional Gachet family you will meet next in Auvers-sur-Oise.

Dr. Paul-Ferdinand Gachet was a doctor in the French national home guard protecting Paris during the 1870 Franco-Prussian war, who was to become Vincent's doctor and "*friend*." He was not a surgeon and abhorred blood. He was a specialist in matters of the mind and melancholia, which today would be a psychiatrist, focused on depression. Theo, on the recommendation of Camille Pissarro, had arranged for Vincent to be under the medical care and supervision of Dr. Gachet in Auvers-sur-Oise. Dr. Gachet was also an avid collector of Impressionist art with many contacts in the art world, and he owned works from some of the best artists of the period. Meeting Dr. Gachet and his family should be intriguing and enlightening. Vincent looked forward to meeting him. Little did the artist know, as he boarded that train from Paris to Auvers-sur-Oise, that it was a one-way ticket to the place of his impending death.

Chapter Two

The Critical Auvers-sur-Oise Period:
The Last 70 Days of Vincent's Life

The Auvers-sur-Oise period, Vincent's last 70 days, is a separate challenge to fully appreciate, as we already have the knowledge of how it all tragically ended. It is the least well-documented time of his artistic career, as well as of his many personal challenges. Vincent's final adventure began when he stepped off the train in the small vacation town of Auvers-sur-Oise after his brief family visit in Paris on May 20, 1890. Did he have any inkling of what life, love, and death surprises were awaiting him in Auvers?

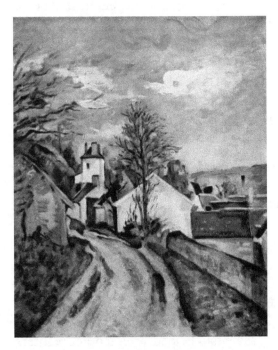

Fig 33. Paul Cézanne,
The House of Dr. Gachet in Auvers,
1873. 41 x 27 cm, Musee d'Orsay, Paris.

Vincent came to the artists' village of Auvers-sur-Oise, 20 miles north of Paris, specifically to be under the medical care and supervision of Dr. Paul-Ferdinand Gachet and start his new life. They met the same day he arrived. Dr. Gachet's consulting practice included three days each week when he would routinely commute into Paris, but he would see patients like Vincent at his home for a consultation, maybe over lunch. A plan was agreed on by which Vincent would meet with the doctor at his home frequently and as needed, for any consultations. Dr. Gachet's villa on a bluff was once painted by Paul Cezanne in 1873 (Figure 33). It was also photographed from the river up to the compound on the bluff in 1906 (Figure 34). The Gachet home and unique household were an integral part, if not the focal point, of Vincent's social awakening in Auvers as you will see.

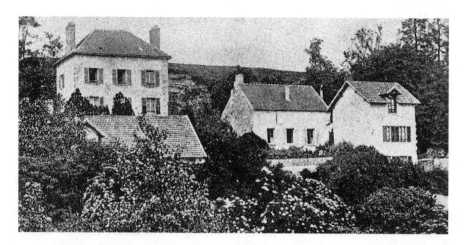

*Fig. 34. Photo of **the Gachet property from behind**. Circa 1906.*

Artistically, you also will see that the year of introspection and technical experimentation from his time in the asylum was now open to his fullest exploration and uninhibited production in the pleasant absence of what we now know were intermittent vertigo attacks separated by symptom-free periods. His general health and demeanor seemed so much better than in Arles. The solitude of the asylum had allowed Vincent to adjust to his own reality, accept himself as an artist, and further his ongoing development of his unique artistic flair and style. He was so much better now after the asylum than before that he no longer felt the need for self-portraiture to center himself as to who he really was. He no longer needed that self focusing in the mirror for long periods of self reflection and astute, deep introspection. This can be considered a form of therapeutic meditation. It worked for Vincent, he was now much calmer, and in control. He became fully engaged and able to totally focus on his art, enjoying the freedom to explore more subtleties of color and other nuances of his evolving technique, insight, and perspective. He was also now able to explore his social awakening as well.

The Basic Accepted Narrative

What really happened in Auvers, or at least the most basic accepted sketch of the last 70 days of Vincent's life, is as follows. Upon arriving from Paris on May 20, Vincent left immediately from the train station to meet Dr. Paul-Ferdinand Gachet, the homeopathic doctor whom Pissarro had recommended to Theo. Dr. Gachet was interested in melancholia, or what today we would think of as depression. Dr. Gachet was accepted in the Impressionist artist circles, as he had helped several other painters with their various melancholias, maladies, and also collected their art. Upon their first meeting, Vincent's initial impression was that the doctor was very strange, even more strange than Vincent himself. Even so, they agreed to meet a couple of times a week, often over lunch. Dr. Gachet had told Theo that Vincent would do well with all the peace and quiet of the village and the fresh air.

Due to budgetary constraints that Vincent was now much more aware of after his brief visit in Paris, Vincent opted to stay at the Ravoux Inn, as it was a less expensive alternative to the hotel suggested by Dr. Gachet. He then took up residence in the most modest accommodations possible at the Ravoux Inn in the town square across from the city hall. He had a windowless garret room on the third floor with only a skylight-type window. He also had his meals provided.

The old Ravoux Inn (Figure 35) has not changed much 100 years after Vincent died in the room with the skylight window (Figures 36-38).

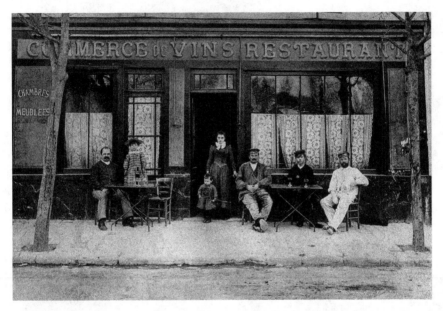

*Fig. 35. **The Ravoux Inn in Auvers-sur-Oise**, Adeline stands in the doorway. Circa 1900.*

*Figs. 36-38. **Vincent's room** with a view to the landing on the attic floor (36). Vincent's room with the built-in cabinet (37) and the only "window" built into the roof of Vincent's room (38).*

The overhead vent window (noted by the arrow) would allow the contained heat on those strikingly hot and humid July days a chance to escape (Figure 39-40). Vincent's room was located adjacent to another artist's room (Figures 41-42), Anton Hirschig.

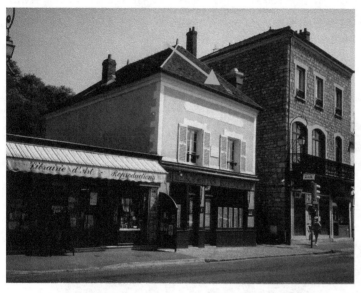

Fig. 40. *The two arrows point to the **garret windows in Vincent's room as well as Anton Hirschig adjacent room**. Photo by author, 1990.*

Fig. 39. ***The old Ravoux Inn*** *(arrow pointing at Vincent's window) as it looked in summer 1990, 100 years after Vincent's murder. Photo by author, 1990.*

41

42

Figs. 41-42. ***Anton Hirschig's adjacent garret room to Vincent*** *where he heard Vincent screaming for someone to cut on his belly. Note, this bed is likely to be the same bed as Vincent's. Photos by author, 1990.*

Vincent began to paint almost immediately after his arrival and settling in to the inn. He often set up his easel and paints in the village nearby. Many have said this was his calmest, most peaceful, and most productive time. He extended his painting and sketching efforts all over the surrounding environs and could often be seen finding his focus and planting himself there for hours. Canvases, drawings, sketches, and even an etching were produced at an astounding rate. He ultimately painted over 70 canvases, about 40 drawings, and one notable etching during this especially prolific final period of only 70 days. Notably and most interestingly, during this brief time, he produced relatively fewer letters. He was focusing even more on his art, or…what else could have distracted him to decrease the rate of his letters but not his painting and drawing? What new personal challenges did he face in Auvers that he did not face prior to his arrival? Maybe the pace of his correspondence diminished after his arrival, but did not slow down his artistic productivity—or maybe it even enhanced it? Why was he distracted from his family but not his art? What may have been this new distraction that so changed Vincent's old behavior patterns and his family's relative importance to him?

It became apparent that despite leaving his many personal problems behind him at the asylum, he still had several significant unmet challenges to face in the real world, including the personal and financial challenges he was forced to confront after his brief visit with Theo and his new family in Paris. He seemed much more focused and calm now, but was he really better prepared to deal with all these new and heightened challenges, and to start fresh on an even more daring, yet serene artistic path in Auvers?

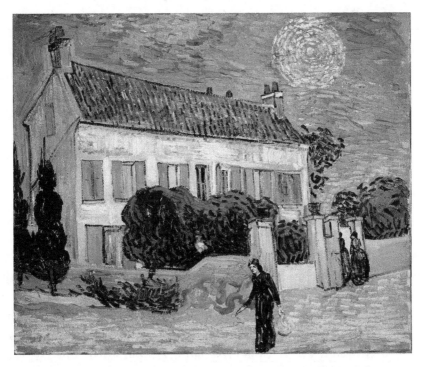

*Fig. 43. Vincent van Gogh, **The White House at Night**, 1890. Oil on canvas, 59.5 x 73 cm, State Hermitage Museum, Saint Petersburg, Russia.*

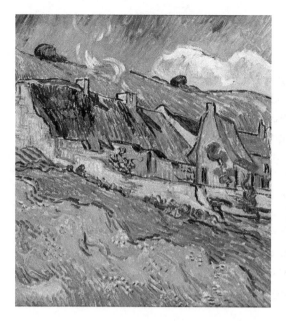

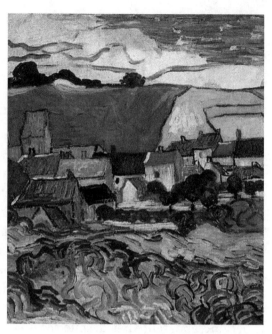

*Fig. 44. Vincent van Gogh, **Thatched Cottages and Houses**, 1890. Oil on canvas, 60 x 73 cm, State Hermitage Museum, Saint Petersburg, Russia.*

*Fig. 45. Vincent van Gogh, **View of Auvers**, 1890. Oil on canvas, 50 x 52 cm, Van Gogh Museum, Amsterdam.*

His long-term awareness of his unmet challenges were reinforced while Vincent was last in Paris. These new challenges were the focus and distraction of his apparent diminishing rate of ongoing familial correspondence. Maybe he felt no need to continue to rehash the obvious. Theo now had a family and his apartment was inadequate for all of them. Vincent had seen what a burden he was and understood what stress he was placing on his brother and his new family. His artistic endeavors, however, continued to blossom and flourish unabated, even possibly accelerated, despite any troubling family financial needs discussed with his brother on their cab ride from the train station to the apartment. Still, he appeared to have handled these new challenges with much more rationality than he would have prior to his year in the semi-solitude of self-imprisonment at the Saint Rémy asylum.

Vincent's Social Activities

It is necessary, if not truly essential in solving Vincent's murder, to seek answers to so many unanswered questions and to have some understanding of who he met in Auvers, what kind of friends he made, and where he went. How did he spend his free time? While relatively little is known for sure about how he spent his time when he was not occupied with painting, eating, and sleeping, it is still important to have an awareness of what facts and gossip were known or at least bandied about town when he was not with brush. Did he socialize with those he met at the inn where he stayed, or with the wealthy teenagers from Paris who summered in Auvers?

How else did he spend his time, besides focusing on his unbelievable artistic output? Did Vincent fall in love again? Was all of his free time focused on courting Mademoiselle Marguerite Gachet, the 20-year-old daughter of his doctor? If so, was it another heart-rending romantic disaster in the making, or was it a mutually endearing and loving relationship? We will find out how a significant relationship evolved and the role she was to play in his death. Both Vincent and Marguerite knew Dr. Gachet's schedule, and the times when he went to his consulting offices in Paris three times each week. It was therefore easy for Vincent to spend personal time with Margueritte when the doctor was in Paris and focus on his art when Dr. Gachet was about in Auvers. Truly, he could crank out paintings at an unbelievable rate and still have time for courting Marguerite.

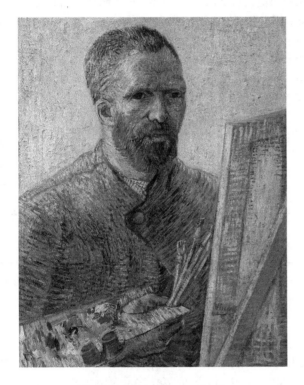

Fig. 46. Vincent van Gogh,
Self Portrait, *1888. Oil on canvas,*
65 x 50 cm, Van Gogh Museum, Amsterdam.

Did Marguerite provide the missing love from his life that he had always been seeking? There were rumors and gossip that he may indeed have fallen in love. What impact may that love affair have had on his life or his death? Let's look at these many questions, mysteries, and other intriguing aspects leading up to the day van Gogh was mortally wounded when he may have been shot or knifed. The answers to these many diverse questions will shed light on what really may have happened to Vincent in those last 70 days.

Vincent's prolific output from Auvers can speak for itself, but there is very little documentation to speak to the state of the rest of his life at that time. This critical period was not well-recorded in his correspondence, and Vincent's last few days represent an especially large and glaring gap and information deficit. No letters to rely on. The prevailing historical narrative has relied largely on uncorroborated first-hand and second-hand accounts that were passed down orally; many of them were not only conflicting but also blatantly self-serving, fed to the written media many years after Vincent's death and most importantly, by a person of interest after Vincent's reputation was rising to legendary heights. This renders such *"facts"* less than useful. Did all of Vincent's letters from Auvers survive? Van Gogh scholars suggest that possibly some critical last letters from this period have gone missing, were destroyed, or still may exist, but are not available to the public because of *"family considerations."* What critical information may be withheld?

When Vincent was not off painting alone, he did spend time at the Gachet home with his doctor-artist friend, doing things such as learning how to make etchings. He mastered this technique in very short order, creating another amazing image of Dr. Gachet. However, he did not enjoy this medium or find it expressive enough for his style. His one known etching of the doctor is all that survived (Figure 131, Chapter 16). Vincent and Dr. Gachet spent time discussing art and literature and the cultural goings-on in Paris.

Vincent often ate with the Gachet family but clearly did not actively interact with 17-year-old Paul Gachet Jr., whom he never painted nor gave any indication that he even liked him. Paul Jr. desperately wanted to be a painter like his father, and also sought that goal believing he would learn from painting alongside Vincent. But that was not to be. Apparently Paul Jr. really wanted to be with Vincent, but Vincent's only real interest appeared to be focused on Paul's 20-year-old sister, Marguerite. This was evident to the entire family—including to the keen eye of Madame Louise Chevalier, the old housekeeper and probable long-term mistress of the good doctor since before his wife died from consumption when the children were very young.

When Vincent was not with Marguerite in the home, in the garden, or in public view, and when Dr. Gachet went into Paris three days a week for his consulting practice, it is not hard to imagine that Vincent and Marguerite found plenty of opportunities to talk, meet, and become the best of friends. Both were clearly open and in need of such a liason, according to the rampant rumors all over town, that even young Adeline Ravoux was aware of.

The Accepted Story About What Happened on the Day van Gogh was Fatally Injured

According to the most prevalent theories and accounts of what happened on July 27, 1890 when Vincent was mortally wounded, it was a hot and muggy Sunday afternoon. After a brief lunch, it is said in the gospel account of his "*suicide*" that Vincent walked to a wheat field near the Chateau Auvers, which was located on a butte, produced a gun whose origin and location remain an enigma, and shot himself in the belly (or alternatively in the chest) in an attempted suicide. No one reported hearing a gunshot, and there were no witnesses, no crime scene, and no suicide note—except in the movie *Lust for Life*, where the need for a suicide scene was felt essential to give the suicide narrative credence, so a last minute pencil and paper scribbled note by Vincent (Kirk Douglas) was made just before that gunshot was heard by a farmer in the wagon. Therefore, who could question the suicide?

Somehow, Vincent stumbled back to the inn, climbed the 17 stairs to his garret room in the windowless attic, calmly smoked a pipe, and told the innkeeper, "*I wounded myself*." The next morning, before his brother arrived, he told the policeman Rigaumon, "*Do not blame anyone, I did it myself*" or "*It was me, I tried to kill myself, do not blame another*"

(and similar uncorroborated statements). Was he telling the truth, or trying to protect someone? Who would he try to protect and why? What could be his motivation to protect anyone, if his intent was truly to end his life? Did he really say those things, or was that a critical part of the cover-up suicide narrative regaled to Theo and Emile Bernard upon their arrival the next day?

Interestingly, no police report exists to substantiate any of this narrative or any of Vincent's deathbed statements. Moreover, any deathbed statements made to Rigaumon would be considered uncorroborated and hearsay evidence. Two doctors evaluated Vincent and concurred that *"nothing could be done."* They offered no treatment or attempt to get him to Paris for the best possible treatment. Interestingly, these medical reports, police reports, and drawings disappeared as well, if they ever existed. Theo arrived the next day from Paris and stayed with his dying brother all night until he passed away in his arms. His funeral was quickly arranged, and some friends came from Paris to pay their last respects. He was buried in that peaceful little town whose picturesque landscapes had inspired him in his final days, and all his secrets were buried with him.

The Provenance of the Art From This Auver's Period

Much like the circumstances of his death, mystery surrounds Vincent's art from this last period. His artistic output, though known to be abundant, is somewhat sketchy and the least detailed and rarely documented. So, art historians are left with very limited access to his intent, his thinking, and the provenance of his art from the Auvers period. Scholars have assumed that the many canvases and drawings attributed to Vincent's Auvers period were all done by his hand. However, an art forgery ring was busted in the 1950s that may have produced van Gogh forgeries (Tromp, 2010, Van Der Leek, 2018).

David Sweetman pointed out the uncertainty surrounding Vincent's time in Auvers when he wrote:

> *"It was too late. Something had happened to Vincent* [after July 22] *that had put him beyond his brother's help. If he had another attack similar to those he suffered in Arles and Saint Rémy, no one knew, for he was effectively unsupervised by then. All of the reports of these lost days were written up much later and frequently contradictory or self-justifying."*
> —(Sweetman, p. 337, 1990)

A simple yet basic example of the blatant contradictions Sweetman mentions was the question of whether Vincent was drinking in Auvers-sur-Oise.

Two different people gave two quite opposite opinions and contradictory statements many

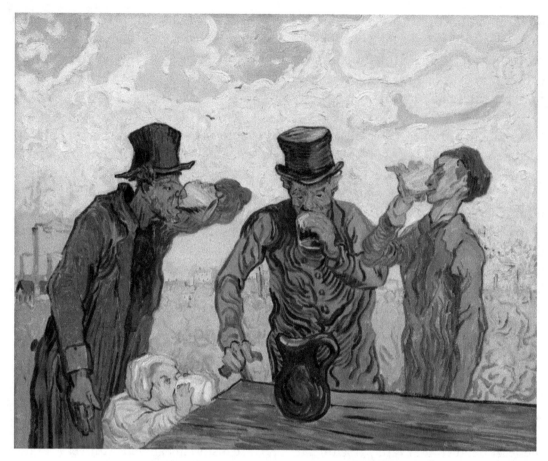

*Fig. 47. Vincent van Gogh, **The Drinkers**, 1890. Oil on canvas,*
59.4 x 73.4 cm, The Art Institute of Chicago, Illinois.

years later: Adeline Ravoux, the innkeeper's daughter, and others said Vincent wasn't drinking. Adeline was a teenager at the time, and portrayed Vincent as very friendly and kind to her, her little sister, her parents, and the other guests. She was surprised and very upset to hear all the "*lies*" and contrived stories after his death. Since she helped run the inn and the bar with her parents, as well as feed Vincent, she would be aware of his drinking habits and almost all the goings on in her family inn. It being France, having wine with dinner was so normal as to not be considered unusual or problematic. She stated somewhat emphatically, however, that "*Vincent never drank*" (Tralbaut, 1969).

René Secrétan, a teenage vacationer that summer in Auvers, said he and his older brother, Gaston, were often drinking with Vincent (Doiteau, 1955). René was wont to play "*cowboys and Indians*" after seeing a Wild West show at the Paris Exhibition the prior year. He wanted to portray Vincent as a crazy oaf and made him the butt of jokes and pranks, often threatening Vincent with his loaded gun. He wanted everyone to accept Vincent as a drunkard (*ibid.*). Who do you believe? If something relatively minor, like Vincent's drinking habits, is so unknown and diametrically opposite, it goes to say that more important and consequential aspects of his time in Auvers are similarly contested.

The Calm, Serene, Prolific Last 70 Days

David Sweetman does find consistent meaning in Vincent's artwork produced in Auvers. Sweetman's biggest contribution to our understanding of the Auvers period is his focused analysis of the significant changes in Vincent's painting in Auvers compared to his prior efforts in Arles and Saint Rémy. He writes that what the Auvers works reveal is:

> *"...an artist struggling to find a new way forward. He knew that the violent, tortured colors of the south had pushed him further and further down the road to abstraction, away from his earlier fidelity to nature."*
>
> —(Sweetman, 1990)

*Fig. 48. Vincent van Gogh, **Daubigny's Garden**, 1890. Oil on canvas, 54 x 101.5 cm, Van Gogh Museum, Amsterdam.*

As Sweetman continued,

> *"The simple fact is that while Vincent the man suffered [from 'le vertige'], his great gift to us is the glorious sanity of his work."*

See Figure 48 for an example of a serene scene in Daubigny's Garden that is more characteristic of Auvers, and what I believe Sweetman refers to as an example of Vincent's *"glorious sanity."*

> *"His struggle was not to infect his canvases with his violent seizures [vertigo], but to exclude them."*
>
> —(*ibid.*, 1990)

> *"So, did he really mean to kill himself? True, he went out that day with a gun, probably up to a lane beside the local chateau, where he put a bullet in himself."*
>
> —(*ibid.*, 1990)

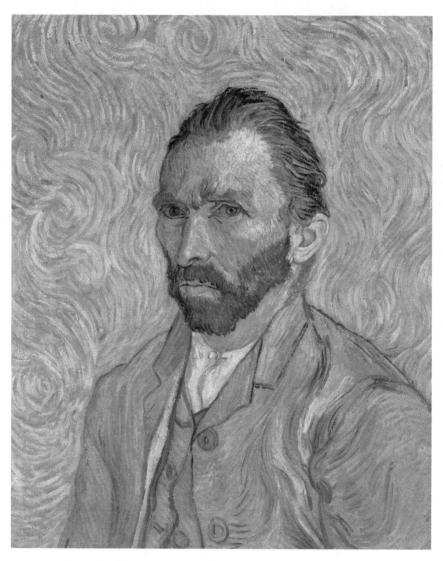

*Fig. 49. Vincent van Gogh, **Portrait of the Artist**, 1889.*
Oil on canvas, 65 x 54 cm, Musee d'Orsay, Paris.

Vincent's *Portrait of the Artist* (Figure 49) first appeared in public as "*Self portrait, collection of Paul Gachet fils, 1928*" in the frontispiece to the book (Doiteau, "*La folie de Van Gogh*"). It was then gifted to the Musée du Louvre in the 1950s and now resides in the Musée d'Orsay, Paris. I consider this self-portrait, one of his last, to be a very serene and calm painting by Vincent, notably different from those created during his Arles and early Saint Rémy periods.

In the end, I do believe that Vincent found more inner peace, apparent calm, self-confidence, and personal happiness in Auvers than he had ever had before. One of the strongest signals of this for me is the lack of a self-portrait created in Auvers—in fact, Vincent did not paint self-portraits at all between the end of his stay in the asylum in May and his death in Auvers, in July 1890.

Perhaps after the asylum he had found such serenity and a new level of self-comfort and self-confidence that he no longer needed to explore his inner mind and expound upon it on canvas. Maybe he was actually happy with life and Marguerite, and was not as troubled by the familial and financial problems he was aware of, but more or less appeased his brother, as he was considered by some a "manipulator," and needed that monthly stipend.

Vincent thought now he could just paint whatever he felt deeply moved him and caught his eye, and so he did! He thought with Marguerite by his side and his muse, he was finally an artist, the one he always wanted desperately to be. Sadly, he was never to reach his full potential or his productive capacity thanks to a penetrating abdominal wound, sustained in Auvers, that was not a suicide or an accident, but a planned murder and exhaustive cover-up. Let's explore what really happened...

Chapter Three

What Happened the Day Van Gogh was Mortally Wounded?

Vincent van Gogh got up at daybreak as usual on July 27, 1890 on what was expected to be just another beautiful sunny, hot, and sticky humid day in Auvers-sur-Oise, France—a lovely bustling yet bucolic vacationers' getaway only 20 miles from the hustle and bustle of an equally sweltering, muggy, and notably congested Paris. He had been discharged from the Saint Rémy asylum a little over two months prior to this day, "*cured*" of his mental and physical ailments, and was now settled at an inn owned by the Ravoux family in Auvers. The Ravouxes provided this unusual and quirky painter with a reasonable, yet spartan attic bedroom with a skylight window, a studio-like room to paint, places to dry and store his many canvases, and meals in their inn. Vincent painted their lovely teenage daughter, Adeline, several times while he stayed there.

After taking his breakfast at the inn, Vincent headed out that fateful day. Did he leave with all his art equipment intending to paint in nature, as was his routine? Or did he have a very different agenda that morning? No one thought anything was unusual that Sunday morning in July. Vincent returned to the inn for lunch and quickly departed again; he finally returned for good after dinnertime, without any of his painting supplies or a last canvas, but with an ultimately fatal abdominal wound. There were no witnesses to his wounding, there was no weapon or bullet in hand, and there was no crime scene known. Any crime scene investigator would have come away with an empty evidence bag and no certain place to search. The most basic details—where Vincent was injured, what weapon caused the injury, or what happened to his belongings, particularly that last canvas art historians believed him to be working on that fateful Sunday—are not known to this day and may never be definitively proven or accepted.

It is very strange to even speculate about why, on that classically gorgeous summer day in Auvers, when the vacationer population often doubled and most everyone was outside trying to catch a breeze, nobody heard a gunshot or seemed to notice the strange

red-headed painter returning injured from his outing. It's hard to imagine that not one person saw Vincent staggering back to the center of the village and toward the Ravoux Inn that Sunday eve from any place or any direction, presumably holding his bleeding belly and hiding his blood-stained shirt. Many believe he was injured in a wheatfield, but which one? Everything in Auvers-sur-Oise was surrounded by wheatfields.

Vincent walked alone into the Ravoux Inn restaurant and bar, where he was finally noticed by the inn owners. He was able to climb up the 17 stairs to his garret room unassisted, without any apparent shortness of breath and without coughing up any blood. Gustave Ravoux, the innkeeper, noticed that his guest failed to take his dinner, which was unusual, so he followed Vincent upstairs to check on him and discovered the horrible truth. Even with such a presumably painful wound, Vincent seemed lucid and calm. He climbed into his bed and requested to smoke his pipe.

Vincent van Gogh never left his bed again, and instead remained there for the duration of 30 hours, until he passed away in his brother Theo's arms early on July 29. The days between the time Vincent returned to the inn wounded and the day he died are even more mysterious than the circumstances that caused his death. Many of the stories from witnesses of that time conflict with each other. What really happened in the time between the grisly discovery in the evening of July 27 and van Gogh's eventual death in the early hours of July 29? Again, the mystery deepens, because the answer to that question depends on who was asked. Contradictory statements paint a confusing story of the ensuing bedside vigil. Vincent's brother, Theo, did not receive word of the tragic situation until the day after Vincent was wounded, July 28. Instead, Dr. Paul-Ferdinand Gachet, apparently devastated by his close friend and patient's plight, was said to have remained in Vincent's room the entire first night, and another doctor, Dr. Mazery, was reported to have been called to his bedside to evaluate Vincent on his deathbed. Both doctors eventually agreed and jointly decided that "*nothing can be done*." Neither doctor was able or willing to make any effort to save the doomed artist's life. No written notes or medical reports survived, if they ever existed. As you'll find out later, it's not known for certain if Dr. Mazery was actually ever even there. As with so much of the painter's life, even the simplest details turn into an ever-deepening mystery.

Vincent was buried, along with his many secrets, on July 30, 1890. His funeral was attended by a small group of friends, colleagues from Paris, and several people from the town. It was another beautiful sunny day, and his coffin was surrounded by many yellow flowers and his many paintings. Because his death was thought to have been a suicide, the church did not allow his funeral to be held on sacred ground, which was a devastating blow to Vincent's legacy, as he had a deeply religious background and internal belief system. He even once aspired to become an ordained preacher in an effort to appease and become more like his minister father.

Almost immediately after his burial, many of Vincent's oil paintings and sketches were collected from his rooms and taken away by Dr. Gachet and his son, Paul Jr. A mere six

months later, Theo, also a patient under Dr. Gachet's care in his Paris consulting rooms, unexpectedly died as well under somewhat unclear and suspicious circumstances. Theo was eventually buried next to his brother. Both had their remains disinterred and moved to their final resting place. Vincent's remains were re-interred in 1905 by the father and son Gachet; Theo's were re-interred in 1914 by his wife, Johanna, so that he could be with his brother through eternity's gate. They now remain together to this day, finally at peace after their years of brotherly love and ongoing fraternal conflict.

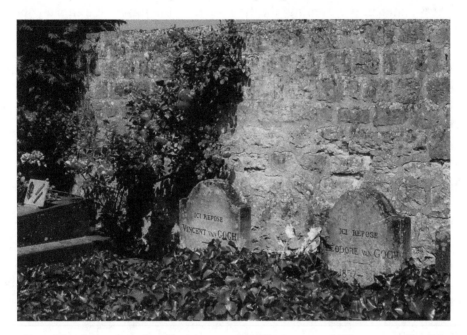

Fig. 50. "Are they finally at peace?" **Vincent and Theo van Gogh's Gravestones**, *Auvers-sur-Oise, France. Photo by author, 1990.*

Little had Vincent known that, after his brief lunch on July 27, he would be dead about 30 hours later...or did he know? At first, the word on the street in Auvers was that Vincent was simply *"wounded."* Suicide was first mentioned in a letter written just after the funeral by the artist's friend, Emile Bernard, to the art critic, Albert Aurier. Bernard got his information from Dr. Gachet upon arriving by train from Paris. Almost immediately, this account of Vincent's death became the most common and accepted narrative in Parisian art circles, as well as among the residents of Auvers-sur-Oise. This basic narrative even appeared in the local weekly newspaper on August 7, 1890.

Since then, the traditionally accepted, predominant story of Vincent's life is that of a struggling, brilliant, innovative artist who famously cut off his own ear and then shot himself many months later in a wheatfield. Many conflicting and self-serving statements given in the years after Vincent died were taken to support and propel this prevailing theory of Vincent's death and are still regarded as true. Vincent's suicide is a legend accepted by many, yet backed up by no definitive facts, only speculations and hearsay to avoid committing a *"blasphemy."*

But for anyone who would challenge the unsubstantiated "*evidence*" of the old suicide narrative gospel, Vincent's death becomes an incredible, bizarre, and epic cold-case homicide mystery in the art world. Over 100 years later, there are still many questions about that historic day when the life of one of the world's greatest artists came to an untimely end—when the course of modern art history was changed forever. Did Vincent really plan to commit suicide that day, or was his death still not yet set in stone as he left that morning? Where did he go after lunch at the inn, to paint? Who did he meet up with? How, later in the evening, did he return to the inn with a mortal abdominal wound? What really happened that afternoon to change his life so drastically?

There are no surviving contemporaneous notes, no reports by any attending doctor, and no police report to support the prevailing suicide narrative in the newspaper story. There is really nothing today that can help us understand and confirm what really happened to Vincent back then. So why do so many people believe with such certainty that he committed suicide when there are so many critically unanswered and challenging questions?

According to many people who knew Vincent well, the period of 70 days he spent at the Ravoux Inn before his death was his calmest, most reasonable, and most prolific. He had exhibited no further violent attacks of unexpected vertigo—the affliction that had originally sent him from Arles to Saint Rémy—after leaving the asylum. His soul was burning like fire to paint. He aspired to share his remarkable visions of nature with the world. Vincent spent these last 70 days of his life painting one, sometimes two canvases per day in this idyllic setting of Auvers.

Intriguingly, he did not paint any introspective self-portraits in Auvers, perhaps a signal that he had found inner peace (and possibly even romance, acceptance, and love) to finally turn around his unpleasant and lonely personal life, despite the overbearing concern of losing his financial security safety net. But this calm, serenity, and apparent happiness, so uncharacteristic for Vincent, was so tragically short-lived. Why? What really happened on July 27, 1890 to so dramatically cut this brilliant creative geniuses life short? If you believe that Vincent committed suicide, why would he do that? What could have upset him so much on that specific Sunday, during the best, happiest, and most productive period in his brief career as an artist? Were there dark circumstances at play that have, until now, been left out of his story? Can we now connect all the "*dots*" necessary to provide a reasonable scenario and alternative explanation for his death other than suicide? In short: what is the true story of the death of Vincent van Gogh?

To answer that critical question, this book will explore all possible scenarios of Vincent's death, no matter how unlikely they may appear to be at first glance. Which scenario puts all the facts, stories, and legends together and connects all these odd and disparate "*dots*" in the most persuasive manner? Sometimes the truth is more unbelievable than the reality it discloses or covers up. There is a tremendous amount written about Vincent's life, but very little is known with certainty about his death. There are many theories,

unanswered questions, and, unfortunately, unsubstantiated rumors surrounding Vincent's death that have perpetuated a false suicide narrative for what one can only assume are nefarious reasons. New and critical information will now be brought to your attention so that you can enter the world court of public opinion. With this fresh, historical account, you should be sufficiently well-informed and able to decide for yourself: in this epic, enigmatic, and romantic twisted cold case, was Vincent's death a suicide or a murder? If you decide it was not probable for Vincent to have wounded himself, committing suicide, then whoever did create that fatal wound in fact murdered Vincent van Gogh....and the BIG questions are then who and why?

Chapter Four

Welcome to the Court of Public Opinion

Now that we have reviewed Vincent's life and days up to his fatal wounding, it is time to dissect the events that led to his death. This intriguing and epic cold case of the death of Vincent van Gogh involves multiple theories and scenarios of what happened on July 27, 1890. With almost no agreed-upon facts, it remains one of the most enduring legends and enigmatic unsolved mysteries of art history. It was the shot heard 'round the art world! Even *TIME* magazine's cover once asked in 2011, "*WHO KILLED VAN GOGH?*" and then followed that up with "*Was van Gogh's death really a suicide?*" Vincent was at the cultural epicenter—if he was not the catalyst himself—of the transition of impressionism to modern art.

*Fig. 51. The Seat of the International Court of Justice, **The Peace Palace in The Hague**, Netherlands. Public Domain, Wikimedia Commons.*

The accepted suicide narrative of Vincent van Gogh is now on trial. Maybe it was a suicide as we have been told and retold, maybe it was an accident, and maybe it was really a murder and cover-up. We do not know for sure—and nobody does—but now we have some new information and several different potential scenarios to explore to take a more modern look at the mysterious death of this iconic painter. Let us question everything we know or think we know as well as all of our sources, and drill down on all the different possible scenarios, no matter how odd they may seem, with a completely open mind. We will look at his mental and physical health, his state of mind, the people he associated with, and the motivations that those people might have had to kill Vincent—or that Vincent might have had to kill himself. Ideally we can eliminate all of the past, old, unsupported information and revisit the big picture with our pre-existing bias left outside the covers of this book. A re-examining of all the pertinent evidence will allow you, the reader and jury, to make your own judgment in this case. We can explore all aspects of this infamous cold case together and then you can, with a more expansive and comprehensive perspective, decide for yourself who is responsible for the death of Vincent van Gogh, and not succumb to the unsubstantiated false suicide narrative that has prevailed.

Given the many suspicious circumstances surrounding van Gogh's death, I want to bring these different pieces of evidence and different theories together for the public to judge, unfiltered, in a "*world court of public opinion*," so to speak. This is in fact a challenge to the reader: who murdered Vincent, if he did not commit suicide? Assembling all of the facts and theories will advance solving the mystery and clarify what still needs to be discovered and accomplished. Our challenge is to connect all the "*dots*" and determine whether this really was a suicide, or a homicide with a careful cover-up. Together, we will attempt to solve this challenging conundrum now after 128 years.

A 21st Century Crime Scene and Forensic Analysis

No homicide detective today, if faced with a mortally wounded person or a dead body, but no suicide note, no weapon in evidence, no crime scene, and no witnesses, would write off the case as a suicide without a proper investigation, so why should we? Even if the mortally wounded person proclaimed to all that he did it himself, all the facts and evidence would be gathered and evaluated in a detailed investigation. Assuming that the death was said to be a suicide by a doctor, a coroner would still need to perform an independent evaluation and possibly an autopsy. In the case of van Gogh's death, not only was there no proper investigation and no coroner's report, but all of the related contemporaneous stories are conflicting, self-serving, and have changed over time. There is also no unbiased account from that time period to substantiate any of the claims made. Some "*witnesses*" have notable bias and their own agenda, and some are persons of interest themselves, and simply just not believable. Much of the information regarding Vincent's death comes from a person of interest whose testimony would receive the greatest scrutiny under any cross examination, and whose integrity and credibility would rightly be challenged.

Vincent was not well known at the time of his death. Ever since his untimely demise, however, his fame has risen to amazing heights. The art world and the general public are curious to know the details of his life, as well as the mysterious circumstances surrounding his suspicious death.

Questioning The Validity Of The Suicide Story

In 1990, David Sweetman famously titled an article *"Who Killed van Gogh? The Doctor Did It!"*, but did not specifically address the suicide. Then, as a result of a definitive biography, *Van Gogh: The Life* by Steven Naifeh and Gregory White Smith (2011), *TIME* magazine entered the fray to suggest that suicide was not probable based on forensic analysis of the wound and its trajectory, as determined by a world renowned forensic expert, Dr. Vincent J.M. Di Maio (2013). The expert focused on the physical impossibility of Vincent being able to self inflict such a wound on himself without the critical black powder burn in the wound description. Naifeh and Smith included an appendix in their book questioning the longstanding 19th century theory of suicide of Vincent's death (*ibid.*, 2011, 2013).

Dr. Di Maio reviewed the available data about the penetrating abdominal wound that ultimately proved fatal and concluded, within a medical degree of probability greater than 50 percent, that a self-inflicted wound was very unlikely if not impossible (*ibid.*, 2013). He stated specifically that Vincent did not commit suicide—a statement and statistic that would hold up in a court from a sworn expert witness. A detailed examination of the forensics in the case, including newer, 21st century forensic studies can be found in Chapters 22 and 27 of this book (see also a letter from this expert, Dr. Di Maio, in the Appendix, Chapter 26).

Reflecting a larger conflict in the art world, even the many dramatic portrayals of Vincent's life cinematically do not agree on a set and generally accepted narrative of his death. The brilliant, award-winning animated film *Loving Vincent*, released in 2017, offered a new approach to the events and circumstances leading up to the day van Gogh was mortally injured. It brilliantly tells the story of Vincent's last days through 65,000 hand-painted oil frames in his artistic style. The "Dr. Mazery" character cleverly questions the technicalities, anatomic flexibility, and the impossible logistics of Vincent shooting himself.

The movie provokes many more questions about the mystery of his final days than it can answer. These screenwriters and researchers even come very close to saying that Vincent was murdered but do not actually make that claim outright (they did not pull that trigger, so to speak). They do, however, continue to raise the possibility of a scenario other than a suicide. This is significantly changing art historians', curators', and other biographers' historical perspectives on Vincent's last days and the controversial circumstances surrounding his death.

If even *TIME* magazine has been reexamining and questioning Vincent's death as either "*suicide*" or "*murder*," it must be time now to finally seek these answers for ourselves. Maybe it has become the correct time to put aside all that we think we know about the death of van Gogh and completely wipe clean our understanding of the various old narratives of his death and his presumed suicide, as any judge would so instruct his jury at the beginning of a case. If it is not a suicide, then, as *TIME* stated, he may have been killed—meaning that a murder occurred, either accidental or premeditated. In other words, if Vincent van Gogh ultimately succumbed to this penetrating abdominal wound 30 hours after he returned to the Ravoux Inn, then whoever created this fatal wound in effect murdered him. So, what really happened on the day Vincent was mortally wounded?

We need to take a completely wide-ranging new look at this enigmatic cold case. We need to look at everything, everyone, and every aspect of his 19th century death and try to come up with a true and abiding 21st century understanding about the death of the iconic Vincent van Gogh. Perhaps then we may be able to answer the challenge *TIME* magazine presented us all. Clearly, the issue of van Gogh's death is not an obscure or unimportant question as a world, cultural icon. It is truly a topic worthy of national and international discussion and investigation, not only in the art history world, but also in the criminal justice world. It's an enigmatic unsolved murder mystery with a beguiling romantic twist as well.

Our Sources Can Testify From Their Graves, or Can They?

It is important to emphasize at the outset that we know a great deal about Vincent and Theo from their voluminous and extant correspondence. Still, as important as their written words are—and they should certainly be taken seriously—I believe that often what is not said is equally important. Meaning that what is implied or must be "*read between the lines*" should also be considered. As a result, I do not agree with the experts that said that Naifeh and Smith:

> "*...were more reluctant than earlier biographers to [not] take van Gogh's correspondence as the sole and hallowed point of departure [for their facts]*"
>
> —(von Tilborgh, p. 456, 2013)

and that they choose,

> "*... to use the earlier and now outdated, interpretative translation of his correspondence by Johanna van Gogh-Bonger.*"
>
> —(*ibid.*, 1958)

I agree with Naifeh and Smith in relying on the older translations with which I am much more intimately familiar, as well as their letter numbering system which I have used, and which has been the standard for van Gogh historians and researchers for many years (van Gogh-Bonger, 1958). I identified the quotes from their correspondence utilizing the three-volume set of English translations from the New York Graphics Society (*ibid.*).

I also disagree with these authors (von Tilborg, *ibid.*, 2013) when they challenge their colleagues (Naifeh, 2011), "...*who they claim consistently explore the differences between what van Gogh wrote and what he did, until in the end they believe that they have enough evidence to state that the letters (alone) are not a necessarily reliable record for the events of his life or even of his thinking at anytime—at least not directly. By consistently reading between the lines, as it were, they conclude that van Gogh invariably concealed the truth (manipulatively) or conveyed it indirectly.*" (von Tilborgh, *ibid.*, p. 456)

It is also very important for the art historians to try to interpret what is really meant "*between the lines,*" just as it is important to try to interpret what was in Vincent's mind when he painted any canvas not described in his letters. I agree that Vincent was cleverly manipulative and able to position the "*truth*" that best suited his purposes to maintain his generous stipend from Theo. Thus, you cannot always rely on the brother's letters to include the all encompassing truths of their lives.

A Critical Example of the Brothers' Secrecy

Vincent did not discuss in any detail his loves or feelings for any of "*his women*" with his brother. Certainly the romantic activities with the potato eater's wife and Mme. Bergamon were not known or discussed until after the facts came to light, and after her attempted suicide. If the brothers supposedly shared all of these deeply felt emotions, then why did Vincent not tell Theo more about Marguerite? If Mme. Baize's story is fact, why not share that with Theo? Maybe they did share more in face-to-face encounters that were not reduced to the gospel of their written words?

> "...*But in the end [Vincent] always confided in Theo, telling him what was going on in his associative, if passionate mind.*"
> —(*ibid.*, p. 457)

I find it challenging to accept that Vincent "*always confided in Theo.*" If the letters are the only source of the truth, then why did Theo fail to tell Vincent that he retained his job and his old salary in order to reduce his brothers' transparent concerns? So much happened in Paris on his arrival from the asylum and again on his last trip to Paris when he left so abruptly that is incompletely described in any surviving letters. What was so "*incomprehensible*" that had stymied Jo, if everything of importance was included in their letters? Often the letters failed to be all-inclusive of their thoughts.

Possible thought patterns should be pursued to try to connect the "*dots*" in their writings, just as an effort should be put forth into analysing the thought patterns in Vincent's art, including subject matter, design, palette, brush stroke, and color choices. So much is assumed or amplified to fit the old narratives, but there is no solid basis in the important letters to support so many mistaken "*facts*." It is all conjecture. So, yes, the letters are very important, but I agree that reading between the lines and trying to connect the dots at this point is an equally valid effort...and yes, Vincent was highly manipulative and was always trying to retain his monthly stipend so he could only work on creating art! He obviously did not always confide his most important, personal thoughts to Theo, though if he did, where would the challenge remain for the art historian if it was all completely spelled out?

Whether Naifeh and White's book (*ibid.*, 2011) is really "*more journalistic, or literary, or more novel, than essay or academic*" (von Tilborgh, p. 456, 2013), it seems to me that the authors were not focused on the finer, nuanced academic points as much as they were trying to present Vincent in a more comprehensive, emotional, and illuminating realistic human light. They present his biography in a "*nonchalant brilliant weaving of significant, but overlooked or purposely not included details*" (*ibid.*) that questions the desired old narrative, and they do it quite well! Kudos to them for breaking new ground, breaking old traditions, and for presenting a different yet reasonable and extensive look at Vincent that all who can successfully navigate their magnus opus will appreciate (Naifeh, 2011).

Why Maintain the 19th Century Myth of Suicide?

Who started the martyr narrative of the brilliant, creative, and mad genius who killed himself for his art? Who helped to create this likely false account and the distorted legend that is still staunchly defended to this day? There are several possible answers to this question. The top of the list is the Gachets. So much of the information for this suicide narrative comes from Dr. Paul Gachet and, later, his son's remembrances in an interview that took place 36 years after Vincent's death. Paul Gachet Jr. gave an important, yet rambling interview that was the basis for the preface of the book, *La Folie de Van Gogh* (Doiteau, 1928).

In regard to their testimonies, both the father and son Gachet, each a person of interest, have questionable reliability and credibility, and they have their own agendas to distort the truth. Given these clear conflicts of interest and questionable integrity on several levels, it is easy to see them as unreliable witnesses. It would be difficult to look past any bias they may have harbored.

Subsequent statements from people Vincent knew tell many different, conflicting, and unverifiable stories. Upon further investigation into the circumstances of his death, some of the evidence that surfaces potentially disrupts everything we presumed to know about even the most basic facts regarding the suicide narrative. As difficult

and unlikely as some of these possibilities may appear, we must now reexamine the assumptions and conclusions accepted at the end of the 19th century with the evolving understanding of a modern perspective.

Paleoanthropologists have made notable progress in investigating the deaths of people who had died in the distant past using modern scientific equipment and forensic techniques. Given these newly developed tools, there is little reason why the old legendary suicide story of the death of van Gogh should just be accepted if new evidence could be found to challenge that myth. The experts today are limited to only anecdotal descriptions about the wound itself, and in the absence of any crime scene information, witnesses, and no definitive weapon or bullet in evidence, it is hard to believe how anyone could possibly have concluded Vincent's case as a suicide, and write it off without a formal investigation.

The investigators must stick to facts, not hearsay or unsupported theories. Why should we all have been so lax and willing to accept a suicide narrative unsupported by irrefutable facts then, and still are now? It is not unheard of that, over time, a new perspective forces one to revisit our old thinking and adjust our theories to fit new facts as they are discovered. The various scenarios, once one opens their mind to these other possibilities, become intriguing and worth examining. Let's follow the trail to solve a mystery of a story when basic greed, familial honor, professional jealousy, and national interests runs amok. The closing arguments are presented to the court of public opinion in Chapter 24.

Please help me solve this homicide cold case. Your help and feedback will be greatly appreciated by all. I look forward to your comments and critiques at the court of public opinion currently provided at our interactive forum on my website, www.killingvincent.com.

Part II

Re-Examining Van Gogh's Medical, Mental, and Physical Health Issues

Chapter Five

The Mysterious "Attacks", Misdiagnosis, and their Impact

Vincent's Violent "Attacks"

Vincent van Gogh was known in the art world and among his many biographers to have suffered from violent attacks of some malady about which there has been no general agreement. After he recovered from the ear mutilation in Arles, Vincent admitted himself to the Asylum for Lunatics and Epileptics in Saint Rémy, about 20 miles from Arles. Dr. Peyron, the admitting doctor, concluded in his intake history that Vincent's episodic attacks were epilepsy. A plethora of other diagnoses have flooded both the art history and medical literature over the ensuing years. Still, no consensus has emerged. This diagnosis of epilepsy stuck with Vincent until 1990, when I published a *"Special Communication"* in the *Journal of the American Medical Association (JAMA)* that concluded that these violent attacks were attacks of inner ear vertigo. Vertigo is a key element that distinguishes between a diagnosis of an inner ear disorder known as Meniere's disease and common forms of seizure disorders and epilepsy, or any kind of generic dizziness. This article was the cover story 100 years to the week after Vincent's death (Arenberg, *JAMA*, 1990).

It is not the purpose of this book to refocus on Meniere's disease or any other of the various additional medical diagnoses given to Vincent van Gogh over the years. Clearly, anyone, including Vincent, could have had more than one medical problem, which he did. The purpose of discussing his clinical diagnosis of Meniere's disease and not epilepsy in the context of *Killing Vincent* is primarily to look at these intermittent attacks and hallucinations of motion from this inner ear disease, in order to determine what impact these attacks may have had. How did these violent, unexpected, and unpredictable attacks effect Vincent's life and his art, particularly his productivity? These *"attacks"* would subside and were followed by various periods of calm, in which he was able to paint undisturbed. Did these uncontrollable attacks lead to any propensity for a

possible suicide, or—even more significant in the context of the Killing Vincent Project (KVP)—have any impact on his death? Given how much impact these "*attacks*" had on his life, his focus, and his productivity as an artist in his last three years, it is important to establish whether these attacks of vertigo, were only "*madness*" or seizures which drove him to suicide, as was suggested by Johanna van Gogh-Bonger (1913). Did these attacks contribute in any way to the circumstances of his untimely and mysterious demise? It then becomes worthwhile, if not imperative, to perform a comprehensive investigation to better understand what medical problems Vincent was confronted with in general, and how these problems could have disrupted his focus on his family, his art, and his life.

The "*Attacks*" Historically

During his time in Arles, and again in Saint Rémy, Vincent van Gogh had violent attacks of vertigo with hallucinations of rotation and ear noises. The admitting doctor at Saint Rémy, Dr. Theophile Peyron, wrote in the register of the asylum upon Vincent's self-admission that these attacks were caused by epilepsy. This was a reasonable diagnosis before Dr. Jean-Martin Charcot revamped our understanding of neurological disorders (1881). While it was historically accurate in 1889, when it was reviewed more recently by modern clinical medicine, the diagnosis of epilepsy was considered clinically inaccurate to explain his unexpected and unprovoked attacks (Arenberg, 1990). His unpredictable attacks were coming from a disorder of the inner ear called labyrinthine vertigo, and not a disorder of the brain.

Vertigo

So what is this labyrinthine or inner ear vertigo, and why is it so important to distinguish between it and generic dizziness? Vertigo is best defined as a subjective manifestation of an inner ear disorder in which the patient experiences violent, unexpected attacks of a hallucination of motion, most often rotary, in which the room is spinning or the patient is spinning inside himself. With a Meniere's disease attack of inner ear vertigo, an observer may only see jerking eye movements, known as nystagmus, but cannot see any other body movement. Only the patient experiences these hallucinations of rotary motion. There is no other visible response to these unreal perceptions. What can be seen by an observer, besides the nystagmus, is the patient's response of nausea and often violent vomiting as they seek the floor, a chair, or wall to gain a sense of stability. They may say some unexpected words as they are assaulted by these violent spasms of nausea, vomiting, and a world spinning out of control.

A typical vertigo attack is thus characterized by an unexpected violent onset of a spinning sensation with hallucinations of rotary motion, often associated with

uncontrolled nausea and vomiting, followed by intermittent periods of calm. The attack can end almost as abruptly as it starts. Alternatively, these attacks can last hours. It is very difficult to simply describe what an attack of vertigo is like for the many Meniere's disease sufferers, so I have interspersed some quotes from some of my Meniere's disease patients, taken from interviews they gave the media in the past. Their news videos can be seen in their entirety on the website, www.killingvincent.com/videos.

The Critical Relevance of Vertigo and the Diagnosis of Meniere's Disease

It is important to understand the connection between vertigo and Meniere's disease. Vertigo is the critical clinical diagnostic element required to make the unique diagnosis of Meniere's disease. Meniere's disease—which I have suggested, since 1990, that Vincent suffered from—is a somewhat common condition of the inner ear primarily manifested in acute, violent attacks of vertigo and hallucinations, which often resolve on their own until the next attack occurs unexpectedly. It is noteworthy to accept that the well-known and frequently heard about attacks that plagued Vincent were from his inner ear and Meniere's disease, and were not from any form of epilepsy or brain disorder. The same applies to the often noted and directly connected hallucinations associated with these attacks. If we understand this updated diagnosis, a newfound understanding of van Gogh's health, mental state, and inner motivations as an artist may now be possible. Did this characteristically episodic disease play any role in his death? Did an unrequited fear of another, more violent attack of vertigo that would leave him incapable of painting drive him to suicide?

> *"A more violent attack [of vertige] may forever destroy my power to paint."*
> —(Letter #605, Sept. 10, 1889)

More likely, this intense fear that he expressed was a major factor in his compulsive, obsessive need to paint a canvas a day.

The Impact of the Fear of a Recurrent, Violent, and Never-Ending Vertigo Attack

During the onset and progression of his inner ear symptoms with major and minor attacks, van Gogh began to paint a canvas a day, almost like keeping a diary. During this period, he completed 60 paintings in two months. Between February 1888 and May 1889, he produced roughly 200 paintings, 200 drawings and watercolors, and 100 letters. It would be interesting to speculate further on whether van Gogh would have

been as prolific an artist if he had not had Meniere's disease, or if his Meniere's disease could have been successfully treated. Perhaps Vincent would not have been prompted to embark on such a frenzy of artistic activity if he did not fear his unexpected, recurrent, and violent Meniere's disease attacks so much. He was so fearful of a severe, never-ending attack of vertigo that would overtake him and prevent him from ever painting again, that he could have been driven to paint by this constant fear in the back of his mind. So, it is not difficult to see how such a fear would motivate and drive him to paint a canvas or more a day! Oddly enough, maybe we have his afflictions to thank—not for his death, but for the remarkable nature of his life and his abundant output.

Making a Clinical Diagnosis of Meniere's Disease Based on Vincent van Gogh's Medical History and His Own Extensive Hand-Written Descriptions

To better understand the impact of his debilitating attacks and hallucinations on his life and his art, and the impact of applying a modern inner ear disease diagnosis, I have reviewed these medical issues in greater detail. This is an in-depth review of Vincent's self-described and specifically named and handwritten symptoms of his "*attacks*." Namely, his use of the word *vertige* in his own hand (Figure 52), which can only translate to "*vertigo*." There is no other alternative meaning in English for the French word *vertige* than vertigo. Here you have Vincent van Gogh unequivocally stating that vertigo was the critical element of his recurrent attacks (Van Gogh, #605). Vincent was very articulate and well-read, with the ability to speak and read several languages, and I must assume that he knew what "*vertige*" meant and how to use the word correctly to describe what he felt.

*Fig. 52. Photograph of a **letter in Vincent's own hand**, saying his violent "attacks" were "vertige". This critical sentence is highlighted above in red from letter #605 to Theo (T605), which is dated September 1889.*

The translators of the two comprehensive works of his letters interpreted *vertige* as "*dizziness,*" which is clinically incorrect. Vertigo is a much stronger, more complex symptom than the generic term "*dizziness*" would imply. While "*dizziness*" may seem similar and correct to most people, it is an oversimplification that does not reflect the true depth of the clinical meaning of vertigo to a doctor. Therefore, these distinctions seem minor, but may actually distract one from assessing the real significance and impact—or lack thereof—of these vertigo episodes on Vincent's art and his day-to-day life.

Vincent's Violent Vertigo Was An Inner Ear Disease: Meniere's Disease

The most likely accepted cause and diagnosis of Vincent's debilitating attacks of vertigo is the condition known as Meniere's disease. This disease was first described in 1861 by Prosper Meniere and now bears his name. Meniere was an ear doctor far ahead of his time. Prior to his brilliant insight, such attacks of vertigo were considered to be coming from the brain and not the inner ear. As a consequence, they were lumped together as a type of central nervous system problem, placed in the "*junk drawer*" of everything that had a violent onset but resolved on its own. Back then, any similar attack was considered a form of epilepsy, not a stroke or a brain tumor. Only if the problem did not get better was it considered a stroke or a brain tumor. This huge category of "*brain problems*" remained accepted until Charcot (1881) opened up the door to the modern concept and organization of neurological disorders, distinguishing the many kinds of brain problems into more specific clinical subcategories. Meniere wrote in 1861 about the inner ear problem that would bear his name. This work preceded much of Charcot's work, and thus clearly put Meniere far ahead of his time for effectively first distinguishing inner ear disorders as an important entity clinically distinct from brain disorders. A society, the Prosper Meniere Society, was created, and a gold medal honor award (Figure 53) was presented to distinguished ear specialists every few years, who addressed and made significant progress in the field of this challenging disease. The medal was a reward for the most notable achievements in the field of

Fig. 53. ***Prosper Meniere society gold medal*** *with his image emblazoned on the front. The authors medal.*

Fig. 54. The only image of ***Prosper Meniere****. Private collection*

*Fig. 55. The **author paying homage**, to another giant and hero, Prosper Meniere at his mausoleum in Paris. Circa1993*

inner ear medicine and surgery. The medal depicts the only known image of Prosper Meniere, which was incorporated into the medal design.

Prosper Meniere had said in 1861:

> *"Let us give thanks to seeking spirits, to those with initiative, who raise questions of interest, stimulate active researches, provoke opposition, because in a word, science gains and humanity applauds."*

Meniere's disease runs along a very diverse spectrum with lots of volatility, and it can outwardly manifest itself in many different ways to both the viewer, the doctor, and the afflicted patient. In a major attack, this hallucination of violent motion is often accompanied by an increase in the patient hearing noises inside his ears or head, called tinnitus. This can be accompanied by a transient or permanent loss of hearing in the affected ear. At the same time, an attack can be accompanied by pain or pressure in the ears or head as well as headaches, nausea, vomiting, and profuse sweating. The patient could have difficulty standing, walking, and maintaining his balance. He could end up prostrate on the ground, retching, as this might be the only safe position of relative stability until the hallucination of motion stops. The patient in the midst of such a dire attack most likely would be nauseated and even vomiting. If suffering a severe enough reaction for a protracted time, the victim can fall, lose consciousness, and—in rare cases—lose bowel and bladder function. In a minor or less severe adjunctive spell of vertigo, after a briefer vertiginous episode, any of the other symptoms described above could occur concurrently, but are usually less severe.

Meniere's disease is not an uncommon disorder; in 1973, the projected incidence and prevalence in the United States was between three and seven million people (Stahle, 1978). This disease is an unfortunate affliction that is not rare and could easily explain Vincent's "*attacks*" and hallucinations. It could further explain the strange noises in his head and the ear pressure he sensed. Additionally, this inner ear affliction could also explain his volatility and mood swings between his periods of calm and his almost daily, frenetic painting with explosions of color. That never-ending, nightmarish, gnawing fear of another, more violent attack could explain his biggest fear of having have another, even more violent attack that would not go away or would leave him so impaired that he would forever lose his ability to create art. It could have been what drove him to continue to experiment. It could also significantly contribute to his exceptional drive to paint a canvas a day, as if each painting were his last.

The hallucination of rotary motion would send Vincent, or any patient, spiraling down through a vortex, seeking something solid on the ground to try to gain a sense of stability until the attack, often accompanied by nausea and vomiting, subsided.

*Fig. 56. An **artist's portrayal of Vincent van Gogh** in the midst of a violent attack of vertigo and hallucinations. The hallucination of rotary motion sends him, or any patient, spiraling down through a vortex, seeking something solid and stable on the ground to try to gain a sense of stability until the attack, often accompanied by nausea and vomiting, subsides. Art by Darrell Anderson*

Meniere's Disease From the Patient's Perspective

To those who witnessed one of Vincent's attacks, he may have exhibited some very unusual verbal and physical behaviors, leading outsiders to assume he was "*mad*" or intoxicated, or both. He may have appeared as if he had been drinking and was inebriated, with nausea and vomiting that can often be hard to distinguish from drunkenness. These unexpected, unprovoked drunk-like hallucinations and other unpleasant symptoms, which interrupted his intense focus on his painting, may also have provoked extreme frustration and outrageous outbursts of anger and verbal abuse. But he was not crazy or mad, as he would have appeared during an acute attack, when observed by another person watching and listening to him.

As such, Meniere's disease is a very challenging, non-lethal disease to have to contend with for many patients. Rather than for me to try to describe such a diverse disease clinically and how it might have similarly affected Vincent, I decided to let some patients tell you themselves what it was like for them to live with this disease. Then you can try to imagine poor Vincent dealing with this disease, as he was similarly affected and afflicted, so much so that most everyone thought he was a "*nut job*." True, rotary, hallucinatory vertigo is so much more clinically significant and meaningful than dizziness, disequilibrium, imbalance, and other lesser forms of an inner ear or brain balance discomfort and malady. An attack is not accompanied by any of the uncontrolled body movement you may expect in a seizure disorder.

As one contemporary patient described:

> *"You really get low on yourself when this disease attacks you. You're helpless, and you feel like your life is going to be virtually over. Vertigo is when everything around you is spinning. You have no sense of up or down or left or right. The only thing you want to do is find the floor."*
> — Paul McNamee, Meniere's disease educational video

Another patient said:

> *"I became extremely dizzy. Falling over chairs and objects. Tried to regain my composure and it was as if I was drunk. One moment you will be fine. 5-10 minutes later you will be in a full-blown attack. You'll have difficulty standing up. You'll be bouncing off of walls. It's very difficult to describe to the normal person."*
> — Tom Brown, Meniere's Patient, Channel 2 News Cover Story Segment

Another patient noted:

> *"All of the sudden the room would start spinning violently. You start wondering what is happening to you. You feel a little bit crazy because it comes and goes. It's not something a person can visually look at you and see something is wrong."*
> — Jan Hurst, Meniere's Patient, Interview 9 News with Sherry Sellers

A Meniere's Disease Attack in Progress

In the Calm After an Attack

Fig. 57. Vincent van Gogh, or any patient, **in the midst of a violent attack of a full-blown Meniere's disease** *with symptoms: vertigo, hearing loss, ear noises (tinnitus), and fullness or pressure in the ears or head.*

Fig. 58. After the attack, **all symptoms have dissipated,** *and the patient can now go into a calm period or a "remission".*

What it's Like to Have a Full-Blown Inner Ear Vertigo Attack

What are these vertigo attacks, with hallucinations of rotary motion, really like? I have presented you with a few samples already. My experience with many Meniere's disease patients shows a case history directly comparable to that of Vincent van Gogh. In my 50 years of evaluating, diagnosing, and treating patients with many inner ear disorders, dizziness, and Meniere's disease, I have seen over 50 thousand cases and lived with all aspects of these *"dizzy"* patients for my entire medical career. I know how adversely the intermittent and unexpected violent attacks of vertigo have affected their lives. Many Meniere's disease patients are surprised and unprepared. They will readily tell you how great the impact on their daily lives is because of the fear of another violent attack at any time, without warning, and no way to know where or when it will happen. It can be devastating, particularly if the patient is told nothing can be done to help them, or even worse, that *"it is all in their head."*

Vincent was sadly no different than any of my many patients with inner ear disease. He had a very characteristic clinical history consistent with Meniere's disease, not epilepsy. Therefore, Meniere's disease is the correct, clinically accurate diagnosis and explanation

***FOOTNOTES: These are some additional quotes from interviews of some of my patients telling their Meniere's disease stories, and can be viewed in full on Killing Vincent website, www.killingvincent.com under video tab:**

"It's very crippling to an individual because you don't have very good balance, you're very nauseated, you're very dizzy. They would have to bring me home from work because they thought I had a problem with alcohol or some other situation." — Larry Veber, Meniere's Patient, Interview

"I was in a grocery store going down the can food aisle and all the sudden the cans started moving and the room started moving and I said to myself, 'Not here'" — Phyllis Warburton (News inside Aurora, Ear Trouble Piece

"Most of the times when my attacks came I just immediately hit the floor, crawl to the bathroom and spend the next 2-3 hours in there." — Paul McNamee (Channel 4)

"That (inner ear valve)surgery…changed my life. I no longer had vertigo attacks, the tinnitus subsided, and I could go out in public with total confidence I wouldn't fall. To this day I have not had one vertigo attack in the operated ear" — Randy Foshee e-mail, July 1, 2008

of his violent attacks of *vertige* and any hallucination of (rotary) motion with strange ear and head noises.

Another patient's story to further exemplify this is as follows:

> *"When the attacks came the world was spinning. There was no way to keep your balance. If you weren't holding yourself against the wall trying to get somewhere, you were crawling."*
> — Paul McNamee, Interview News 7, Mike Fenwick

Vincent's Outer Ear and the Notorious Ear Mutilation Story

Where did Vincent van Gogh experience his first attack of violent vertigo? Was it Paris, Arles, Saint Rémy? According to Marc Edo Tralbaut, a 20th century biographer of van Gogh (1969), these attacks really started in Arles. Did he have an attack on December 23, 1888, that may have precipitated the unusual confrontation with Paul Gauguin? There are many theories regarding what drove van Gogh to mutilate his own ear, including the possibility that it was not self-mutilation at all, but the result of a physical altercation with Gauguin (B. Murphy, 2016), and Paul Gauguin may have wielded the razor (Van Der Leek, 2018). Still, it is possible that a violent and unexpected attack from this inner ear condition could have caused this frightened and frustrated man to seek a desperate solution with extreme action. Did Vincent hallucinate rotational vertigo and hear noises inside his ears and head that night? Maybe in the heat of the moment, during an early episode, it seemed like cutting off his left ear would make the symptoms of vertigo and/or the ringing noises in his left ear and his head go away. We do not know, but that has been speculated as a possibility (*ibid.*).

Is it possible that cutting off his ear had nothing to do with Gauguin's abrupt departure from the Yellow House in Arles, and nothing ties the two incidents together except bad timing, coincidence, and the story later told by Gauguin? Is it possible that Gauguin cut off van Gogh's ear and declared him "*mad*" to the police as he left Arles? This theory has been broached before (*ibid.*). Vincent was very aware of the recently described inner ear balance function in pigeons (Royal Soc. London, circa 1862) by Marie-Jean-Pierre Flourens. He well understood much about the ear for a non-professional and possibly connected his "*attacks*" with a problem in his inner ear as well as his ear noises or tinnitus. Did he try to eliminate the source of his ear symptoms himself? No one knows, but much speculation on both sides has been noted. A quite compelling analysis of the strained relationship between these two diametrically opposite artists and the bizarre ear episode was made by Van Der Leek (2018) and supports the theory that Gauguin was, in fact, the instigator and aggressor of Vincent's missing ear.

The accepted legend about this ear event comes to us primarily from Gauguin's later memoirs in his *Intimate Journals* (Gauguin, 1923). Would it not have been easier to blame Vincent for the ear episode, since Gauguin always maintained he was *"mad"*? Why blame himself or say what really happened? When Gauguin finally put down his story in his journals, both Vincent and Theo had already both died, and he was far away from Paris as Vincent's fame was growing. No fact checking was possible.

There are no corroborating accounts from Vincent himself, or anybody else. As such, this story has become mainstream history, even though it relies only on Gauguin's possibly unreliable and biased recollections. As Vincent's fame began to catch on, Gauguin made some self-aggrandizing gestures that he took credit for, like pointing Vincent on the correct path when they roomed together in Arles. His path, he shared, brought Vincent's art to such an acceptable and recognized level—but this is yet another story without substance, elaborated on only years after Vincent died. Perhaps it's just another story fabricated for the teller's own benefit (Van Der Leek, 2018).

Van Gogh, the Prolific Artist; Did His Inner Ear Disease Impede His Art or Stimulate Him?

Van Gogh's output was as prolific in Saint Rémy as it was in Arles, once he was allowed to paint again. The only thing that would stop him from painting was an attack of his violent vertigo, nausea, and vomiting. He painted in the high winds and blowing dirt of the infamous mistrals, he painted outside in the blistering sun and heat of Provence, and he painted in the rain. He even painted in the evening with candles lit around the brim of his hat.

Tralbaut (1969) says that Vincent had four more major attacks of *"madness"* in Saint Rémy. I believe his attacks of *"madness"* and his attacks of *vertige* are one and the same, at least when Vincent names them *vertige*. He had a series of these episodic attacks in 1889, covering the period from July 8 to mid-August. The rest of 1889 was not a good year for Vincent either, in terms of his attacks of his inner ear vertigo. Holidays, particularly Christmastime, had frequently been a problem period for Vincent over the years. Familial stress may have exacerbated his symptoms, and he had a miserable time from December 24 through the start of the new year. Again, Vincent had both major and minor attacks lasting the entire week of January 23 to 30, 1890. He then had a calm and productive period followed by another series of major and minor spells from mid-February to mid-April 1890. Vincent expressed a major life- and art-changing fear, writing in that letter (#605, Sept. 10, 1889), that *"a more violent attack [of vertige] may forever destroy my power to paint."* However, instead of allowing his affliction to slow him down, the overhanging, persistent fear and dread compelled him, I believe, to paint even more obsessively and uninhibited.

Yet, despite this terrible fear of another attack occurring unexpectedly, Vincent, who had just had a notable series of less severe attacks lasting two months, was able and anxious to leave the asylum in the spring of 1890. He desperately wanted to go to Paris to see his brother, his new sister-in-law, Johanna, and their new son, his namesake. Now there was another Vincent Willem, the third van Gogh in 38 years blessed with that name and big shoes to fill. After a year of lessened anxiety in which he painted as much as possible, he arrived in Auvers-sur-Oise on May 20, 1890. Some have suggested that he manipulated Theo into letting him stay in the asylum and paint unimpeded. Maybe he did put undue pressure on his younger brother, pushing him to the brink? But he was allowed to paint, virtually unimpeded, and what marvelous paintings he made when he had no real concerns but to meditate and paint.

Vincent's Quotes About His Attacks

Vincent wrote frequently about his disease to family and friends. Below are some quotations from selected letters:

> *"Life passes like this, time does not return, but I am dead set on my work, for just this very reason, that I know the opportunities of working do not return. Especially in my case, in which a more violent attack may forever destroy my power to paint....During the attacks I feel a coward before the pain and suffering—more of a coward than I ought to be, and it is perhaps this very moral cowardice which, whereas I had no desire to get better before, makes me eat like two now, work hard, limit my relations with the other patients for fear of a relapse—altogether I am now trying to recover like a man who meant to commit suicide and, finding the water too cold, tries to regain the bank....I also feel frightened faced with the suffering of these attacks. It is the work that keeps me well balanced. I cannot live since I have this dizziness [vertigo] so often."*
>
> *—(To Theo #605, Sept. 10, 1889)*

> *"Oh, if I could have worked without this accursed disease—what things I might have done, isolated from others, following what the country said to me. But there, this journey is over and done with."*
>
> *—(To Theo #630, May 1890, Auvers, two months before his death)*

To Emile Bernard, his colleague, friend, and peer:

> *"I still have many things to say to you, but although I am writing today, now that my head has gotten a bit steadier, I was previously afraid to excite it before being cured."*
>
> *—(Letter #B21, Dec. 1889)*

Vincent felt good enough to leave the asylum in mid-May, only a month after this last flurry of milder attacks in mid-April, 1890. After that last two-month-long interval of recurrent spells of his vertigo with periods of calm in between, he never had any further attacks of vertigo. Nor did he have any more "*attacks of madness*," presumably describing the same clinical phenomenon after arriving in Auvers-sur-Oise.

There were some strange behaviors reported by Dr. Paul-Ferdinand Gachet and later his son, Paul Jr. What were these strange and threatening episodes, and why don't the Gachets' statements fit with what others saw and reported regarding Vincent's unusually pleasant and calm demeanor and behavior in Auvers? This final period of his last 70 days in Auvers was reported by many to be his most calm and productive period, without any further mention or apparent manifestations of this mysterious medical problem, or any form of "*attacks*" that have baffled so many for so long. What were these strange behaviors reported by Dr. Gachet and then Paul Jr. after Vincent's death? Were their reports consistent with others? We will explore the Gachets and Vincent in the last 70 days in Auvers-sur-Oise in much greater detail, and why the Gachet's accounts may have been so different, non-confirming and purposely misleading.

One would have to believe and speculate that had Prosper Meniere and Vincent van Gogh met, they would have each admired the other's creative works and inherent genius to see something no one else had yet seen. They might have even been friends.

Chapter Six

Mad or Misunderstood

What other medical problems besides his inner ear disease did Vincent have? In addition to the apparent misdiagnosis of epilepsy, there are several other misconceptions about Vincent van Gogh's health and mental condition. While the popular narrative regarding the famous painter is that he was simply crazy or mad, there is reason to argue that he may have also suffered from other more nuanced mental conditions, such as Asperger's syndrome. Fine-tuning his mental diagnoses could help us better understand his apparent depression and his difficulties with interpersonal relationships, as well as the possibility that he was propelled to suicide.

Vincent, like so many patients, may have had several overlapping and intertwined medical and mental problems. In addition to his Meniere's disease and possible Asperger's syndrome, Vincent may have also had episodes of severe depression, mania, and bipolar disorder according to modern psychiatric thinking. Were the medical and mental stresses he confronted sufficient to make him want to end his life and to leave this world—and the comforts, productivity, and calmness he was experiencing in Auvers—just when everything finally seemed to start going his way? Would he have likely committed suicide if he finally found the love of his life who really understood him, accepted him, and was the new fountainhead of his art, his muse, his soulmate, his everything?

The diagnosis of Meniere's disease in the previous chapter is hardly all-encompassing and is unlikely the only, and total, explanation for all of Vincent's problems. Unfortunately all patients, Vincent included, can have more than one clinically significant problem at the same time. Often, these clinical problems can overlap and present a confusing diagnostic and treatment challenge for both the patient and the doctor.

What other diagnosable problems did Vincent have besides his inner ear disease? Part of the prevalent narrative about his life is that he suffered from some form of madness, possibly hereditary, that in the end caused his suicide (N. Bakker, 2016). Still, as part of this reexamination of the popular narrative, it is worth asking whether Vincent was really

"*mad*," as people claim. Was there a reasonable explanation for his unusual, eccentric, and solitary behavior? Upon further examination, it is likely that the assumption that Vincent was somehow the victim, on the verge of a tragic fatal insanity, is one of the major misconceptions surrounding the story of his life (*ibid.*). What is so often easily dismissed as a crazy man's behavior may in fact have a more nuanced explanation that can give newfound understanding to this genius's life, relationships, and final days.

Could Asperger's Syndrome Explain Some of Vincent's Mental Problems?

It is impossible to put all medical problems into one neat little basket. Overlapping disorders can be difficult to diagnose, and it is often difficult to assess clinical outcomes of any treatment, particularly when several unusual symptom complexes overlap. My working differential diagnosis of all likely possibilities centers on Meniere's disease—episodic violent inner ear vertigo with hallucinations of rotary motion, followed by symptom-free periods—which is still the most critical to understanding Vincent's last three years, as discussed in the previous chapter.

In addition, however, most of Vincent's medical problems and so-called mental, psychological, and antisocial behavioral issues are possibly due to his affliction with another newly emphasized disorder, namely a high-functioning variant of Asperger's syndrome.

Vincent was a brilliant and creative person, and in my opinion in a class of genius on par with Albert Einstein, Pablo Picasso, or Leonardo da Vinci. He was also an obsessively focused soul. Traits he shared with someone who has Asperger's syndrome include "*madness*" and ongoing difficulties with social graces, often to deleterious excesses; an unbelievably good memory; the ability to focus intensely on one thing at a time; and an overwhelming need to finish each day what he started. This way of looking at Vincent's medical, mental, social, and psychological problems could more easily explain why so many others could not relate to Vincent, just as he was incapable of relating to them and maintaining a modicum of friendship. He could not stop talking about his view of art, life, and society in a very controlling, manipulative manner, even with his brother; he was often argumentative to the point of exhaustion, fighting until the other person accepted his point of view, or just gave up. This routinely turned off nearly everyone he interacted with. Almost all of his relationships with friends, acquaintances, and colleagues ended in a downward spiral. Asperger's syndrome offers a possible explanation for many of these problems. He would have had Asperger's since childhood, meaning it would predate the late onset vertigo attacks that were the classic hallmark of Meniere's disease. The Asperger's syndrome preceded and formed much of his basic self and personality characteristics, and the Meniere's disease occurred many years later in his mid-thirties—an unfortunate add-on for an already distinctly unusual and brilliant person.

Asperger's Syndrome

Asperger's syndrome was first described in the first half of the 20th century and would not have been something Vincent's doctors would have been aware of during his time. However, when one looks at the diagnostic criteria, many of the pieces fit in with how he was described in his youth and throughout his troubled life (Naifeh, 2011). A person with Asperger's typically displays no notable amount of the language problems that are associated with similar, related autism disorders. Asperger's patients are often actually noted for having above-average language skills and vocabulary, which Vincent certainly showed through his many eloquent letters, his mastery of multiple languages, and his selection of the very specific French term, *vertige*, to describe his violent spinning vertigo instead of the more generic *"dizziness."* One of the most notable signs of the disorder is a difficulty understanding social rules, boundaries, and interacting with others in an acceptable way, which is a recurring theme in Vincent's life for which there are a multitude of examples (*ibid.*).

According to the *Diagnostic and Statistical Manual of Mental Disorders IV* (DSM-IV, 2016) diagnostic guidelines, someone with this condition must show:

> *"...severe and sustained impairment in social interaction...that must cause clinically significant impairment in social, occupational or other important areas of functioning."*

Many of Vincent's romantic failures were marked by a lack of social normative behavior and boundary issues. Vincent had an inability to notice and accept someone's romantic disinterest, and he was famously unable to maintain friendships for long periods of time. His relationships with friends and peers often devolved into arguments and verbal fights, which is not atypical of a communication disorder of this type, since someone with repeated difficulties understanding people in a social context may turn their frustration into anger and have an argumentative persona.

Another sign of the disorder is a tendency toward obsessive interests in narrow topics. According to the DSM-IV diagnostic criteria, they may have an:

> *"...encompassing preoccupation with one or more stereotyped and restricted patterns of interest that is abnormal either in intensity or focus"*
> —(*ibid.*, 2016)

A person with Asperger's syndrome often obsesses over very specialized topics, dedicating themselves to learning everything about their chosen interest. Some people with Asperger's have been known to memorize sports statistics, collect specific types of items, or obsess about a particular hobby until it consumes a disproportionate amount of their life.

This is clearly something that Vincent demonstrated early in his childhood when he turned to unusual pursuits like collecting insects and memorizing facts about them. When looking at his professional life, this becomes clear as well. He threw himself zealously into his interest in religion, to the point that it caused him to be fired from a career as a missionary for having "*too much zeal.*" Likewise, he had an obsession with painting to the point where he painted in bad weather, low light, and other extreme conditions. This occured even when doing so in effect prevented him from becoming financially stable. These behavior patterns are typical of this condition (*ibid.*).

Asperger's syndrome would explain his creative brilliance, his introversion, his antisocial nature, his inability to stop a painting unfinished, and many more bizarre behaviors going back to his childhood. He had a dramatic and unrelenting need to finish what he started, and Asperger's would explain why he likely became so upset and frustrated and acted out when an attack of *le vertige* occurred in the midst of painting, making it impossible for him to continue. Many of Vincent's other so-called "*problems*" could be explained as a savant-like, focused brilliance within an Asperger's-like diagnosis.

Was Vincent Suffering Other Medical and Mental Disorders and Challenges?

Many times, people just place the blame for Vincent's suffering on depression. While the idea of a diagnosis of intermittent depression is hard to deny, it does not rule out the possibility of an additional diagnosis of Asperger's syndrome. People suffering from Asperger's are also at a significantly higher risk for other problems, particularly chronic depression, social isolation, and irritability.

Vincent's time in Saint Rémy may not have resolved his ongoing social issues or his recurrent depression completely, but it did make him so much calmer, almost serene by comparison to his persona in Arles. It would be hard for anyone to argue that the year in the asylum did not help him turn into a new, more serene man. He was notably calmer, more comfortable with himself and others, and much more open and capable of enjoying and pursuing a new life. Sanford Finkel, a noted psychiatrist (and my old college roommate) questioned my suggestion of Asperger's syndrome as an additional diagnosis, atop the host of other and more definitive mental diagnoses that overwhelm the world literature. Finkel said there is:

> "*...plenty of good evidence for a cyclical mood disorder with severe mood swings, schizophrenia, and a severe bipolar 1 disorder.*"
> —(Finkel, personal communications, May 2018)

I stand by the new proposal to add to his differential diagnosis that Vincent also had Asperger's syndrome. Over 100 articles and books have been written about Vincent's many perceived mental problems, of which Asperger's syndrome could readily be added to that differential diagnosis list.

What Other Significant and Contributory Medical Problems did Vincent Suffer From?

Neurosyphilis

In addition to his other medical problems on his expanded differential diagnosis list, Vincent suffered from central and peripheral nervous system dysfunction caused by his progressive neurosyphilis. Clinically, his disease was at an earlier stage than that of his younger brother, Theo, who subsequently died from the disease. Theo's syphilis was a significant component of the mental and physical collapse that he suffered within weeks of the death of his beloved brother, Vincent. So, some aspects of central nervous system dysfunction from Vincent's own milder progressive neurosyphilis may need to be factored into the more complete differential diagnosis of all his medical problems as well.

Substance Abuse

Vincent was also a substance abuser, most notably involving alcohol (absinthe), paint, and turpentine. It was another way in which Vincent was overzealous, as well as disdainful of his personal health. He used absinthe excessively, which was known at the time to cause lasting damage to both the body and the brain. In the asylum, he had no alcohol, but he may have tried to drink his turpentine and eat his paints in an effort to fight off the symptoms of his withdrawal from these other substances. His recurrent substance abuse would also clearly put him in a higher risk group for potential suicide. Notably, though, Vincent did not use any alcohol in his last 70 days Auvers-sur-Oise, according to Adeline Ravoux (1953, 1956). But according to René Secrétan many years later, Vincent would drink—at René's urging—and then René would play terrible jokes on the crazy artist (Doiteau, 1956).

Fear, Anxiety, Neuroses, and Panic Attacks

Vincent also had several significant fears that underlaid his very existence in his last years. His biggest fear, of course, was that another violent, unremitting attack of vertigo would forever take away his ability to paint. This was a gnawing fear always present

in the back of his mind. These attacks were well known to Vincent in his last three years—violent, intermittent, unpredictable, distracting, frightening, and devastating bouts of vertigo with a hallucination of rotary motion from his Meniere's disease. This fear was there even when he was misdiagnosed with epilepsy as his original admitting diagnosis by Dr. Peyron in 1889. Vincent was much more fearful of the reality and unexpectedness of another attack than he was of the diagnosis itself. It was the attacks during which he could not paint that really upset him.

What Other Social Issues did Vincent Face?

On top of his medical problems, Vincent's inability to find out the true cause of his health problems possibly contributed to a seemingly endless cycle of frustrating social issues and challenging personal emotional distress. His health conditions may have caused a great deal of anxiety and social isolation. He often found himself alone—or worse, the victim of bullying and harassment (Naifeh, 2011).

Vincent constantly feared the loss of his financial safety net, which was provided by his beneficent brother, Theo. He was frustrated with the reality that his paintings were not selling, and his expectations that Theo would sell his art and then recoup some of his investment while his own career as an artist was, in his view, faltering. In addition to financial support consisting of that essential monthly stipend, Vincent was also dependent on Theo for acknowledgment, love, and acceptance. Vincent certainly had lots of family and financial problems, and worrisome undercurrents can be detected between the lines of all his letters and the corresponding letters in response. He desperately wanted to reconnect with his family and obtain their love and approval, but he would always overreact to the slightest misinterpreted provocation. He pushed family and friends away, sabotaging his real goals of love, acceptance, recognition, financial success, and independence as an uncompromising artistic individual.

Vincent also had a terrible temper. He often said whatever came into his mind, almost like Tourette's syndrome. Was Vincent able to control his verbal assaults, or did they just come out unfiltered? This anger and frustration most likely appeared as a result of the fear and anticipation of another surprise Meniere's attack.

He was unhealthy in his personal habits and would let his personal hygiene, and particularly his teeth, get the least attention. He had often tried to emulate the poor souls he was trying to paint, with poor hygiene and rags for clothing. He did not eat properly, and when he worked as a missionary in the coal-mining Borinage region of Belgium, he would give the poor, struggling souls *"the shirt off his back,"* living in abject poverty by dissipating his own modest church finances. Are these issues with finances, temper, and hygiene signs that may also point to bipolar or Asperger's?

The list of Vincent's social problems is extensive and continues. Vincent had terrible social skills, even worse boundary issues, was an introvert with no real friends, and always took any early relationship to its extremes—effectively destroying the possibility of any mutually enjoyable long term friendship. He initially felt that his new doctor, Dr. Paul-Ferdinand Gachet, was also his new friend, as they had much in common in their interests and understanding of all aspects of art and literature. Maybe it was the year of solitude in the asylum, when he had so much freedom to only go and paint, that allowed him to recover psychologically. After all, once in Auvers, he interacted pleasantly with others, such as the Ravoux family—in particular the daughter Adeline Ravoux and her little sister, Germaine—and of course, Marguerite Gachet.

Vincent was truly troubled with a wide assortment of difficult challenges, as mentioned above. I am not trying to minimize or exclude any of them. But none individually or in combination had as much impact on van Gogh as did his Meniere's disease, as far as driving his obsessive, productive, and creative genius to produce art. His prolific Auvers period is truly on a scale with Einstein's annum mirabilis (extraordinary year), in which Einstein produced and published four world-changing publications in physics journals in a single year. Vincent had his own annum mirabilis—an extraordinary period of only 10 weeks in Auvers, where he produced so many works of art, including three of his largest canvases. This can certainly suggest a bipolar component of mania or Asperger's. What do those experts say?

It intrigues me that a recently published book, On the Verge of Insanity: Van Gogh and His Illness (2016), was authored by four imminently qualified curators, art historians, and researchers all directly involved with the Van Gogh Museum, Amsterdam. They write about insanity and van Gogh's illness, but of the four authors, none have any extensive background in medicine, neurology, psychology, psychiatry, psychoanalysis, neurology, brain disorders, or the like. These areas of expertise would seem essential to understanding Vincent's so-called "*insanity*."

Laura Prins (N. Bakker, 2016), a noted author and researcher on 19th century art, stated:

> "*Yet Van Gogh never painted while suffering an attack of his illness, with the exception of a single period in the asylum in the early spring of 1890.*"

I would concur that he never painted when he was having an attack of his inner ear illness; such an attack of vertigo would stop most everyone in their tracks. Vertigo would preclude trying to paint or do any activity requiring focus and fine motor skills and control. I also agree with Prins's suggestion that "*his artistic achievement was most definitely not a side effect of his illness.*" His illness, and his attacks, only stopped him from painting for the duration of the attack and the recovery phase afterward. If anything, the attacks—or the fear of another devastating attack— propelled him to paint like a "*madman*" a canvas or more per day, without the anticipated salon expectations or inhibitions.

It is my opinion, as *"Vincent's ear doctor"* (diagnostically speaking), that his greatest motivation was that an even bigger, more severe attack would come and never end, thus preventing him from any further painting. I believe this fear was legitimate and overlaid his Asperger's syndrome components, along with his other issues, and was the significant driver of his prolific output. While Vincent's compulsion to finish whatever he started fits with an Asperger's syndrome diagnosis, it wasn't necessarily caused by Asperger's so much as it was a protective measure given his gnawing and insurmountable fear of a permanent, destructive vertigo attack.

The impact of his recurrent, unexpected inner ear disorder on his art is well expressed in his own handwritten letters. Vincent's art demonstrated his unquenchable and obsessive need to create magnificent works of art on canvas almost daily. So, in contrast to being remotely suicidal, you have alternatively to accept that this genius's primary need was to create and capture all the beauty in the world that he saw so clearly. This unbelievable creative drive and process that generated one or two masterpieces a day would not willingly be snuffed out in any moment of despair. He was at the height of his creative genius. Yes, he had other problems, unquestionably—but his art, and his desire to have it be enjoyed and appreciated by others prevailed.

Ultimately, was there a hereditary excuse for his unusual, eccentric, and solitary behavior? Was he really *"on the verge of insanity,"* as others have written extensively (N. Bakker, 2016)? The assumption that Vincent was somehow the victim of a tragic and possibly familial insanity is one of the major misconceptions surrounding the story of his life. In my professional opinion, he suffered from some combination of Meniere's disease, Asperger's syndrome, progressive neurosyphilis, intermittent depression and dramatic mood swings, bipolar disorder, and substance abuse. I do not personally believe he was clinically or *"certifiably"* insane and should have been in the asylum. He did have some bizarre behavior that today we might describe as an eccentric having a high stress *"meltdown."* There are certainly arguments to support many of these psychiatric diagnoses, but in the end, given the historical lack of clear evidence, a definitive diagnosis of Vincent's mental condition may never be reached. Still, some conclusions are clear. It is hard to deny that he suffered from some number of mental problems, Asperger's or otherwise. What does this mean for the larger picture of the circumstances regarding his life and his potential for suicide? Did these various mental problems, including Asperger's, increase his risk for suicide or only better define his life and his capabilities as an evolving artist? To better answer these questions, let us next explore together the legendary myth of Vincent van Gogh's suicide.

Chapter Seven

The Suicide Legend - Myth, Fact, or Fiction?

If the question at the center of this case is "*Who killed Vincent van Gogh?*", most people, prominent art historians included, would simply point to Vincent himself. Depending on one's point of view, the theory that Vincent's death was a suicide makes a great deal of sense. His past was full of failures, both professionally and personally. He was neglected emotionally by his mother, not accepted by his father, and supported financially by his younger brother. He had no obvious personal ego successes to build upon. His self-esteem was modest to lacking. His art failed to sell, and in fact he often had trouble giving any of his art away as a gift or a thank-you. Additionally, he had failed at least two previous attempted career paths, and failed miserably at several prior attempts at "*love*," and most all interpersonal relationships. Although he had finally found his calling as an artist, he had not received the success, accolades, or critical attention many of his peers had enjoyed, and worse, he seemed to consider himself a failure. Does he not seem like an excellent candidate for suicide?

How and Why the Suicide Myth Started, When it was First Questioned, and the Alternative Scenarios Back in the Day

This legendary suicide narrative has been the most readily accepted, perpetuated, and promoted position since it was introduced in summer of 1890 by Dr. Gachet and his son, and the others involved as collaborators of misinformation and misdirection. They started spreading the story immediately, once they were seen taking as many of Vincent's canvases as they could carry from his rooms after the burial. To counter any suspicion over the years, Paul Jr. perpetuated his father's myth that Vincent was crazy, that he wanted to die and committed suicide with a self-inflicted gunshot wound. His success in this major disinformation effort, often with co-conspirators, held up

reasonably well until the 1940s and 1950s when a lot of other information, interviews, and conflicting theories appeared. This was a time when Vincent's worldwide acceptance was the hottest topic in the art world.

Antonin Artaud—the famous French actor, painter, playwright, and poet—wrote that Dr. Gachet killed Vincent. He wrote that van Gogh did not commit suicide in a fit of insanity but had succeeded in discovering "*what he was and who he was.*"

He concluded that:

> "*...under the pressure of a malicious mind that Dr. Gachet, his 'psychiatrist' in the two days before his death, pushed him to suicide because he hated van Gogh as a painter, but more importantly as a genius.*"
>
> — (A. Artaud, 2014)

Interestingly, Artaud says that Vincent committed suicide at Dr. Gachet's house (*ibid.*), offering an interesting alternative and intriguing new location for the crime scene. Like Vincent, Artaud unexpectedly died under suspicious circumstances in 1948 after publishing this book (*ibid.*)—an apparent suicide without a suicide note, again by a well known artist and prolific writer.

In 1934, Irving Stone's fictional historical novel of Vincent's life, *Lust for Life*, was extremely successful and created an amazing appreciation for Vincent, his life, and his art; however, it also significantly supported and enhanced the mythical suicide narrative. He put forth the theory that Vincent's attacks were a form of epilepsy or madness, and that he committed suicide. The *Lust for Life* film adaptation (1956)— a major MGM biopic starring Kirk Douglas as Vincent and Anthony Quinn as Paul Gauguin—perpetuated the narrative even further. Three years later, Stone further advanced appreciation for Vincent by introducing the world to Vincent's letters to Theo in Dear Theo (Stone, 1937) and their amazing fraternal relationship. The actor Leonard Nimoy echoed this old-school suicide narrative in his one-man play, in which he played Theo lamenting his loss a week after Vincent's death (*Vincent*, 1981).

And in 1954, the artist Friedrich Karl Gotsch further spread the narrative of a suicide when he recalled a conversation that he had with Paul Gachet Jr., which was reported in a cultural almanac (Der Spiegel, 1990). Gotsch said that Paul Jr. told him that:

> "*Marguerite was responsible for 'Vincent to shoot himself.' She allegedly had an 'aversion to the foreign painter' and 'she herself was afraid of Monsieur van Gogh and did not wish to sit for him as a model'*"
>
> —(*ibid.*)

He continued,

> *"She was very ashamed to say so, but Monsieur van Gogh talked to her about love. Then my father and Vincent had a 'rift'; and Vincent since avoided our house."*
>
> —*(ibid.)*

The Current Positions of the Art Experts

How do the world's experts on the life of Vincent van Gogh line up on the issue of suicide, accidental death, or murder? There is no consensus among them, and the ongoing dispute is chaotic and increasingly heated. Some art history folks, van Gogh experts, and biographers have more recently supported the suicide theory, including David Sweetman (1990) and the experts from the Van Gogh Museum, Amsterdam: Nienke Bakker, Louis van Tilborgh, Laura Prins, and Teio Meidendorp (N. Bakker, 2016).

Interestingly, even though he affirmed Vincent's wound as a self-inflicted gunshot, Sweetman (*ibid.*) pointed the finger directly at Dr. Gachet as the person ultimately responsible for Vincent dying from such a wound. In his article "*Who Killed van Gogh? The Doctor Did It*" (Sweetman, *Connoisseur*, 1990), he focused on the fact that Gachet allowed Vincent to die without any opportunity for the 1890's state-of-the-art surgical treatment available a mere 20 miles away in Paris. By purposely withholding any possible chance of surgical treatment in Paris, Dr. Gachet effectively killed Vincent for certain. Sweetman's overall analysis of Dr. Paul Gachet as a person of interest was innately spot-on. Despite accepting the then still widely accepted gunshot wound and suicide theory, he was obviously distrustful of the Gachets and their stories when he said:

> *"Nothing in the accepted story bears examination [more than] the accounts of those who knew him in Auvers [and] are [so] contradictory and self-serving"*
>
> —(Sweetman, *ibid.*)

Some art historians and biographers do not support the suicide theory and thus, by default, support the idea of murder or accidental death. These experts are: Steven Naifeh and Gregory White-Smith (2011), Antonin Artaud (1948), William Arnold (personal communication, 2018), Dorota Kobeila (*Loving Vincent*, 2017), Hugh Welchman and Jacek Dehnel (*ibid.*, 2017) and J. Schnabel (2018).

I come down on the side of this latter group, who do not consider suicide a plausible explanation for Vincent's death. Though Vincent was certainly intermittently depressed, his love of painting was the driving force in his life. He was a man obsessed with his

craft at the height of his creative power. He was also driven by fear. He suffered from what at the time was a misunderstood condition whose symptoms jeopardized his ability to paint. As outlined in the previous chapters, possibly his greatest fear was of a catastrophic onset of irreversible vertigo that would unquestionably end his career as an artist. This fear drove him to dedicate nearly all his free time to his art, throwing all the traditional artist and salon practices away in favor of constant, uninhibited experimentation and creation. Given this knowledge about his motivations and how it affected his behavior and his art, it becomes difficult to believe that he would do something that would so suddenly and completely end his ability to create art and share the beauty he saw in all of the world with his fellow man.

Something else put an unexpected and unplanned end to the life of Vincent van Gogh, and it was not this 19th century mythical concept of a suicide as martyr for his art, or payback for his brother who footed the bill for all his artistic life. What other explanation for the death of van Gogh has more meaning and truth today? Let us explore together the possibilities.

Vincent's Stresses and Challenges Faced in His Last 70 Days

Despite all of his challenges, Vincent's need for success and achievement was much greater than his fear of failure. In the end, none of his many problems, individually or cumulatively, would likely lead him to commit suicide. Yes, he might have been despondent, aggravated, and frustrated at times, but this obsessive focus on his need to create and finish each day what he started trumped all else in his very complicated life. It is critical for any realistic analysis of Vincent's last 70 days in Auvers-sur-Oise to accept that he was truly a quite different person, mentally and physically, when he stepped off that train in May of 1890. He left the asylum of his own volition to meet up with his brother, sister-in-law, and his new nephew. He was well-rested and well fed after doing nothing for a year except thinking, meditating, writing letters, and most importantly, painting!

He arrived a new man, ready to accept and try his new life. He met his challenges so much better after leaving the asylum "*cured.*" What would Vincent have done or how would things have gone for him if before the "*ear episode,*" Theo had dropped the same bombshells on Vincent in 1888 that he did in 1890, with his new family and increased obligations, not putting Vincent's needs ahead of the others? Would that have precipitated another "*attack,*" or a flurry of attacks? Who knows? We do know that he had no further attacks or "*madness*" since before leaving the asylum and none noted in Auvers. Vincent handled all of this new, "*bad*" news so much better in Auvers than anyone could have predicted. What else may have changed for Vincent in Auvers?

His only real stress and concern in these last 70 days was his financial safety net and stability that allowed him the ability to pursue his art otherwise unperturbed by the normal

challenges of life. His brother Theo's deteriorating health and new family made his safety net seem much less secure to him now than in the past. But despite all this drama, Vincent was reported to have been very calm during most of these last 70 days in Auvers-sur-Oise. He had no further attacks since he left the asylum, and he even ordered more paint and canvases a day or so before receiving his mortal wound. It is difficult to believe that a man who intended to end his own life would order more supplies that he never intended to use, particularly if one of his worries was being a financial burden to his family.

Additionally, his stress level—significantly reduced after a year of rest, reflection, peace, quiet, and the ability to paint as much as he could without significant obstacles at the asylum—was even further reduced during his time in Auvers. He was away from the destructive temptations of the big city and finally had a quiet place to focus on his work. He had a reliable work schedule and seemed to be much less prone to erratic behavior. Furthermore, he was in regular contact with his brother by mail, and he was within very close, easy walking range of Dr. Gachet. The good doctor, Dr. Gachet, his friend, was supposed to be able to see him on demand for any health and psychological concerns, and Theo paid him to watch over his brother and make certain no harm came to him. It seems odd that he would choose to commit suicide in this relatively calm, happy, very productive, and peaceful time in his life. Importantly, he never gave any indication of any such plan to commit suicide in Auvers.

The only upsetting events noted by many in the village were the loud arguments overheard between Dr. Gachet and Vincent at the Gachet's villa. There were also rumors around the small town that Vincent may have even been in love with Gachet's daughter, Marguerite. Someone in that mindset would not have wasted resources or planned for future artistic endeavors in that manner, and then killed himself. A love affair, at this juncture, may have become a stressor only because this particular affair presented a new phenomenon for him. Was this love mutual, in contrast to his past romantic endeavors and dramatic failures? How was this love affair received by all involved?

Did Attacks or Fear of Attacks of "*Vertige*" Make Him More Likely to Commit Suicide?

Did Meniere's disease impact Vincent's normal life? Certainly yes! Did it impact his art? Yes. Did it impact the possibility of him committing suicide? No—if anything, it made him a less likely candidate for suicide. Though he was afraid of these attacks possibly ending his artistic career, the disease made him even more driven and determined to make the most of the healthy, calm, quiet periods in between the unpleasant and disruptive attacks. He was painting at an incredible pace in Auvers, which demonstrated hope and determination rather than hopelessness.

The attacks definitely interfered with his act of painting, making him frustrated and possibly prone to lashing out, and as we would say today they *"really messed with his head."* How bizarrely he acted during an attack witnessed by anyone is most likely the basis for the unusual descriptions of these events. Vincent certainly had a temper, and one would expect that he reacted quite strangely and severely in the midst of an attack, possibly appearing *"mad"* to his observers at both the hospital in Arles and the asylum in Saint Rémy. Thus it would seem to those mellow souls around him that he was very strange and difficult to understand and be with socially; then, along with his alleged self-mutilation history and frenetic behavior, it would seem to others like maybe he really was a *"mad"* genius who was unfortunately prone to suicide.

However, when one looks beyond the obvious and the long-standing, accepted gospel with a willingness to espouse a *"blasphemy,"* this conclusion of suicide begins to appear less likely. There was no basis for the possibility of a suicide if you really understood what made him tick, what motivated him, and what he was obsessed with. Nothing was going to stop him from his art and his painting (or his Marguerite). His art and his painting of what he saw—the colors, the light, the impressions that it all made on him— were his life. He needed to capture and share all that beauty, that amazing play of light and colors...and get it all from his vision onto his canvas.

That's psychologically why suicide was not possible. His need to paint and capture the beauty he saw all around him completely overrode his depressions and other mood disorders. The only thing that absolutely stopped him from his obsessive painting, his unquenchable need to finish a canvas on the day he started it, was his unpredictable, violent Meniere's disease attacks and his fear that his career and his life's work would be over forever with the next devastating, prolonged, and never-ending attack that would make it impossible even for Vincent to paint.

To Theo, Vincent stated his biggest fear was that he would eventually lose his ability to create beauty from nature:

> *"...a more violent attack [vertige] may forever destroy my power [ability] to paint."*
> — (Letter #605, Sept. 10, 1889)

What About all the Other Problems Confronting Vincent?

Though there is no definitive foolproof list of risk factors for suicide, it does not seem likely that someone so obsessed with a single positive pursuit would take such an overt and drastic life-changing action that would forever end these life-fulfilling goals. It is difficult to believe that someone so driven and afraid of a possible end of his career would make the choice to end the career prematurely, and his life immediately.

Therefore, even with his attacks of vertigo, history of alleged self-mutilation, and behavior that appeared to others as being "*mad*," it is essential to understand and accept that his Meniere's disease, Asperger's syndrome, and other medical issues had likely nothing directly to do with the possibility of him committing suicide. Despite all of this, to an outside observer looking at his psychological state, it would be near impossible to deny that he appeared a suicide risk. He easily fit most of the statistics pointing to a suicidal personality.

One does not have to look far to find more specific warning signs. According to the National Alliance on Mental Illness, people who already have another previously diagnosed mental illness account for 90 percent of suicides. If we believe the evidence that Vincent likely suffered from depression, bipolar disorder, and/or Asperger's syndrome, that would place him in this high-risk category.

Further risk factors continue to point to the possibility of Vincent's suicide. Substance abuse is a known risk factor, and Vincent certainly was known for his consumption of various substances like turpentine, paint, and alcohol, particularly absinthe. He was also known to have been prescribed many medications, under the expertise of other doctors as well as Dr. Gachet, to help him with his many other and various medical issues—including syphilis and gonorrhea treatments, as well as many other nostrums and concoctions of those days that the good doctor handed out to both Vincent and Theo. He was even possibly given digitalis from the foxglove plant, which is known to be powerful enough to influence a person's perception of colors and other actions, and in higher doses can build up to lethal levels.

Vincent clearly felt as if he was a burden to the people around him, particularly his brother, on whom he was financially dependent. If one places a high level of importance on these risk factors, it is easy to believe that he would have simply shot himself, but with a "*kill*" shot, not a belly shot. It is an uncomplicated and logical conclusion to reach. When factoring in the additional knowledge that he did not offer any explanation for his injury, only allegedly asking that no one else be blamed, suicide seems like the most likely and reasonable theoretical explanation. Vincent's doctor at the time agreed with that conclusion as well, based on what he supposedly told the police. The weekly newspaper and the townspeople gathered their initial information from Dr. Gachet, most likely, and thus believed this undocumented suicide narrative as gospel coming from the good doctor.

One of the strongest factors to argue against the theory of suicide lies in his background. Vincent was brought up in a very devout Protestant (Dutch Reform, Calvinist) family; his father was a preacher, and his mother ran the church social and charity functions. As he grew up, Vincent even tried divinity school and attempted to become an ordained preacher. He worked as a lay preacher, evangelist, and teacher of catechisms until he was castigated and then terminated for, in effect, too much zeal. Vincent gave it his all, in an amazing but doomed effort. Although that path was ultimately unsuccessful, Vincent remained deeply religious at an inner personal level. His religious convictions were one

of the most important things to him, and suicide would have gone against everything he had been taught and believed his entire life, even though he stopped going to church. He believed taking one's life would have even condemned him to further suffering in the afterlife. Suicide is not only a crime, but also a sin against God. Despite Vincent's wide swings in religious fervor, he was not a sinner, nor a likely suicide candidate.

No Focus, No Planning, and No Intent: His Letters Do Not Suggest a Definite Plan to Commit Suicide

All the letters written by Vincent to his family and friends—and those written back to him—that have been saved, organized, and published or recovered over the years by Theo's wife demonstrate a brilliant, well-read young man who was very argumentative, opinionated, and possibly even manipulative, but not clearly crazy or clinically mad (Naifeh, 2011). His writing was very literate, and he was very well-read in multiple languages and knowledgeable about art, color theory, poetry, the arts, music, theater, and literature. If he had not become a great artist with an indefatigable drive to paint, he would have easily become a man of letters, and probably a very prolific writer, poet, and philosopher in several genres.

His letters do not give the impression of a man suffering from madness or intending suicide; instead, they indicate a compulsive, obsessive, neurotic individual who is initially and intimately focused on the human condition, particularly the poor workers and peasants. Ultimately, he focused on himself and his art, after his family. God and religious precepts were paramount until his last several years. He was someone who bragged about reading Shakespeare so he could better understand the English language, and he even worked as an unpaid teacher of French and German while in England. He was someone who dreaded evil ideals and was often helping the downtrodden and the poor working man, literally giving them the shirt off his back in the Borinage. His letters show this kind of person (*ibid.*).

In reality, Vincent van Gogh frequently disagreed with the idea of committing suicide, and the topic came up in his letters. In Drenthe, he told Theo, in effect, that suicide was an unbecoming notion and that neither one of them should ever consider or attempt it (*ibid.*).

In his correspondences, he never stated serious intent, nor a time, nor a method, nor a specific place that would prompt one to take his thoughts of suicide seriously. This is especially important because most mental health professionals today only consider alerting authorities if a possible suicide is perceived as a credible threat worth acting upon; the person must have expressed a definite plan to carry out the action, with a specified time, place, and method.

His letters also did not indicate irreconcilable hopelessness. Though he expressed

sadness, and some of his paintings have been interpreted as demonstrating a sadness, he also wrote about hope, such as in this excerpt from a letter written in 1888:

> *"The more ugly, old, vicious, ill, poor I get, the more I want to take my revenge by producing a brilliant color, well arranged, resplendent [canvas]."*
> —(Letter W#7, September 1888)

By his own admission, he expressed a desire to turn adversity into a drive to create beautiful things. This is not the ongoing thought process of someone on the verge of insanity or on the precipice of committing suicide. Though he lived an earlier life with a great deal of stress and suffering, his sincere desire in Auvers was to rise above despair, particularly after the restful and restorative time spent in the asylum.

Maybe he really achieved that higher state of calm after a year of contemplation, meditation, solitude, and nothing to do except eat, sleep, rest, read, sketch, draw, paint, and write letters, and paint some more. His lived almost like a monk on an isolated retreat for a year, before rejoining the others as a prisoner, with very limited freedoms and access to the outside world. After he left the asylum "*cured*," he was noted by so many as calm and even unperturbed about the potential financial bind he found himself in.

An Attempt to Connect The Absence of a Suicide Note and the Absence of A Last Canvas Failed

Still, someone who believes in the suicide theory would state that much of this is conjecture, that Vincent could have been hiding his true feelings when writing to his family and pretending to be content and outwardly acting calm. Some may have thought him cleverly "*manipulative*" (*ibid.*). There needs to be more solid evidence to disprove this possibility. Such evidence can, in fact, be produced.

It is a well-known fact that people planning a suicide do not typically make plans for the future, and they often take steps to settle their affairs by doing things such as writing wills, giving away possessions, and drafting suicide notes. However, a search of Vincent's belongings did not produce such a note—only an unfinished, draft of a letter to his brother that had initially been interpreted as his suicide note. However, Jan Hulsker, an eminent van Gogh biographer and accepted expert on all of Vincent's letters and Vincent himself, said that the letter found in his pocket was only a draft of a much more mellow letter that he actually mailed before his wound occurred (Hulsker, 1977, 1990).

Though there is no existing proof to confirm which painting was Vincent's last, art historians and the psychological community have interpreted his "*last painting, Tree Roots,*" as a suicide note based on the draft of the note that Jan Hulsker had already

definitively debunked as the suicide note and combine that with their intriguing and inventive psychological analysis of *Tree Roots*.

> *"Well that faith flickered out in July, and his state of mind at the end is alluded to in 'Tree Roots,' his last picture, made in the morning of the event, as has recently been put forward ... We are looking along the side of a mound or a slope with coppiced trees with a sagging group in the middle, and this detailed portrayal of the struggle for survival of unstable, subsiding elms can be seen along with the letter in his jacket as a premeditated, programmatic adieu."*
>
> —(Maes and van Tilborgh, p. 462, 2013)

An intriguing analysis no doubt, but the letter has already been dismissed by the expert, Jan Hulsker (*ibid.*, 1970, 1999) and eliminated as *"the suicide note."* Moreover, there is no explanation to reasonably consider Tree Roots as his last painting. It is not accepted as his last painting by his hand on July 27, 1890, as there is no evidence to support that he even took any of his art supplies with him that day; he went to meet with all the Gachets and ended up mortally wounded (Tralbaut, 1969).

Lastly, as an aside to this discussion, for a prolific letter writer and facile debater with an amazing vocabulary and interest to continually express himself, it seems bizarre that Vincent did not leave any distinct suicide note, if in fact he really intended to end his life himself...painfully with a non-fatal belly shot instead of a death certain head shot. He loved words—why would he miss the chance to leave an explanation for why, now, he wanted to leave this world and everything he loved and worked so hard to achieve? This remains another mystery: why was no serious, well thought-out, premeditated, and truly erudite suicide note written by Vincent? The answer to this challenging question is that he never left the Ravoux Inn that day with any thought of committing suicide, or stealing a gun to shoot himself...in the belly of all places. Vincent was too savvy to do something so stupid and painful!

It is of notable interest that in the making of The Academy Award winning film, *Lust for Life*, there was a major, public opportunity to enhance and spread the story that Vincent was a martyr who committed suicide for his art. It is apparent that the director, Vincent Minnelli, and the producer, John Houseman, were convinced of the critical necessity of adding a suicide scene where Vincent (Kirk Douglas) pulls out a scrap of paper and scribbles his *"suicide note"* on a tree limb before shooting himself. The note, though fictional, was essential to making the suicide case more believable for the audience. Though the filmmakers surely knew a note was never found, perhaps they thought that the suicide story would not have been accepted without *"proof."* I believe the movie would not have been as successful if the suicide was not readily believable and documented with a suicide note, literally written into the script for the definitive ending of an otherwise magnificent biopic. Without that additional scene, this great cinematic experience may have faltered and cast doubt over the truth of Vincent's death.

Where Do We Go from Here if We Deny Vincent's Suicide as a Self-evident Truth?

Given the fact that this cold case is over 100 years old, it is of course possible that there is evidence that cannot be recovered or remains unknown to those of us who study van Gogh. There will always be room to doubt. Still, there now seems to be much more doubt placed on what had previously been portrayed in the art history books as an unquestioning, near-certain suicide narrative. It is noted with some interest that one of the academic elites, credited solely as *"a curator at the van Gogh Museum,"* predicted that if the suicide narrative was denied or disputed it would be considered a *"blasphemy on the van Gogh gospel"* (Naifeh, 2011). He further stated to Naifeh and White (*ibid.*) that:

> *"The biggest problem you'll find after publishing your theory is that suicide is printed in the brains of past and present generations and has become a sort of self-evident truth. Vincent's suicide has become the grand finale of the story of the martyr for art, it's his crown of thorns."*
>
> —*(ibid.)*

There seems to be sufficient cause and enough unanswered questions to justify investigating other possible scenarios for Vincent's mythical death besides suicide, including a tragic accident or even the more troubling possibility of murder. This serious questioning of the old suicide narrative would necessitate a reopening of this 128-year-old cold case to modern scrutiny and 21st century forensics analysis, simulations and recreations, and even reenactments. All the facts, evidence, theories, reports, and stories now need to be brought together in one comprehensive analysis to answer the obvious question as it now stands: if Vincent didn't kill himself, who else could be responsible for his mysterious death?

It is most intriguing now that what was first told, that Vincent was *"wounded,"* rapidly turned into a *"suicide,"* and then everyone involved had their own stories about Vincent and his death that expanded this early myth into an enduring legend. Many of the *"facts"* in the narratives were in direct conflict with each other and often self-serving. Who was the driving force behind pushing this false narrative and who had the motivation for disseminating this narrative of purposeful disinformation and misdirection? Who helped spread the word, sign the death certificate, talk to the police, and provide the information to the weekly newspaper? Who was respected and would easily be believed? If the old doctor said his friend and patient committed suicide, who was to argue, even without a suicide note, crime scene, or a witness to this final act? The legend of the mad but brilliant artist who committed the sin of suicide, as a martyr for his art and all artists, was promoted even further by both Dr. Gachet and Paul Jr. until they each reached their final resting places.

Putting this Old Suicide Narrative "*Out to Pasture*"

Why in the world would a very intelligent man, if he really wanted to commit suicide and end his life, allegedly shoot himself in the belly, most likely knowing this to be a very slow and painful way to die? Why not shoot himself in the head and die with certainty, with just one trigger pull? Oh, and then there is that unanswered question of whose gun he supposedly used? How and where did Vincent get the gun in the first place? How did Vincent get any gun in the correct position to shoot himself in the abdomen? Why walk back to the Ravoux Inn in pain, from wherever the crime scene was, instead of just dying wherever that deed was done? It makes no sense. This entire mythical story has so many flaws and obvious faults, no mystery writer today would ever accept all of theses glitches or try to make a conceivably acceptable narrative crime story from this weak information.

If this false suicide theory is finally put to rest—as is my intent, based on this recent analysis by Naifeh (*ibid.*) and Dr. Di Maio's forensic analysis (Chapter 26), now combined with the newer, in-depth forensics presented in Chapters 22 and 27—then a serious look at his death as an unsolved homicide must now be vigorously pursued. "*Blasphemy*" it may be to some, truth ultimately must prevail: Vincent van Gogh did not commit suicide with a self-inflicted gunshot wound to his abdomen. He was murdered! How, why, where, and when exactly? But most importantly ... by who?

Part III

Let's Look at the Evidence!

Chapter Eight

Killing Vincent: "*Facts*," Myths, Stories, and Findings

When searching for the "*facts*" related to the mysterious death of Vincent van Gogh, one should first ask the obvious question: why is this still considered an unsolved homicide, now, after 128 years? This is a cold case because there is no certain crime scene that has ever been identified or corroborated. There is no agreement on where Vincent was wounded or who did it, if it was not a suicide. There was no weapon initially identified, no black powder burn signature on the entrance wound to confirm that it was a self-inflicted gunshot, and there was no exit wound noted. There was no autopsy. No bullet or bullet cartridge casing was ever identified or recovered, or seriously looked for as it should have been. No suicide note was ever found.

Critically, no eyewitnesses ever stepped forward at the time to assist the police in their investigation, which was quickly accepted as a suicide based on the statements of Dr. Gachet. If Vincent's own doctor stated that it was a suicide, is it at all surprising that the police did not do a serious homicide investigation with any retained police report or written records? They had it from the victim's doctor's own mouth that there was no foul play, so why bother with an in-depth search and investigation of a potential crime scene on such a hot and muggy day, even though there was no supporting evidence for a suicide other than a (biased) doctor's word?

If we are to conclude that Vincent was—based on his psychological state, writings, and behavior—ultimately unlikely to commit suicide, then his killing must by default be an accidental death or a murder. When you add in my recent forensic analysis showing the distinct unlikelihood, if not impossibility, of a self-inflicted gunshot wound to his abdomen, which is explored in great detail later in this book (Chapters 22, 26, 27, and 28), then suicide appears to be a virtually impossible explanation for the artist's death. By eliminating suicide from the equation, we free Vincent's death from the stigma that it was caused by his other mental and medical issues. As a result, his vertigo, his Asperger's syndrome, his various strange and "*mad*" behaviors, and even

his neurosyphilis all become irrelevant and moot. This creates an important opening and a need for a serious, wide-ranging, and unbiased investigation into any and all other scenarios for how and why Vincent was killed.

If it was not a suicide, then it is imperative to erase all of our old thoughts and leave our unproven concepts, assumptions, and "*truths*" at the door. Then begins the challenge, as *TIME* magazine urged, to proceed and solve the mystery of "*Who killed Vincent van Gogh*" (October 31, 2011). We must together take another look at his last three days. Armed with old 19th century information and perspective, let us analyze this cold case from square one in the manner of a serious 21st century criminal investigation. This would necessitate solid police-type work, and it would require us to methodically and logically pursue all possible leads, suspicions, and intuitions. We must integrate our findings, along with any and all generally accepted facts, into a unified theory. Was Vincent killed accidentally or deliberately, and were one or more others directly involved beyond the artist himself? We need to find out the "*who*" and the "*how*," and determine if their involvement was planned, conspiratorial, or opportunistic; and then the "*why*."

Some experts believe, as suggested by *TIME* magazine and others, that a new examination of the available evidence with modern-day techniques and tools would help paint a better picture and uncover additional facts and details about his death. Luckily, there is now a greater acceptance of the science of forensics, and a greater expectation that they might be able to resolve the many unanswered questions regarding the death and murder of Vincent van Gogh. Forensics have become part of mainstream entertainment and a source of a widespread fascination, with crime novels and television shows gaining popularity around the world. At the same time, an investigation of Vincent's death has turned into something of a global phenomenon; the mythical legend of Vincent has been exploding since the *Lust for Life* book and movie were released, and it has been bolstered by all the media hype since his tragic death in other movies, TV documentaries, and new books. However, there is minimal available information on the mortal abdominal wound that eventually killed Vincent, The media's coverage of it has been limited in terms of the forensic and scientific data; instead, it is directed only at the description of the wound, presumably a bullet wound. No significant or notable forensic attention has ever been directed to the notion that the bullet that presumably killed Vincent was never found and what clarity that information might add. Nor has proper attention been focused on the weapon itself, which is also missing and remains unknown! Was it really a revolver? What else could have created a similar puncture wound in the belly that fits that description?

Beyond psychology and word-of-mouth stories and oral traditions alone, facts and physical evidence would be needed to support a conclusion of either accidental death or murder. In order to accomplish this task, we need to start fresh and look again at what brought him to his last three days of life in Auvers-sur-Oise. We must take stock of all the available facts—a challenging task that has been left undone for so many years. The

following lists serve as sort of a base *"crime report"* of what we know about Vincent's death thus far. Note that the truth is contested, with many unanswered questions and (purposely) misdirected information in play, mixed with few accepted "*facts.*"

The Undisputed Facts in this Cold Case

Background

- Vincent van Gogh was a 37-year-old, right-handed Dutchman residing in Auvers-sur-Oise, France, at the time of his unanticipated death and for the 70 days prior to this tragic event.

- His family remained in Holland except for his younger brother, Theo, who was an art dealer. Theo resided in Paris with his wife and new baby.

- In Arles, and then in the asylum, Vincent had a series of violent "*attacks*" and hallucinations that were then diagnosed as epilepsy. In between these "*attacks,*" he had completely symptom-free periods and was able to productively focus on his art.

- Vincent had an unusual episode in Arles on Christmas Eve of 1888 after an argument with Paul Gauguin, where a good portion of his left ear was amputated, allegedly by Vincent himself. This event, the long and difficult hospital recovery, as well as the reaction of his neighbors signing a petition to the mayor to have Vincent removed from the Yellow House is what led him eventually to escape this torment and admit himself to the asylum in Saint Rémy.

- Vincent had been discharged by Dr. Peyron, "*cured,*" on May 16, 1890, from the Asylum for Epileptics and Lunatics in Saint-Rémy-de-Provence, 20 miles from Arles. He had voluntarily committed himself there after his Arles hospital stay from the ear amputation episode.

- Vincent had no further attacks or hallucinations after his departure from the asylum. He remained attack-free until his demise. His old diagnosis of epilepsy from 1889 was clinically re-assessed in 1990 and changed to an inner ear disorder, Meniere's disease, by an internationally recognized team of inner ear specialists and a neurologist who specialized in epilepsy.

- Vincent traveled by overnight train from Saint Rémy to Paris on May 17, 1890. He arrived in the morning, without difficulty traveling by himself. Theo picked him up at the train station on schedule.

- When he arrived in Paris to meet his new sister-in-law, Johanna, and his namesake nephew, there were discussions about family finances. Theo was now supporting five people since he was also sending money to his mother, Anna. He sent money without any increase in his salary, which put both Theo and Vincent under significant stress. This concerned Vincent, as he had not worked for a salary for years, hoping Theo would be able to start selling his art.

- Yet he appeared much calmer after his year in the asylum and seemed to handle this stress very well, certainly much better than would have been expected in Arles prior to his year in the asylum.

Vincent's Last 70 Days

- Vincent left his family after a four-day visit, which was pleasant but tumultuous, and traveled by train from Paris to Auvers-sur-Oise on May 20, 1890.

- When Vincent stepped off the train in Auvers, he went directly to meet his new doctor, Dr. Paul-Ferdinand Gachet, who had been recommended to Theo by artist and friend Camille Pissarro.

- Vincent also met all of the Gachet household: the 20-year-old daughter, Marguerite; the 17-year-old son, Paul Jr., home from classes in Paris; and the longtime housekeeper, Madame Louise Chevalier.

- He also knew very well the entire Ravoux family: the father and owner, Gustave; his wife, Louise; the teenage daughter, Adeline; and her little sister, Germaine.

- It had been widely reported and accepted that people in Auvers heard loud arguments between Vincent and Dr. Gachet emanating from inside the Gachet villa prior to his death. It was thought that because of these arguments or "*rifts*," Vincent did not mention Dr. Gachet in any later letters.

- Vincent had no known access to a gun during this time, and no adult experience with a firearm.

The Day Vincent was Wounded

- Vincent got up early, as he often did, on Sunday morning, July 27, and had his breakfast.

- Many thought he would go off to paint as usual, but it is unclear whether he had his art equipment with him that morning when he left the inn. Where he went that morning, and whether he painted or sketched that day, remains uncertain.

- There is no known certain "*last*" painting or sketch done by Vincent's hand and definitively attributed to the day he was mortally injured, July 27, 1890.

- Vincent returned to the inn for lunch, but his meal was apparently shorter than his usual noon repast. He reportedly rushed off afterward, but it was not known to where he went with such purpose.

- There is a notable gap in time when it is agreed that no one saw Vincent until he returned to the Ravoux Inn in the early evening, holding his belly and bleeding.

- Intriguingly, it is also agreed that no one else in the village saw him return from wherever he was injured on that bright early summer Sunday eve, when most everyone was out and about trying to catch a breeze on what was reported as a stiflingly hot and muggy day.

- There were no reported eyewitnesses to his injury or "*wounding*" at the time.

- No one reported hearing a gunshot that day.

- There was a report of a gunshot heard from a "*trusted grandfather*" which came out in an interview many years later. In this report, the grandfather also confirmed seeing Vincent leaving the Ravoux Inn that Sunday afternoon and appearing at the barnyard off the road to Chaponval, on the rue Boucher.

- This "*trusted grandfather*" had heard a gunshot but did not go to investigate until later; he found nothing at the farm or barn—no body, no Vincent, no art equipment, no gun, no shell casings, and no other suspects. Amazingly, he did not report any of this to the police. His granddaughter reported that he thought it was "*not important.*"

- Vincent had missed his evening supper that day.

- Vincent initially only said to the Ravoux family that he was "*wounded.*"

- When Vincent returned to the Ravoux Inn injured (from where, we do not know), he was able to climb the 17 stairs to his windowless attic room without assistance. The room had a skylight.

- No one ever described him as having any difficulty breathing—no shortness of breath, sucking air, coughing up blood, or foaming at the mouth—which would have indicated a chest wound.

- He climbed into his bed for the last time, asked for his pipe, smoked, and was initially reported to be calm, serene, and lucid.

- Dr. Gachet made a "*brief visit*" to his bedside but—in an alleged consultation with a second local doctor, Dr. Jean Mazery—decided "*nothing could be done*" because of the location of the bullet close to the spine and major vessels in the midline.

- The wound description made many years later by Paul Gachet Jr. on behalf of these two doctors, who were deceased at the time of the interview, is unfortunately the only basis we have now for any historic forensic analysis or confirmation of validity of Vincent's mortal wound.

- There was no exit wound reported.

- There was no autopsy to corroborate any of this oral history contemporaneously. An autopsy would likely have only been done if foul play was suspected, not if the victim's doctor said it was a suicide.

- This old description of the wound was supplied to a forensic expert recently, who concluded in effect that Vincent van Gogh could not possibly have shot himself for several significant reasons reviewed and detailed in a later chapters (see also the original letter report, from Dr. Vincent Di Maio to Steven Naifeh, in the Appendix, Chapter 26).

- No one tried to alert or move the injured Vincent to Paris by train or buggy even though Paris was just an hour away, and Parisian hospitals had Franco-Prussian War-trained surgeons on their staff to try to treat such injuries.

- Dr. Gachet said he would send Theo a message at his gallery in the morning, wasting precious valuable time that potentially could have helped save Vincent's life.

- Anton Hirschig, the other Dutch painter staying at the Ravoux Inn in the adjacent garret room, heard Vincent scream "*is nobody going to cut on my belly?*", indicating that Vincent did not sound like someone who wanted to kill himself and die, but someone who wanted immediate medical attention, which was in effect denied him by Dr. Gachet.

- Anton Hirschig was dispatched the next morning, July 28, to Paris to inform Theo of his beloved brother's perilous condition. Theo arrived from Paris by train that afternoon.

- Theo sat with his brother at his bedside all day and into the night crying, until Vincent quietly passed away at around 1:30 A.M. on July 29, about 30 hours from the time he entered the Ravoux Inn mortally wounded. The time difference from his actual wounding event until his arrival at the inn is not known.

- There was no suicide note found and several have said that he had seemed fine, calm, and did not appear depressed or suicidal. Theo found a note or draft letter in Vincent's jacket pocket after his passing, which sounded like it could have been a suicide note.

- However, eminent Vincent van Gogh letter expert and scholar Jan Hulsker (1977, 1990) confirmed that this was not his "*last note*" or a suicide note. Vincent had only drafted it as a letter to Theo. A later letter, posted after this draft note was written, confirmed it was not a suicide note.

- The actual "*last*" letter from Vincent to Theo, of which there is only a draft, was upbeat, not suicidal or depressed. Sweetman said that the letter was "*perfectly calm and shows a quiet determination to get on with his work*" (1990).

- Unlike the actions of a suicidal man, Vincent also ordered large quantities of paint, supplies, and canvases just before he died. There were no actions or suggestions of an impending suicide. There was no indication of a planned time, place, or method.

The Wake and the Funeral

- The village carpenter, Levert, made Vincent's coffin on July 29, after he was notified of Vincent's passing. He had made all of Vincent's stretched canvas frames for his Auvers period.

- Theo and Dr. Gachet went across the street to the city hall to register and sign Vincent's death certificate. This building was famously painted by Vincent on July 14, 1890—Bastille Day.

- Vincent was placed in his coffin on the pool table, or on two sawhorses from Levert, in the Ravoux Inn for his final viewing on July 30, 1890. According to Emile Bernard, he was surrounded by his art supplies, easel, and palette, but no definite "*last painting*" was noted.

- The local church denied Vincent's family the use of their hearse because Vincent sinned and broke the law by committing suicide. Apparently, Anton Hirschig had to acquire a hearse from the next village to use for Vincent's funeral procession from the inn to the cemetery.

- Emile Bernard helped Theo and Dr. Gachet hang many of Vincent's paintings on view in the inn on the walls surrounding his coffin that morning. This is where, how, and when Bernard got all his "*facts*" about Vincent commiting suicide from Dr. Gachet.

- Bernard touchingly described Vincent's funeral procession and the funeral in a letter from August 2, 1890, to the art critic Albert Aurier. He described what the room looked like and who was there to pay their last respects at his burial:

- *"On the walls of the room where his body was laid out, all his last (many) canvases were hung making a sort of halo for him, and the brilliance of the genius that radiated from them made this death even more painful for us artists who were there. The coffin was covered with a simple white cloth and surrounded with masses of flowers, the sunflowers that he loved so much, yellow dahlias, yellow flowers everywhere. It was, you will remember, his favorite color, the symbol of the light that he dreamed of as being in people's hearts as well as in works of art."*

- Bernard also described the friends of Vincent who attended from Paris and Auvers. It was noted that both the father and son Gachet were present for the funeral.

- Marguerite Gachet was notably not present at the wake or burial. Many thought this was strange, because Vincent painted and sketched her on several occasions.

- It was also noted that Dr. Gachet and Paul Jr. went directly from the burial back to the Ravoux Inn and removed as many of Vincent's works as they could literally carry away in a cart.

- The weekly newspaper reported on August 7, 1890 that Vincent van Gogh *"wounded himself with a revolver"* and had died on July 29, 1890.

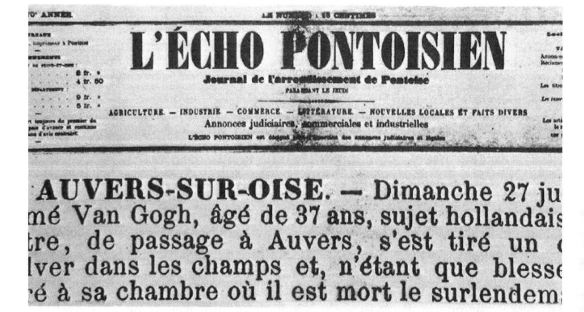

Fig. 59. **Announcement of the Death of Vincent van Gogh,**
L'Echo Pontoisien, August 7, 1890

What Is Significantly Disputed in The Accounts
Of the Day Van Gogh Was Wounded?

- There are acceptable sources that were independently written by unbiased third parties, which tell stories from witnesses years after Vincent's death. This is, however, where all the original reports become confused, often sound strange and bizarre, and are even sometimes in direct conflict! Who to believe becomes a major conundrum. Who is believable, trustworthy, reliable, and honest, with no hidden or obtuse agenda? These old reports, told by those involved directly in the events surrounding Vincent's death, are distinctly different from those stories emanating years later from independent observers. These later accounts are only stories alleging certain occurrences and remembrances to be true "*facts*," despite the lack of any contemporaneous evidence to corroborate or support them as factual.

- I can accept another person's account of the events, given years later, as "*reasonable fact*" when it was derived and recorded by an independent third party who was not directly involved in the outcome of this cold case or noted as a person of interest. These independent third parties must clearly be free of any bias or free of any transparent vested interest. This is an important reality to understand and accept, because without utilizing any of these later accounts at all, we would have nothing else available to piece together an acceptable narrative connecting all the "*dots*" of the murder of Vincent van Gogh. Let us investigate the aspects of the case that are muddled by significant disputes and controversy.

Where Was Vincent On the Morning He was Shot?

- Did he go off to paint or was he at the Gachet villa? In an interview with Paul Jr. and Marguerite, Tralbaut (1969) wrote that van Gogh was at the Gachet residence. According to Paul Jr., on the day of July 27 there was a meeting between all three Gachets and Vincent at the Gachet home. The Gachets were not off fishing, as first offered by the housekeeper.

- This meeting ended with another loud argument, allegedly over the lack of framing of a now infamous nude by Jean-Baptiste Armand Guillaumin. Guillaumin was one of Vincent's colleagues and artist friends; the painting was sitting unframed on the floor in a hallway, which Vincent viewed as disrespectful (*ibid.*).

- Tralbaut was told by Paul Jr. that "*towards the end of the afternoon of Sunday, July 27, the Gachets watched Vincent leave [their home]*" (*ibid.*).

- The face-to-face interview with Paul Gachet Jr. and Marguerite Gachet by Marc Edo Tralbaut confirms that Vincent was at the Gachet Villa on July 27, 1890, the day he was fatally wounded (*ibid.*).

- Paul (and Marguerite) stated on that day that Vincent "*seemed perfectly calm, but they nevertheless felt uneasy about him. Something was wrong. Vincent seemed to have some hidden intention*" (*ibid.*).

- Dr. Gachet, in consultation with Dr. Jean Mazery, concluded that "*nothing could be done*" to save Vincent after he was wounded. Paul Gachet Jr. and Adeline Ravoux emphatically disagreed on this point (see next chapter for details of this significant dispute).

- There was no mention all day, by anyone, of the whereabouts, presence, or absence of all Vincent's art supplies. Nothing was found on the next day, July 28, 1890, when the police looked for the weapon and his art paraphernalia to designate a crime scene, nor apparently after the police went to search for it in the wheat field after his death on July 29, 1890. Did he take the art supplies with him the morning he was wounded, or did he leave them at the Ravoux Inn because he was going to the Gachets' house that day for a very important, planned meeting? This is a big conundrum related to his missing "*last canvas.*"

- No one can confirm definitively what was Vincent's last painting, or if any was made on that day he was fatally wounded. Various paintings, over the years, have been claimed by the experts to be his "*last painting,*" but there is no consensus and no proof (see Chapter 20).

- Interestingly and unexplained is how the artist's palette, paints, and easel were somehow miraculously found shortly thereafter, and then brought to the funeral and placed beside him at his last rest at the white draped platform. All his art paraphernalia was there, except any specific, last, still wet canvas. Where did that "*last canvas*" disappear to? He must have had at least one canvas he was working on with him? He always did, unless he did not intend to paint that day and never took any of his art supplies with him that fateful afternoon.

- The description of the mortal penetrating abdominal wound is disputed—opposing descriptions by two doctors were presented only by Paul Jr., on behalf of both his father and Dr. Jean Mazery, in an interview with Victor Doiteau and Edgar Leroy in 1926. At this time, Dr. Mazery had been dead for 10 years, and Dr. Gachet had been dead since 1909. So, ALL of our available information and description of Vincent's mortal wound comes from Paul Gachet Jr., a person of interest in this case. This was 36 years after the event, and was not based on any written reports or drawings, for none existed. It was all based on a very well-rehearsed oral tradition perpetuated first by the father and then carried forward by the son, who rose to defend his father's honor, and made the Vincent story his life's work.

- The brothers René and Gaston Secrétan were said to be involved with Vincent's death. This is a major controversy. If it is true, did they shoot him? Could they have been involved in an accidental shooting because of a negligent discharge or malfunctioning firearm? Was it teenage harassment, a prank, or bullying gone very wrong? Were these teenagers role-playing Wild West gunslingers with a loaded gun that then misfired? Were they even there in Auvers on that day, or were they just the "*patsies*" set up years later to take the heat off of the real culprits?

- Is there any other possible person of interest, no matter how unlikely they may be implicated, that is being overlooked now? Maybe!

Critical Missing Evidence

The Police Report. Vincent's gunshot wound was reported to the police, but only a preliminary and cursory investigation was allegedly performed by gendarme Rigaumin. Unfortunately, there remains no available record of any contemporaneous police report, if any ever existed.

Suicide Note. There was no suicide note. There have been several failed attempts to characterize one of his paintings as the "*last painting*" based on a psychological analysis of what and why he chose to depict and paint the canvas as he did. There is no indication of his truly last painting in his writings except maybe sketches he made in letters, but it would be a stretch to characterize any of those sketches as suggestive of any suicidal thoughts, let alone suicidal intent. Certainly not a time, a method, or a place.

The Crime Scene. It is unknown where he went that day and where exactly he was injured. The murder weapon could have been taken away purposely from the murder site and discarded by Vincent's killer. Was he injured in any of the wheat fields outside of town (as is the primary lore), near the church, near the barn, at his doctor's house, along the Oise river bank, or at any one of the other locations he was known to frequent?

The Pathway. He walked back bleeding to the inn without any assistance. One can only imagine the painful journey Vincent suffered. Vincent was ambulatory after being injured, so the crime scene information as well his route back to the inn have remained a secret.

The "*Belly*" Forensic Evidence. The critical case to definitively answer suicide or murder, utilizing forensic evidence, remains "*in his belly*" (the bullet), or literally "*on his belly*," (the powder burn). Vincent's belly had much of the missing information. Can any of that information be respectfully obtained yet? Was there a visible powder burn on his skin or not? A better detailed description of his entry wound contemporaneously would have been extremely helpful. Was there a bullet in his belly? Where? What caliber? Was there a powder burn? (See the forensics Chapters 22 and 27).

Any Witnesses? No one admitted to having seen him that day on his way back to the Ravoux Inn with his mortal wound in his belly, except maybe the *"truthful grandfather,"* but he did not come forward himself, and his story was only recounted years later as family oral tradition passed down through the generations but unfortunately not told to the police at the time.

The Doctor's Report. There are also no extant doctor's reports that were written while Vincent was still alive that describe his abdominal wound in any detail. The only reports we have to rely on were presented orally 36 years later, as an interview for a van Gogh book, and again, only an oral tradition passed down father to son.

A Description Of The Wound. No notice was ever made of any signature powder burn on Vincent's belly around the bullet hole (which was reported in a well-detailed description as having concentric color rings around the pea size entry wound, but no description of a carbon black powder burn). Without this necessary description and detailed observations, and absent any findings that would involve the essential black powder burn, a suicide is impossible to confirm as concluded by Dr. Di Maio (2013). Such a report would be the basis for all modern forensic investigation and allow for a more definitive analysis.

Where Is The Missing Bullet If The Wound Was Inflicted By A Gun? This mysterious, missing, and *"magic"* bullet is absolutely essential to find. It would confirm whether a self-inflicted wound by a black powder weapon was discharged close enough to the body to leave the indisputable powder burn signature for any modern crime scene investigator to describe or today photograph.

Which Doctor Or Doctors Saw Vincent's Wound? Was it Dr. Gachet? Was it Gachet in addition to Dr. Mazery? This is a major divergence in two completely different stories—that of Adeline Ravoux and that of Paul Gachet Jr. (see next chapter for the details of whose accounts to believe).

Where Is The Gun Used To Wound Vincent? The weapon that wounded Vincent has never been definitively found or confirmed. It is assumed that Vincent was shot, but no gun has been found and indisputably tied to the wounding incident. An old rusted 7mm caliber revolver was found in a wheat field more than 60 years after Vincent's death, but it remains unclear whether this weapon is definitely related to Vincent's death or merely a coincidental finding. The Van Gogh Museum, however, believes this to be the gun that was used to fire the *"kill shot"* into Vincent's belly. Confirmation of the date this gun was discovered and exactly where would provide very useful information. It is unclear why the museum withheld this information.

Who Was The Owner Of This Old Rusted Gun? The museum experts named Gustave Ravoux as the owner of this ambiguous gun in an attempt to strengthen and confirm the weak suicide argument. This theory is also disputed, unless the missing bullet,

presumed to still be in Vincent's body or his coffin, is found and matches the 7mm caliber of the old rusted revolver found 60 years later.

A Bullet Or Bullet Cartridge Casing. No bullet or bullet casing has ever been presented or retrieved for analysis in connection with Vincent's death. It most likely would have had to be a black powder bullet in 1890. This now mysterious, *"magic,"* missing bullet should be in the forensic criminal investigator's evidence bag but is not! What mysteries could it solve? It is certainly necessary to confirm the existence of a bullet in Vincent, or his casket, to confirm that a gun was used to commit this murder. If no bullet is found, was a gun used...or another weapon? Was a gun used, but the bullet was removed when Vincent's remains were moved to his final resting place in 1905? Who, then, removed the bullet and why? What caliber might that now missing bullet be, and would it match the old rusted revolver 7mm chambers?

Newspaper Obituary. Who made the report to the newspaper that Vincent shot himself? The local newspapers reported the death as a suicide. What facts did they rely upon? There was no suicide note, no autopsy, and no coroner's report, so therefore the factual basis for this article is disputed. Dr. Paul Gachet was the logical source of this story, as it gave him the opportunity to cement that Vincent shot himself, thus continuing and adding to the false suicide narrative.

Theo's Suspicious Death. The unusual, almost bizarre behavior and unusual death of Vincent's patron and loving brother Theo—less than six months after Vincent's death—is shrouded in mystery as well, with several different versions. It is important to remember that Theo was also under the care of Dr. Paul-Ferdinand Gachet at his Paris consulting rooms, before Vincent's murder. Did he also continue his treatments with Dr. Gachet after his brother's death to help with his *"melancholia?"* Did the nostrums and other homeopathic potions he received help him feel better or did they speed up his demise? That's another story, for another day.

The Crime Scene; Vincent's View of Auvers-Sur-Oise

We can now pick up the story with what clues Vincent himself physically saw in Auvers then, and what we can see and reconstruct now. These would be considered *"facts,"* as Vincent saw them in those last 70 days. Did he inadvertently paint the crime scene? These views of what he saw and painted, regardless of his interpretations, give us some notable insight into the picturesque village of Auvers as he experienced it. Where Vincent was on the day he was shot, *"the crime scene,"* may be depicted in any one of the many of his timely paintings during those last 70 days. Unfortunately none of his paintings give us any insight as to the crime scene itself. Any and all of his paintings could capture a possible crime scene in and around Auvers-sur-Oise, but...which one?

Critical Unanswered Questions

Some of the many questions one should seek to answer are: what exactly was the penetrating wound that caused Vincent's death? What was the weapon used? Who was Dr. Jean Mazery, and was he really the second doctor to see Vincent? Did he really corroborate Dr. Gachet's opinion that *"nothing could be done,"* effectively guaranteeing Vincent's death, when early intervention and an hour of travel to Paris may have changed art history? Why was it essential that Vincent could not be taken alive to Paris? Significantly, who was notably absent from his funeral? What happened to many of Vincent's paintings immediately after his burial? What happened to Theo and his new family in the ensuing months? These questions regarding the level of Vincent's medical care, his visitors, the way in which he was left to die, and who was (and wasn't) present at his bedside death vigil as well as his funeral all raise suspicion about the people he was believed to have trusted most.

An Early Short List of Persons of Interest

Perhaps, as we seek answers to these questions, one person will appear to be involved in almost every aspect of Vincent's death and its aftermath—what name keeps recurring in our search for an answer? And who can we trust now if not the main sources of our information about the day Vincent was fatally injured and its aftermath? Are our primary sources of information also persons of interest? How reliable and believable can that be? What if they are involved in the murder and the cover-up? Who can you trust, at this point, as the most reliable source of any information that could be useful to attempt to connect all dots and present the most likely scenario of what happened on the day Vincent sustained his fatal injury?

Fig. 60-62. This is **the famous 17 stairs Vincent climbed up to his room and bed,** *for the last time. The first steps up to his attic room (60). The landing across from his room (61). The view from the landing into his room (62).*

Who is the Most Reliable and Believable
At This Point, almost 130 Years Later?

I have relied mostly on later interviews with witnesses, not the false suicide narrative originally promulgated immediately after Vincent's fatal injury. If the interviewee had nothing to gain and was independently sought out, I find him or her to be more acceptable and much more credible. If an investigative reporter or art historian sought out witnesses and used reasonable journalism standards, asked important questions, and documented their statements, I find their testimonies most helpful in connecting the "*dots.*" At this point, I have no alternative sources. I hope you can form all of the integration of these limited facts and "*dots*" into a cohesive and acceptable story of what most likely happened on July 27, 1890. Most importantly, how, where, and why needs to be comfortably addressed. Then, who murdered Vincent van Gogh may become obvious.

Chapter Nine

Opposing Stories: Whose "*Facts*" To Believe?

All we really know now about Vincent's death comes from detailed interviews long after the artist was buried with all his secrets. Our limited understanding was supplied by the statements of Dr. Gachet and his son, Paul Jr., letters that Theo wrote, primarily those to his wife, Johanna Bonger-van Gogh, and the story told by René Secrétan when he was an old man. Another key witness was Adeline Ravoux, who was, at the time of Vincent's death, the teenage daughter of the innkeeper at the Ravoux Inn, where Vincent stayed and died. She probably saw him more than most before his injury, and certainly was an eye-witness to all the events from when Vincent returned to the inn wounded until he died, about 30 hours later. She was the only surviving eye-witness to all the events at the Ravoux Inn when she was interviewed several times in the 1950s. Despite some inconsistencies (Naifeh, 2011) in her story over several years by a lucid septuagenarian, her account is more believable than the old, repeatedly rehearsed Gachet account. One must certainly take the first account by Adeline as the most truthful, reliable, unadulterated, and uncoached retelling of her tale. That is usually the case, that the first account has the most weight in court, before legal counsel has access to the witness. Adeline had nothing to gain by her story. Paul Gachet Jr. had everything to gain. You decide.

The obvious problem now, as we delve deeper into this crime, is that so much information and testimony that we have relied on for so long is severely tainted, not believable, and in direct conflict with others' stories and remembrances. When I first encountered such distorted information from very unreliable sources, I had to assess whose story was most believable. I had to make judgments about the integrity and honesty of each story and determine whether it added up. If a "*witness*" clearly had their own agenda and purposely went public with their own version of the day Vincent was injured that "*looked and smelled funny*"—like the father-son team of Dr. Gachet and Paul Jr.—then I looked at their testimonies with great suspicion. These stories were not readily accepted, particularly if there was an alternative that seemed more plausible, honest, and supported by other stories or corroborating interviews. This credibility

factor played an important role when I was stringing together these diverse stories to create a cohesive, connected, and believable narrative.

I was most inclined to believe and give the greatest weight to the stories that were only offered up years later when they were reported or sought out by neutral parties, such as Rewald (1956, 1973), Tralbaut (1969, 1981), and Wilkie (1978, 1991, 2004). The interviews of Adeline Ravoux stand out as particularly credible (1953, 1955, 1956). These interviews were offered as opportunities to tell the truth and set the record straight, without any hidden agenda. Meanwhile, the Gachets' own agenda was clearly to distort the truth and misinform you, the art-history loving public, about the murder of Vincent van Gogh and the subsequent cover-up. When this so clearly happened, their story lost all credibility and actually served the opposite of its intended purpose—I believe it actually helps demonstrate their guilt in a case of homicide.

Dr. Paul-Ferdinand Gachet's Story

Dr. Gachet declared to the police that Vincent's wound was self-inflicted, thus creating the legend of suicide, and he bolstered it with authoritative government support by presenting it to the local newspaper. He enlisted Emile Bernard's unwitting help in disseminating this false story to Vincent's friends and the Paris art world with a letter to a respected critic. Did Dr. Gachet ask, convince, or cajole Bernard to write that letter, giving credence to the suicide narrative? Since, at this point, I am confident that Vincent's death was not a suicide, Gachet was clearly sowing misinformation and misdirecting us in our search for the truth about Vincent's death and who might be implicated. But why did he misdirect the police and the townspeople with information that he knew to be untrue? Perhaps he was being devious and knew that he

*Fig. 63. **Portrait of Dr. Paul-Ferdinand Gachet**. Circa 1852. Photo by Ambroise Detrez.*

was spreading lies. Why would he perpetuate and amplify this suicide story? What were his motives—money, professional jealousy, protecting his family name from an undesirable match for his daughter, Marguerite? Or was it a combination of multiple motivations? Maybe all of these played a role.

Even though the first story was that Vincent was just *"wounded,"* his injury rapidly turned into a suicide after Emile Bernard declared it so in his letter of August 2, 1890, to the critic Albert Aurier. Suddenly, everyone involved had their own stories about Vincent and his death as the suicide legend was affirmed by so many and so rapidly that it grew quickly to mythical proportions. Bernard confirmed the story to everyone at the funeral and, in effect, to the entire Parisian art community by telling the critic Aurier (*ibid.*). It is of more than passing interest as to how, why, or where Bernard was able to relay all of the *"details"* of Vincent's *"suicide"* so quickly and convincingly. One can only assume he got all these details from Dr. Gachet himself, as Bernard and Gachet hung Vincent's canvases in the room around his white-draped casket before the guests arrived. They had plenty of time and opportunity to discuss and catch up on all these depressing details. It is otherwise hard to understand how any of these details would be known by Bernard unless they were directly and purposely positioned before him that morning, to relay to all in Paris. Almost all of the information Dr. Gachet told him was disputed by others, such as how Vincent placed his *"easel against a haystack"* and shot a revolver *"at his heart"*; the story sounds like a terribly dramatic spin on the truth. But Dr. Gachet was respected and would easily be believed. If he said his friend and patient committed suicide, who was to argue?

Bernard also described the funeral itself to Aurier. He said the palette and easel were present but made no mention about which of the several paintings that hung around Vincent's laid-out body was specifically his still-wet, last painting. Maybe it was left unfinished? Maybe there was no last, wet canvas to place near Vincent. Bernard mentioned how bereaved Dr. Gachet seemed to be:

> *"Dr. Gachet (who is a great lover of art and possesses one of the best collections of impressionist paintings of the present day) wanted to say a few words of homage about Vincent and his life, but he too was crying so much that he could only stammer a very confused farewell ... (the most beautiful way, perhaps)."*
> —(E. Bernard, letter to Aurier, August 1890)

*Fig. 64. Dr. Paul-Ferdinand Gachet, **Death mask sketch of Vincent van Gogh**, July 30, 1890.*

Of course, this display of grief occurred just before Dr. Gachet and his son took many of Vincent's paintings away with them before everyone dispersed back around town, or to Paris. It is interesting that despite his grief for his friend and patient, the good doctor found the effort and the time to sketch quickly, Vincent van Gogh's death mask (Figure 64).

Dr. Gachet did find it in his heart, or just found it good, to say kind words about Vincent. According to Bernard's recollections of the event, Gachet stood before those in attendance and said "*a few words of homage about Vincent and his life*," calling him "*an honest man and a great artist.*" Gachet said, "*He had only two aims, humanity and art. It was art that he prized above everything and which will make his name live.*" Paul Jr. was there to nod along with such praise, but Marguerite was not—perhaps she was too emotional to be able to attend the funeral, or perhaps her father did not allow her to attend for reasons to be explored and elaborated upon in Chapters 15 and 22.

This absence of Marguerite, the doctor's daughter who had modeled for Vincent's paintings on several occasions, is a major red flag in this unsolved murder mystery. Even though Vincent was denied a church burial due to the perceived sin of suicide, from Bernard's description, the wake was, at least, a beautiful and touching tribute to the artist. Why was Marguerite not present at such an important event, when she spent so much time with Vincent and cared for him? And then placed flowers on his grave almost daily thereafter? This is certainly something to look at more closely.

Paul Gachet Jr.'s Story

In 1926, Paul Gachet Jr. delivered an oral report as an interview to two physician-authors, Victor Doiteau and Edgar Leroy, and penned a bizarre preface for their book *La folie de van Gogh* (The Madness of van Gogh, 1928). When one reads the preface, it comes across like an overt effort to preserve and protect the family name and the father's honor and reputation as a good doctor. It further perpetuates the story that Vincent was a mad, brilliant artist who committed suicide for his art. Doiteau and Leroy did no serious investigative work on their own to corroborate Paul's information. However, they apparently took the opportunity to publish a book explaining and framing Vincent's life, art, and "*suicide*" in whatever way Paul Jr. wanted them to—and they too wanted the world to continue to accept and believe as fact that Vincent committed suicide. Were they also a part of the cover-up conspiracy or just compliant authors looking to write an intriguing book, as Vincent's fame was beginning to blossom?

One of the most important details that Paul Jr. shared was that his father attended to Vincent after he was wounded, alongside another doctor Dr. Jean Mazery from down the road in Pontoise. Paul Jr. said that Mazery made a report and diagrams of Vincent's abdominal wound, and that after doing so he seconded the opinion of Dr. Gachet that "*nothing could be done*" to help heal the artist. He said that, subsequently, Dr. Gachet stayed at Vincent's bedside all night to care for him. By 1926, there was no way to corroborate any of this story with Dr. Mazery himself, as he passed away about a decade earlier. Paul's father, Dr. Paul-Ferdinand Gachet, had predeceased his medical colleague in 1909, long before this key interview could have been fact checked.

This oral interview and report are now the only basis for any belated, possible forensic evaluations, and form the basis for the "*truths*" that we must now accept...or are they? The sole description of Vincent's wound that has survived the decades—given the absence of any contemporaneous medical or police reports—is one that Paul supplied himself to Doiteau and Leroy. He described the bullet as being near Vincent's spine and great vessels and said that, for this reason, Dr. Mazery supported the choice not to move Vincent to a hospital or attempt any treatment.

In this way, Paul Jr. carried on the story that his father had told years earlier: that Vincent shot himself and by the time Dr. Gachet got to his bedside, the artist was beyond help, despite the fact that Vincent survived for 30 hours and could have easily been moved to a hospital in Paris in the first hours when he was still relatively comfortable and smoking his pipe. What was the real reasons that Dr. Gachet did not want Vincent to be seen, alive, by a surgeon in Paris? There may be an answer for you in Chapter 18.

If we no longer believe this to be true, why did the Gachets say it was so? Did the father and son plan a cover-up to deflect from their involvement in his death, and to blame the death as a suicide on Vincent's alleged madness, self-mutilation, and depression? Or, did they have a plan B, to blame it on the local patsies, the Secrétan brothers? The Secrétans quickly left town after they heard of the shooting. The Gachets may have known that the Secrétans would be under suspicion because of their regular harassment of poor Vincent, including taunting him in public with a loaded revolver. Did they plan to use this as a ruse if needed after the murder? Was that alibi and story already baked in the cake?

Paul Jr. also described a pistol in Vincent's pocket, which the artist allegedly started to draw during a heated argument with his father, Dr. Gachet. Paul Jr. was supposedly a witness to these events, but only discussed them years later. If this tale is true, where would Vincent, recently discharged from an insane asylum, have gotten a gun? The possibility of Vincent acquiring a gun has been discussed frequently. Most recently, including the possibility that a gun, the gun, was purposely left out and placed specifically so that Vincent would find it. This gun was owned by none other than Dr. Gachet himself (Wallace, *Leaving Van Gogh*, 2011). This scholar has even suggested that Dr. Gachet himself "*loaned or placed the gun*"—his own military service weapon—"*for Vincent to find.*" Some reports even suggest Dr. Gachet said, "*I have never regretted leaving the gun for him to find. In fact, I sometimes think it was the finest thing I ever did.*" (*ibid.*)

In my view, the story of Vincent threatening anyone with a "*phantom pistol*" is weak given that Dr. Gachet was the one known to have a gun to wield. The story seems like an amazing attempt by the Gachets to demonstrate that Vincent had a history of bad intentions and crazy behavior—making him look like a potential suicide victim or a murderer himself. This unsubstantiated commentary, many years after Vincent's murder, also seems like a revisionist attempt to place the "*suicide*" weapon squarely in Vincent's possession before July 27, 1890.

Adeline Ravoux's Story

Figs. 65. **Portrait of Adeline Ravoux**, *(The Lady in Blue) Vincent van Gogh, 1890, Oil on canvas, 67 x 55 cm, private collection.*

Figs. 66. Photograph of **Adeline Ravoux** *at a later date.*

At the time of the most remarkable fascination with *"everything Vincent"* in the 1950s, Adeline Ravoux was sought out for several interviews. She did not seek any publicity herself but presumably responded to a call in the newspapers, for anyone who knew Vincent van Gogh. Prior to her response, she was an unknown in the Vincent saga, and only because of her response and her interview was she appropriately identified as the *"Lady in Blue."* During all the raging buzz about Vincent as the 100th anniversary of his birth was being celebrated, she knew what she was hearing and reading was a false story that was significantly distorted and blatantly untrue. She wanted to try to set the record straight. She is a critical part of focusing reality and facts on this cold case from an eyewitness perspective. She was the only uninvolved eyewitness who observed all of the pertinent events of Vincent's last three days, except for how he actually sustained his abdominal wound.

It is interesting to note that, prior to her interviews, portraits of Adeline only referred to her as the *"Lady in Blue."* Her true identity only became known once she was an adult and gave these interviews, and her paintings were properly renamed and attributed. She was called to describe, in several interviews, her awareness of all the details as best she could remember them some 60 years later. She became a critical part of the discovery of more of the missing aspects of van Gogh's story and the mystery surrounding his death. Her direct involvement in all aspects of Vincent's last three days, and as the only living eye-witness to his death is critical and helpful in clarifying what really happened! She was there and saw and heard everything! She has no obvious or nefarious agenda.

The main interview with Adeline took place in April 1953, with M. M. Gauthier, and was published in *Les Nouvelles Literacies* (1953). Later, her own story to the town of Auvers-sur-Oise (1956) was published. Adeline was over 70 years old at the time and had many years to think about what happened back in 1890. It sounds like she simply felt compelled, at her interviews, to set the record straight about prevailing misinformation from the Gachets. The interview, titled "*The Woman in Blue*," tells an interesting alternate story about the death of the man with the cut ear.

According to Adeline, when Vincent returned to his room at the Ravoux Inn in the evening, he was only in moderate distress, holding his belly and bleeding. When he entered the inn, he was able to walk, talk, and navigate on his own. He was able to climb the 17 stairs up to his room and into bed without obvious difficulty, and he did not require any assistance. He asked for his pipe and smoked it calmly, and appeared quite lucid. Adeline described the moment of seeing Vincent enter the inn during an interview with Tralbaut in the 1950s (1969):

> "*When he came near us, he passed like a shadow, without saying 'Good evening.' My mother said to him, 'Monsieur Vincent, we were worried at not seeing you. What happened to you?' He leant for a few moments against the billiard table in order not to lose his balance, and replied in a low voice, 'Oh nothing, I am wounded.' Then he slowly climbed the 17 twisting steps up to his little attic room with its whitewashed walls and his skylight looking up to Heaven. We wondered what he meant.*"

Though Adeline also said medical attention was summoned, she stated in her interviews that no Dr. Mazery was ever present to support Dr. Gachet's conclusions about Vincent's wound and the rationale for not trying to help him get the best available care at a hospital in Paris. Adeline also said in her interviews that when Dr. Gachet came to see Vincent, he briefly looked at him, apparently without any notable physical exam, and declared "*nothing could be done*." Adeline stated that Vincent and Dr. Gachet, in the brief time they were together in his room, looked at each other and stared (glared?) coldly for what seemed like a long time. Neither spoke at all directly to the other.

Adeline's father had wanted to bring in a practicing physician in the village, but when Gachet came, the Ravouxes "*had the impression that M. Vincent and he [Dr. Gachet] absolutely did not know each other.*" This is very strange behavior under these sad circumstances, particularly when Dr. Gachet was supposed to be not only Vincent's friend and artistic colleague, but also his paid doctor in charge of his care in Auvers. Which of them was mad at the other, and why? Very transparent negative body language to a teenager...Adeline said that Dr. Gachet did not stay all night with Vincent as he had claimed—it was her father, Gustave, who sat at Vincent's bedside all night. Nothing is known, with certainty, of what was said that first night when he was most alert and smoking his pipe.

The lack of proper care for the dying painter was not just apparent to the innkeeper and his daughter, it was even apparent to the other patrons. Anton Hirschig, another Dutch painter staying at Ravoux Inn, heard Vincent asking for help that apparently never came. He said he heard his neighbor yelling in anguish, asking, "*Is not there anyone cutting my stomach?*" It is difficult to understand how a doctor like Gachet could have left his patient, even if he was a lost cause, to die while crying out for treatment, rather than trying to get Vincent to someone somewhere in Paris who was more capable then he. These do not seem like the actions of a compassionate and ethical doctor, which further raises the possibility of negligent, possibly purposeful actions or benign neglect. As such, Vincent van Gogh died about 29 or 30 hours after reaching his bed at the tavern (Tralbaut, p. 326, 1969).

Who Should We Believe?

In multiple ways, Paul Jr. and Adeline offer directly conflicting testimonies, but somehow Paul's story is the one that has prevailed in history and is the basis of the suicide narrative. I am inclined to believe Adeline's story instead. She participated in interviews only by request and did not seek publicity, whereas Paul Jr. volunteered to publish his view of events at what appeared to be a strategic time for his own purposes and self-aggrandizement. He would actively pursue opportunities to present his (false) case to everyone.

Even though Adeline was older when she gave interviews, she was deemed quite lucid and forthright, and purportedly only sought to let the world know the truth of Vincent's death. I find her much more believable and credible, especially given the Gachets' record of bad behavior (namely art theft, art fraud and forgery). Given that Adeline and Paul Jr. were both teenagers when Vincent died, one could question their reliability and maturity. But only one of them had potentially nefarious, if not criminal reasons to lie, and Adeline was the eyewitness to all the goings on inside the Ravoux Inn. She had no obvious reason to lie or obfuscate the narrative. Paul Jr, on the other hand, was not an eyewitness to all the events, and obviously had definite reasons to support and promote the false narrative initiated by his father.

Paul Jr. had good reason to embellish or invent a story of what happened, given his father's involvement. Dr. Mazery, whom Adeline said was not actually present, seems like a convenient construct that Paul inserted into the story to shift blame away from his father. Paul may have been covering up the fact that his father let Vincent die— particularly in failing to transfer him to Paris for better care—to avoid accusations of medical negligence. Or, perhaps there were even more serious motivations at play, such as the direct involvement of Paul Jr. and/or his father in causing Vincent's fatal wound. It is also convenient that "Dr. Mazery" (if he ever really existed in Auvers that day that van Gogh was wounded) died 10 years before Paul Jr. told his story in a public realm.

In my view, Paul said that his father stayed at Vincent's bedside all night to make him come across as a more attentive and compassionate doctor, when really (as Adeline said) he did not stay, glared, and was only there briefly, not speaking. It was Adeline's father, Gustave, who sat with Vincent that entire night until gendarme Rigaumon arrived in the morning to investigate the death, and until Theo arrived from Paris later that morning. Was Theo at Vincent's bedside to hear his statement to Rigaumon, or did he arrive later, and only was told what Vincent had presumably said from Dr. Gachet? Dr. Gachet only returned to discuss matters with Theo, and apparently to express how hard he tried to help Vincent, but in reality he did not actually try to medically help or intervene on Vincent's behalf. There are so many conflicted, disputed, and just unbelievable statements made by Paul Jr. over the years. A colleague of mine summed Paul Jr. up so well and once told me that he:

> *"...tried to put all the conflicting stories he [Paul Gachet Jr.] told about van Gogh over the years side by side, and it was such a mess it gave me a headache. In the end, you just can't believe a word the man said."*
> —(W. Arnold, personal communication, Summer, 2018)

Adeline obviously had great distrust for both Gachets. Now we must connect the dots for her and put the blame squarely on Dr. Gachet, at least for Vincent's inability to get the best available and timely surgical care in Paris. That burden rests on Dr. Gachet alone. I believe Adeline. I do not think there was any supporting second doctor present who shares any blame for allowing Vincent to die a slow and painful death. Sweetman was correct when he stated: *"The Doctor Did It!"* (1990).

The Most Believable Story of What Happened After Vincent's Mortal Wounding

I believe Vincent did not go out that morning to paint, lugging all his art equipment or any canvases. Vincent had gone to meet with the Gachet family as Tralbaut indicated in his later interview with Paul Gachet Jr. (1969). This is a much more plausible account, and Tralbaut met with all three of the key characters in the mystery of what happened on the day Vincent was wounded. Years later, he met with Paul Gachet Jr., Marguerite Gachet, and separately with Adeline Ravoux (*ibid.*). His accounts of these meetings must be accepted as the most reliable *"interview facts"* we can readily rely on today. No matter what you think of Tralbaut as a Vincent biographer, at least he went out and journalistically interviewed these still living witnesses of what he was told transpired on that day. As for Adeline Ravoux's accounts of Vincent's last days at the inn, she went to the interviews in good faith to set the records straight without any obvious agenda. Her first account remains the most believable and untainted account of those last days she witnessed. If there was not all of this hullabaloo about Vincent and his 100th birthday

celebration, The *Lady in Blue* would have passed into history unknown, and we would have lost her eyewitness account of the last days of Vincent van Gogh and took this story to her grave. No one else could have provided any eyewitness testimony to expose the Gachets and their false suicide narrative and their criminal actions in the 1950s.

Why did the Gachets cover up and obfuscate the truth about their roles in preventing Vincent from going to a doctor in Paris? What was their motivation? Why did the doctor go out of his way to make sure Vincent died on his watch? Why did Paul Jr. continue the cover-up and embellish this story until he died too? He executed an amazing and successful campaign to smother and cover up a murder by promoting the concept of the crazy, mad artist who had already cut off his own ear and decided to end his tormented, dark, sad, and suffering-filled life by shooting himself in the belly. He painted Vincent as a martyr for his art and for all artists.

But I am not buying it, and I hope I can convince you not to accept this blatantly false narrative and cover-up of the murder of Vincent van Gogh. It may be *"blasphemy"* to the legend, but it is not a blasphemy if it is true! I must admit that once I confirmed my longstanding suspicions that Vincent van Gogh did not commit suicide, I have found it very difficult to accept, believe, or rely upon anything attributed, *"said,"* or written by either Dr. Paul-Ferdinand Gachet or his very devious and even more evil son, Paul Gachet Jr.! Nor can I accept, believe,or rely upon the ephemeral existence of "Dr. Jean Mazery" at Vincent's bedside. The stories of Vincent van Gogh's last days are so contrived and full of holes like swiss cheese. These false stories are the real blasphemy against the name, honor, and truth of Vincent!

Chapter Ten

The Place: Where Was That Crime Scene?

O ne of the most puzzling unanswered mysteries about Vincent's death is that nobody seems to know exactly how or where he received that fatal wound. Because there were no witnesses, and nobody reported hearing a gunshot that day, no one can know for certain where the crime scene was. It was known that Vincent enjoyed painting near the wheatfields by the edge of town, near the Auvers chateau, and that has become the mythical location of Vincent's wounding according to the generally accepted 19th century narrative created shortly after he died. This narrative of the wheatfield was written in stone by Irving Stone in 1934. However, it is unclear and often disputed as to whether that is where Vincent was on that Sunday afternoon.

According to alternative sources, there is reason to believe that he could have been in one of several other locations. One author puts him at the Gachet residence, down by the river and boat landing, another at a barn at the farm down the road, another on the road to Chaponval near the Gachet residence, and another somewhere between two railroad stations. Identifying the crime scene may have better helped us better determine motive and opportunity, as well as lead us to any physical evidence, such as a gun, knife, bullet, cartridge casings, or Vincent's art equipment, and particularly his *"last canvas."* This last canvas, if it exists, like a photographer's last photograph, can provide evidence of where the murdered person was, or what he was looking at before the crime was committed.

It is important, therefore, to examine all the possible evidence, follow every lead, and determine the most likely location where the wounding could have taken place. Any place Vincent painted was a location that he had been previously and could likely revisit, so all of his canvases show potential crime scenes, as well as Vincent's view of the new world surrounding him in Auvers-sur-Oise. Images of the town through Vincent's eyes, and others from more recent years, show Auvers as a pastoral and bucolic town—it is an unexpected site for a murder even now, but certainly a century ago it would have been very unusual for a murder to occur there.

Fig. 67. *A scene in the placid little village of Auvers-sur-Oise in 1890. Vincent van Gogh,* **Village Street and Steps in Auvers with Figures***, 1890. Oil on canvas, 49.8 x 70.1 cm, Saint Louis Art Museum, Missouri.*

Fig. 68. *Vincent van Gogh,* **Houses at Auvers***, 1890. Oil on canvas, 73 x 60.5 cm, Museum of Fine Arts, Boston.*

Fig. 69. *Vincent van Gogh,* **Village Street in Auvers***, 1890. Oil on canvas, 73 x 92 cm, Ateneumin Taidemuseo, Helsinki.*

Fig. 70. **Old, historic restored house on the main street in Auvers-sur-Oise***, Summer 1990. Photo by the author.*

Fig. 71. **View overlooking the picturesque town of Auvers-sur-Oise**.
Circa August 1990. Photo by the author.

Fig. 72. *Vincent van Gogh,* **Thatched Sandstone Cottages in Chaponval**,
1890. Oil on canvas, 65 x 81 cm, Kunsthaus, Zurich.

Various Dead-End Explorations to Find the Crime Scene

There really is no proof of where Vincent van Gogh was injured, shot, or stabbed and in effect murdered in Auvers-sur-Oise on July 27, 1890. If one looks at the map of Auvers-sur-Oise as it looked in July 1890, it is easy to appreciate how many possibilities for the crime scene existed, particularly if you believe it was in a wheatfield. Does the old rusted gun that was found in a wheatfield about 60 years after Vincent died indicate where Vincent was murdered? It is hard to tell, since the presence of an old rusted gun is not clear-cut evidence of a crime scene. Even though the predominant old story is that Vincent was shot in a wheatfield, on the road to the Ravoux Inn lie several other possible key crime scenes. All of these many wheatfields are in close proximity and easier to walk to from the Ravoux Inn than any of the wheatfields or the bluff, on which sits the chateau Auvers. Then, there is the unlikely possibility, which Artaud suggested, that Vincent was killed in Gachet's three-story villa (the largest home in the area) (2014). Other options for the murder site are the area near the Secrétan villa, and the farmyard or barn on the rue de Boucher (Wilkie, 1978). These locations are all marked with various death crosses on the map of Auvers (Figure 73).

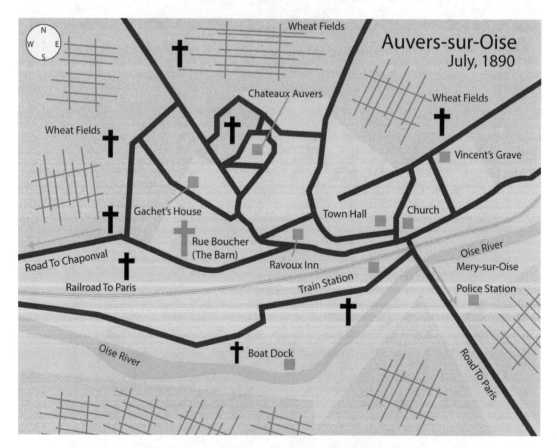

Fig. 73. **Map of Auvers-sur-Oise in 1890**. *The black crosses denote the various possible crime scenes. The Blue Death cross on the map depicts the most likely site of where Vincent van Gogh was mortally injured.*

The murder weapon could easily have been taken away from the crime scene by hand and buried or discarded in any of the many fields by the killer, or planted in a field many years later for other nefarious reasons. It was good for the murderers to not have to deal with moving a body from the murder site since Vincent was still ambulatory. He could have been injured anywhere in and around Auvers. The murderer only had to deal with removing any incriminating evidence, namely the weapon! Vincent was a very compliant victim and even allegedly took the blame. The problem with removing the gun from any crime scene was that it would weaken any impression that Vincent shot himself. Maybe that is why it was "*found*" years later to firm up the suicide story. An interesting timing coincident with the 100th anniversary of Vincent's birth and the start for filming on-site, the movie, *Lust for Life*.

In the end, although much significance has been ascribed to the whereabouts of Vincent's missing art supplies, easel, and "*last canvas*" on the day he was injured, there is a believable and equally valid scenario in which Vincent did not go out to paint, with all his gear in tow, on the morning of July 27, 1890. Instead, perhaps he went out that morning to meet with the Gachets at their home—I speculate about the purpose of such a meeting later in this book along with an interview statement from Paul Gachet Jr. to Dr. Tralbaut (1969). After a brief lunch, perhaps they met again in the barnyard on the road to Chaponval, where Vincent was reported to have been seen (Wilkie, 1978, 2004) and where a gunshot was heard (*ibid.*). This would readily explain the mystery of the missing art supplies and explain why there is no obvious last painting from the day van Gogh was shot. I think he never took any of it with him to paint that morning, and there really was never any "*last painting*" done by his hand that day he was fatally wounded! The quixotic search for a specific, nonexistent "*last painting*" has been a terrible wasted effort in any attempt to help pinpoint the crime scene.

Conflicting Accounts of the Crime Scene

Again, we are confronted with what narrative to believe. Many years after Vincent's death, a woman named Giselle Baize told several journalists and writers a story she had heard, regarding information her grandfather possessed about the location of Vincent's wounding (Wilkie, 1978, 2004, Tralbaut, 1969). One of the people Baize retold the story to was Ken Wilkie, who we have to thank for his diligent investigative footwork and relentless pursuit of the tips he received on his van Gogh assignment. He published his findings in the books *The Van Gogh Assignment* (1978), the updated reprint edition *In Search of Van Gogh* (1991), and, most recently, *The Van Gogh File* (2004).

Baize's grandfather, a "*trusted*" citizen of Auvers, had told the story to his daughter, Mme Leberge, who then passed it down to Baize, her own daughter. This grandfather, whose name is not known for certain, said that Vincent was wounded in a barn on the rue Boucher—which led to the next town, Chaponval—near the Gachets' villa and between

the two local train stops. Interestingly, this barn was on the way to the Secrétans' villa as well. The grandfather also said he saw Vincent leaving the Ravoux Inn that afternoon and then placed him at that barn. He is also the only one who later said he heard a gunshot that Sunday afternoon, coming from the barn.

Tralbaut had mentioned to Ken Wilkie:

> "...if and when I visited Auvers-sur-Oise, where Vincent died, I should try
> and trace the descendants of a certain Madame Liberge, concerning the
> relationship between Vincent and his doctor's daughter, Marguerite Gachet."
> —(K. Wilkie, p. 88, 1991, p. 128, 2004)

When Wilkie got to Auvers, he found at the town hall that Mme. Liberge had died in 1947, but she had a daughter, Madame Giselle Baize, still living in the old family home. He went directly there and found a 50-something, pleasant woman who took him directly into her kitchen after he told her his mission (*ibid.*).

According to Wilkie's details of that interview as it was reported, Mme. Baize said:

> "You may be interested in this photo of my grandfather."

Wilkie asks Madame Baize, "*Why him?*" The answer is quite astounding. She answered:

> "Because he is the only person who knew the truth about where Vincent
> really shot himself in Auvers, replied Madame Baize...our family has always
> wondered about all the books that assume, for some reason—probably the
> romantic appeal—that Vincent shot himself in the cornfields. These fields
> frame the cemetery near where he painted the canvas of the wheatfields and
> crows not long before his death. For some reason the local paper, L'Echo
> Pontoisien (Chapter 8, Figure 59) stated vaguely that Van Gogh shot himself
> in the fields. And all the biographers went along with it. My grandfather said
> he could not understand why no one ever told the true story. He told me he saw
> Vincent leave the Ravoux Inn that day and walk in the direction of the hamlet of
> Chaponval (which also happens to be in the direction of the Gachets' house)."
> —(ibid., p. 124)

So, they could have met in between the inn and the Gachet home (see map, Figure 73).

> "Later he saw Van Gogh enter a small farmyard at rue Boucher. My
> Grandfather said he heard a shot. He went into the farmyard himself, but
> there was no one to be seen. No pistol and no blood, just a dung heap. The
> pistol was never found."

Wilkie:

> *"'Did your grandfather tell this to the police?' I asked. 'No,' said Madame*
> *Baize. 'He said he thought it would complicate matters unnecessarily. He felt*
> *it wasn't really important where the man shot himself.' Madame Baize insisted*
> *that anyone who knew her grandfather would say he was always to be trusted."*
> —*(ibid.*, p. 124)

Do we believe the unsubstantiated, mainstream suicide narrative of Vincent shooting himself in a wheatfield, which consists of many conflicting stories but no evidence? Alternatively, should we accept the potentially more credible, reevaluated story of the "*trusted grandfather,*" which proposes a potential crime scene where the victim was allegedly observed, and connects it to a gunshot heard that same afternoon? Unfortunately, of course, he did not witness the actual crime or feel the need to report any of what he saw or heard to the police. Still the big blue "*death cross*" on the map of Auvers, which marks the barn in the grandfather's story, is in my view the much more likely crime scene than any wheatfields.

The other possible crime scene would be the bank of the Oise River or a quarry, as suggested by the fact that some scholars now consider Vincent's "*last painting*" to be an image of tree roots on limestone banks. The river bank was also close to the Gachets' home, which Artaud had stated was the location of the wounding. Tralbaut's interview with Paul Jr. years later after the passing of Dr. Gachet also mentions and confirms that he and Marguerite saw Vincent at their home that day (1969).

Perhaps Vincent went to the riverbank that morning, after taking René Secrétan's revolver? But according to some of the conflicting stories, the Secrétans were already out of Auvers, making that story improbable. Then Vincent would have had to have stolen this gun earlier and carried it around, maybe in his pocket like the "*phantom gun*" that Dr. Gachet noted? But where he went that afternoon after lunch, and whom he met with and talked to, is the critical missing element that needs to be answered. And yet, maybe it has already been answered and is apparently known, as Tralbaut had interviewed Paul Jr. and Marguerite and confirmed that Vincent was at their home and met with all the Gachets that sad day (Tralbaut, 1969).

The Most Believable Location of the Elusive Crime Scene

Paul Jr. offered another hint, and maybe a confession of sorts, at the crime scene when he said that his painting *Chemin des Berthelees* (Figure 74) depicts "*the place where Vincent van Gogh shot himself.*" This painting looks much more like a farmyard, with a barn and cottages, and is not immediately recognizable as a wheatfield (Figures 78-85). There probably was a wheatfield just beyond the structures, but the stone fence on the

right is characteristic of the stone fence on the rue Boucher. Was this Paul Jr.'s view of the farm and barn on the rue de Boucher, where the trusted grandfather had seen Vincent that afternoon and also heard a gunshot? That makes sense, particularly if this painting was some form of a disguised confession of complicity, if not a veiled admission of guilt or involvement. Unfortunately, Paul Jr. was not any more detailed, forthcoming, honorable, or specific, and was truly an unreliable witness.

Fig. 74. *The location of the painting "**Chemin des Berthelees**". Paul Gachet Jr. painted under the name Louis von Ryssel, suggests by it's title that this is a view of the crime scene, and was titled by the artist; "the location where Vincent committed suicide", 1904, Musée Tavet-Delacour, Musée Camille Pissarro, Pontoise, France.*

How would Paul Jr. know that the exact location of Vincent's wounding was the *Chemin des Berthelees* unless he was there? He made this painting in 1904, five years before his father passed away. Was Paul Jr. there when Vincent was injured, perhaps with his father? Was he a witness? Was he the shooter? The trigger man? To be able to paint this and suggest it as the place where Vincent was shot would presume some firsthand or secondhand knowledge rather than reliance on the common village tale. There are lots of possibilities, but we have very few facts and lots of speculation and conflicting testimony. It all leads me to believe and think that Paul Jr. was involved somehow, and that he and the "*trusted*" grandfather were both telling the truth about the barn being the crime scene.

Looking for The "*Last Painting*"

As previously mentioned, no canvas or canvases have been definitively identified or accepted by the art history community as the last one Vincent worked on before he died. There is also a lack of documentation and explanation related to what specific canvas or canvases he was working on July 27. It is possible that he was working on more than one canvas and may have taken several out to finish them. Whatever he was painting on July 27, 1890, if anything, would show us at least what he was looking at and where he was that day. However, if he was not painting that day, then no useful insight into the crime scene can be determined.

If we are to believe the prevailing narrative that Vincent was at least shot in a wheatfield, which of the many wheatfields around Auvers was it? Really, even though a wheatfield is the least likely actual crime scene, it has been the most readily accepted historical crime scene for over 100 years. Because of this, early art historians believed that *Wheatfield with Crows* (Figure 75) was his last painting and effectively his suicide note by art, even though a handwritten note would have been expected from this amazingly prolific letter writer. Dr. Jacob Baart de la Faille wrote a major comprehensive catalogue of van Gogh's works in 1928. He described another canvas that he believed was the artist's last painting. This was another canvas done in a field, but the painting that La Faille apparently described has since been considered a fake—not a product of Vincent's hand and removed from his catalogue (perhaps it's an example of the early work of the Gachet forgery ring?).

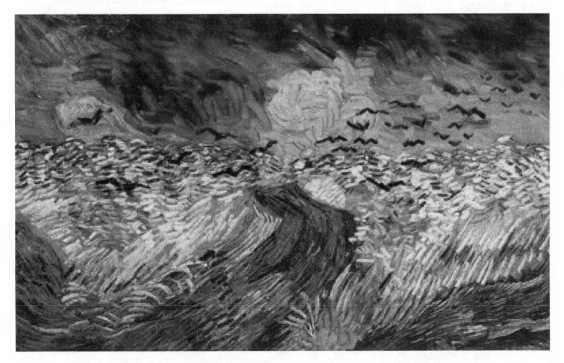

*Fig. 75. Vincent van Gogh, **Wheatfield with Crows**, 1890. Oil on canvas, 50.5 x 100.5 cm, Van Gogh Museum, Amsterdam.*

It is apparent that Vincent loved painting wheatfields, many of them around the village, the church (Figures 76, 77), and the château of Auvers-sur-Oise. If he was wounded while making his last painting in one such field, which one? Vincent's oeuvre shows just a sampling of all the wheatfields surrounding the little town in walking distance in any directions from the Ravoux Inn. He even painted wheatfields in the foreground of his paintings of the church in Auvers (Figure 76). The point is that Vincent really liked to paint wheatfields (Figures 78-85), but he most likely was not mortally injured in one.

Fig. 76. Vincent van Gogh, **The Church in Auvers**, 1890. Oil on canvas, 74 x 94 cm, Musee d'Orsay, Paris.

Fig. 77. **Cathedral in Auvers-sur-Oise**, Summer 1990. Photo by author.

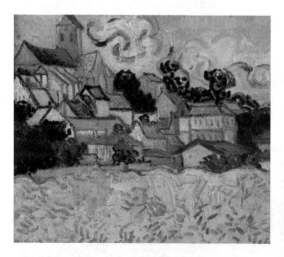

Fig. 78. Vincent van Gogh, **View of Auvers with Church** (with wheatfield in the foreground), 1890. Oil on canvas, 34 x 42 cm, Rhode Island School of Design Museum, Providence, Rhode Island.

Fig. 79. **A field in Auvers-sur-Oise**, Summer 1990. Photo by author.

*Fig. 80. Vincent van Gogh, **Wheat Fields at Auvers under Clouded Sky**, 1890. Oil on canvas, 73 x 92 cm, Carnegie Museum of Art, Pittsburgh, Pennsylvania.*

*Fig. 81. Vincent van Gogh, **The Wheat Field with a Lark**, 1887. Oil on canvas, 54 x 65.5 cm, Van Gogh Museum, Amsterdam.*

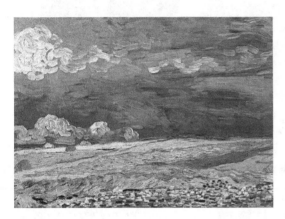

*Fig. 82. Vincent van Gogh, **Wheat Field Under Clouded Sky**, 1890. Oil on canvas, 50 x 100 cm, Van Gogh Museum, Amsterdam.*

*Fig. 83. Vincent van Gogh, **Farmhouse in a Wheat Field**, 1888. Oil on canvas, 45 x 50 cm, Van Gogh Museum, Amsterdam.*

*Fig. 84. Vincent van Gogh, **Landscape at Auvers in the Rain**, 1890. Oil on canvas, 50 x 100.5 cm, National Museum of Wales, Cardiff.*

*Fig. 85. Vincent van Gogh, **Plain Near Auvers**, 1890. Oil on canvas, 73.5 x 92 cm, Neue Pinakothek, Munich, Germany.*

If Vincent Was Not Wounded In Any Wheatfield, Then Where?

Vincent's "*last painting*" might be a clue as to his whereabouts on that day—if in fact he was actually painting then. If Vincent was not injured in the wheatfield with the crows, another more recent suggestion is that his last painting was actually that of tree roots. The authors of *On the Verge of Insanity* (2016) state,

> "*This image of tree roots [named Tree Roots and Trunks] on a limestone slope is van Gogh's last painting (Figure 86).*"

However, it is difficult for me to concur that this was his last.

Fig. 87. Detail of Figure 86 showing the **moving water flowing past tree roots** in top left of the painting.

Fig. 86. Vincent van Gogh, **Tree Roots and Trunks**, 1890. Oil on canvas, 50 x 100 cm, Van Gogh Museum, Amsterdam.

These authors stated:

> "*He worked on it [Tree Roots] during the morning of 27 July, but never had a chance to finish the canvas. He decided that same afternoon to end his life.*"
>
> — (*ibid.*)

So where was *Tree Roots* painted, and is it unfinished as the experts claim? Was Vincent trying to finish it on the day he was mortally injured? Why wasn't the *Tree Roots* canvas present at Vincent's funeral along with his missing palette, paints, and easel? It should have been noted as what he was working on that day, still wet. There is no obvious documentation that these authors are relying upon for their statement that this is Vincent's final painting by his hand on July 27, 1890. It may be the last painting he worked on (unfinished), but it is only speculation. There are no known corroborating letters or other evidence to firm up their theory of it being painted on that last day.

If *Tree Roots* is indeed Vincent's last painting from the day he was mortally wounded, then finding those tree roots would be essential to determining where he might have

been that day. One would have to assume he was there in person, painting what he was looking at, since he rarely painted from memory. The tree roots are unlikely to be near or in any wheatfield. Rather, they appear to be in an eroded area, like the edge of a river—likely the banks of the Oise River.

*Fig. 88. This an example of **tree roots exposed in a creek bed**, detail of fast moving water past exposed tree trunks, which were eroded by fast flowing water in a creek. Not a likely place to correlate with his last painting! No big trees, or eroded tree roots in the middle of a wheatfield. More likely the Oise river bank? "Exposed Tree Roots along Creek." April 2018. Colorado. Photo by author.*

*Fig. 89. Vincent van Gogh, **Study of a Tree**, Black and white chalk, 1882, pen and black ink, pencil, watercolor, 51 x 71 cm, Rijksmuseum Kroller-Müller, Otterlo.*

Maybe Vincent was down by the river near the boatman's landing (Figure 90) as would be necessary to find exposed tree roots with moving water.

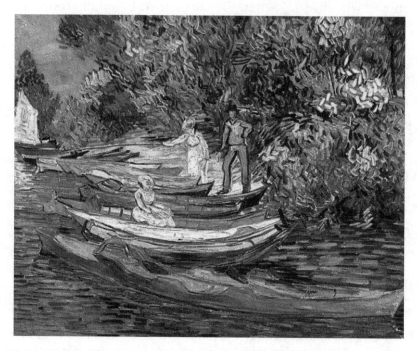

*Fig. 90. Vincent van Gogh, **Bank of the Oise at Auvers**, July 1890. Oil on canvas, 73.3 x 93.7 cm, The Detroit Institute of Art, Detroit, Michigan.*

In Tree Roots, did Vincent depict the river flowing in the top left of the painting (Figure 87)? It also possibly depicts an eroded area along the small butte at the base of the Chateau Auvers. We do not know if Vincent was at the Oise riverbank instead of a wheatfield that morning "*borrowing*" René Secrétan's .380 pistol. Maybe he just skipped painting that morning altogether because he had another, much more important meeting elsewhere?

The Most Reasonable Location of the Crime Scene

In my opinion, Vincent was not shot by himself or by anyone in a wheatfield. There is no meaningful support for this mythical theory other than the romanticized notion that Vincent's life ended where he felt most at home. Vincent painted what he saw and felt, and he expressed his "*impressions in all focused colors.*" He certainly liked the beauty of the wheatfields, likely feeling content and at peace there—but that does not mean that that is where he was injured and nearly died. All the investigations into the wheatfields may just have been a misstep in the quest to logically pinpoint another, unknown crime scene. In the end, the most likely crime scene is still the barn on the farm on the rue Boucher, off the Chaponval road.[1]

[1]Currently the old Chaponval Road is named rue Francois Villon and is the "D4" roadway.

Moreover, too much effort has been expended trying to diagnose his mood from his paintings, as well as trying to psychologically read a "*suicide note*" into his paintings. Trying to construct and define the crime scene from the same overinterpreted and unsupported analysis of his presumed "*last painting*" is a big reach when, in fact, there may not have been a last painting done by Vincent's hand on July 27, 1890.

It is interesting, however, that a painting not by Vincent may be the best documentation of the crime scene, if not a "*subliminal confession*" by a prime suspect, Paul Gachet Jr. in *Chemin des Berthelees*. Paul Jr. painted and pointed toward a barn, like the one the "*trusted grandfather*" had mentioned. I will standby the old trusted grandfather's eye and ear witness story relayed to his daughter for the crime scene location, since it at least was based on two independent interviews (Tralbaut and Wilkie). I am very comfortable with combining this "*eye-ear witness*" account with the "*confession*" of Paul Gachet Jr. when he named the painting in 1904 "*the location where Vincent committed suicide*." Now we must ask, was Paul Jr. present as only a witness, or was he the killer? How did he know the location of Vincent's wounding?

Chapter Eleven

The Weapon: Did They Find The *"Smoking Gun"*?

A vital step in our cold case investigation must be to start with any physical evidence. In a case like this, it is of critical importance to be able to identify the weapon that was used to inflict the fatal wound. It was reported almost from the very beginning that Vincent van Gogh shot himself. If the explanation is so straightforward, then it should be easy to answer any other question related to that premise: what gun did he use? Where did he obtain the gun? Did someone give it to him, or did he borrow it? Did he find a gun purposely placed for him to find? Where is the gun now? Who owned that gun? Where exactly was Vincent's wound? Where did he shoot himself? Even though this seems like a simple set of questions expecting a ready set of answers, we are missing answers to most all of these questions. Yet, art history scholars have readily accepted the explanation that Vincent shot himself.

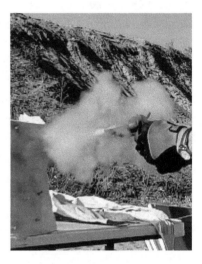

Fig. 91. **Dr. Arenberg test fires the same model Lefaucheux gun discovered in the wheatfields.** *Photo by Matt Sebesta.*

In this case, it is not known for sure what specific type of gun was involved, or if it was another type of weapon that produced the pea-sized penetrating wound into Vincent's abdomen. Intriguingly, in a book on van Gogh, art historian Simon Schama referenced a *"shotgun"* as the weapon:

> *"[Vincent was]...still vulnerable...to epileptic seizures and manic depressive attacks—that made him pick up the gun rather than his brushes on 27 July. It was probably difficult to shoot himself with a shotgun, and if he aimed for the heart, he did not hit the target"*

—(*Schama*, p. 350, 2006)

No gun, revolver, or shotgun was found at the time of the murder by anyone, including the police, who did a cursory look around the wheatfield where Vincent was thought to have been painting. However, there were several individuals of interest in the case who were known to have owned or possessed a firearm. Further confirmation of the weapon and the caliber of the bullet, when found, could help to figure out whose gun might have been used, thereby pointing to a possible suspect known to be in Auvers-sur-Oise at the time. And what if there is no bullet in Vincent's casket? That would certainly deepen the mystery.

The Finding of the Lefaucheux Pistol

In the 1950s, decades after Vincent's death, a farmer near Auvers found an old "*badly rusted*" revolver in his field near where the supposed suicide was reported to have taken place, behind the chateau in Auvers-sur-Oise (N. Bakker, p. 80, 2016). Exactly when and where this weapon was found is not known to the public, but would be very helpful in solving this case. The field was near one of Vincent's favorite painting spots. The exact location where the gun was found was never marked with a plaque or the like, which would have helped historians determine precisely where Vincent may have been wounded. Was this "*smoking gun*" dropped in this spot? Thrown to this point? Maybe, purposely placed here years later to further misdirect away from the truth, yet indirectly support the gospel suicide story? It is also not known for sure who owned this firearm. Did it belong to René Secrétan? Gustave Ravoux? Dr. Paul-Ferdinand Gachet or his son, Paul Jr.? Someone else entirely? In the end, museum experts attributed the ownership of this found gun to Gustave Ravoux.

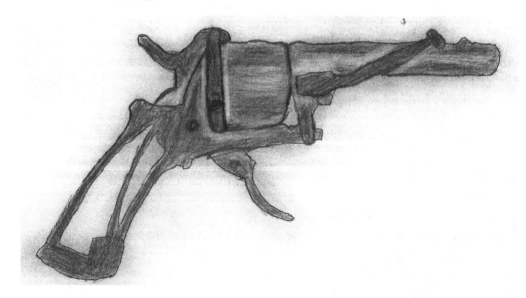

*Fig. 92. This is a sketch of **the old, badly rusted revolver that was found in the 1950s** and is considered to be the weapon used to shoot Vincent van Gogh. Sketch by Edward Kobobel, December 2017.*

Many art historians believe that the gun found in the field was possibly the one used to end Vincent's life. However, there is some reason to cast doubt on the validity of this theory, since some people think the unexpected discovery of this old rusted gun may have been unusually serendipitous and well-timed and unrelated to Vincent's death. This gun was shown to the staff of the Van Gogh Museum, Amsterdam, and photographed, but it may only be on loan to the museum (*ibid.*). According to museum officials, it is an antique "*7.65 caliber Lefaucheux pinfire pocket revolver [with a folding trigger]*" (*ibid.*).

The Lefaucheux Revolver

The discovered gun was a late 19th century European gun often carried for self-defense by both men and women. This antique revolver was made around 1870 in Liege, Belgium. In 1835, the notable gunmaker and inventor Casimir Lefaucheux patented one of the first self-contained firearm cartridges, which he had designed back in 1828. This early design included a case with a ball, powder, and primer, but what made it special in terms of cartridge development was the "*firing pin*" that projected 90 degrees from the side of the case (thus the term "*pin-fire*"). It was this pin that was struck by the hammer and detonated the primer inside the shell casing, causing a black powder explosion that propelled the lead bullet down the barrel and out of the muzzle of the gun. Eugene Lefaucheux, Casimir's son, then built on his father's invention, designing a novel pistol to take advantage of this new self-contained, innovative cartridge. The hammer was flat and smashed down on the side of the cylinder, from which the pin of the cartridge projected, thus causing the primer to ignite the gunpowder and fire the projectile.

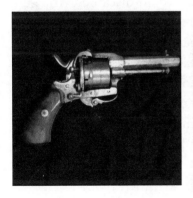

*Fig. 93. **Lefaucheux 7mm, black powder model revolver** with the trigger folded up. This is the same model as the gun found in the wheatfield, all rusted, that may have killed Vincent. Photo by Edward Kobobel. Private collection.*

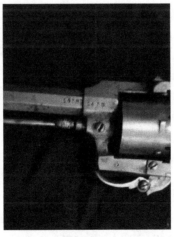

*Fig. 94. You can see from the reverse side that **the serial numbers on the barrel** match the serial number on the frame. Photo by Edward Kobobel. Private collection.*

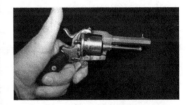

*Fig. 95. It is important to appreciate how small this gun truly is in my hand. This demonstrates **how difficult by today's standards it would be to control the accuracy**, even with the use of a two hand grip. Yet this gun was the most popular gun in western Europe in the second half of the 19th century. Photo by Edward Kobobel. Private collection.*

This revolver and pistol design became widely popular and prolific, especially in Europe, throughout the latter half of the 19th century. It was adopted by militaries, used by civilians and police, and even sold for use during the American Civil War. The Lefaucheux pistol was one of the most popular non-military handguns of the time. It was broadly distributed and was an affordable choice for most budgets. Moreover, one of its most impressive features was that the folding trigger allowed it to be conveniently collapsed, so that it could easily be concealed in a pocket or small bag. Given the popularity of this gun model, I find it reasonable to cast doubt on the belief that this abandoned Lefaucheux pistol is the only possible gun that may have shot Vincent. If it was that popular and apparently widely distributed, then how could anyone, even scholars at a museum, be so certain that the gun found in the field was the one and only weapon used when nothing further connects it to Vincent's murder? It is only theoretically linked to Gustave Ravoux, or, alternatively, René Secrétan by conjecture.

Who Owned that Lefaucheux Revolver?

According to the Van Gogh Museum, there is a strong possibility that the Lefaucheux pistol found in the field was the gun used in the suicide attempt. The museum does not readily supply any additional useful information about this key piece of evidence, such as the exact, specific location where the gun was found or the date when it was found. Still, the place where the gun was found would not necessarily prove where Vincent was shot. He could have been shot anywhere—in a wheatfield, or near the barn—and the murder weapon taken away from the scene by the murderer and discarded. The gun could have ended up in the field when Vincent's killer threw it as far as possible from the road, or later carried it into the field and buried it. We have no idea how carefully the police searched for the murder weapon, but I presume that they were unlikely to find it—they were looking in wheatfields, and Vincent was almost certainly not shot in one. The search in the fields was probably a purposeful wild goose chase to direct the police in the opposite direction of the actual crime scene. Remember, Vincent was wounded, but walked away from the injury. So the mortal injury and the found weapon are not convincingly connected as to a definite crime scene.

I suspect and surmise that the police viewed searching for a gun in a wheatfield—especially on a hot summer day at the end of July—equivalent to finding the proverbial needle in a haystack. Rigaumon, the gendarme, never got any specific information about the gun's whereabouts from Vincent when he took his statement, and no police report still exists about this event. If there was no reward, no congratulations, no kudos, and no promotion for solving a challenging murder case, why bother to search carefully or thoroughly? The police certainly wouldn't do so if they believed the case was just a suicide, as they were told by Vincent's doctor that morning.

Even if the found Lefaucheux pistol was in fact the gun used to kill Vincent, there is still no proof of who fired it at him. There are no reported identifying characteristics to say for certain who this gun belonged to. The museum officials state:

> *"The revolver with which [van Gogh] shot himself belonged to Arthur-Gustave Ravoux, owner of the lodging house where he was staying. It is not known how van Gogh came to have it."*
>
> —(*ibid.*, Bakker, 2016)

The only problem with this suggestion is that Adeline Ravoux had initially said her father no longer owned a gun at the time Vincent was shot. Gustave Ravoux had apparently sold his gun, possibly to René Secrétan. Maybe the Secrétan brothers heard that Vincent was shot, panicked, and then decided to get rid of their gun out of fear it would implicate them. But it is a big assumption to claim that the revolver found in a field after 60 years of rusting was the same one (previously) owned by M. Ravoux. This is merely circumstantial, unsubstantiated evidence that would not hold up in court.

Strangely, a few years later, Adeline said that gun was her father's revolver. Why did she change her story? Did someone coach her? For what reason was it important to change her first, unfiltered story?

As for René Secrétan, when asked about the gun in question 67 years later, he claimed that the gun he owned at the time was not a 7mm caliber like the found Lefaucheux, but instead a .380 caliber *"pea shooter,"* which he kept in his hunting bag (Doiteau, Aescalape 40, 1957). An example of a possible .380 revolver (Figure 96) was the Galand and Sommerville pistol, which would have been logistically available to the Secrétans. In appearance, this size revolver would have closely resembled the ones René envied at the *"Wild West"* show at the Paris Exhibition in 1889. René was a huge fan of Buffalo Bill's American Wild West. Having idolized the American cowboys and their big, intimidating guns, René would not likely have been interested in owning a common, quite petite pistol that fit discretely in his pocket or, worse, in a woman's purse. If one understands René's personality and family wealth, the possibility of him owning the gun from the field becomes even more remote. He would be much more likely to opt instead for a flashy, larger pistol like the .380 Galand to match his heroes.[2]

Both of René's interviews were most likely conducted before the discovery of the Lefaucheux pistol in question, although we do not yet have the exact date of when that gun was found. Was the gun strategically placed to further the suicide narrative and support Secrétan's story? An interesting possibility, especially considering that, in an interview he gave a year before he died, René actually admitted that he was present when Vincent was shot (*ibid.*). Although, he maintained that his gun was a .380 revolver, not a 7mm. What if he was telling the truth?

[2]The .380 Galand was also made in Belgium and is somewhat closer in appearance to the even larger Colt "Six Shooters," so popular in the old west.

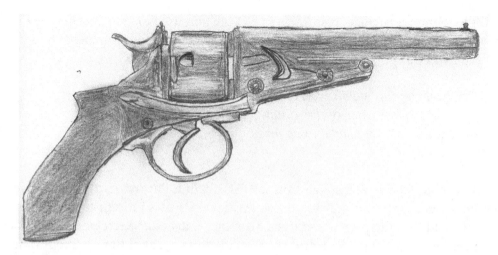

Figure 96. **Galand and Sommerville Revolver**, *Belgian. Circa 1870. A "380" pistol available to the Secretan's as Rene claimed to have had in his hunting bag, the Vincent may have "borrowed". In appearance, this size revolver would have much much more likely resembled the ones he saw at the "wild west " show at the Paris Exhibition in 1889. Not quite like the famous Colt, "Peacemaker". Sketched in colored pencil, 2017, on bond paper , 8 x 10, by Edward Kobobel.*

And so the search for answers continues. What do we know for sure about the other possible weapons available at that time and place? There were at least three known gun owners connected to Vincent. We've determined that two of the three were unlikely to have been connected with Vincent's death: Gustave Ravoux and René Secrétan. We do not have any evidence to show that the gun owned by Gustave Ravoux and the gun found rusted in the field 60 years later are one and the same. We do not know any details, in fact, about Ravoux's specific gun, or the timing of the transaction if and when Ravoux sold that weapon to René Secrétan. We do know that if René's gun was indeed a .380 revolver, the gun found in the field could not possibly have been his.[3]

That leaves one known gun owner and suspect left: Dr. Paul-Ferdinand Gachet. The doctor was known to have possessed at least one gun, which he kept in a cabinet in his home. Given his previous military service as a captain in the medical corps of the home guard during the Franco-Prussian War of 1870, he had his choice of sidearms, as did all officers (See Figure 129, Chapter 16). Most likely he retained his service revolver, as was common practice. What gun and what caliber weapon did he retain? Unfortunately, we do not know. We do know that Gachet had a curious interest in collecting macabre items. Perhaps he obtained other weapons over the years, which were unreported. His daughter, son, and housekeeper, Louise Chevalier, all stated after Vincent died that the doctor's gun was still in the cabinet at the time, though they could have been hiding the truth about its location to protect their household from being implicated. Sadly, the police did not check or confirm anyone's stories.

[3]Apparently, anyone could buy a handgun at a hardware store for five francs back in the 1890s.

Whatever the model, and whomever the owner, the gun involved in Vincent's death holds the answers to countless questions. The bullet shot from that gun is particularly important. We definitely need confirmation of the caliber of the fatal bullet in order to get closer to these answers, and to confirm or deny the validity of the Van Gogh Museum's claim that they have examined the gun that was used in Vincent's death (*ibid.*). The key to solving this aspect of the mystery, and to determining the significance of the old rusted gun, lies with the mysterious, "*magic*," missing bullet—if in fact there was a bullet at all. A bullet lodged in Vincent or found in his casket is essential to proving a gun, and which gun, was used to murder Vincent! Without the proof of a bullet in hand, in the crime scene investigators' evidence bag, you would have no proof that a gun was even used in this unsolved crime. Then you must ask what else could have produced that fatal pea-sized penetrating wound in Vincent's belly?

Chapter Twelve

The Mysterious, Missing, "*Magic*" Bullet
And Its Significance

There is no record of a bullet being recovered from Vincent van Gogh's body following his death, which means the caliber of the gun used—if in fact a gun was used at all—is yet undetermined. There was no exit wound described by anyone, which raises further questions considering Vincent was a skinny, average-sized male who supposedly shot himself from up close. How is it possible that there was no exit wound if no major organs were damaged and he survived for at least 30 hours? As such, a bullet may still be in Vincent's body or rattling around in his coffin, if he was indeed shot. This critical piece of missing evidence is desperately needed to prove that the penetrating abdominal wound was actually created by a bullet and not, perhaps, by a knife. If both the bullet and the powder burn are not known to exist, how can one prove Vincent was shot—even by himself—when the only evidence is the description of a small, "*pea-sized*" entry wound by a person of interest, 36 years after the fact? This should be very disturbing to any "*gumshoe*" detective then or now.

Finding the missing, mysterious, and "*magic*" bullet now may be the vital missing piece of the puzzle to confirm the "*how*," and it may even help lead to the "*who*." The bullet's caliber determines which gun it was fired from. Ideally, a bullet, a cartridge casing, and a gun would all one day be found and matched up, leading investigators to the person who was in possession of that gun on that fateful day, and may have fired that fatal shot into Vincent's belly.

Forensics of Powder Burns and Explosive
Black Powder Bullets

The Lefaucheux 7mm folding trigger revolver used in these new forensic studies is the exact same model of gun that was found in the wheatfields of Auvers in the 1950s and is attributed by some scholars to be the gun that killed van Gogh. The actual gun

found in the field is currently located in a private collection. In order to prove this theory that THE gun involved in Vincent's death has been correctly identified, we must locate the missing bullet and determine whether its caliber at least matches the 7mm size as ascribed to the old rusted found gun.

The bullet from that gun would most likely have had to be a black powder bullet, as noted by forensic expert, Dr. Vincent Di Maio (see his letter in the Appendix). Black powder bullets were the most common type of bullet available in 1890, prior to the widespread use of *"smokeless"* powder[4]. By definition, a black powder bullet must leave a powder burn if fired at point blank distance. The absence or presence of a powder burn is critical to any investigation of a presumed gunshot wound in this time period.

A powder burn, also called a gunshot *"tattoo,"* is essentially a type of visible burn caused by proximate exposure to the very hot explosive residue and searing flame, like a blow torch, emitted from the muzzle of the gun (see Chapters 22 and 28). The closer to the skin, the larger the *"tattoo."* Notably, no powder burns were ever described by Dr. Paul-Ferdinand Gachet or "Dr. Mazery" in 1890, nor by Paul Gachet Jr. in his 1926 account, nor by anybody ever.

When the black powder bullet is fired, it explodes red hot gunpowder residue that burns into the skin—hence the name *"powder burn."* The presence, size, depth, and spread of the tattoo around the entry wound would indicate to a forensic expert the distance the muzzle of the gun was to the entry wound. The size and spread of the tattoo would depend on the amount of powder that was packed into the shell casing.

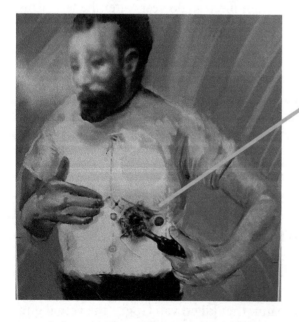
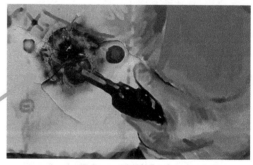

Fig. 97 (left & above). **This is the black powder burning.** *The cloth will also catch on fire. So will the skin also sustain at least a second degree burn, not just a wipe away sooty smudge. Photo by Matt Sebesta, Family Shooting Center, Cherry Creek State Park, July, 2018*

[4]It is very important to recognize the distinction between a black powder bullet from Vincent's era, compared to the smokeless bullets commonly in use today.

It would be virtually impossible to self-inflict a bullet wound—either at skin level or from a few inches away—using a black powder bullet and not create a signature black powder tattoo. Yet, in Vincent's case, no such powder burn was ever noted by either Dr. Paul-Ferdinand Gachet or "Dr. Mazery" in 1890, nor by Paul Gachet Jr. in his 1926 account, nor by anybody ever, despite a very detailed attempt to describe the mortal wound as "*pea-sized,*" and with purple and tannish brown rings circumferentially around the "*bullet*" hole entry wound. Note in this description, the concentric rings were described as purplish and tan and of variable color and intensity, but not black! If a carbon black color was not reported, but tan/brown or purplish rings were, it can only be concluded that there was no carbon black gunpowder residue or signature tattoo on the belly of Vincent van Gogh. And with no mention of a signature powder burn on Vincent's belly after the detailed description of the wound just described, we can only conclude that there was no powder burn. Thus, there are really only two possibilities: one, the muzzle of the gun was at a greater distance from van Gogh's skin than a foot or two away. Two, the wound was created by a knife, screwdriver, icepick or some other type of sharp weapon.

Proximity of the Muzzle to the Skin

Forensically, the black powder signature is necessary to help determine the proximity of the muzzle of the gun to the victim. , As noted above, none of the doctors and visitors to Vincent's bedside observed or reported any powder burn anywhere on Vincent's body. To miss seeing a powder burn, if present, is virtually impossible. To miss reporting it is even less likely, given their detailed description of colorful, concentric rings around the entry wound. The only explanation is that there was no powder burn to observe.

Certainly, the most likely explanation if, in fact, Vincent did not shoot himself up close was that someone else shot him from a foot or two away as described by Rigaumon, the policeman, when he visited Vincent on his deathbed. Unfortunately, there is no surviving police report from Rigaumon that verifies this theory (Tralbaut, 1969). Yet one would have to conclude that the lack of powder burn suggests Vincent was shot at a distance of one to two feet away, as Rigaumon stated and Dr. Di Maio confirmed.

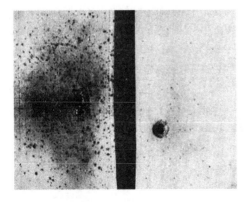

*Fig. 98. A **comparison of a black powder bullet entry wound with the characteristic spatter of a black powder burn** on the left is compared to a smokeless bullet entry wound with slight stippling on the right. Both fired from six inches. Permission of Dr. Vincent J. M. Di Maio, from his letter in the Appendix (Chapter 26).*

No powder burns strongly suggest no suicide. It would be virtually impossible for Vincent to hold the gun himself and stretch far enough away to avoid a powder burn, and yet self-inflict a wound in alignment with the described A>B>C trajectory theory presented in (Figure 146, Chapter 22). There was also no mention of even stippling with such an otherwise detailed description of the skin surrounding the entry wound itself, that would suggest even farther away.

Alternative Theories Attempt to Reinforce The Suicide Narrative

In order to uphold the accepted suicide narrative, Louis van Tilborgh and Teio Meedendorp attacked Dr. Vincent Di Maio, the forensic expert that Naifeh and Smith used to support their conclusion that Vincent van Gogh could not possibly have committed suicide (Van Tilborgh, p. 459, 2013). These researchers readily admit *"we are not experts."* They question the concept of murder as *"too far out"* and state that the wound *"was anyway, in the chest, and not the abdomen,"* though they offer nothing to support this contention (*ibid.*).

Moreover, these statements contrast with the wound description from Paul Gachet Jr., which is the only available description—and, thus, necessarily the only generally accepted description—of the location of the wound and its details (Doiteau, la Folie, 1928). JPaul r's testimonial is truly all we have to rely on, as no extant police report or any doctors' notes have survived. His description of the wound is what Dr. Di Maio relied on to make his forensic analysis. Additionally, Di Maio considered the fact that Vincent was able to walk back from wherever he was injured and climb 17 stairs to his bed unassisted without experiencing shortness of breath or coughing up blood, all while appearing to be calm, lucid, and not immediately in great distress. He concluded, based on these evidences, that it would be extremely unlikely that Vincent had sustained a chest wound. Everything—including Paul Jr.'s original description of the wound in 1928—points to a penetrating wound of his abdomen, not a chest wound (*ibid.*).

In order to strengthen their argument to continue to support the 19th century mythical narrative of suicide, these non-experts enlisted the consulting support of Alain Rohan, who apparently is considered a ballistic expert. Alain stated that:

> *"...the brown and purple halo around van Gogh's wound that was described at the time show that the gun must have been fired from very close range... (Gachet, p. 92, 1957). The purplish ring was caused by the bullet's impact, but the brownish one indicates that the barrel of the gun was close to the chest, because it was caused by powder burn."*
> —(Van Tilborgh, p. 459, 2013)

There appears to be a disconnect between the reported observations of the concentric rings around the wound—Alain introduces the term *"powder burn"* in an unusual revisionist attempt to amend the original description to further support the suicide theory.

However, *"...the brownish one [ring]...caused by powder burn"* makes no sense. Brown is not carbon black. Powder burn can only be black, CARBON BLACK! If all they saw was as described, their conclusion is inaccurate.

Rohan also enlisted specialists at the Institut de Recherche Criminelle de la Gendarmerie Nationale to help back up the suicide theory, though this strategy backfired. The specialists state that:

> *"...in order to leave such a trace [powder burn], the muzzle of the gun has to be no further than 2-3 cm from the body."*
>
> —*(ibid.)*

I agree that a 2-3 cm distance for a powder burn is valid, but unfortunately, what Rohan does not understand is that the brownish ring was not caused by a black powder burn (see Chapters 22 and 27). Such a black powder weapon discharged at 2-3 cm from the skin, with or without a *"lifted shirt"* would actually burn the skin, leaving a very red or second-degree burn, and searing the cotton garment (see Chapters 22 and 27). These authors try to steer around this obstacle when they state further that:

> *"In order to leave such a trace [powder burn] the impact area would have been bared, and that seems to point to van Gogh as the only perpetrator. Or did someone else ask him to lift up his shirt?"*
>
> —*(ibid.)*

Despite the amazingly naive suggestion that Vincent would have thought to lift his own shirt before committing suicide—or, more ridiculously, lifted up his shirt to aid in his own murder (*ibid.*)—the searing hot explosive powder still would have burned his skin and lifted shirt. I suggest they have their forensic experts relook at the photos and videos from the reenactment scenarios (in Chapter 22 and 27, or visit www.kilingvincent.com/forensics) and maybe reposition the black powder burns' significance and relevance to their arguments, and maybe correct and hopefully restate their inaccurate observations and conclusions.

A Look at Pin-Fire Black Powder "*Vintage*" Bullets

An intriguing alternative to the 7mm bullet pinfire lead ball tip round is a 7mm pinfire shotshell. There was an amazing amount of variation of what was available back in the day in 7mm rounds. This 7mm shot shell would also fit the Lefaucheux pistol being evaluated and can fire multiple, small lead pellets instead of a lead ball.

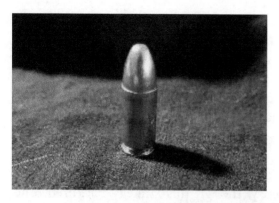
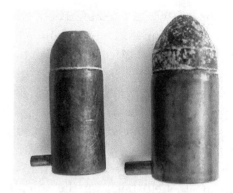

Figs. 99-100. **A modern bullet** *(left, 99), centerfire adjacent to two different 7mm black powder* **pinfire bullets** *(right, 100).*

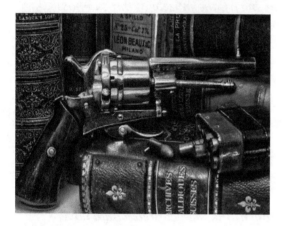

Fig. 101. An example of a **Lefaucheux revolver with the black powder pinfire cartridges** *and a stylish leather carry case for the ammo. Photo courtesy of Aaron Newcomer, www.Freemycollection.com.*

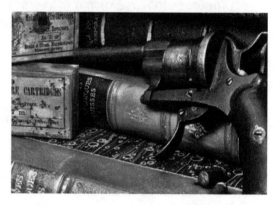

Fig. 102. Several examples of **boxes of pin-fired 7mm rounds**. *Note the tolerances were not so tight back then and all those 7mm rounds would fit the 7.65mm Lefaucheux revolver found in the field. Photo courtesy of Aaron Newcomer, www.Freemycollection.com.*

Caliber comparisons in mm and inches are the same today as vintage ammunition

inches	mm	name
.224in	5.6mm	"22" / Varmint Round
.284in	7mm	Pin-fire
.355in	9mm	"380"9mm short
.355in	9mm	9mm FBI
.452in	11.43mm	"45 ACP" / "45 AUTO"

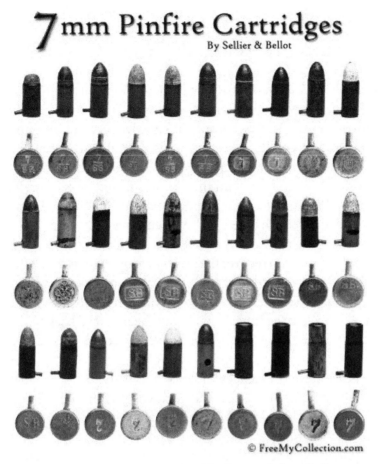

*Fig. 103. A vast **array of 7mm pin fired bullets** and shot shells were readily available back in the day to fit the "found" revolver from many manufacturers. Photo courtesy of Aaron Newcomer, www.Freemycollection.com*

*Figs. 104-105. Same **pinfire shotshell before and after being cut in half**. Photo courtesy of Aaron Newcomer, www.Freemycollection.com.*

Footnote: It should be noted that the "7.65mm" stated for the Lefaucheux found rusted in the field is incorrect, as there was no such thing as a 7.65mm round. All the vintage antique boxes only specified 7mm. Any 7mm pinfire pistol cartridge from any manufacturer would fit that gun. The tolerances were very imprecise back then. The only thing I can speculate for stating "7.65mm" is maybe they measured the internal diameter of the barrel at the muzzle tip?

Can We Locate the "*Magic*" Bullet in Vincent's Remains Or His Casket?

As we know, Dr. Gachet did not remove a bullet from Vincent's body when treating him at his bedside—he may have been afraid of what would be found out. Since there were few known pistol owners in Auvers, additional knowledge about the gun and the caliber of the bullet in question could cause any number of disturbances in the quiet little town. Another possibility is almost impossible to ignore: what if the recovered bullet implicated a murderer, someone whom the Gachets would prefer to remain unknown? Who might that be? We can't help but wonder about the caliber of Gachet's old service revolver, which he supposedly had "*safely*" stashed away in a cabinet.

Knowing what it would mean to recover the bullet now opens new, albeit dark possibilities. However, the bullet that wounded Vincent is the critical missing piece of evidence in this very suspicious cold case. Police forensics at the time were advanced enough that if the bullet had been recovered at the time, it could have been traced back to the caliber of gun that fired the shot. Imagine what 21st century forensics could yet uncover!

If a search of the gravesite and Vincent's remains finds no bullet, that evidence would lead to two theories. First, perhaps the bullet was removed post-mortem by the Gachets who were known to have disinterred van Gogh's body in 1905, with only the grave diggers present. Did the Gachets remove and discard the bullet? What would their motives for this be? Why would they seek to keep such information a secret? Who would they be seeking to protect? Second, perhaps the fatal wound was not caused by a gun at all, throwing the suicide theory into serious doubt, since suicide by stabbing oneself is highly unlikely. Ultimately, if no bullet is found at Vincent's gravesite, did one ever exist? Was the mortal penetrating abdominal wound created by a gun? Then show me the missing bullet! If no bullet, then a knife wound is equally possible without a powder burn.

Chapter Thirteen

The Knife Theory
An Intriguing Alternative to the Gun Theory

There is a possibility—only if no bullet is ever recovered—that the penetrating abdominal wound that eventually killed Vincent van Gogh was caused by something other than a gun. With so much of history's focus being on the alleged gun and bullet, any alternative theory about the weapon has gone unexplored. Remember, at first no one reported hearing a gunshot that day, and supposedly no one witnessed the crime firsthand. Could the murder weapon of choice have been something else very quiet by comparison—something like a knife or similar weapon? A puncture wound of such a small size without any reported powder burns could have plausibly been caused by a knife of some sort. The alternate theory of a killer with a knife, given how commonly available knives were (and are), is intriguing and surprisingly different.

A pocket knife, a screwdriver, or even an ice pick would fit the available forensics reasonably well. A stab thrust from such a tool could just as easily have caused a puncture wound comparable to a bullet hole, obviously without leaving a signature black powder burn. The location of the wound on the body was described as a small hole on the upper-left side of Vincent's abdominal wall. Such a penetrating wound is consistent with where a right-handed individual would be likely to thrust a knife or any sharp, pointed instrument into an opponent's belly when face-to-face.

It is also important from a medical standpoint to consider that Vincent survived this injury for over 30 hours without any notable medical intervention or meaningful treatment being offered, not even any pain medication, wound irrigation, anti-bacterial packing, or even basic dressing changes. For the first half of the 30 hours, Vincent was relatively comfortable, sitting in bed smoking a pipe. He was not coughing up blood or short of breath, which would have indicated a chest wound; rather, his symptoms were consistent only with an abdominal wound. This level of comfort would be highly unusual for someone who had been shot and sustained what would be a presumably more extensive injury than a single knife thrust would cause.

A bullet, given its force, can achieve much more significant damage and reach greater depths than a knife wound would. A bullet can even move in multiple directions within the body, possibly hitting several bones and organs before finally coming to a stop. It is more likely to cause greater damage and near-unbearable pain. A knife thrust, by comparison, is limited and can only go so far. The absence of an exit wound helps supports this knife theory. While the knife wound can still result in death after a longer period of time, the early pain can be more manageable, depending on what exactly was injured within the body. A knife wound would account for Vincent's seemingly relaxed behavior during the first hours following the injury. It was the bacterial infection and sepsis from his gut that finally killed Vincent, and took the 30 hours to weaken his untreated wounds until his core organ systems were overcome and shut down.

Even though the town of Auvers-sur-Oise was well-populated for the summer holiday, there is no record of any witness stepping forward to report seeing the incident or seeing Vincent walking back from wherever he was injured. Nor did anyone that day report hearing a gunshot. The trusted grandfather who reported hearing a gunshot only relayed this story years later via his granddaughter when she was interviewed by Ken Wilkie (1978). This is particularly strange, given that a noise like a gunshot would have been easily noticed in this tranquil village and would have likely been the subject of many questions and gossip. Surely, if a shot had been fired, the residents of the small town would have known and reported it to the authorities.

A small knife, on the other hand, would have offered any would-be killer the maximum amount of discretion in multiple ways. It would have been easy to hide in a pocket or bag and easy to explain away as a common tool in a rural town. Additionally, its lack of noise and close-range capabilities would keep the possibility of witnesses to a minimum, especially if used in an isolated location.

If a knife was in fact the weapon used, there is even greater doubt cast on the old, common suicide narrative. After all, what would motivate someone to commit suicide in such a way? The motives for suicide often lie in a desire for a quick and painless escape, which is extremely unlikely to be achieved by stabbing oneself in the abdomen with a short-bladed knife. This would be quite different than a Roman Praetorian guard falling on his sword or a Samurai committing hari-kari.

It is important to note that having worked in several inner-city emergency rooms in the distant past, I did see suicide attempts as well as suicide successes. I cannot imagine anyone seriously wanting to commit suicide, making that attempt, getting up to walk home, and later screaming for someone to "*cut on [his] belly*." If Vincent really had an intent to kill himself,why would he then scream for help? He would likely have just stayed down on the ground, bled until he passed out, and then passed away quietly into the "*dustbins of history*," possibly with all his glorious art and letters being lost as well.

According to statistics by the National Institute of Health, "*suicide by self-stabbing*" is extremely uncommon. It constitutes only 1.3 percent of suicide attempts and results in an even lower instance of suicide successes. Though Vincent was an exceptional individual in many regards, it is distinctly unlikely that he would fit in with this particular minority. He would surely have known that a knife wound to the stomach would result in a prolonged and painful ordeal that could be treated, and thus a suicide attempt would be ultimately unsuccessful if he was taken quickly to a surgeon. Despite his notorious history of melodramatic emotional manipulation and possible self-injurious behavior, it is hard to believe that even Vincent would have chosen this method to end his life.

If one believes in this new knife theory, as well as how unlikely it would be for this theory to support suicide, it opens many possibilities and questions about the accidental death and, even more likely, murder of van Gogh. In a rural town like Auvers, a pocket knife or a hunting knife would have been a common tool for all types of situations. Considering means and opportunity for this theory, almost anyone would have been able to visit the painter in any number of isolated locations and stab him.

The knife theory is even more intriguing given that Dr. Gachet was a collector of gruesome items like the death masks of guillotine victims and human skulls, so why not the fashionable gangster Apache knife pistol (Figure 106)? As a medical professional, he certainly had access to unusual surgical tools, such as various sharp knives that could create a puncture wound easily mistaken for a bullet wound. The Apache knife pistol, was designed only 30 years earlier and was manufactured nearby in Belgium. It incorporated a dual-edged knife and folding "*knuckle duster*" in place of a more conventional handle This clever weapon was the best-known combination knife, revolver, and brass knuckles and was very popular in the Paris underworld, where, as we know, Gachet spent three days a week consulting.

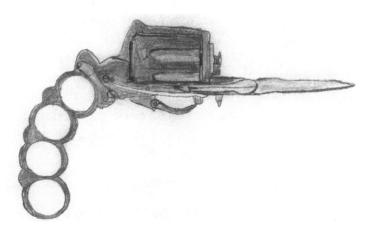

*Fig. 106. A sketch of **the infamous folding Apache knife pistol** (Walter, p. 135, 2013)*
which could have been a murder weapon. Usually chambered for a 6mm or 7mm pinfire
cartridge (black powder). It was 8 inches long but weighed in at only 12 ounces.
Colored pencil on bond paper. Sketch by Edward Kobobel.

Given its lack of a long barrel, the Apache knife pistol firing range and aim was less than ideal, but it was arguably a very effective weapon at an extremely close range, allowing the wielder to either shoot, punch, or stab his victim. Its design allowed for it to be folded so that it could fit in a bag or a pocket with ease. It was a unique weapon with an eye-catching design that would have been a tempting addition to any collection. It is not out of the realm of possibility that a weapon like this, or any other item from a myriad of sharp pointed objects, could have made its way into one of Vincent and Dr. Gachet's intense arguments, ending with an ultimately fatal wound.

Another possible suspect that could fit with this knife theory is one or both of the Secrétan brothers. They were supposed to have bullied poor Vincent—playing cruel, painful, and even dangerous pranks on him. They were known to call him demeaning nicknames, put pepper on the paintbrushes he routinely chewed, and hide a snake in his paint box. They could have easily wielded a knife in a *"playful"* or threatening confrontation that ended in a shoving match on the ground. Perhaps Vincent was accidentally stabbed as they were wrestling in the dirt.

Imagine Vincent leaving his rented room to return to one of his favorite spots to paint. Either on the way or sometime during his work session, he is approached by the Secrétan brothers and maybe their friends. The boys are full of their usual bravado and the boredom of having to entertain themselves during the hot summer holiday. Seeing Vincent, they decide to engage in their favorite pastime, playing tricks on the strange lonely painter. After all, nobody is around to chastise them for it. They approach Vincent with some new scheme, shouting and disrupting his work, possibly even threatening to damage his paintings and supplies. The painter, after years of being the victim of many bullies, finally loses his patience. An argument erupts between the man and the youths, which possibly turns violent. A shove turns into a scuffle, and one of the boys pulls a knife. Maybe it was actually Gaston who wielded the knife in an attempt to help and protect his brother, René? Self-defense or malicious intent is irrelevant in the end, because the result is the same, and the painter is mortally wounded. The boys run in fear and quietly leave town, while Vincent is left to stumble home alone, accepting his misfortune, and even taking the blame to save the boys from punishment. This scenario can readily replace the gun in the artistic renditions (Figures 107-111, Chapter 14) with a knife, and all the interactions and outcomes will essentially be the same. Knife or gun? You decide…until a bullet from Vincent's grave is verified, the method and the tool remain uncertain, but sadly the outcome is determined…

The Merits of The Knife Theory

In the end, what merit, if any, does this knife theory have? Does the possibility of a knife present a more logical story than the gun? The use of a knife rather than the infamous and mysteriously found rusted pistol may provide new thoughts on this

cold case conundrum. It can help provide motives for different suspects, dismiss the questionable, promoted public assumption of suicide, and even explain the suspicious behavior of several key players in this story. I'd say the knife theory certainly has some merit. Prove me wrong! Show me the bullet from Vincent's grave! If a bullet is found in Vincent or his casket, then the knife theory is eliminated.

On the other hand, without a signature powder burn, an exit wound, a witness, or an autopsy, the knife theory remains equally valid until proven otherwise. If, in a recovery mission/exhumation, no bullet is finally found in Vincent's casket, then the knife theory remains viable. Until then, we are forced to admit that either a gun or a knife could produce a simple puncture wound of the abdomen. The missing *"magic bullet"* needs to be found to answer these critical questions and address this mysterious, and provocative conundrum!

Part IV

The Cast of Characters

Chapter Fourteen

The Teen Hooligans From Paris

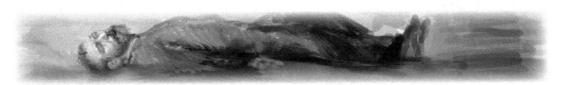

Who might have been responsible for the death of Vincent van Gogh? I would be remiss not to at least consider the role of the Secrétan brothers, 17-year-old René and 19-year-old Gaston, since they top the list of suspects for some investigators like Naifeh and White Smith (2011), or recently, Schnabel (2018). The brothers were from Paris but visited their wealthy father's family villa in Auvers every summer. They, along with other hooligans, often pulled dangerous pranks on the eccentric and lonely Vincent—knowing that they would likely not face repercussions for their actions—and then they would buy him a drink. René was known to have bullied Vincent during his time in Auvers in the summer of 1890 and to have threatened him with his loaded gun on at least one occasion. He had access to his own revolver, the .380 *"pea-shooter"* pistol (Doiteau, 1955).

There was no obvious malicious intent or motivation, but the brothers did have opportunity to commit murder, what with their frequent interactions with Vincent and known access to a loaded gun according to one critical interview (Doiteau, 1957). Given their record of behavior and their abrupt departure from Auvers soon after Vincent's death, they are likely suspects for any possible wrongdoing, either accidentally or on purpose. Whose gun was it—did it belong to René back in Paris, or did he acquire it from Gustave Ravoux in Auvers as has been speculated? Is it possibly the same old revolver that was found rusted in the field in the 1950s? No one seems to have any answer to these important questions except further unsubstantiated speculation. Of course, if René and Gaston were indeed responsible, that means Vincent lied about their role, never naming them as the cause of his wound. Why would Vincent have wanted to accept blame and protect these kids?

Are They Suspects?

Yes. René Secrétan was the leader of a group of troublemaking teenagers during a hot, muggy summer vacation in Auvers-sur-Oise. He is also, however, the best possible "*patsy*" on whom the real killers would pin the crime of an "*accidental*" gunshot wound to the belly many years later.

Did They Have Access to a Lethal Weapon?

Yes. Was it René's .380 pistol, brought with him from Paris, or did he buy or borrow a gun from Gustave Ravoux? René was seen brandishing a pistol around the village in the manner of a Wild West gunslinger (Doiteau, 1956). It would be no surprise to anyone if the brothers had been incriminated in an accidental murder of Vincent van Gogh.

If René's gun was a .380 caliber, that round would not fit in the Lefaucheux gun found in the field that is thought by many to be the murder weapon. Lefaucheux only made a 7mm and 9mm folding-trigger model. They did not make a .380 model, so the old rusted Lefaucheux could not be René's gun, unless he had several different guns. If René was telling the truth and his gun was used to shoot Vincent, then the old rusted gun found in the field 60 years later could not possibly be the murder weapon.

What Was the Possible Motive and Intent?

The brothers had no known vendetta against Vincent, though René enjoyed routinely harassing and tormenting the strange painter while he tried to work. Did he push Vincent too far on July 27, 1890? These distractions from his life's work would expectantly infuriate Vincent on some occasions, but it has been described that after one of these unpleasant sessions, René would often buy Vincent a drink. Did he do this as an apology, or to get Vincent inebriated enough to entertain him and his friends with an intriguing and possibly violent response when they continued to push all his buttons? It is unlikely and difficult to postulate any specific intent other than a prank gone very badly.

Where Would the Crime Scene Have Been?

The most frequently speculated place was, of course, a wheatfield overlooked by the bluff where the Chateau Auvers sits. Alternatively, they could have wounded Vincent near their summer villa, close to the Gachet home and near the road to Chaponval, at the barn at the farm on rue Boucher. Possibly, they could even have done it at the boatman's place, near the "*tree roots*" of the exposed trees along the Oise river, or in any of the other many wheatfields surrounding Auvers.

What Are Their Alibis?

The accounts of the Secrétans' whereabouts varied initially. The earliest version is that they had left town the day before and gone to another summer home and thus were not near the crime scene. However, René Secrétan later admitted to having been in Auvers. He also said that Vincent had taken a pistol out of his hunting bag, a .380 *"pea shooter"* that would often malfunction (*ibid.*, 1957). But René denied being present at any shooting. It is assumed that his brother, Gaston, followed the same path and was probably in town but also not directly involved. So did Vincent *"borrow"* René's pistol prior to that fateful day, or did he take it that morning, down by the Oise river bank with all the exposed tree roots where they may have hung out together? Where did Vincent get the gun he was supposed to have used to shoot himself on purpose if not from them? There is no reasonable explanation for how or where Vincent otherwise got a gun.

When the Secrétans heard that Vincent was shot, but not by them, maybe they panicked. They wanted to disconnect themselves from the investigation quickly and get out of town, as they realized their Wild West roleplaying was likely to put them directly in the spotlight as prime suspects for foul play. What convenient *"patsies"* they were for the real murderer(s). Perhaps they took the little pocket pistol back from wherever the fatal injury occured to a wheatfield and discarded it there. The weapon could have been thrown as far away into any of the fields as possible from the road or carried to the middle and buried. That scenario could explain the old rusted gun found 60 years later in the wheatfield.

Or, if one of the Secrétan brothers shot or stabbed Vincent, was it a murder, an accidental discharge of a malfunctioning weapon, or just a playful negligent discharge? Or was a knife pulled to ward off an unexpected retaliation by Vincent, resulting in a scuffle, an entanglement, and an inadvertent stab wound? Contrary to the initial reports, it eventually came out that the brothers may have made an unexpected rapid departure back to Paris the day after Vincent was injured, not, conveniently, the day before. This departure would have cut short their traditional family August vacation by an entire month. This all seems highly suspicious, if they were supposedly not involved in the crime.

Why Would Vincent Accept Total Responsibility for the *"Accident"*?

John Rewald, an esteemed art historian, visited Auvers-sur-Oise in the 1930s and reported that some old-timers told him that van Gogh was accidentally shot by some youths. According to the story, these kids were fearful of the consequences of their actions, so Vincent said he wounded himself. He famously said *"do not blame another"* because he did not want to get the boys in trouble. This rumor was passed on, and finally Naifeh and White Smith made this their explanation for why Vincent did not commit

suicide (*ibid.*, 2011). In Rewald's book *Post-Impressionism: From Van Gogh to Gauguin* (1956), Rewald adds that maybe this could explain how Vincent got the gun he would have needed to shoot himself. An intriguing speculation, but certainly unsupported.

Reenactment: The Secrétans Wound Vincent

What follows is an artistic storyboard reenactment of what might have played out if indeed the Secrétans were directly involved in Vincent's fatal injury as suggested by Naifeh and White Smith (2011).

It's July 27, 1890. Vincent is placidly painting in a wheatfield at the base of the Chateau Auvers, or possibly elsewhere near the Ravoux Inn, as the Secrétan brothers approach, verbally abusing Vincent while brandishing their pea shooter revolver (Figure 107).

Upset by the continued verbal abuse and trying to protect his wet canvas, Vincent begins arguing with René. An altercation ensues as René charges and knocks over Vincent's easel and canvas. Vincent responds as René pulls his gun (or his knife), while Gaston stands by, aghast (Figure 108).

*Fig. 107. **The Secrétans approach Vincent in the wheatfield** below the Chateau Auvers with loaded gun in hand. Gun in green circle Art by Darrell Anderson.*

Vincent tries to stop René from damaging his art. René then points his loaded gun at Vincent. Vincent responds unexpectedly and moves toward him to stop the threat with his hands in the traditional signs of "*STOP! DO NOT SHOOT!*" In the ensuing tussle, René is surprised and off balance, and as he falls backwards, his firearm discharges, hitting Vincent in the stomach. Was it an accident, or intentional (Figure 109)?

*Fig. 108. An altercation erupts as **Vincent advances to protect his art** and fend off his attacker. Art by Darrell Anderson.*

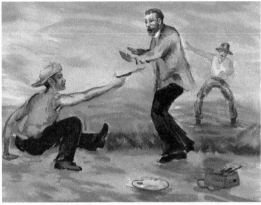

*Fig. 109. The end result of **the prank and argument gone wrong. BANG!** Or you can replace the gun with the knife as they tustle. Either weapon could have produced that small, round, pea-sized fatal entry wound. Art by Darrell Anderson.*

They start running away and then throw the gun out into the middle of the field, as far as they can fling it, leaving Vincent for dead (Figures 110-111).

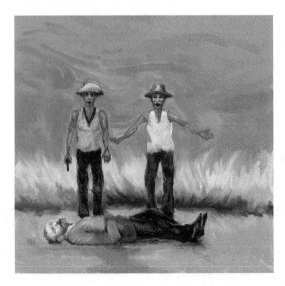

*Fig. 110. Standing over Vincent's body. **"...OOPs!...What now?"** Art by Darrell Anderson.*

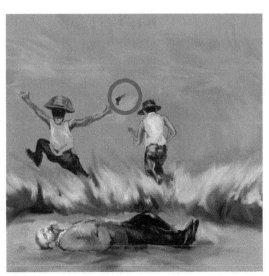

*Fig. 111. "**Let's get out of here** quickly and ditch that gun." The gun is circled in green. Art by Darrell Anderson.*

In this reenactment of the murder (Figures 107–111), René was most likely tormenting Vincent again, wherever he had set up his easel and canvases for the day's work. That very special spot is where his easel, canvases, supplies, and palette should have been found that day or wherever the police cursorily investigated after his death. Obviously, someone found most of it and brought it to Vincent's funeral, except his last painting, but did not tell anyone the details that would be needed to determine the scene of the crime with any degree of certainty. The Secrétan brothers may have been the ones who brought back his easel and all his art supplies to the Ravoux Inn, but what happened to his last canvas? Is this likely what really happened? There are still too many unconnected dots and flaws. This scenario, on many levels, just doesn't smell right to this gumshoe. It does not all comfortably fit together for me, regarding motive, location, witnesses, the missing art equipment, and the "*last canvas.*"

The Key to Discovering the Secrétans' Involvement

Maybe the Secrétans panicked in the heat of the moment of a possible accidental discharge or a real crime, and in their attempt to hide their involvement, if any, they got rid of their tiny Lefaucheux pistol. They threw it out into the middle of a field, as far away as they could throw it from the crime scene, only for it to be found serendipitously about 60 years later by a farmer, all rusted, the wooden grips disintegrated in the dirt. Today, the Secrétan brothers are the prime suspects in killing Vincent in the widely discussed appendix of Naifeh and White Smith's mega-biography, *Van Gogh: The Life* (2011).

How believable is this scenario? René Secrétan, when interviewed during the Vincent hullabaloo (around the time of the 100th anniversary of the artist's birth, and the filming of *Lust for Life*), said he did not shoot Vincent, but did admit that the murder weapon was his gun and that Vincent took it from his hunting bag. If this is all correct, then the missing magic bullet should be a .380 round (or 0.355 inches and known as a 9mm "*short*"), as Secrétan admitted it was a .380.

The missing, "*magic*" bullet still holds the key to whose gun may match the bullet remaining in Vincent or his casket. In addition to pointing to who may have murdered Vincent accidentally or on purpose, the missing bullet, if found, may also be able to eliminate a suspect and clear the Secrétans' names if it is not a .380. However, if a .380 bullet is found in Vincent or his casket, then the Secrétans would quickly move to the top of the list of persons of interest, supporting Naifeh and White Smith's killing Vincent theory.

Finding this missing bullet should also disprove the knife theory. It would seem imperative at this point, to prove or disprove the Secrétan's direct involvement in the killing of Vincent, that we must find and determine the caliber of the missing and "*magic*" bullet. A careful and respectful search for this key piece of evidence in Vincent's casket, will ultimately answer the key questions in this ongoing cold case homicide.

Chapter Fifteen

The Lover: Marguerite Gachet

In the search for answers regarding Vincent van Gogh's death, Marguerite Gachet may be the vital missing piece, the true linchpin of this investigative mystery puzzle. Marguerite—who had just turned 21 at the time of Vincent's death—is known for willingly posing as his model for one of his most famous Auvers paintings. However, when we investigate further, we discover that Marguerite may have been even more intimately involved in Vincent's life and his artistic accomplishments than we would expect from the widespread *"family-friendly"* narratives.

Fig. 112. Sketch of **Marguerite Gachet** *by Darrell Anderson*

Marguerite's best friend, Madame Liberge, another 20-year-old in the village at that time, confirmed the town rumors many years later: Marguerite and Vincent were in love. When Liberge's daughter, Giselle Baize, was interviewed by the author and investigative journalist Ken Wilkie in the 1970s, she stated that her mother told her that Marguerite and Vincent were romantically involved and in love, and they wanted to get married. But the very controlling father, Dr. Gachet, was against any personal relationships, particularly with Vincent. If that is true, then what may have happened when Vincent asked Marguerite's father, the good doctor, for her hand in marriage?

When Wilkie started his book, *The van Gogh Assignment*, in 1972, he undertook a major traveling investigation to garner as many new stories and facts about Vincent van Gogh as he could (p. 88, 1978). In Provence, he met with the van Gogh scholar Dr. Marc Edo Tralbaut. Apparently, Tralbaut mentioned:

> *"...that when I visited Auvers-sur-Oise, where Vincent died, I should try to trace the descendants of a certain Madame Liberge concerning*

the relationship between Vincent and his doctor's daughter,
Marguerite Gachet. I wrote down the names."

<div align="right">—(ibid.)</div>

Wilkie then learned more details about the love story between Marguerite and Vincent; after meeting with the daughter of this Madame Liberge, he wrote:

> *"In Provence, Dr. Tralbaut had told me that back in the thirties he had*
> *heard about events leading to Vincent's death that involved Dr. Gachet's*
> *daughter. This intrigued me. I had found his first love [Eugénie Loyer];*
> *perhaps Marguerite was his last. But where was the evidence? The only name*
> *Tralbaut could give me was a certain Madame Liberge who was said to have*
> *information related to the affair....The town hall register showed she died in*
> *1947, but her daughter, Madame Giselle Baize, still lived in the family house*
> *on a road where Vincent often set his easel [now the Rue Vincent van Gogh]."*

Wilkie went to her house and met a woman in her fifties, *"who took me into her kitchen and over a mug of café au lait, she told me her story"* (Wilkie, p. 120–22, 1991). As Wilkie wrote, Baize told him:

> *"'My mother was Marguerite Gachet's best friend. And she was the only*
> *person, as far as I am aware, who knew about the love affair between*
> *Vincent van Gogh and Marguerite. Marguerite was a proud girl but*
> *suppressed by her father. She confided to my mother that Vincent and she*
> *had fallen in love with each other and that Vincent wanted to marry her.*
> *But the thorn in the flesh was Marguerite's father, Dr. Gachet. Though*
> *an advocate of free love theory, he was strongly against an association*
> *between Vincent, who was of course his patient, and his daughter. Gachet*
> *forbade Marguerite to see the painter.'"*

<div align="right">—(ibid., p. 122)</div>

Baize reportedly continued:

> *"'After Vincent's suicide, Marguerite's depression became so serious that*
> *she practically never went out and withdrew more and more. She was never*
> *able to get over the shock of his suicide, my mother said, and she never*
> *married. She became reclusive and the only times her eyes are said to have*
> *come to life were when Vincent's name was mentioned.'"*

<div align="right">—(ibid., p. 122)</div>

It is important to appreciate that this same story was essentially also described by Tralbaut in previous years (1969). That this same story was known to two different investigators at two different times shows that Wilkie's story confirms, expands on,

and, in effect, corroborates Tralbaut's awareness. If we can accept the story Madame Liberge related to her daughter (who then told it to the two investigators years apart) about the doomed love affair between Vincent and Marguerite, then we can understand that Dr. Gachet "*forbade Marguerite to see the painter*" out of fear of lost honor, humiliation, and anger. What else may have concerned the doctor? The doctor was a widower who was presumably very protective of his only daughter, or at least wanted to keep her around to help manage his household, a form of servitude. Perhaps he primarily thought his daughter would sully the family name, make him an unwilling grandfather, hurt their respectable standing in their small, gossipy community, or damage his reputation and his consulting practice in Paris. Of course, the good doctor knew his patient's medical history and may have also been concerned that any liaison with Vincent might result in his beloved daughter contracting "*the French Disease*," syphilis (Van Der Leek, 2018).

Now add in the fact that this widower's only daughter had fallen in love with not just any man, but this unkempt, uncouth, and "*mad*" but brilliant artist, and it is not hard to believe that he forbade his only daughter from seeing Vincent in no uncertain terms. This can readily explain the loud arguments that villagers heard between the doctor and Vincent, who was always ready to argue about most anything for sport or intellectual curiosity. Presumably they argued about Vincent spending private time with the doctor's beloved daughter. Then consider that this was not an intellectual or art-related disagreement, but a disagreement over the matter of Vincent's heart and his soul, and his lifelong idyllic dream of finding a loving life partner.

A relationship between Vincent and Marguerite could also explain why Vincent and the good doctor had that rift around this time. Vincent wrote to Theo:

> "*I think we must not count on Dr. Gachet at all. First of all, he is sicker than I am, I think, or shall we say just as much.*"
> —(Letter #648, *ibid.*, p. 294)

Whatever caused the "*rift*" between the two men, as Paul Jr. later called it (*Der Spiegel*, 1990), Dr. Gachet was no longer mentioned in any way in Vincent's letters after this observation. What else would Vincent have said if he could have? It would be hard to deny that the suppression of Marguerite's love for Vincent and their inability for close, personal time was a viable yet unwritten explanation for this significant change in the relationships among Vincent, Marguerite, Dr. Gachet, and his son, Paul Jr. Instead of encouraging Vincent to paint his daughter, he was now forbidding him from even seeing her. Remember that Dr. Gachet had promised Vincent that he would have another chance to paint his daughter at the small piano/harmonium. Why was that offer never fulfilled? Dr. Gachet clearly wanted as many of Vincent's paintings as he could literally grab, as evidenced by his post-funeral ransacking of Vincent's studio... why not another one of his daughter at the harmonium?

We must also remember that what went unsaid or unwritten in these letters between the brothers about their most real and loving relationships is critical. They did share their insignificant relationships and frequent whoring, but never their true love, until Theo told Vincent about Johanna just before they planned to marry. Vincent first mentioned Marguerite to Theo when he described planning to paint the young woman at the piano in a pink dress. He described a possible portrait session. He also said he was hopeful that Marguerite and Johanna, Theo's wife, would make friends "*quickly.*" Was he hopeful that Marguerite would come into the family so both brothers would finally have companions other than each other? What was written between the lines between the two brothers?

For Theo's part, he wanted his brother to find love, his muse, and marry:

> "*...I hope from the bottom of my heart that you too will someday have a wife to whom you will be able to say these things: it is from her I receive the germs [germinating forces—a muse?].*"
> —(Letter T39, Paris, June 30, 1890)

Theo then says specifically, "*Your portrait of Miss Gachet must be wonderful.*" Would Marguerite have been this sort of "*germinating force*" for Vincent—in other words, his muse? This was very likely Marguerite's role, to bring out the best in Vincent's artistic ideation, visions, and productivity, as well as help him maintain his calm and focus on his brilliant work. However, Vincent did not put any of this closeness down, pen to paper, as he fully understood Dr. Gachet's violent opposition to their relationship. You can readily imagine Vincent's own violent, reactive arguments with Dr. Gachet, heard by all outside of the walls of the Gachet villa. It is hard to forget Vincent's quite unnerving outspokenness when he was challenged verbally. Vincent held nothing back. This was true ever since his childhood, and accentuated by his sad relationship with his father and their frequent confrontations, as well as his short-lived "*friendships*" like with Anton van Rappard or Paul Gauguin. Vincent's ongoing arguments were well-documented in the extended correspondence with his brother (Naifeh 2011). He was a fighter and would not readily give up on any argument—let alone when the love of his life, his muse, and his dreams of tranquil married life, happiness, and maybe even a family like his brother Theo had were at stake!

Vincent's response to Theo's hopes for him was very enlightening. Did he write his reply on the day of the big domestic dispute heard about all over Auvers, or after one of several other arguments between him and Gachet? He wrote:

> "*And if my disease returns you would forgive me. I still love art and life very much, but as for ever having a wife of my own, I have no great faith in that.*"
> —(Letter #646, *ibid.*, p. 293)

Vincent's violent vertigo attacks ("*my*" disease) were still an obvious fear in the back of his mind and a required consideration before he could decide to have a wife and family. He wrote that he did not "*know what direction things may go.*"

How close had Vincent and Marguerite become when this letter was written? Both, I suspect, were still in the early infatuation phase of their love and were probably already lovers in the physical sense, and already married in the eyes of God. Neither of them had any real experience in reciprocal love, so I would think that their feelings were quite transparent and obvious to everyone—subtle touches, making eyes at each other, rosy cheeks, etcetera. Was Dr. Gachet's concern that they were too overt in their feelings? Did the Gachets' housekeeper, Madame Chevalier, report any suspicious activities to further alarm the doctor? How did Mme Chevalier interact with Marguerite versus her father? What really was her role? Just housekeeper, or something more? What else or who else was she hiding?

Vincent had written to Theo that he enjoyed painting Marguerite, but it was "*difficult.*" What aspect was so difficult? Most likely it was not the painting itself but working under the watchful eyes of the father and son, as well as Mme Chevalier. This controlling watchfulness when he was trying to paint Marguerite was a big challenge and certainly would have been a major distraction, offset only by the positive opportunity to be in her company for hours. Despite the drawbacks, Vincent excitedly reported to Theo Gachet's promise that his daughter would once again stand and model by the harmonium for him.

> "*Yesterday and the day before I painted Mlle Gachet's portrait, which I hope you will see soon....It is a figure that I enjoyed painting—but it is difficult. He has promised to make her pose for me another time at the small organ. I will do one for you.*"
>
> —(Letter #645, *ibid.*, p. 288)

New Information and Insights From a Recently Uncovered Letter

Many new insights and observations were published in 1990 in *Der Spiegel* by Mattathias Arnold, who discovered a missing letter labeled "*T41a*" that was misfiled in the archives of the van Gogh research foundation. My old research and newer observations combined with Arnold's conclusions add "*further color,*" as the editor notes, to our quest (see Chapter 21 for a deeper dive into this newly found, missing letter T41a, presumably the last letter from Theo to Vincent before he was dead):

> "*M. Arnold adds further color to this loving relationship and what was going on, but only in whispers. The letters of Vincent van Gogh, however,*

only at most hint about Marguerite. In his report on the garden picture and the first reference to a possible portrait session, he lets the thoughts flow, Jo would 'make friends quickly' with the doctor's daughter. Does he fantasize Marguerite into a familial constellation in which the two brothers correspond to two harmonizing companions?

More conspicuously, Theo, always sensitive to Vincent's messages, praises the consolation of the marriage in a solemn letter of July 1, and expresses the hope that the brother will 'one day have a wife' to pour out his heart. Then, as in the same breath: 'Your portrait of Miss Gachet must be wonderful.' Vincent answers promptly, 'I do not think I'll ever have a wife. I'm afraid that, let's say, when I'm 40—but let's prefer to just say nothing. I'll explain that I'm whole, whole and I do not even know what turn it can take with me again.'"

—*(ibid.)*

Arnold concurs with the accounts of the known and gossiped-about love affair in the summer of 1890, between that strange Dutch artist and the young daughter of the eccentric old doctor (Der Spiegel 1990). Arnold believed that this was not a one-sided love affair but a true, mutually loving relationship that had surprised many.

Fig. 113. Vincent van Gogh, *Marguerite Gachet at the Piano, 1890. Sketch, Current Location Unknown.*

"An intimate lore [gossip in Auvers] wants to know more about a love affair between the painter and the model. Jo, however, ignored van Gogh, his story of the love affair...with silence and did not publish anything to add to this rumor (it was not a family friendly story in Johanna's opinion). In the other literature it is usually swept aside as a baseless rumor. But there are quite accurate statements about this [love affair, despite Jo's silence]."

—*(ibid.)*

Theo's wife, Jo, had control of all the letters and was able to tell the story the way she wanted and in the most family-friendly way possible. After all, it was Johanna's family image too. What Arnold suggests is that Jo withheld pertinent information that might have strengthened the circulating stories of the love affair between Vincent and Marguerite. The affair might have distracted

from the story she wanted remembered of the complete and undying filial devotion of her husband Theo to his older, but dependent and needy brother Vincent. It is very important to understand this aspect that M. Arnold is emphasizing as how the perspective is "*colored*." He then continued:

> "*Marc Edo Tralbaut in 1969 stated that a woman in Auvers known as Madame Liberge, a best friend of Marguerite Gachet, was firmly convinced that the doctor's daughter returned the painter's affections and was only 'too proud' to admit it. She did admit to the interviewer: 'But her whole attitude and everything she told me betrayed her true feelings for him.'*"
>
> —(*ibid.*)

Obviously, Tralbaut read the body language from that interview and believed in the validity of the love affair, and that their plans for marriage were legitimate, truthful, and believable. He goes on,

"This could sound like [Mme Liberge's] a mother's assumption [that it was only gossip that Marguerite and Vincent were lovers] as interpreted by her daughter [Mme Baize]. However, van Gogh researcher M. Arnold also had analyzed a remark by the painter's nephew, Vincent Willem, that raised suspicion about the relationship between his uncle, Vincent van Gogh, Dr. Gachet, and Paul Gauguin. Apparently there were some yet unknown words or letters that would now prove extremely interesting. What did the heir know as a specially trusted confidant of his mother, Jo?"

—(*ibid.*)

Does the same apply to the incident with Vincent's ear and Gauguin? What information has not been released from the depths of the Foundation's vaults about Vincent and Paul Gauguin? The information alluded to in that quote and that insight into Dr. Gachet (and possibly his son too) are quite intriguing. That information would be extremely helpful to have now to better and fully understand what really happened on the day van Gogh was mortally injured.

It is also intriguing that Arnold captured a subtle remark from Vincent's nephew, Vincent Willem—the "*engineer*," as the head of the van Gogh Institute in Amsterdam—that, in effect, Paul Gachet's involvement in the death of Vincent actually has not been discussed to the "*last word*" (*ibid.*). Is he suggesting by this somewhat off-hand remark that it was known that there was more to the rumors of Dr. Gachet's involvement in the death of Vincent van Gogh than was openly discussed among the artists in Paris?

Were there any other observers who might be able to add color to this romantic relationship they may have witnessed while in Auvers? There were two other artists who talked and painted with Vincent in his last weeks: an Australian, Walpole Brooke, and a Frenchman, Louis DuMoulin. Would these fellow painters have had

any inkling of Vincent and Marguerite's relationship? Did they see them together? What could their recollections of meeting and painting with Vincent tell us now? Unfortunately, this was a dead end and nothing of their interaction was maintained. Was there anyone else lurking around in the shadows of the Gachet's home that could shed some light on this challenging story?

The Purposely Hidden Identity in Vincent's Unattributed Paintings and Sketches of Marguerite

The painting of Marguerite Gachet in the garden (Figure 114) is quite well-known, and its naming and attribution are not in doubt. It is interesting to note that this painting of Marguerite was done without the permission of Dr. Gachet and apparently was upsetting to him. Subsequently, the famous painting of Marguerite at the piano was done only after Vincent was given permission, and the pair was monitored by all in the Gachet household during the sitting session. Why was the painting of Marguerite at the harmonium initially approved but never executed? Are there perhaps other paintings and sketches that were hastily completed in quiet corners away from watchful eyes maybe of Marguerite, but not thusly attributed?

*Fig. 114. Vincent van Gogh, **Marguerite Gachet in the Garden**, 1890. Oil on canvas, 46 x 55.5 cm, Musee d'Orsay, Paris, France.*

An intriguing speculation about another painting completed about this same time, titled Peasant Woman Standing in the Wheatfield, may also be ascribed as a painting of Marguerite. At the time of this painting, Vincent was struggling with several issues—most notably trying to hide his new and exciting relationship with Marguerite from the male Gachets and their housekeeper, Mme Chevalier. Certainly, the simple solution was to just sketch and paint Marguerite briefly, freely, and from memory without a formal sitting, to avoid naming her as the model. This would be a very clever loophole for Vincent to paint his Marguerite more often without permission. Let's analyze this theory.

The figure above (Figure 115) is one of those that may have really been an unnamed, more detailed portrait of Marguerite, this time including some basic facial details not seen in Figure 114. Given that the image lacks any depth, perspective, background, or reference points, I believe it was originally a sketch that Vincent started with Marguerite as his model, and later finished in his little studio from only an image emblazoned in his memory. The background could just as easily have been based on wallpaper. And are those little heart doodles around her skirt?

*Fig. 115. Vincent van Gogh, Peasant women Standing in the Wheatfield, also known as **A Young Girl Standing against a Background of Wheat**, 1890. 66 x 45 cm, National Gallery of Art, Washington, D.C.*

Furthermore, this portrait is certainly one of Vincent's most casually detailed face of a woman in Auvers. The figure stands out replete with careful attention to the face, mouth, and eyes, which is unlike any other prior Marguerite painting; but such a studied focus would make sense for someone who found himself enamored by her beauty. Despite the greater detail of her face, Vincent avoided specifically naming Marguerite in order to distract the good doctor and his team of spies from the affair, thereby avoiding their ongoing scrutiny. Instead, he indicated that it was just a "*peasant girl*" with dark hair. By not labeling Marguerite thusly, Vincent may have thought that their love affair remained secret, when in reality it may have been obvious to all that the two were lovers.

Was this tactic of anonymity also a strategy to circumvent Paul Jr.'s several requests to sit and be painted by Vincent? Why would Vincent not want to use Paul Jr. as a model anyway, when he spent much of his career as an artist chasing after models? Was he afraid of Paul Jr. or was he just too bizarre? Or did he just prefer to spend time with a different Gachet whenever he was in their home? Either way, between Vincent's evasion of Paul Jr. and his infatuation with Marguerite, he significantly further upset both father and son. Paul Jr. was very jealous that Vincent had painted his sister at least twice and sketched her several times. Vincent had shown no interest in sketching Paul Jr. once, let alone painting his portrait, or allowing him—a would-be artist craving self-esteem and acceptance from a fellow artist—to even sit with Vincent while he painted. Despite that, the young man desperately craved Vincent's attention and encouragement as he pursued his own artistic efforts, namely his painting "*career*," subsequently under the name of Louis von Ryssel. As Paul Jr.'s art went mostly unrecognized, an insignificant footnote in the art world, Vincent's stardom only grew, and so did Paul Jr.'s anger and jealousy of both Vincent as well as his sister, and their obvious love for each other. How did Paul Jr. manifest his anger, frustration, and boiling jealousy? Did he make Vincent pay for his indiscretions with his life?

*Figs. 116-117. When **comparing the two images**, Marguerite Gachet in the Garden and Peasant women Standing in the Wheatfield, sized side-by-side, they do appear to be roughly the same person.*

Fig. 118. Vincent van Gogh, **Dr. Gachet's Garden in Auvers,** *1890, Oil on canvas, 73 x 51.5 cm, Musée d'Orsay, Paris, France.*

Considering all the misdirection on both sides of the love affair of Vincent and Marguerite, and the later effort to maintain a family friendly story, it is thought that Johanna purposely swept all of those relevant stories under the carpet and purposely did not address their relationship. It is likely that Vincent did not want to draw any unnecessary attention to the couple by painting his lover publically so often. Yet he snuck quick sketches and finished portraits in private. Both the sketch and the finished portrait of the *Young Peasant Woman with Straw Hat* sitting in the wheat (Figures 119 and 120), I believe, are also part of Vincent's arsenal of private frontal portraits featuring significant facial details and the rosy cheeks of his Marguerite Gachet.

This likely painting of Marguerite, apparently done at the same time as the other, also has no depth or background but has some notable portraiture detail. Note the similarities between the background, the hat, and the face in Figures 100 and 102. Just another very clever cover-up in this ongoing saga of Victorian mores. This time it is Vincent covering up his ongoing sketching and painting of Marguerite Gachet. Most likely these were painted for his private enjoyment, much the same as one would keep a photo today at his bedside of his loved one.

Fig. 119. Vincent van Gogh, Sketch of **Young Peasant Woman with Straw Hat sitting in the Wheat** *1890. Another "sketch" of Marguerite in a pose Vincent enjoyed*

Fig. 120. Vincent van Gogh, **Young Peasant Woman with Straw Hat sitting in the Wheat** *1890. Oil on canvas, 92 x 73 cm, Hahnloser collection, Bern, Switzerland.*

The Subject of Love and Lovers

Despite the stilted and eventually hostile relationship among Vincent and the Gachets, Marguerite was his primary focus, so he painted her at every opportunity he could get or was promised. Vincent painted Marguerite in the garden at her home. The painting of Marguerite in the garden in a long white dress and yellow hat is very peaceful. It is not a frenetic work like those he painted in Arles.

*Fig. 121. Vincent van Gogh, **Two Lovers**, 1888, Oil on canvas, 32.5 x 23 cm, Private collection*

When Vincent arrived in Auvers, he had been nursing a particular fascination with the concept of lovers arm-in-arm, and it was a motif he painted often (Figures 121, 122). It was his own personal dream. But this subject took on new meaning once Marguerite came into his life. Perhaps Vincent's painting *Undergrowth with Two Figures* (Figure 123) was also meant to be of the two of them, arm-in-arm, walking down the aisle in the woods—nature's church? Was that Marguerite in her long, light green wedding dress, and Vincent in his top hat and tails as suggested by Derek Fell (2004)? Why was she not wearing *"the white [dress] with pale yellow overtones,"* and *"dressed as the bride"*? Was it because she was already *"compromised"*? Was this painting Vincent's announcement to the world that they were already lovers, so white with yellow overtones was no longer appropriate?

Was this Vincent and Marguerite walking down the aisle after (or more properly before) their marriage ceremony? Did Vincent believe they were forever lovers and already married in the eyes of God? An intriguing concept suggested by Fell, 2004.

*Fig. 122. Vincent van Gogh, **Public Garden with Couple and Blue Fur Tree: The Poets Garden III**, 1888, 73 x 92 cm, Private Collection*

Fig. 123. Vincent van Gogh, **Undergrowth with Two Figures**, *1890, 50 x 100 cm, Cincinnati Art Museum, Cincinnati, Ohio.*

Anecdotal Evidence of Vincent's Obsessive Infatuation with Marguerite Gachet

Fig. 124. Henri de Toulouse-Lautrec, **Portrait of Vincent van Gogh**, *1887. Pastel on cardboard, Van Gogh Museum, Amsterdam.*

Another exemplar that points to the significance of Marguerite in Vincent's life is a trip he took to Paris in early July 1890—just a couple of weeks before he was mortally wounded—to visit Theo, Johanna, and baby nephew Vincent. On this visit, he also met with old friends, the artist Henri de Toulouse-Lautrec who had recently painted a portrait of Vincent (Figure 108) and the critic Albert Aurier.

Vincent had also planned a meeting afterward with his old colleague, Jean-Baptiste Guillaumin (the painter of that alleged, yet infamous "*argument-provoking*" nude sitting unframed on the floor of the Gachet's residence (See Figure 173, Chapter 23).

However, Vincent left Paris abruptly and unexpectedly after his lunch with Toulouse-Lautrec to catch the next train back to Auvers before the scheduled meeting with Guillaumin. What triggered such an abrupt change of plans? One theory states that his rapid departure from Paris was thought to be because Vincent viewed a painting Toulouse-Lautrec had just done of an older, dark-haired woman sitting at a piano, in a pose very much like his painting of Marguerite. The

painting in question—Toulouse-Lautrec's, *Portrait of a Lady Musician* (Figure 125)—is so strikingly similar to Vincent's recently finished portrait, *Mademoiselle Gachet at the Piano* (Figure 126), that it must have acutely reminded him of his Marguerite—so much so that he apparently quickly, and quite unexpectedly, left his friends and family all behind to catch the next train and get back to Auvers to see his love.

Portraits at the Piano

Comparing the two paintings side-by-side, it is not difficult to imagine Vincent's reaction and urgent need to get back to Auvers and to Marguerite, though he had been away for only a day. This occurrence illustrates an unusual moment in Vincent's life, when he focused on something other than his family first, even amid all the financial and familial stresses that were surely on his mind. He focused on his Marguerite, obviously and obliviously in love, and for the first time, lost his focus on his family and friends.

Fig. 125. Henri de Toulouse-Lautrec, ***Portrait of a lady at the piano***, *also known as.Mlle Marie Dihau At The Piano. Courtesy of www.toulouse-lautrec foundation.org.*

Fig. 126. Vincent van Gogh, ***Mademoiselle Gachet at the Piano***, *1890. Oil on canvas, 102.6 x 50 cm, Offentliche Kunstsammlung, Basel, Switzerland.*

Vincent's portrait of Marguerite at the piano was reportedly deeply important to her, and it hung sentimentally in her bedroom above her bed. It was her most prized possession, according to multiple accounts. After Vincent died, Marguerite continued to live in her family home. Though she did not appear at the artist's funeral, she did take flowers to his grave the next day and almost daily for many years after. She became reclusive and sad. Even following Dr. Gachet's death in 1909, Marguerite remained a recluse in the dark and foreboding family home, alone with her very strange and more reclusive brother and his mousy wife. She was essentially alone—an old maid with nothing but memories of her only love, and the lonely routine of visiting his grave with a now famous hommage of yellow flowers. As Giselle Baize told Ken Wilkie over 60

years later, her mother had told her the story of how *"Marguerite was quite depressed and despondent and only brightened her demeanor when Vincent's name was brought up"* (Wilkie, 1978). She had a truly sad life without her Vincent.

Fortunately, she had the portrait of herself at the piano to look upon; it was the last thing she saw before she went to bed and the first thing she saw when she awoke. The painting remained there for 44 years, until Paul Jr. forced his sister to relinquish it to auction in 1934 (A. Richman, *The Last van Gogh*, p. 300–304, 2006). It seems particularly cruel of Paul Jr. to have forced her to sell her cherished painting and only real memento of Vincent, when the Gachets had an entire house full of fantastic and very valuable art! Why did Paul Jr. make her sell this one painting? Was it a punishment and an example of his way to continue to control her and maintain her silence? What was he so threatened by? What could she say so many years later after Vincent took all those secrets to his grave?

The Gachets' Attempt to Write Their Own Version of this Tragic Love Story

In 1954, five years after Marguerite passed away, Tralbaut described an interview he had in 1927 with Friedrich Karl Gotsch, a German painter (1900–1984). Gotsch reported to Tralbaut a discussion he once had with Paul Jr. about Vincent's death (Der Spiegel, 1990). In the interview, Paul Jr. clearly tried to paint a picture of Marguerite and Vincent's relationship that is far different from what the other stories suggest. Paul Jr. said people *"should know what really happened to Vincent,"* stating:

> *"We have not yet let it be known because…it was my sister that caused Vincent to shoot himself. Oh, basically he did not want to kill himself, he was just so desperate, so headless, Vincent was not a pleasant guest in the house. He was loud and rude and uncouth."*
>
> —(*ibid.*, 1990)

Paul Gachet Jr. further elaborated on how his sister caused Vincent to commit suicide:

> *"Vincent wished to paint her likeness. He had previously made a study of her while playing the piano. My sister was just recently grown up at the time. She had a clear aversion to the foreign painter who had only one left ear. When the modeling sessions to the portrait began, my sister confessed that she herself was afraid of Monsieur van Gogh and did not wish to sit. She was very ashamed to say so, but Monsieur van Gogh talked to her about love [sex]. That naturally had followed with a discussion between my father and Vincent after the 'love' episode. It was a rift; Vincent since avoided our house."*
>
> —(*ibid.*, 1990)

This account is diametrically opposed to that of Madame Liberge and Giselle Baize, and it stands out as an attempt at revisionist history to propagate a false suicide narrative. So again—as we face a question we have faced many times in this cold case—who do you believe? Do you trust Marguerite's best friend retelling a story to her daughter, only years later when her story was sought out? Or the potential misguided tale of someone who was a known liar, forger, and con-man trying to rewrite a favorable historical account by planting false stories in the midst of the art world? So, it is not just a question, again, of who to believe, but also, and more importantly, who do you trust? Who had an agenda? Who is just telling the old stories passed down in the family oral tradition, only when unexpectedly asked to recount these old stories many years later (Mme Liberge and her daughter)? Or who is spinning a false suicide narrative to misdirect the truth of Vincent's murder away from themselves, (the persons of interest and the perps)?

The Need to Maintain Marguerite's Silence

In that interview with Gotsch, Paul Jr. explained Marguerite's absence from the funeral and her ongoing silence on the subject of Vincent by saying, "*discretion was indicated*" (*ibid.*).

He asked Gotsch, "*How would she have talked when later world fame began, and curiosity resulted?*" By the time this story has been written and recounted, Vincent's fame has already spread worldwide, and his art was increasing in demand and value. Further, what was Paul Jr. so worried about his sister saying in public to anyone? And so many years later? It maybe the murderer's guilty conscience was driving him to say such things and trying to rewrite history.

Did Marguerite Reject Vincent and His Proposal of Marriage?

It is interesting that Derek Fell, in his 2004 analysis, *Van Gogh's Women*, also strongly believed in the mutual love affair between Marguerite and Vincent, but argued that her final (undocumented) rejection of him was the reason he commited suicide:

> "*Although Dr. Gachet gave Vincent permission to paint his daughter a second time, the resulting motif deepened his concern over their relationship. [The] white and pale yellow overtones [Figure 99]....could be interpreted as a wedding garden scene, with Marguerite dressed as the bride.*"
>
> —(*ibid.*)

The "*rejection theory*" for Vincent's death by suicide is difficult to accept now in the absence of a powder burn necessary to accommodate the old, self-inflicted gunshot wound theory.

Johanna van Gogh-Bonger and Her Role in Negating Marguerite in Vincent's Life

Clearly M. Arnold believed that the love affair was true and meaningful for the lovers. Arnold also believed that Johanna van Gogh knew more information than she was releasing for public consumption. Was the relationship between Vincent and Marguerite embarrassing for the family in general, or for Johanna specifically, or was she trying to protect her son's name while building the basis for his future in the art world as Vincent's fame spread far and wide?

Was there any component of suppressing this story of their love affair an affront to Jo personally as she continued to have a very special, feeling of love for her brother in law, originating with their first meeting in Paris, and forming the basis for her life long pursuit of making sure (her) Vincent achieved greatness, but purposely excluded Marguerite, so that, in her heart and mind, Vincent was really *"hers"*? How else to explain both her dedication to Vincent on the one hand, and bury the love and marriage plans of the loving couple on the other?

Was Marguerite "*Compromised*"?

After the funeral, Dr. Gachet and his son returned to Ravoux Inn to offer Gustave Ravoux a selection of Vincent's canvases that legally belonged to Vincent's brother, Theo*. Adeline Ravoux replied that *"her father already had several and was content."* Adeline then noted that the Gachets rolled up one canvas after another. She stated that:

> *"...such a generous gift, without much market value, probably compensated Gachet 'for seeing his daughter compromised'"*
>
> —*(ibid., 1990)*

Most likely the use of the word "*compromised*" was stated to emphasize, in effect, a "*family-friendly*" version that Marguerite was no longer a virgin. Or perhaps worse, to suggest that she was possibly pregnant with Vincent's child and would require a secret abortion or suffer the fate of having a bastard child...an intriguing possibility that would explain much of her apparent lack of social interaction with her old friend. Thus came the Victorian need for absolute "*discretion*," as such things were just not discussed in any good society or in open company. "*Discretion*" was often a code word for illegitimate pregnancy back in those days, and for the sake of family reputation, Jo may have just

*Footnote: It should be pointed out and legally emphasized that all of Vincent's art and other property would pass to his next of kin, Theo and Johanna. His art was not available for Dr. Gachet to be able to offer to M. Ravoux or anyone under any circumstances.

buried the story. But the truth was probably well known within the families. Matthias Arnold seemed to agree that these stories were understated, and confirmed their validity when he observed:

> *"But, regardless of the stories of the ladies Liberge and Giroux [corrected to Baize] here, and from the close family circle of those affected, both the love affair and the consequent discord is confirmed."*
>
> —(*ibid.*, 1990)

Arnold tried to separate and distinguish these two divergent stories of their relationship and the encounters of Marguerite with Vincent thus:

> *"Distinguishing difference: One-time Marguerite Gachet reciprocates the feelings of Van Gogh, the other time she should have dread before him. It is conceivable that Mrs. Liberge falsely interpreted the hints of her friend Marguerite. Alternatively, at least as likely, however, is that Gachet Junior, perhaps in good thoughts, spread a family-friendly version of their relationship. In any case, the conflict must have hit the sensitive artist hard."*
>
> —(*ibid.*, 1990)

The Real Role of Marguerite Gachet in the Death of Vincent Van Gogh

If the stories of Vincent and Marguerite are true, the early happiness of their relationship might explain why Auvers was Vincent's calmest, serene, and most prolific period, despite the reality of his tumultuous family (both immediate and extended) and financial concerns. It might further explain why this period is marked by a greater focus on his art than on his family, his financial concerns, or his letters. But, was his real focus only on his art and Marguerite? Was she his muse? How often could these two lovers steal away for some time to be together and explore their personal feelings without starting rumors?

Marguerite was well known and gossiped about around Auvers as a "compromised" woman. Apparently, so much so that even young Adeline knew about Marguerite's "compromised" situation. How much did this intense gossiping sully her image and besmirch the family name? Was this a likely reason for the honor killing of Vincent van Gogh?

It is plausible to think that as Marguerite's love for Vincent grew, the other two Gachets' envy and hatred of the artist also grew in equal measures. Certainly, if Vincent had compromised the only Gachet girl, and thereby the entire family reputation, the men of the family would have motive to murder to protect their family honor.

What Was Marguerite Gachet's Life Like After Vincent's Death? Spinsterhood

Marguerite lived the rest of her life without ever speaking or writing of her Vincent again (one could only hope her diary may have yet survived). She became essentially mute beginning at the time of his death, even with her best friend Mme Liberge. She lived with her father, a known "*nervous evil*" and then with her brother Paul Jr. "*blatantly evil and black-hearted*," and his wife until she died in 1949—a broken-hearted recluse, an old maid who missed her Vincent terribly.

She never divulged the terrible family secrets she was forced to take to the grave with her. It is a very romantic, heart-breaking, and truly sad story. Marguerite helped Vincent finally find love in his life after so many failures, only for them both to lose it all so tragically. Unfortunately, Marguerite never spoke or wrote anything about Vincent and their loving relationship (not even a "*lost*" diary), or about what happened the day her Vincent was mortally wounded. She presumably lived in great fear of her family, who forbade her from ever uttering a word about what she saw the fateful day of her lover's death, lest she meet the same fate.

Fig. 127. **Marguerite Gachet** *in her later years*

Some photographs of Marguerite in middle age show that her face reflected a certain sadness (Figure 127). Could this sadness be a manifestation of unrequited love and profound loss? Remorse? Anger? One cannot help but read into her expression a sense of guilt and sadness as she remained trapped, a prisoner of her own family and past. She remained stuck in her own home with her evil brother, and without her Vincent or his portrait of her at the piano. All that was left was shattered hopes and extinguished dreams.

One can only imagine how sad her life was after losing Vincent. She had nothing. No hopes, no dreams—only solitude and memories. Did she have to have a very quiet abortion of Vincent's child? Or did she birth and raise a child, sequestered in that dark and gloomy old house, with the help of the housekeeper and Dr. Gachet's mistress, Louise Chevalier? Who else was around that creepy old house that could be a very important helping hand with eyes and ears, in raising Vincent's bastard child, until she was old enough to be sent away to boarding school or escaped? Then Marguerite, in fact, really lost everything possible from Vincent. She had nothing tangible from her Vincent, and she could only watch painfully as he posthumously reached superstardom in the art world.

As painful as it must have been for Marguerite to be surrounded by Vincent's success, it must have been as equally aggravating and frustrating for Paul Jr. to witness Vincent's exceptional talent as a youth, and the subsequent rise of his reputation, while his own artistic endeavors effectively failed. Did he take out his frustration and anger on his silenced, dishonored sister, living a reclusive, very unhappy life under his dominant control? Did he use the fear he put into her very vulnerable state to manipulate and control her when she witnessed him and her father murder Vincent in the barn in cold blood?

Thus, Marguerite is the central reason why her father and brother would both intensely dislike Vincent and become suspects in his murder. Paul Jr. felt a deep sibling rivalry for the attentions of Vincent and possibly also those of his own father. Killing Vincent would allow him to regain his father's love, attention, and respect, and eliminate the object of his fierce jealousy. Regarding Dr. Gachet, to say he did not approve of Vincent for his daughter's serious affections and marriage into his family is probably an understatement. He was very controlling of his 21-year-old daughter, even before Vincent's murder. She was considered to be heading toward an obvious reclusive spinsterhood without anyone else ever being allowed to court her or visit her. It got even worse after Vincent's death for fear of what she might say. She was a virtual prisoner and a "*Cinderella*" locked in her home with no possibility of escape. No Prince Charming was allowed to meet her. But even though Vincent was perhaps her last, obvious hope, Dr. Gachet did not remotely find him a worthy match for his daughter in any sense. Once what was happening between these two lovers became obvious, he and his son decided on a final solution to the Vincent problem.

Given all of this, imagine what might have happened when Vincent and Marguerite— who were madly in love and wanted to marry, despite obvious major roadblocks to their relationship—came to ask her father for permission. What ugly reaction might this have provoked? Was this problem the basis for the real "*rift*" described by Paul Jr. to Gotsch, and the cause of arguments heard by many around town between Vincent and Dr. Gachet? Did Dr. Gachet and/or Paul Jr. conspire to threaten Vincent—with a gun, a knife, or both—so that he would stand down and stop courting Marguerite? Or did they just agree to end it all, there and then? How did Marguerite find out about their plan, and did she try to thwart it?

Vincent's Silence About His Killer(s)

Knowing van Gogh as well as we do now, we can consider what might have been his reaction when Dr. Gachet rejected Vincent's request for Marguerite's hand in marriage. It is important to note that it is the father rejecting Vincent, not the lover. Would Vincent go off to the wheatfields with a stolen gun and try to commit suicide? That seems very unlikely. Maybe, when mortally wounded and faced with the final choice of his life, Vincent tried to protect Marguerite's honor as he knew he was dying. Did Vincent

believe, or hope, that Marguerite may have been pregnant with his child? Was this an honor killing of sorts? If Marguerite's family was indeed responsible for Vincent's death, out of respect for his beloved Marguerite, he would logically have attempted to protect her by not telling the truth and saying his wound was self-inflicted, rather than say his "*friend*" and Marguerite's father and son teamed up to murder him. It is most likely that Vincent wanted to spare Marguerite the potential shame that acknowledgement of their love affair, and potential illegitimate child would bring in Victorian-influenced France. This would be particularly true among the village gossips and the status-conscious Gachet family, who, like the van Gogh family, was always determined to keep up appearances and spin the narratives in the most family friendly way. Both the Gachet and van Gogh families desperately wanted to maintain that family-friendly spin on the story of these two lovers. What was poor Marguerite to do?

And if the "*compromised*" Marguerite was pregnant, it makes sense that her family would isolate "*the spinster*" at home, where the unwanted problem could be "*taken care of*," and Marguerite could be cared for by Madame Chevalier under the guidance of the good doctor. What if Marguerite started to show months after Vincent was dead and buried, but it being Catholic France, mother and child were allowed to go to term and birth? Certainly an interesting possibility. Dramatically, this was an epic, Shakespearean tragedy on so many levels. Vincent took the blame because he desperately wanted to protect the love of his life, the only woman who really loved him for who he was, believed in him, accepted him, provoked his passion to paint uninhibited, and could see his eventual successes as an artist. There is no other reason that Vincent, on his deathbed, would try to take the blame, saying, "*Do not accuse another, it was me*," if not for his greatest love.

Chapter Sixteen

The Doctor: Paul-Ferdinand Gachet

*Fig. 128. **Paul F. Gachet***

The one person who has several times been considered a suspect in Vincent van Gogh's death is Dr. Paul-Ferdinand Gachet. At this point, it seems as if he is involved in nearly every aspect of this case—he was the sole individual who had personal and medical contact with both Vincent and Theo, the one whose role in caring (or not) for Vincent was questioned by Adeline Ravoux, and the one whose medical opinion declared the dying man a lost cause, essentially sealing his fate. Perhaps it is finally time to talk about this man who played such a vital role in Vincent's last days and, most importantly, the day he was fatally wounded.

Dr. Paul-Ferdinand Gachet was an important figure in Vincent's life in Auvers-sur-Oise. A major reason why Vincent moved to the village was to be placed under Dr. Gachet's care due to the homeopathic doctor's specialty in melancholia, and his knowledge of the art world. Dr. Gachet was supposed to be the perfect person to monitor and interact with Vincent after he was discharged from the asylum in Saint Rémy. He was also a painter and etcher who hoped to learn from Vincent. While the relationship at first seemed ideal—with Vincent visiting the Gachet household frequently and painting portraits of both the doctor and Marguerite, but not Paul Jr.—some folks at the time noticed a growing tension in their relationship.

Is He A Suspect?

Given the widespread stories of conflict and arguments overheard between the two men and the doctor's apparent medical negligence in Vincent's final hours, it is not difficult to imagine that the doctor played a major role in the artist's death. Dr. Gachet is also the likely culprit for starting the false narrative that Vincent killed himself, which people were uncomfortable challenging or correcting until many years later—especially since Dr. Gachet was viewed as so well-respected.

Did He Have Access to a Lethal Weapon?

In addition to owning at least one revolver from his military service, Dr. Gachet was also known to have had a bizarre collection of weapons, including military and non-military knives, and even a model of a guillotine that resided in his dark study along with the skull on his desk.

After the shooting, the police did not look for Dr. Gachet's gun or check whether it had been recently fired. Was it where it was supposed to be? Was Dr. Gachet the only one with access to it? Mme Chevalier had stated that "*the gun was never out of the cabinet on that day*" Vincent was possibly shot (Naifeh, 2011).

What Was the Possible Motive and Intent?

Dr. Gachet may have had multiple motives to be rid of Vincent—namely, greed, jealousy, and personal dislike. Dr. Gachet was a devotée of Vincent's art and a connoisseur of Impressionist art. He had the foresight to acquire as much of Vincent's art as possible, with no qualms about taking many pieces straight off of Vincent's walls and out of his storage area immediately after the artist's burial. Through the years, Gachet accumulated an impressive and substantial personal art collection—some of it acquired by potentially nefarious means. He also longed to be an artist himself. Despite the great effort and time he spent trying to copy Vincent's work, he was an abject failure with none of Vincent's outstanding talent. It would appear he was very jealous of the unkempt but brilliant Vincent, whose greatness he fully understood and appreciated long before the entire art world did. His stockpiling of Vincent's paintings after his death indicated that he saw their future value. Maybe Gachet and a circle of co-conspirators expected to profit from Vincent's death. Remember, a Millet painting sold for a very large sum of 500,000 French francs 15 years after his death.

Moreover, Dr. Gachet's dislike for Vincent, verging on hatred, was evident in their often-overheard arguments—possibly, as discussed in the previous chapter, due to the

Fig. 129. **Dr. Paul-Ferdinand Gachet in his military uniform** *holding his service weapon in his right hand. (green circle)*

budding romance between the artist and Marguerite. The doctor realized that Vincent and Marguerite had a very serious, evolving relationship, and he did not approve of it. He wanted to protect his daughter's honor, her health, and the family name, and did not want Vincent as part of his family.

In addition to motive, Dr. Gachet had opportunity to harm Vincent as well. Since Vincent was his patient, Dr. Gachet could easily and unsuspiciously set up a meeting with Vincent anywhere, at any time he wanted. He was being paid by Theo to care for and watch over Vincent ever since he left the asylum at Saint Rémy. Vincent was often at his home, painting him or Marguerite, and, initially, was a frequent guest at meal times.

It was known, from the later interview with Paul Jr. published by Tralbaut (1969), that Dr. Gachet, Paul Jr., and Marguerite had seen Vincent the morning of the day he was fatally wounded. Did they also see him that afternoon in a follow-up attempt to resolve their ongoing arguments? One thing is for sure, Dr. Gachet was not off fishing with his son that day as was initially claimed by the Gachets' housekeeper, Mme Chevalier. This claim was eventually overturned by Paul Jr. himself, in his later interviews with Gotsch and Tralbaut.

But opportunity and motive are not enough—Dr. Gachet also needed to have serious intent to act against Vincent. Did his various motivations turn into intent?

The True Dr. Gachet

Dr. Paul Gachet was a well-regarded doctor more than 20 years Vincent's senior. He had a great deal of experience in matters of both the body and the mind, having studied at the University of Paris, worked at multiple mental hospitals, and written papers about melancholia. He was also interested in chemistry, homeopathy, and various plants with medicinal properties. His talents did not end at medicine, though. Gachet was also a man of introspection and culture, preferring the freedom and relative quiet of private practice to the frantic pace of working in the city hospitals. He was known to enjoy walking around his picturesque Auvers home and its garden. Gachet had a passion for art—primarily drawing and painting, plus a few experiments in etching and printmaking—and he eventually gained a reputation as the preferred doctor of many of the great artists of the time, including Pierre-Auguste Renoir and Paul Cézanne. Several renowned artists took the time to paint portraits of the doctor, as

well as images of his beautiful house and garden. These factors made Dr. Gachet the ideal person to help Vincent, as far as Theo was concerned. As the biographers Steven Naifeh and Gregory White Smith so eloquently stated, Theo saw:

> *"...that this eccentric country doctor, with his funny white cap and too-heavy-for-summer coat, fully embraced the modern world of the mind, even as he worked to cure its inevitable ills."*
>
> —(ibid., 2011)

Dr. Gachet was a man of science who could reason with Theo's eccentric brother while also identifying with his greatest passion. The doctor would be able to treat various physical issues, keep an eye out for any potential depressive episodes, and be a friend and mentor to the ambitious artist. With such personalized care and attention, Gachet could also keep Vincent busy, which would be of great help to Theo, who needed to spend more time focusing on his own family situation. Gachet seemed like the solution to all their problems.

Fig. 130. Vincent van Gogh, **Portrait of Dr. Gachet**, 1890. Oil on canvas, 66 x 57 cm, private collection.

Fig. 131. **Etching of Dr. Gachet**, Vincent van Gogh, Museum of Fine arts, Boston, Massachusetts

At first, Theo's hopes seemed to be proving true. While in Auvers, Vincent visited the Gachet home and used what he saw there as recurring inspiration for his work. His portraits of Dr. Gachet from the summer of 1890 are known today as some of his most famous and valuable surviving works, and his paintings of the garden and its flowers are also well known. Dr. Gachet was also the subject of Vincent's only known etching; the doctor taught Vincent this technique and allowed him to use his equipment.

Dr. Gachet was an aspiring artist with an admiration for Vincent's work, as well as a macabre sense of reality. His

etching *Meditation* (Figure 132) is perhaps an image of his desk, prominently featuring a human skull. He was widely considered to be strange, reclusive, and eccentric. He was never described as friendly, gregarious or outgoing, nor did he have any real friends. And remember, Vincent once wrote that the doctor was "*sicker than I am.*"

*Fig. 132. Dr. Paul-Ferdinand Gachet, "**Meditation**", not dated. Etching printed on watermarked laid paper, titled on verso, signed on verso, and in the plate stamped with his stamp (Lugt 1195b), 110 x 130 mm, private collection.*

At some point, the initially idyllic relationship between Vincent and Dr. Gachet seems to have gone south. In Vincent's letters to his brother, he expressed a growing dislike for the doctor and eventually stopped mentioning Gachet at all. The most telling sign of all is the remarkable absence of his planned and promised work featuring Marguerite at the harmonium, which he had mentioned to Theo. Given that no painting or sketches of this scene exists, it seems as if the young woman was suddenly off limits and no longer allowed to be his model.

Adeline Ravoux's testimony about the vigil at Vincent's bedside, if taken as fact, also makes it clear that the supposedly strong relationship between the two men had soured some time before. While Gachet and his son claimed that the doctor was present all night at Vincent's bedside, the innkeeper's daughter clearly remembered a short, tense visit in which the doctor only stayed for a few minutes; the two men said nothing and just glared at each other. Why would Vincent say nothing to his "*friend*?" Why the dramatic change in their friendship? Why the arguments?

Vincent might have tried to steer clear of Gachet as their friendship unraveled, but what if one summer day, he encountered the doctor while on his way to paint in the wheatfields for the afternoon? The doctor's jealousy and resentment got the better of him, and he saw an opportunity to get what he felt Vincent deserved. Perhaps it was a momentary lack of self-control, or the culmination of a long-considered plan, but the result remains the same. He took out his pistol and shot the painter up close, before Vincent even had the chance to defend himself. It would be the perfect crime. In such an isolated location, there would be no witnesses to contradict Dr. Gachet's story. He could just say Vincent was crazy, and he finally killed himself. Nobody would deny the possibility. Reassured of his plan, Gachet left his friend behind to quietly die, quickly walking home to speak to his son and housekeeper so he could establish his alibi and suicide cover story. Then they could plan together and figure out how he could get his hands on what he knew would someday become valuable works of art. Is this really the most likely scenario for the role of Dr. Paul-Ferdinand Gachet and his direct involvement in killing Vincent? I'm not sure the dots quite connect. Let's keep exploring.

Dr. Paul Gachet and His Son, Paul Jr.—The Team Gachet

These two are almost impossible to separate, particularly in light of the significant role Paul Jr. took on to defend his father after his father's death in 1909. It turns out that maybe he was guiltier than his father. It is hard to separate these two around the time of this mortal injury. Please consider that possibility when analyzing these two characters as serious persons of interest in trying to solve this cold case. I like to think of them as *"Team Gachet."*

Their initial story, or alibi, was that the two of them were off *"fishing together."* No witness exists to corroborate this story, but years later, Dr. Tralbaut interviewed Paul Jr. and his sister Marguerite (*ibid.*, 1969). Tralbaut does not get separate statements from each of them, so I must assume that Paul Jr. did all the talking, as he did in the previous interview he gave the authors Doiteau and Leroy in 1926 for La Folie (1928). In this critical Tralbaut interview, which followed *"the prior alleged explosion of hostility,"* both Paul Jr. and Marguerite spoke about bearing witness to the argument over the unframed Guillaumin nude in the foyer and their father's described alleged reach for the *"phantom"* pistol. *"They were [both] astonished to see him turn up the next day as if nothing happened! Vincent offered no excuses. Five days after July 20, 1890, Theo heads to Paris from a family trip to Holland."* That would make it July 25, 1890 when Theo wrote the famous letter to Jo about the *"quite incomprehensible"* letter from Vincent. Critically, Tralbaut records that:

> *"Two days later, toward the end of the afternoon of Sunday, July 27 [1890], the Gachets watched Vincent leave. He seemed perfectly calm, but they nevertheless felt uneasy about him. Something was wrong. Vincent seemed to have some hidden intention....An earlier incident had begun to give*

Dr. Gachet some concern....One Sunday, when he was lunching with the
Gachets, Vincent had suddenly thrown down his napkin and left in order to
go back to his paints."

—*(ibid.,* 1969)

What happened, when was this? Was this around July 2 or July 10, 1890, after which no further mention of Dr. Gachet appears in Vincent's letters? Was this lapse or *"rift"* brought on by any discussion of the blossoming relationship between Vincent and Gachet's 21-year-old daughter? Dr. Paul-Ferdinand Gachet, a Captain in the French National Guard serving in Paris home guard during the Franco-Prussian war, certainly knew or should have known that Vincent needed immediate surgical attention after he was shot. Rushing Vincent to a Paris hospital with war-trained surgeons by coach and telegramming ahead to the closest and best hospital and surgeons was critically essential. Every possible effort and opportunity to save Vincent's life should have been pursued. So why didn't that happen?

It is intriguing that Dr. Gachet's name comes up so frequently as the person of greatest interest, along with his son. So, if all five main characters (Vincent, Marguerite, the housekeeper, the doctor, and his son) are claimed in an independent interview by Tralbaut—an accepted Vincent biographer—to all have been together at the Gachet home and arguing on the day Vincent was mortally wounded...were they all involved in his death, directly or indirectly? He subsequently died from an injury (shortly) after their meeting that day and a known argument.

Ultimately we know that if Vincent did not commit suicide, and his death was unlikely accidental, then he was murdered. So who had the means, the opportunity, the motive(s), and the weapon to kill Vincent? What scenario best fulfills and connects all the *"dots"* in this most amazing art history cold case homicide? See if you can agree with me on the *"what really happened"* scenario (Chapter 23) and the conclusions in the *"closing arguments"* (Chapter 24), where I answer all the penetrating and pertinent questions to wrap up this killing Vincent fact-finding mission, and prove today that Vincent did not commit suicide with a self-inflicted wound.

Chapter Seventeen

The Doctor's Son: Paul Gachet Jr.

Fig. 133. **Paul Gachet Jr.**

Paul Gachet Jr., the doctor's 17-year-old son, came home from school in Paris to spend the summer in Auvers with his small family, without any specific job or activity to occupy his time. He was focused on becoming a painter, which his father encouraged, and it seemed like the unexpected arrival of Vincent van Gogh in his town was a great boon to this goal. Now this artist was going to be around his home as he and his father seemed to get on well, both as artists and apparently friends with similar interests. The young man thought maybe Vincent would teach him the art of painting, in a sort of summer apprenticeship. However, like what eventually happened between Vincent and his father, it seems that Paul Jr.'s relationship with the artist went sour, and now Paul Jr. is also a person of interest in Vincent's death.

Except for their obvious age difference, Dr. Gachet and Paul Jr. really were difficult to differentiate, and it was hard to tell which of the two men was stranger. Paul Jr.'s motivation to harm the artist would run parallel to his father's, and he may also have had some of his own issues with Vincent that enhanced his motivation to injure or kill him. It is thought that, ultimately, Paul Jr. was a hanger-on trying to curry Vincent's favor and hopefully gain some tips for a novice painter, but he was flat-out rejected. Paul Jr. was not even invited to sit for a portrait like his father and sister were, despite requests—not just from

201

him, but also from his father. As a struggling aspiring painter, Paul Jr. was jealous of Vincent and, most importantly, of how his father initially worshipped Vincent's genius, and treated him like the son he may have wished he had. He may have felt rejected and feared failure—he would never be as good a painter as Vincent. Young Paul had as much opportunity to kill Vincent as his father, possibly more, since he had no job and had the summer off from school. Opportunity could have turned into intent to excise the strange painter from his life and earn the loving recognition he yearned to receive from his father—ironically, an exhausting and ultimately useless mission Vincent knew only too well himself. Vincent brought conflict, jealousy, and disruption to the Gachets' otherwise well-ordered household, and perhaps this was enough to cause Paul Jr. to take matters into his own hands without his father's planning or approval.

Is He A Suspect?

Yes, but it is unclear whether Paul Jr. would have been able to commit a murder on his own. The Gachets were all rather introverted and antisocial, and Paul Jr. was especially strange given his sheltered upbringing. By all accounts they were a tight-knit family, maybe tight enough to kill together. Was Paul Jr. his father's accomplice? Was he as prepared to pull the trigger as his father was? Or maybe he was, in fact, the "*trigger man?*"

Did He Have Access to A Lethal Weapon?

It is unknown whether Paul Jr. understood how to use a gun. Most likely he had or likely carried a pocket knife as so many did back then. Still, his father had a gun from his military service, which was kept in a cabinet, presumably unlocked. No one knows for sure if Paul Jr. knew where the gun was kept, but most likely he did if the housekeeper, Mme Chevalier, also knew. He could have had access to the gun on his own, or his father could have let him use it for hunting, target practice, or the joint crime of killing Vincent. Dr. Gachet possibly had other guns as well, plus his bizarre collection of weapons; his house was dark and filled with many things that Vincent thought could be used as backdrops or components of still lifes. Other available weapons included knives, screwdrivers, ice picks, or any variety of tools from the kitchen, the garden, or the doctor's bag.

What Was the Possible Motive and Intent?

Initially, Dr. Gachet treated Vincent like the older son he never had, and at the same time Marguerite and Vincent forged a budding romance that was probably obvious to all who saw them together. Paul Jr. was most likely quite jealous of Vincent getting

so much attention from his father and then his sister, and he was effectively shunned from interacting with Vincent except at the dinner table. He was likely concerned with protecting his sister's honor and the family name, taking the lead from his father or maybe coached by the housekeeper, who was essentially the doctor's live-in mistress, who never liked Vincent. He desperately wanted to minimize Vincent's growing importance in their otherwise quiet and mundane family life. He did not want Vincent as a brother-in-law, since his obvious rejection as an artist or even as a willing model changed his adoration and expectations to hate.

And why was Paul Jr. never a subject of Vincent's painting, even though the artist was constantly looking for new models? We know he wouldn't refuse to sit for Vincent, given that both father and son apparently made numerous requests for Vincent to paint Paul Jr. So why did the artist reject him? Vincent may have recognized early on that Paul Jr. was even stranger than his father. Or maybe he was hanging around too much, being a pest, and interfering with Vincent and Marguerite's *"quiet time together."* This type of social and professional rejection while Paul was only a teenager, and the impact of this obvious rejection in his father's eye, could be meaningful motivation on its own.

Paul Jr. certainly had as much or more opportunity than his father did, too, as Dr. Gachet went to Paris three days each week for his consultations and his regular patients, so Paul Jr. was left in Auvers on his own. Did he ever putter in the garden or around the house, or go fishing or hunting with friends? Did he even have friends, or was he an introvert who preferred to paint at home like his father? Was he really worse than his father? He obviously had knowledge of Vincent's habits from spending so much time around him, so he might have known when Vincent might stop by or where his favorite spots were to set up his easel. This would have made the artist's whereabouts quite easy to anticipate.

Did he also pay very close attention to the interactions and disappearances of his older sister with this amazing but uncouth artist? Did he understand their small talk, body language, and the eyes, whenever they were together or at dinner? Did he follow them when they left the house? Who may he have reported his observations to? He likely told his father or Madame Chevalier, who controlled the information flow in the household that she ran like a matriarchal general.

What Was His Alibi?

Tralbaut, years later, conclusively put Paul Jr. at his family home on the day Vincent was wounded, along with his father and sister (ibid., 1969). In interviews, Paul Jr. said that Vincent seemed *"strange"* that morning and had some *"bad intent."* But neither he nor his father had any alibi. They always seemed to control those conversations by redirecting the discussion back to the *"mad"* artist who committed suicide, without any exploration into a possible alternative death scenario.

Why Would Vincent Accept Total Responsibility for the "*Accident*"?

I would seriously doubt that Vincent would have accepted the blame in order to help either Dr. Gachet or his son. There must have been a higher, more important, and more meaningful motivation, such as protecting the neglected third member of the family, Marguerite. She was already effectively a recluse, on a sad life path of personal loneliness, at almost 21 years of age when Vincent first appeared. She was not courting or on any path headed toward marriage and a family, and they all knew that. She was impassioned by Vincent's art and his intellect. Vincent was her ticket out, and she was exactly what Vincent wanted most in life. The father purposely prevented his daughter from any meaningful social interactions or chances to meet boys, or young men, as none were good enough.

Paul Gachet Jr's Significant Role in This Case

Paul Jr. carried on his father's legacy after his death in 1909 in multiple ways. He became the closely guarded manager of everything Vincent-related in France and would rarely allow anyone to enter his home. No one was generally allowed to observe or photograph his van Gogh art collection, and he rarely gave interviews. He eventually took over his father's role as the leader in the now infamous Gachet art forgery ring, which included a talented copier and watercolorist until it was dismantled in the 1950s. Into the 20th century he also had a distinct track record of distorting facts, downplaying his father's role in the death of Vincent, always trying to uphold the Gachet family name, and perpetuating lies about his family's relationship with Vincent. After his father's death, Paul Jr. wholeheartedly took up the family banner to proclaim his father's pivotal role in launching Vincent's successful career in Auvers. At the same time, he actively minimized his father's (purposeful) negligent role in Vincent's death. He very likely invented a second doctor, Dr. Mazery, to justify his father's inactions and medical negligence, a virtual second, confirmatory and supporting opinion to further misdirect. He became increasingly defensive, such as in his 1926 interview and preface with Doiteau and Leroy. His statements were harder and harder to believe, culminating in his last book, 70 Days in Auvers (Gachet, 1959), that reiterated the same defensive posturing.

Paul Gachet Jr's "*Truth Quotient*"

Paul Gachet Jr's "*truth quotient*" was often in serious doubt. Paul Jr. may also have been involved in destroying a definitive book all about Vincent that his father was working on and had been developing for 20 years. It was ultimately left unfinished upon the doctor's death. The unfinished book is mentioned in several catalogues, such as Cezanne to Van

Gogh: The Collection of Dr. Gachet (Distel and Stein, 1986). They speak of Paul Jr. as doing research after World War I that was: "*...aimed at bringing to fruition Dr. Gachet's great project: a book devoted to Van Gogh, illustrated with watercolors....*"

It is probable that, once the project was left entirely in his hands, Paul Jr. purposely destroyed it. Even though the manuscript certainly once existed, no trace of it survives in the Gachet papers at the Louvre—an intriguing fact, given that Paul Jr. obsessively saved every other piece of paper his father ever wrote on. One must wonder what truths might have been unveiled if the old doctor had been able to complete his book and divulged, in the context of his research, what really happened to Vincent? Or more importantly, what in this magnum opus that the doctor was working on so diligently was so incriminating that his son destroyed his father's many years of effort? He was able to take all their family secrets to his grave. What was in that soon-to-be-published book that frightened him so and needed to be destroyed to preserve his peace of mind?

So, what role did Paul Gachet Jr. play in this murder? Was there direct involvement? Was he a co-conspirator? A cover-up facilitator? A shooter and "*trigger man?*" He did everything he possibly could to paint his father and his role in Vincent's death in the best possible light. He framed himself in interviews as the only living person who knew Vincent so well, and as the only living person who knew the truth of the circumstances of the artist's death. This might be the only true statement that ever emanated from him about Vincent. Was his father's lost 20 years of work that incriminating? How would the truth hurt the value of his large holdings of Vincent's masterpieces? Paul Jr. may have played a significant role in killing Vincent—if not as the shooter or an accomplice, then as an accomplice who spun false stories in the aftermath. It really was very difficult and challenging to believe or trust him about most anything, particularly about Vincent and his family. Remember, the investigative van Gogh reporter, W. Arnold, said "*after extensive searching for some element of truth in all Paul Gachet Jr.'s various statements when I tried to put them together side by side, I gave up, frustrated, and said; In the end, you just can't believe a word the man said*" (Personal Communication, July 2018).

Chapter Eighteen

Why It Was Essential That Vincent Could Never Be Taken Alive To Paris

The one thing everyone seems to be able to agree on is that Dr. Paul-Ferdinand Gachet played a critical role in sealing Vincent's untimely fate. According to Paul Jr.'s later testimony, Dr. Gachet, in conjunction with a "Dr. Mazery," examined Vincent's physical condition and declared that he could not be saved. Adeline Ravoux also witnessed Dr. Gachet perform a cursory exam and declare that "*nothing could be done.*" Even though he and Vincent were supposedly friends, Adeline sensed intense anger between them during the brief time they were together. These bad vibes were evidenced not by harsh words, but by silence, perceived body language, and icy glares exchanged between the two men in the short period of time that Dr. Gachet was actually present at Vincent's bedside. It has been said that Dr. Gachet personified a nervous evil. Dr. Gachet was also supposed to have spent some quiet time with Vincent, behind a closed door, when nothing was heard. Did the good doctor purposely introduce his dirty finger to Vincent's wound to make certain bacterial contamination would kill him?

Dr. Gachet made no effort to seek additional treatment or provide more than just the minimal care to keep Vincent comfortable until he quietly succumbed to his penetrating wound. Perhaps Dr. Gachet, whose specialty was melancholia, thought it best to let Vincent just die? Still, there is no excuse for his failure to seek any additional medical help from outside Auvers. That is unless he was so surprised to see that Vincent made it back to the inn alive, when he expected Vincent to already be dead in the barn, that he remained silent, offered only a dirty finger exam, and offered no life saving efforts of any kind.

Though it was over 100 years ago, medical science was advanced enough that doctors merely one hour away in Paris would have been well-equipped and trained to at least attempt to treat a reported non-fatal penetrating abdominal wound. Common knowledge would suggest that the first treatment of such a wound would be to remove the bullet, if present, stop the bleeding, irrigate the wound to dilute the spread of bacteria, and repair the damage if possible.

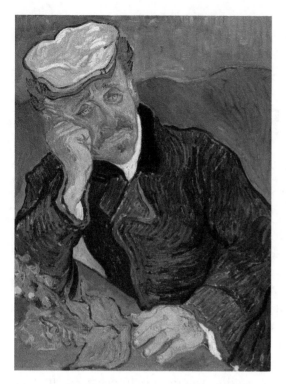

*Fig. 134. Vincent van Gogh, **Portrait of Dr. Gachet**, 1890. Oil on canvas, 67 x 56 cm, Musee d'Orsay, Paris.*

Even if the suspected bullet could not be removed, the wound should have been drained; otherwise, if his bowel was punctured, it would have been leaking bacteria into his abdominal cavity and eventually his bloodstream, causing peritonitis and sepsis. This could have all been done while expeditiously transporting Vincent via buggy to a hospital in Paris. Basic triage—not to mention alerting the hospital and surgeons by urgent telegrams to be ready for Vincent's arrival—was another obvious measure that could have been attempted to save his life. They had plenty of time. In Vincent's case, none of these standard actions were taken. Vincent died about 30 hours after sustaining this wound. This length of time—plus whatever time it took him to get from the crime scene back to the Ravoux Inn—shows that the wound was not immediately fatal and that proper, immediate medical attention might have been life-saving, and possibly significantly changed art history. There must have been a reason behind this apparent oversight or purposeful benign neglect?

Many people in France at that time were deeply religious, and suicide was an unforgivable sin. If, for argument's sake, Vincent had tried to commit suicide, could Gachet really have decided to allow Vincent to just suffer the consequences of his terrible act? This is unlikely given what is known about Gachet's career. As a doctor with a prominent background in mental health care, he had no doubt seen his fair share of suicide attempts from various patients in the past and treated similar wounds. He was a professional first and foremost, not a priest, and could not have justifiably allowed a patient to remain untreated, no matter how the injury seemingly occurred. So why did he not treat Vincent? What happened to the Hippocratic Oath?

Perhaps Dr. Gachet truly believed what he had said, that Vincent was beyond help. Perhaps he saw treatment as a waste of time and thought the pain of an invasive procedure would make Vincent's suffering worse. Paul Jr. alleged years later that the "*bullet*" was not extracted because it was lodged near Vincent's spine and major vessels, rendering it impossible to safely remove. It also made moving him from his bed to Paris perilous, but this allegation was never proven or confirmed by any doctor or outside expert. Realistically, Dr. Gachet had to know that doing nothing was in fact a death sentence for Vincent.

At the same time, Anton Hirschig, another artist staying at the Ravoux Inn, reportedly heard Vincent scream, "*Will someone [please] cut into my belly?*" This gives us evidence that little to no effort was made to treat the wound and, even more importantly, that Vincent wanted help and did not want to die, by suicide or otherwise. It seems odd that such a well-respected doctor would do so little to help his patient and "*friend*," even if the possibility of success were remote. He understood the alternative result of doing nothing was certain death. He surely knew enough from his medical training and military service to remember the basics of penetrating injuries and the likelihood of bacterial contamination from any abdominal wound left untreated, and the need for a proactive plan.

Theo would have come immediately, by horseback if necessary, had he been alerted by telegram. He could have arrived within a couple of hours; one can assume he would have made every possible effort to get Vincent excellent treatment the same night he was injured. Instead, the good doctor curiously waited until the next morning to arrange for Hirschig to contact Theo, which he did by reaching out to him directly at the gallery where he worked. By avoiding contacting Theo right away, who might have been able to aggressively advocate for Vincent's treatment and save his life, the doctor successfully let time, and thus Vincent's life, slip away. Why would his "*friend*" do that? The 12 to 14 hours, out of Vincent's last 30, that passed before Theo got to Auvers could have been the difference between life and death for Vincent. Instead, infection spread in Vincent's body all night until it eventually overcame his systems and killed him.

Dr. Gachet's reluctance to try to save Vincent's life points to a set of disturbing possibilities: that he was responsible for the stabbing or shooting, or he was seeking to protect the perpetrator. If Vincent died in the small town of Auvers, attended to only by Dr. Gachet, it would be so much easier for everyone to accept the cover-up explanation of suicide. This kind of unquestioning and basic acceptance was necessary to promote the false suicide narrative and prevent extensive police investigation.

If he had given Vincent the opportunity to be treated by doctors in Paris, any murder cover-up would have been exposed and much more difficult to pull off. If the Parisian surgeons determined it was a knife wound, that would rule out suicide, and the authorities would be sent in to investigate the attempted murder (or homicide, if Vincent could not be saved). Similarly, if the surgeon determined that it was a gunshot wound, with no evidence of a powder burn around the wound, suicide would have been immediately eliminated that way as well (just as it should be now). Additionally, the surgeon could have tracked the trajectory of the bullet as he removed it, confirming the pathway, and we would have had a written doctors report of the trajectory and maybe avoided an autopsy. The police then would have used this trajectory, the bullet, and the caliber to line up the facts of the shooting and to possibly even identify the killer by tracking down a matching gun in Auvers!

So, either way, knife or gun, Dr. Gachet would do anything and everything possible to prevent Vincent from ever reaching life-saving medical care in Paris while he was

still alive, breathing, and talking. He must have thought Vincent would die where he was knifed or shot and be found dead later, and then he could not tell anyone what happened or who did it! However, the attempt at killing Vincent at the original crime scene did not work, so now Dr. Gachet needed to make sure he died—before Vincent could divulge his secrets and before anyone else could get a good look at the wound. We must assume that Dr. Gachet and his son were surprised when they heard that Vincent had unexpectedly returned to the Ravoux Inn holding his bleeding belly. They thought they had left him for dead at the crime scene.

It appears that this was a "*botched*" attempt at killing Vincent—it was not Vincent who botched a suicide—it was the Gachets who botched their attempted murder. Dr. Gachet and Paul Jr. desperately tried to paint themselves as the good guys in the moments and years following Vincent's death. They continued, with help, to spread the false story of a suicide by claiming that Dr. Gachet dutifully spent the night at Vincent's bedside (an account that, as we now know, has been directly contradicted by Adeline Ravoux).

Some of the most revealing information about Dr. Gachet comes to light in the events following Vincent's death. Though Gachet was seen in attendance at the funeral, apparently distraught and in mourning, Marguerite was notably not present. Why was Marguerite—who had modeled for Vincent for hours, who was important enough to be mentioned by both Vincent and Theo in their letters, who was obviously so affected by the painter's loss that she spent the remainder of her life placing flowers on his grave—not at the funeral? Had she been too distraught to attend, or had she been forbidden to do so by an overbearing father and threatened by a very weird brother?

Even more suspiciously, after the funeral, Dr. Gachet and Paul Jr. were seen mere hours later removing all of Vincent's paintings from the walls and storage spaces at the Ravoux property and hauling them away in a cart. According to inheritance law at the time, those paintings should have been the property of Theo, the closest relative, but the Gachets apparently took advantage of the grieving and distracted family to take possession of a great deal of Vincent's art—which they had no legal claim to—and live off the proceeds of that acquisition for years before finally "*donating*" the family collection to the Louvre.

Considering the obvious "*rift*" between Vincent and the Gachets, Dr. Gachet's broad and possibly deliberate negligence as he "*treated*" Vincent, and the events following the painter's death, it is frighteningly clear that the doctor must be held responsible in some way. Maybe upon first meeting Vincent he was happy to be a supportive figure, giving him advice, providing him with medical treatment and a watchful eye, and even allowing the artist to paint him and his beautiful young daughter. But after watching this man continuously create masterpieces of increasingly high quality almost daily, eventually envy surely started to take root in his mind. Like Salieri's fabled jealousy of Mozart, I believe Dr. Gachet grew to resent Vincent's gifts. How was it that such an incredible talent resided within an "*mad*," unrefined, uncouth man like Vincent van Gogh? Recurring arguments ensued, and I think Vincent, an observant and sensible person deep down, began to see the darkness in his supposed friend.

So, Why Was it Essential That Vincent Could Never Be Taken Alive to Paris?

Clearly Dr. Gachet did everything he could to stall, delay, and lie to prevent Vincent the chance to live, with the incriminating evidence in his belly or on his skin. Dr. Gachet knew enough that an alive, but mortally wounded Vincent could not be seen by an observant doctor, who would clearly know after a few minutes of an exam that this was not a case of suicide, but an attempted murder, whether it was a knife or a gun! Thus, preventing getting Vincent to a surgeon *"to cut on my belly,"* as Vincent screamed. It was essential for the Gachets to keep Vincent in Auvers and tell everyone that *"nothing could be done,"* that it would be *"too dangerous to try to move him [to Paris],"* and wait for him to slowly die an agonizing and painful death. This was all necessary to create the basis for the false suicide narrative, which everyone seemed initially to accept, and Emile Bernard confirmed and disseminated to the entire Parisian art world.

Chapter Nineteen

The Supporting Cast in the Killing Vincent Saga

If Vincent was in fact murdered, did those committing the crime have accomplices, enablers, facilitators, and spinmeisters to help cover it up? In addition to the people who can be considered suspects or persons of interest in this case, there are others whose roles are minor or yet more ambiguous. Why did all the *"witnesses"* who eventually admitted to knowing details about Vincent's death say nothing until asked years later? Was there a team helping the Gachets carry out a crime and orchestrate a cover-up? I think they needed one or more accomplice, with a cover-up story and an alibi, to prevent the truth from being known right away. They could have relied on the help of the same band of criminal associates who helped them perpetuate a variety of other crimes and forgeries over the years.

Dr. Gachet and Paul Jr. stood at the center of an elaborate circle of art forgers and fraudsters within their own home. Dr. Gachet seems to be at the core of every question and controversy related to Vincent's mysterious death, yet he was not accused by anyone of any crime against Vincent until many years later. He was not even seriously questioned about any possible involvement. How did he manage to avoid any real scrutiny or culpability? Who could have helped him in such a complicated cover-up? Who helped him and his son with their other crimes? Unfortunately, we will never know exactly who took part, since none of the participants ever faced any consequences, accountability, or serious questioning.

Since so many of Vincent's paintings were in the hands of the Gachets after the artist's death, the Gachets were able to live off of their holdings by selling the occasional painting and using the ones they had as references to practice against and create fakes. This can certainly fit in with the *"follow the money"* concept of potential guilt. Their forgeries were unparalleled, since the Gachets had unique, up-close access to a massive number of Vincent's works—his brushstrokes, topics, locations, and their general appearances. No art forgers before or since have had such a distinct and longstanding opportunity to practice their illegal craft using previously unknown works by Vincent. Paul Jr. also used

the trove of Vincent's paintings as leverage as he controlled his sister's life. He sold her favorite Vincent painting of her at the piano at auction in 1934, and he later "*donated*" the remainder of the priceless Gachet art collection to the French government in the 1950s.

Team Gachet's Co-Conspirators

Now, allow me to properly introduce you to the amazing cast of characters who may have helped pull off this extensive myth-creating and complicated cover-up from the day Vincent was wounded. We will also look at those who witnessed or were otherwise possibly involved in Vincent's death, with attention to how they avoided the realm of suspicion.

Madame Louise Chevalier

*Fig. 135. **Madame Louise Chevalier***

Dr. Gachet's long-term housekeeper, Mme Louise Chevalier, was also thought to be the doctor's mistress in Paris. She began living with the doctor when he moved his family to Auvers-sur-Oise after his wife died of consumption. Recently some fascinating information came to light that suggests they had an illegitimate daughter, Louise-Josephine, who lived with them in secret (Richman, 2006). Mme Chevalier was thought to have run the doctor's household and his life with an iron fist, effectively as his "*wife*" and life partner, and she certainly was knowledgeable about everything going on in his home. If the good doctor and his son did murder Vincent, it is highly likely she knew all about it and would be considered at least an accessory to murder, if not an accomplice.

It is safe to say that she did not particularly like Vincent, as he was quite a disruptive force in the otherwise quiet, sedate, and simple—albeit seriously dysfunctional—household. Did she help craft a plot to kill Vincent, or did she just look the other way? It would be highly unlikely that she knew nothing. She was thought to be involved in the disinformation campaign and alibis that took place immediately after Vincent's death and over the years. Did she also help Paul Jr. continue to "*whitewash*" and build up his father's image long after the doctor's death?

Louise-Josephine Chevalier (Gachet):
The Illegitimate Daughter

Stories say that a young woman named Louise-Josephine Chevalier was the illegitimate daughter of Mme Louise Chevalier and Dr. Paul-Ferdinand Gachet. Louise-Josephine was conceived prior to their *"working"* relationship—born while the doctor was first married and lived in Paris with his wife. Louise-Josephine would have preceded Gachet's two younger children, Marguerite and Paul, in the family lineage. Common law would suggest that she was, in effect, Marguerite and Paul's half-sister. Dr. Gachet wrote a letter to support that she was not born out of wedlock so that she could later marry, but he did not sign the birth certificate as her biological father, and only referenced himself as a guardian or similar. This is backed up by a birth certificate and other signed documents attesting to her existence and lineage (Richman, p. 302-303, 2006).

Alyson Richman's book, *The Last van Gogh*, while primarily an intriguing work of historical romantic fiction, is backed up with some serious, focused, and diligent on-site investigations and insightful connections with old residents in Auvers. A search of old records, including the birth certificate, confirmed the basis of some of the stories. Richman's book suggests that Louise-Josephine existed, lived with the Gachets in secret, and acted as the full-time housekeeper who snuck around in the shadows as the scullery maid and had the run of the house, except when guests were present. This was Louise-Josephine's existence from the ages of 14 to 23 (*ibid.*). If this creeping, phantom figure of Louise-Josephine is true, then she would have been privy to much of what was going on in this very dysfunctional house, while both she and her mother lived in her biological father's house. She would have lived a very reclusive, servant-like existence; truly a Cinderella-like figure, living in the confines of the Gachet property as if in prison or under house arrest, in a sad, sadistic state of servitude. But she would have always been present, and maybe have seen Vincent, or at least certainly heard him. She was an observer—a listener from Vincent's arrival to the upheavals of his death. She really was the proverbial *"fly on the wall."* Did she report and discuss everything with her mother? With Marguerite? What were their interactions like when it was only the women? Was Louise-Josephine also Marguerite's confidant and a shoulder for her to shed all her travails? What really was her relationship with Marguerite like? Sisters, best friends? Was Louise-Josephine jealous of Marguerite, her life, her new found love with Vincent?

It is unlikely that Louise-Josephine, if she existed, was a co-conspirator or involved as an accessory, but she definitely would have known what was going on in that house. Did she hear all the arguments, the planning, and the plotting? Was she at all involved in killing Vincent? Was she the one who alerted Marguerite about the plan to end the Vincent threat to protect their family honor and stability? Due to her living with the Gachets secretly, Vincent would never have seen her, but she could not have been completely excluded from all awareness of whatever nefarious and criminal activities went on around her. She would necessarily have been aware of any plans to harm

Vincent by virtue of her proximity to her father the doctor and the duty of keeping her mother's trust, even if she was not actively complicit. It is quite certain that she could not say anything to anyone outside this weird household without destroying her own life and her mother's. In a house full of people who were varying degrees of wicked, evil, depressed, and mentally unstable sociopaths, she may have been the sanest, most normal one in the group. It is too bad she did not keep a diary. Did she learn to paint? Was she also helpful in the early years of the art forgery ring? Eventually, at age 23, she escaped the Gachet's clutches, leaving poor and depressed Marguerite truly alone to make it on her own without her friend and confidant.

The Witnesses

The following witnesses were not involved in Vincent's murder itself, nor did they directly see it occur, but they were all on site at the Ravoux Inn for Vincent's arrival (wounded), the bedside vigil, and/or the funeral service and burial. Their stories cover the critical period from when Vincent returned to the Ravoux Inn with his fatal belly wound until his burial and afterward. None of these witnesses spoke up with their stories until many years after Vincent's death, because no in-depth police investigation was made at the time. Dr. Gachet had told everyone, as if gospel, that Vincent had committed suicide, and everyone, including the police, bought this well-planned and well-executed cover-up story. The stories of these witnesses at Vincent's bedside only became of interest once the artist's popularity exploded in the early 1900s, and it reached its first peak around the time of his worldwide 100th birthday celebration, when journalists started looking for anyone who knew the artist.

Anton Hirschig

One person who had a front-row seat to this mysterious death was Anton Hirschig. He has already been introduced as the other Dutch painter who was staying at the Ravoux Inn, in the garret room adjacent to Vincent's (Figures 136-138). He heard and saw much of the post-wounding events unfold and was a direct ear-witness to several important aspects of Vincent's death. Many years afterward, he decided to share his remembrances from the night that Vincent was mortally wounded, before Theo arrived. As we know, Hirschig was the person dispatched to Paris on the morning of July 28 to deliver the bad news to Theo and bring him back to Auvers quickly. He was also dispatched to the next village to borrow their hearse for the funeral, when the church in Auvers denied Vincent the use of theirs because of the sin of suicide.

Hirschig had occasionally painted alongside Vincent in the back room at the inn in their "*art studio*" they shared. He famously heard Vincent that first night scream in

great distress, sounding very unlike anyone wanting to die as he loudly exclaimed, "*Is not there anyone cutting my stomach*" (*Der Spiegel*, 1990). Hirschig is an interesting eye- and ear-witness to what was really going on at the inn that night and in the following days leading up to the funeral.

*Figs. 136-138. This is the **room across the hallway from Vincent's room**, where Anton Hirschig, a Dutch artist, heard Vincent scream and plead for help. *Note his bed and Vincent's were probably the same style. The skylight window (138) indicates his room faces the opposite direction, with a skylight facing the street. Photos by author, 1990.*

Adeline Ravoux

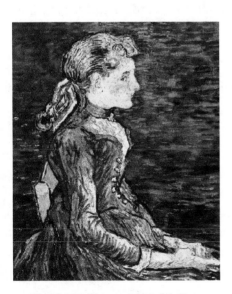

*Fig. 139. **Portrait of Adeline Ravoux**, Vincent van Gogh, 1890, Oil on canvas, 67 x 55 cm, Private Collection*

Adeline was the most effective and believable eyewitness to what transpired in her family's hotel after Vincent was wounded, and she is the person best able to dispute and overturn the suicide narrative created and maliciously spread by the Gachets. She was the only living eyewitness to what actually transpired that evening and the ensuing critical days. She had no special interest in this cold case after so many years. She was searched out and interviewed because she was there, and she was believed to have valuable first-person knowledge. Adeline did not come forth and volunteer to be interviewed and only spoke out when she was specifically asked, and when she felt that the truth about Vincent's death needed to be known.

Though she was just a teenager, Adeline witnessed everything that happened when Vincent returned,

injured, to the Ravoux Inn—his two nights slowly dying, the deathbed vigil, the funeral, and the posthumous fate of Vincent's artworks. She was also apparently privy to the town gossip that Marguerite was "*compromised*" and offered that as an explanation for why the Gachets helped themselves to so much of Vincent's art.

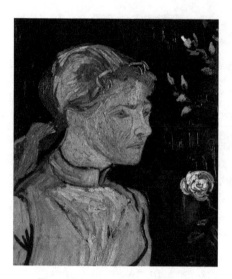

Fig. 140. Vincent van Gogh, Portrait of Adeline Ravoux, 1890. Oil on canvas, 52 x 52 cm, Museum of Art, Cleveland, Ohio.

All of her observations are a critical counterpoint to our understanding of the other side of the questionable and false Gachet suicide cover-up story. Although she only offered up her remembrances about 60 years after the fact, and only as requested in an interview, she was single-handedly able to challenge the myth that had long been entrenched in public awareness of Vincent's death, created and perpetuated by the Gachets. She didn't even get any acknowledgment for her several portraits painted by Vincent until she was identified and accepted as "*The Lady in Blue*" at the time of these interviews. She only spoke out about what she had witnessed at that terrible time to a journalist, M. Gauthier, and her interviews were published (in 1953) as an eyewitness source for the events as they unfolded. She was the best possible surviving eyewitness in the 1950s to shed light on this cold case, so buried in the cover-up of a false suicide narrative. She also wrote her story to the town of Auvers, so that it was in her own words. Did she get some coaching in these follow-up clarifications? If not, why did she speak out and change some aspects of her remembrances if not coached or coerced?

Gustave and Louise Ravoux, Adeline's Parents

Gustave Ravoux and his wife, Louise, managed the local inn bearing their name, and from them Vincent rented his small, inexpensive attic living space. They are not suspects in any crime but are key characters with a fact witness role in this story. The Ravouxes and their two daughters—teenage Adeline, who helped run the inn, and young Germaine—were not especially close with Vincent, but it seems he was a favored customer of theirs. Even though Vincent was just a poor, eccentric painter renting a small single room, he was given special consideration and services, such as an extra space to store his completed paintings. Perhaps the Ravouxes were pleased that Vincent chose to paint Adeline's portrait on more than one occasion. Perhaps they enjoyed some benefit from having Vincent occasionally paint in and around their establishment, helping to further establish Auvers-sur-Oise as an artist colony and their inn as its epicenter.

Aside from the Gachet family, who Vincent was known to visit frequently, the Ravoux family must have known the most about his life in Auvers. They all were in a unique position to receive his mail and packages, see him eat, drink and dine, and be aware of his daily comings and goings. However, aside from playing the role of landlord, the parents were not otherwise connected to Vincent in any personal manner; they were thus in the unique position of having insight into Vincent's life without being overly invested in him in any other way then as a paying guest and as fact witnesses. The neutral nature of this overall relationship is what bolsters my impression that Adeline was the strongest living fact witness to the events that transpired between Vincent's wounding and his death. Most notably, I also believe her story that Gustave was the one who stayed at Vincent's bedside that first evening, not Dr. Gachet, his son, or some other imaginary doctor "Mazery." Adeline, also quite emphatically clarified that first, Dr. Mazery was never present at Vincent's deathbed that night; second, neither Dr. Gachet nor his son, Paul Jr. remained at Vincent's bedside overnight. These new facts further alter that false narrative that the Gachets tried to present to the world, and show to all that the supposed veracity and integrity of the Gachets ought to be questioned now, if not dismissed.

There are also, of course, rumors that Gustave Ravoux's gun was the one Vincent used to allegedly shoot himself. However, Adeline first attested that he had sold it some time before Vincent's death. Since her story in general appears credible, Adeline's statement should render this suggestion moot, even if she was unable to provide details about who the gun was passed on to and where it might be. Her recollections are admittedly sketchy over the course of several interviews over the many years, and in her final interview she changed the story, saying that it was her father's gun after all (Ravoux, 1956). Why did she change this story? Was it due to aging or forgetfulness, or was she "*coached*" or coerced to change her story?

The Cover-Up Facilitators

As part of any criminal cover-up, in 1890 or now, it is essential for the perpetrators and any persons of interest to have a believable alibi, as well as someone else who is set up to take the fall instead. Who else was critical in helping the Gachets promote the story of Vincent's suicide and their lie that nothing else could be done to save him, due to the bullet's location in Vincent's body? Enter now the people who helped provide an alibi, deflect the truth...the behind the scenes cover-up facilitators who helped take attention away from the real perpetrators. Who were the "*fall guys*" and "*patsies?*"

Dr. Jean Mazery: The First Patsy

The character of Dr. Jean Mazery was an essential tool, construct, or "*patsy*" in the Gachets' cover-up. His "*medical opinion*" was necessary to provide a corroborating,

confirmative second medical opinion needed to help support Dr. Gachet's decision not to seek further and better treatment for Vincent in Paris at all costs. It was critical to create Dr. Mazery. Who better to substantiate Dr. Gachet's warped description of Vincent's ultimately fatal wound than another doctor?

Dr. Jean Mazery was supposedly born on the island of Mauritius, a former French colony in the middle of the Indian Ocean. He went to medical school in Paris. According to Paul Gachet Jr. in his Doiteau and Leroy interview in 1926, Dr. Mazery was present at Vincent's deathbed. Whether "Dr. Mazery's" second description of the wound was confabulated by Paul Jr. is questioned and of great concern; I put "Dr. Mazery" in quotes as I believe his presence at Vincent's deathbed, according to Adeline Ravoux's statements, to be dubious. If that is correct, then the only details of Vincent's wound come from Paul Jr., and what he remembers possibly seeing and hearing, or what he was told by his father, the good doctor Gachet. Yet this unknown "*patsy*" was essential to the Gachet's cover-up story to take the focus and sole blame away from Dr. Gachet's negligence and guilt.

To further compound the truths or falsehoods surrounding the mysterious Dr. Mazery character, let's explore where he really was at the time of Vincent's death. One must further question and scrutinize his whereabouts and residence, since he was alleged to be:

1. The local doctor down the road between Auvers-sur-Oise and Pontoise.
2. A resident of Auvers who lived in Daubigny's beautiful old home and gardens facing the train station.
3. An obstetrics doctor from Paris (with a known Paris address), possibly vacationing in Auvers, who may not have even been in Auvers on the day Vincent was mortally wounded.

Paul Jr. stated to his interviewers (Doiteau, 1928) on March 27, 1926: "*We're trying to bring a madman back to life!*" This is something he most likely heard his father say at Vincent's deathbed. That sounds like something Dr. Frankenstein would say to Igor in *Young Frankenstein* when he found out Igor brought him "*Abby Normal's*" brain to implant into the monster (Mel Brooks, 1974). Was this the attitude of a good doctor following the Hippocratic Oath, or of one following transparent disdain and obvious dislike for Vincent?

Paul also discussed where his second description of the wound came from, and this was put into question by Adeline Ravoux when she claimed Dr. Mazery's presence at Vincent's bedside was a fabrication (1953, 1956). Apparently, both wound descriptions that were provided by Paul were ascribed to his father, Dr. Gachet. There are no written records or drawings that have survived, if they ever existed. Importantly, when Paul Jr. told his stories and interview to Doiteau and Leroy in 1926, both his father and Dr. Jean Mazery had both been dead for many years. If there was not actually any other doctor present to provide a real second opinion (as Adeline clearly stated there was not), then the Gachets needed to invent one to share the blame and take the heat off Dr. Gachet's negligence.

Ascribing the only extant description of Vincent's wound to "Dr. Mazery" and his father when both were already dead was a clever way of planting *"facts"*—no one could ever be questioned about them! Even better for the Gachets, and for the false narrative and legend they created, was that Paul Jr.'s interview with Doiteau and Leroy was accepted as fact and published in 1928 in *La Folie*. This myth was *"written in stone"* without any contemporaneous fact checking, when residents in Auvers may still have been available and able to give their remembrances. Paul Jr. had no choice but to invent that "Dr. Mazery" was there to corroborate his father's decision. Either way, "Mazery" was used as a scapegoat after he had died and was no longer able to tell his own version of events, which, as it were, would have been difficult if he was not ever present at Vincent's deathbed. Dr. Mazery was essential to cover up that Dr. Gachet obviously allowed poor Vincent to die without any attempt to give him the available, state-of-the-art surgery in Paris. It was critical to create "Dr. Mazery" to be the second opinion doctor and corroborate that he and Dr. Gachet discussed the case and concluded together that nothing could be done, except let Vincent die peacefully (and painfully) in his bed.

Even if Vincent really did shoot himself and *"all"* Dr. Gachet did was let him die with no intervening medical care, such negligence would still render Dr. Gachet responsible. Thus, regardless of whether one of the Gachet men themselves pulled the trigger, the creation of "Dr. Mazery" was essential to shield them both from culpability of not taking him forthwith to Paris for possibly life-saving treatment.

René and Gaston Secrétan: The Other Patsies

The Secrétan brothers were scapegoats used to deflect attention away from the Gachets at the time of the family's donation of their art collection to the Musée du Louvre. Attention was focused instead on the rusted gun that had just been (conveniently and serendipitously) found in the field in Auvers (Bakker, 2016), as well as René's timely interview claiming Vincent shot himself with René's gun that Vincent had *"stolen from his hunting bag"* (Doiteau, 1956). Even though Artaud (1948) and others proposed that Dr. Gachet was Vincent's murderer, these hypotheses were redirected and overshadowed with the suggestion of a suicide using René's gun. This lasted until just a few years ago, when Steven Naifeh and Dr. Vincent Di Maio showed that it was forensically and logistically impossible for Vincent to have self-inflicted his mortal wound. The Secrétans were very effective patsies for decades, until the truth was exposed, and suicide was deemed not possible or probable (*ibid.*).

Emile Bernard: The Conspiracy Spreader

Emile Bernard, an artist and friend of Vincent's as well as the Gachets, was a critical witness in the sense that he absorbed the many false stories about Vincent's suicide that he was told right before the funeral by Dr. Gachet.

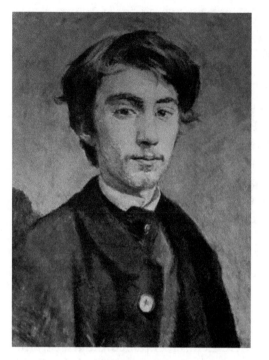

Fig. 141. Toulouse Lautrec, **Emile Bernard***, 1868-1941. Circa 1880.*

His role was to spread this false story to all his friends in the Paris art world, initially with the famous letter to the art critic Aurier (1890). The Gachets chose well, since Bernard was a known storyteller and embellisher who quickly pushed out the narrative to the *"media"* and all the artist's friends. He was also a known friend of Vincent, which made him seem more believable when he trumpeted the tale of his suicide to anyone who would listen. The truthfulness of his story was not questioned, making it easy for the Gachets' false suicide narrative to quickly become the dominant public story until recently (Naifeh, 2011).

How well did the murderers and their co-conspirators cover up the facts and details of this legendary homicide called a suicide? For years the truth that was known to multiple witnesses was completely overshadowed and ignored by effective and aggressive spreading of misinformation, and guilt was shunted from the perpetrators to the patsies. Was Dr. Gachet's medical negligence an unlikely act of kindness, as his associates would have you believe? More likely, it was a grand finale for Team Gachet, who all benefited from Vincent's *"suicide."* It gave them a trove of art to sell and copy, as well as a major, mythical, newsworthy story that would increase the value of Vincent's art and distract any would-be investigators from catching on to their lucrative forgery ring and other nefarious activities. Was this all posturing and spin to misdirect the townsfolk, the police, other artists, and now you away from the truth and scope of the crime? Now, I hope you see through it all and can understand the astounding web of deceit, conspiracy, and cover-up at the core of Vincent's murder.

Part V

What Questions Remain Unanswered, and What's New?

Chapter Twenty

Which Canvas Was Truly Vincent's "*Last Painting*"?

One important question that remains unanswered is, does Vincent's last canvas—one painted by his own hand on the day he was mortally injured—exist? Can it be confirmed without question? No one really knows, hence the ongoing, rampant speculation about which canvas it might be. It would of course also be helpful if a last painting could be confirmed, to guide us to the location where Vincent might have been painting when he was wounded. I have explored all the possible and likely crime scenes in Chapter 10. What is not known for certain is whether he painted that day, or if he left all his paints, easel, supplies, and canvases at the Ravoux Inn because he had a much more important challenge to face that key day, namely meeting with the Gachets to request Marguerite's hand in marriage. It now seems likely that Vincent was not painting anywhere at all on the day he was wounded and did not even have his art gear with him.

The Missing Art Supplies

First, before trying to find that elusive last painting, we need an answer to what happened to Vincent's missing art gear. The artist (Vincent) on his way to work in Figure 142 is carrying lots of equipment. There is really a lot of "*art stuff*" to carry around. If he had all of that paraphernalia with him that day, why was it so difficult to find his big pile of art supplies after he was wounded? The reports say that the police searched diligently, not only for the gun but also for all his missing art equipment. His

*Fig. 142. Vincent van Gogh, **The Painter on His Way to Work**, 1888. Oil on Canvas, 48 x 44 cm. Original work was destroyed in fire and currently resides in a landfill.*

art equipment should have been much easier to find than the gun, but neither was found during that police search the next day.

More interesting yet, and otherwise inexplicable, is how all of Vincent's missing art supplies miraculously appeared surrounding him at his funeral. Nobody claimed to have found it, yet there it was. All was there except for a wet "*last canvas.*" The easiest explanation is that all his art paraphernalia never left the Ravoux Inn that day, and there never was a last canvas painted on July 27, 1890. Nonetheless, many other locations and theories about his last painting will surely continue to resurface from time to time from many experts. It will be intriguing to see if any credible explanation ever surfaces as to how all of Vincent's art supplies, but no last canvas, happened to materialize at his side at his funeral, when no one could find it after days of searching.

This would explain why—if he left for a meeting at the Gachet residence as both Gachet children later confirmed (Tralbaut, 1969)—Vincent did not return to the Ravoux Inn in the evening with his art supplies, easel, and canvases, but only with an unexplained penetrating injury into his belly. He did not return with any last canvas either! The only reasonable answer to this ongoing conundrum is that he just never removed any of his art supplies that day from his room at the Ravoux Inn, as he had no plans to paint—at least, not until after his marriage proposal at the Gachets' house was accepted by all parties.

No one that day described him as having his supplies in tow. The simple explanation for the "*mysterious*" reappearance of the art gear at Vincent's side at his funeral is that someone merely had to gather them up from Vincent's room, the studio storage room, and the inn's shed and place them around him as was described by Emile Bernard.

His most recent art appeared nailed to the walls surrounding his casket. Bernard described some canvases he helped hang that day as still "*wet*" (Tralbaut, p. 330, 1969). Thus, the simplest explanation is that his art paraphernalia had never left the premises of the Ravoux Inn on July 27, 1890. It is too bad Bernard did not name the wet canvas(es). That would help narrow down the fields of "*last canvas.*"

Does a Last Painting Exist?

I think that the last painting Vincent made by his own hand and brush was completed the day before his wounding, or even earlier. Unfortunately, this means that such a painting would offer no useful information as to where he was or who he was with the day of that fatal injury. We know that the Gachets hauled away many of Vincent's paintings after his funeral, which creates a high probability that they also claimed ownership, by possession, of the artist's last work. Therefore, some canvas in the fabled Gachet collection, donated to the Musée du Louvre around 1950, may have contained Vincent's

last painting. I think that collection should be reviewed, and the first owner provenance verified, with that goal of clarification in mind. Someone should see if the documented provenance of any one of them might be Vincent's last canvas and could be traced back to Dr. Gachet's collection that he stole in August 1890.

Alternatively, the last canvas started by Vincent's hand could have been finished by Dr. Gachet and also included among his many paintings, then later "*donated*" to the Louvre. The Gachets and their accomplices (who might have helped cover for them when killing Vincent) were certainly capable of fooling some art experts for a while as they had more "*unknown*" and "*virginal*" originals by Vincent to practice copying, comparing to, and trying to learn from in watercolors, pastels, and oils.

Tralbaut said the "*last paintings provide no more satisfactory explanation of the motives [or the timing] for Vincent's suicide than his letters do*" (*ibid.*, p. 327, 1969).

Was Wheatfield With Crows Both The Last Canvas and a Suicide Note?

Interestingly, *Wheatfield With Crows* (Figure 75, Chapter 10) long held the coveted spot as Vincent's last painting and was thought for many years to have a suicide note expressed in the canvas itself. It is clear now that the art experts cannot readily agree on which painting is conclusively the last one Vincent touched by his own hand. Some have suggested that this painting—because of a psychological interpretation of its content, meaning, and Vincent's intent—was really his suicide note in art form. *Wheatfield With Crows* was only one of multiple works thought to be Vincent's last painting, and it became the object of an elaborate evaluation of how the subject matter and its treatment indicate that he was obviously sad and depressed enough to commit suicide. Unfortunately, all this deep psychological guesswork is now considered inaccurate by subsequent art historians, and so the speculations continue unabated.

Jan Hulsker, an eminent art researcher and expert in Vincent's art and correspondence, dated *Wheatfield With Crows* to several weeks prior to the artist's deadly wound (1977, 1990). Hulsker also concluded that the "*note*" (the potential suicide note) found in Vincent's pocket was only a draft of a somber note he rewrote, a more mellow version, and then mailed to Theo before the events of July 27 (*ibid.*).

Interestingly, Mattathias Arnold, in his Der Spiegel interview (1990), suggested another candidate for Vincent's last canvas:

> "*The picture with the black birds* [Figure 75, Chapter 10] *hangs in the Van Gogh Museum and is rightly famous. But it is by no means the last—at least*

because the artist painted a later state of that field later. So much more could the Grain Sheaves [Figure 143] be his final tableau."

—*(ibid.*, 1990)

*Fig. 143. Vincent van Gogh, **Sheaves of Wheat**, 1890. Oil on canvas, 50.5 x 101 cm, Dallas Museum of Art, The Wendy and Emery Reves Collection.*

Arnold further stated how confusing that last painting was:

"Again, the fairy tale of the 'Crows over the Cornfield' emerging as the last image cannot be correct, no matter whether Gachet or Gotsch got lost [confused] in the late rendition."

—*(Der Spiegel*, 1990)

In addition, one of the earliest van Gogh scholars (La Faille 1929, 1970) claimed that a different painting in the fields was Vincent's last painting, but that painting was delisted and is no longer attributed to the hand of Vincent. It may have been an early forgery from the Gachet art forgery ring.

It is interesting that when I was in Tokyo in 1985 as a visiting professor, there happened to be a van Gogh exhibit in one of the city's museums; of course, it was an unexpected treat, and so I went. In the catalogue (S. Mayekawa, Vincent Van Gogh Exhibition, National Museum of Western Art, Tokyo, 1985), the curator stated that Vincent's last painting was a self-portrait (Figure 144) painted in Arles in 1889. This is another entry in the controversy over Vincent's last painting. The

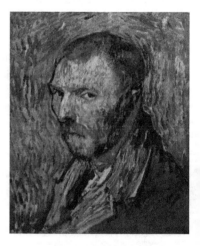

*Fig. 144. Vincent van Gogh, **Vincent van Gogh Self Portrait**, 1889. 55.5 x 45 cm, National Gallery, Oslo, Norway.*

catalogue says that the self-portrait "*depicts Van Gogh in his last days*" (*ibid.*). However, this attribution is not correct and may be an error in the English translation—or, more likely, the curator was pointing out that this self-portrait may have been the last self-portrait that Vincent made, as it may have followed the more famous Portrait of the Artist at the Musée d'Orsay. Thus, it might have been his last self-portrait but not his last painting. However, Mayekawa describes van Gogh's self-portraits as a total of 37 paintings. Interestingly he includes one self-portrait from the Arles period as being from the Auvers period (Figure 144). This is curious given that the author then concluded based on Vincent's letters that, "*There is no reference to him painting a self-portrait during his stay there [Auvers].*" This just shows how many "*last paintings*" have been incorrectly identified, ever since *Wheatfield with Crows* was presumed (and disproved) to be a suicide note on a canvas.

Was Tree Roots Vincent's Last Painting?

What is the provenance of *Tree Roots* (Figure 86, Chapter 10) which was already discussed at length in Chapter 10? Was it ever in the Gachet collection? If it ever was, then how did the Gachets obtain it, if it really was Vincent's last painting? Did they take it, along with his other painting materials, from the crime scene and return his art equipment to his funeral memorial but keep this wet painting? Was "*tree roots*" really the crime scene? If the provenance can be traced back to its origins in the Gachet collection, then that would arguably put the Gachets at the crime scene at the Oise river, maybe even off fishing as per their first alibi. Therefore, the only persons of interest according to this *Tree Roots* theory would be Dr. Gachet and Paul Jr.

The Other, Most Likely Possibility

It may be that no "*last*" canvas is ever definitively identified, accepted by the art history community, or proven with any accepted documentation. We might never know what canvas or canvases Vincent was working on July 27, 1890, if any at all. Perhaps he was working on more than one canvas and took several outside on that fateful day, planning to finish them "*en plein air*" instead of finishing himself off. Or, maybe his last canvas was destroyed. For all we know, it had a bullet hole in it, or knife slashes.

While the whereabouts of his art supplies in the days between the wounding and the funeral constitute another big mystery, it may be that the truth was under everyone's noses all along. In this case, the supplies were probably right where Vincent had left them the day before, in his room and storage area in the Ravoux Inn. Dr. Gachet, Anton Hirschig, Theo, Emile Bernard, and possibly Gustave Ravoux all tried to help make their last viewing of Vincent like he would have wanted it, as Emile Bernard alluded to in his letter to Aurier. They may have all tried to help retrieve his canvases,

easel, paints, and brushes from his room, work area, and shared studio and placed it all around him at his funeral viewing. They could not place the key wet "*last canvas*" at his side, as none was ever painted on July 27, 1890.

Alternatively, if we ever find out that Vincent's art supplies and/or a canvas were found outside the Ravoux Inn, that would reliably help pinpoint where the murder likely occurred. Whoever took his palette and easel, and then made them magically appear at Vincent's side for the funeral, may have been the murderer and would top the list for a person of interest. Dr. Gachet, for one, tried diligently to copy Vincent's painting style— what if he finally had a chance to finish one or more of Vincent's canvases as his own, or later sign it "Vincent"? Remember, many of Vincent's works were held by the Gachets and were unknown in the art world until their major donations. Paul Jr. was very secretive and would not let experts view or photograph his collection. Was he worried that they would spot the obvious forgeries? Apparently, it took curators, van Gogh experts, and restorers a long time—after 60 years—to sort out which canvases were really done by Vincent's hand and which were copies by Gachet and his team of forgers! (Tromp, 2010). Vincent's last painting could have been finished by Gachet and hidden in plain sight all along.

Keep it Simple!

I think—simply put—that there really was no mythical "*last canvas*" that Vincent painted on the day he was fatally injured. This conclusion would solve the nagging mystery of what happened to all his art supplies, easel, brushes, paints, and other equipment. Vincent never took any of it with him on that last day. They were at the Ravoux Inn all along. Vincent did not paint on the day he was mortally wounded. This theory alters the story of Vincent's last days and renders a longstanding art-world mystery largely irrelevant to the case of the artist's murder.

Learning the existence and whereabouts of Vincent's last canvas might help us solve another piece of the mystery. Can art historians ever come to a consensus about which canvas was last touched by Vincent's hand? If so, what day was it painted—the day he was wounded, or earlier? Could Vincent's correspondence somehow hold the key to his last painting? Maybe the people who control all of his letters know the answer. Many believe there are still many secrets retained in the unpublished and missing or lost letters, and the confirmation of the "*last canvas*" could be one of those secrets. While one painting must by default be the last one that Vincent painted, I believe that what scholars seek—the legendary, all-important last painting that Vincent was painting the day he was mortally injured—frankly does not exist.

Chapter Twenty-One

Are The Last Letters Between The Brothers Missing?

At least 25 years ago—it is not clear exactly when—a Munich-based art historian and van Gogh research enthusiast named Matthias Arnold was rummaging through archived files in the study room of the Van Gogh Museum in Amsterdam. He quite unexpectedly found a photograph of a previously unknown letter from Theo van Gogh to Vincent. This miraculous find, a letter now named T41a, has caused quite an uproar in the art history world, and in archivists' offices, as well as in the halls of the Van Gogh Museum.

T41a is the first half of the *"final"* exchange of correspondence between Theo and Vincent prior to Vincent's death. Still missing is the reply, if there was one—the last letter from Vincent to Theo. A most significant and missing piece of this mystery. The details of T41a, and all the related stories it opens up and the rabbit holes one can now fall into, are very intriguing. Various aspects of the letter were explored in some depth in an article in *Der Spiegel* in 1990.

However, much about this letter still remains a mystery. Even though it was discovered by M. Arnold, the 1990 article is listed under an editor's byline (Jürgen Hohmeyer), and Arnold is listed only as being *"interviewed"* for the text by Hohmeyer. The Der Spiegel article discussing Arnold and the significance of T41a is difficult to read and translate, and there is no specifically listed author. The editor apparently conflated an interview with Arnold with his general observations all about Vincent and Theo and how he got greater overall insight into all the key players in the life and death of Vincent. It is challenging to separate M. Arnold and his editor, as to who is saying what.

The article presents Arnold's perspectives and interpretations of prior information through the lens of his interview with the editor. Even through this filter, it is apparent that Arnold's report has much new information, and his interpretive insights are important to understanding the background and circumstances related to Vincent's mysterious death. I offer you all this *"new"* information and additional insight for you to further connect the *"dots"* and reach your own conclusions.

231

Arnold extensively discusses and interprets the contents of this letter in the interview, but the letter itself is unfortunately not available to us—the original was never found, nor has the photograph of it resurfaced since Arnold's original discovery—and its details are in dispute. Apparently, the interview is based on the handwritten notes M. Arnold made in the archives. Might *Der Spiegel* have a copy of this letter or the photograph in their files? Where is the original? Is it marked "*TOP SECRET*" in the vaults of the museum?

The lack of information makes this chapter a challenging effort, as I can only bring to light the thoughts and observations of Arnold as he told them to his editor in that interview in 1990. Matthias Arnold has some unexpected and worthwhile comments, such as his many interesting and different observations about Vincent, Theo, Dr. Paul-Ferdinand Gachet, Paul Gachet Jr., Marguerite Gachet, Adeline Ravoux, Madame Liberge, Madame Baize, and even Paul Gauguin. He really covered all the characters in the Vincent saga and shared his own thoughts, interpretations, and new insights. Moreover, he is the only one to have read the letter and share his research notes, along with his understanding of this letter. An amazing discovery which was brought to the public in such an unusual format, without a copy of the letter itself. Somehow this method and approach feels uncomfortable and not complete. What are we missing...or what is still being withheld from Vincent's adoring public?

This *Der Spiegel* article published in 1990 primarily focuses on Matthias Arnold's findings, interpretations, and his personal rambling. Maybe the editor preferred the article to be in an interview format without cohesive editing. This interview format and analysis of his newly found and publicly introduced "*missing*" letter T41a, was a challenge to follow. This article is extensively studied and analyzed in this chapter because of the new and alternative information it presents. Therefore, I have put forth his various statements for you to consider. Please note that for simplicity, I will henceforth refer to this article as reference "*(DS 1990)*" or just "*(ibid.)*" as appropriate.

Whatever happened to M. Arnold? Did he discover something that no one was meant to find? Several investigative journalists are now hot on his trail, as well as the editor's, to probe more deeply into their findings and interpretations, particularly in light of present day controversies (*ibid.*). Is this another mystery yet to be solved? I suspect that, rather than the article being untrue, it contains truths and unanswered questions that the Van Gogh Museum—the guardians of Vincent's and Theo's legends—did not want questioned or further investigated. This would lead me to believe that this is a very sensitive area for those in Amsterdam. I await the follow-up from the investigative journalism team to garner any additional information, specifically from M. Arnold or his editor.

Where Is That Missing Letter Now?

An obvious question is, if there was a photograph of a missing letter in the archives for Matthias Arnold to find, someone in the archives had to have photographed the original

and "*misfiled*" the photo and then the letter itself. Where is the original and where is the photograph now? Are there other "*misfiled,*" missing, and otherwise unknown Vincent–Theo letters, inside or outside the hallowed halls and archives of the Van Gogh Museum and Foundation? It is very unlikely that these critical letters would have been thrown away or purposely discarded due to their significance and the fact that Theo and Johanna had saved almost everything that Theo and his brother had touched and wrote to each other. Maybe these letters contained such an unexpected truth about the relationship between Vincent and Theo that the trustees deemed them too controversial or damaging to the Vincent–Theo legend to allow the information out to the public? Could these letters purposely be buried somewhere in the extensive archive files, never meant to see the light of day and be studied or scrutinized?

Such a deed would go against the very purpose of the museum archives: to keep, save, protect, and study everything Vincent and Theo touched and shared, in order to gain additional insights into all aspects of their lives, relationships, and Vincent's art as well as their ongoing correspondence. Hopefully, the powers that be will now share the truths these letters may contain with all the world. If there really is a T41a then there must obviously be, or have been, a T41b. T41b may be so explosive that it explains why T41a was separated from it. Was there a real T42 as well? We must find these answers and allow the final chapter of Vincent and Theo's relationship to be factually and truthfully rewritten.

Why is this letter still withheld, why has the *Der Spiegel* article caused such consternation, and where is Matthias Arnold now to answer all these burning questions that potentially could solve this long-standing homicide? Surely when the article was published there was chaos in the Van Gogh Museum boardroom after Arnold suggested that there may be some missing or hidden Vincent–Theo letters in the depths of the archives. Have several investigative journalists now taken on the explosive cover-up as a major challenge to uncover the truth? What are they going to find?

Clues in the Letter

Clues as to what really happened on July 27, 1890 in Auvers-sur-Oise may lie in the still-missing or withheld half, T41b, and any other missing letters between these two brothers. What M. Arnold stumbled on that day, while doing some unrelated van Gogh research, was an amazing find: likely the last letter that Theo wrote to his brother. This new discovery is a vital missing piece as we try to reconstruct Vincent's final days and get a sense of the extent and angst of their familial arguments. These were thought to be mostly over whether Theo would be able, or even willing, to continue to provide Vincent with his generous monthly stipend. Theo now had five mouths to feed: his new family of three, his mother, Anna, and Vincent. On top of that, his bosses at the art gallery would not entertain giving Theo a raise to help him solve his financial

dilemma. Theo even threatened them with an ultimatum—he would leave and start a competing business—that went unheeded. This resulted in a most unpleasant family meeting with lots of apparent residual bad feelings afterward, a sense of which is only touched upon in those contemporaneous letters.

The last letter from Vincent to Theo would hold many secrets and maybe even finally help us to close this 128-year-old cold case. Aspects of the letter were explored in some depth in Arnold's interview with the editor, Hohmeyer, and the article it generated; this explains the article's unusual format, with the writer/editor quoting the finder of T41a. The article was almost like interview notes, but why not do it an interview format (DS 1990)? This is curious! Why did Arnold not just write his own article as an art historian? The Der Spiegel article places his findings and observations in a new context, emphasizing "*violent domestic quarrels and arguments, which had broken out during a visit of Vincent to Paris*" (*ibid.*). Additionally, there was a response from Vincent interpreted as "*incomprehensible.*"

The Importance of These Missing Letters

There has been controversy for many years regarding which letters the Van Gogh Museum has released and when, and what other letters they might be holding back from the public. Finding a missing letter that was presumed lost forever, but which was actually "*misfiled*" in the archives of the museum, has raised many questions.

Letter T41a is dated July 22, 1890—five days prior to Vincent's mortal injury. It would follow that the missing reply from Vincent would have been dated sometime between July 22 and July 27. There are now many concerns that T41b and T42 are only two of multiple missing, purposely withheld, and "*lost*" letters between the brothers. They may have been suppressed or destroyed, because they were deemed embarrassing or contained shocking revelations about the van Gogh family. It would be wonderful if, after all these many years and so many unanswered questions, all the letters were released unredacted for those interested in the truth of the van Gogh mysteries. For instance, we all may find out some further details about both brothers' mysterious deaths, and if there was any connection between them.

Is the Museum Purposely Withholding
Any of the Brothers' Correspondence?

This would not be entirely surprising given that in 1957, Belgian author Louis Roelandt first accused the keepers of Vincent's estate—Theo's wife, Johanna van Gogh-Bonger, and her son (Vincent's nephew), Vincent Willem, who eventually became the head of the van Gogh estate and institute—of hiding certain letters. What did the nephew,

Vincent's namesake, know from his mother and from his unfettered access to all the letters held by the family, the museum, and the foundation that he was able to say, in effect, there is more to the relationship and the stories of Vincent, Gauguin, Theo, and Dr. Gachet than is widely known? That is very provocative! Roelandt said they were:

> *"...disseminating 'falsehoods' and 'half-truths.' Indirectly, he further attacked [Johanna's] son and heir Vincent Willem; because he implied 'until proof to the contrary, the unredacted correspondence between Vincent and Theo, and also Theo to Vincent, become available into the public domain, this cover up remains an unaddressed and an unanswered mystery. All that is available today is only selected, already known correspondence. If these missing letters were fully published and readily available about the relationship between the brothers, those revealed secrets would completely put a mortal blow to the previous official truths.'"*

—*(ibid.)*

The Brothers' Loving Relationship

Fig. 145. Vincent van Gogh, **Portrait of the Artist's Mother**, 1888. Painted from memory, oil on canvas, 40.5 x 32.5 cm, Norton Simon Foundation, Fullerton, California.

The relationship between Theo and Vincent was, on the surface and as portrayed by Johanna van Gogh Bonger, unbelievably positive—almost too perfect. It starts to feel like the brothers' relationship was outwardly wonderful and Theo supported Vincent through thick and thin, sending him a monthly stipend so Vincent was free to roam and paint whenever and wherever he wanted to. However, there appears to have been an undercurrent of ongoing discontent below the surface. Theo, in moments of stress as indicated by letter T41a, may have had his own laundry list of reasons he would be better off with his brother "*gone,*" as his mother Anna (Figure 145) once succinctly stated.

Theo was in a dire financial situation, having to support himself, his wife, and their son, as well his mother, and, of course, Vincent. It was a heavy burden to be the sole supporter of five lives. He was very dissatisfied with his job, especially

after he was denied a raise despite many years of service in a distant family member's art business. He wanted to go off on his own as an art dealer but could not find enough financial backing. His expanded family required a bigger apartment.

His beloved brother Vincent, however, was demanding an increase in his allowance. Theo had supported Vincent as no patron ever had. Their history was a unique one. Theo did not enjoy being like a father to Vincent, who sometimes referred to Theo as "*Pa II.*" They shared an apartment in Paris from March 1886 to February 1888, but Theo was never the subject of a painting by his brother. Why not? They were an odd couple. Theo complained to his sister, Wil, that they had little sympathy for each other and that Vincent said "*he despises Theo.*"

The missing letters between Vincent and Theo may hold the incriminating truths to resolve this cold case. In the *Der Spiegel* article, Arnold noted the critical role of the director of Vincent's estate, his nephew, in the control and management of the brothers' correspondence. Theo's son, Vincent Willem, therefore decided to end the series with 41 letters from his father to his uncle, which he first published in 1953. And how significant was it that he (Vincent Willem) added this remark, "*This is Theo's last letter to Vincent*" (*ibid.*).

Yet Arnold contends that it is not the last letter!

> "*Already from a remark of Vincent's from 23 July of that fateful year that suggests that there was, in the opinion of the experts, an unpublished, and 'clearly lost [missing] Theo letter.'*"
>
> —(*ibid.*)

Arnold observed the volatility in the filial and familial relationships:

> "*The van Goghs did not always deal with each other so amicably....The [missing] letter bears the date of July 22, 1890 and, probably by Johanna's hand, the correct numbering 'T42.' At first glance, it does not seem to offer a spectacular revelation, but references of 'violent domestic quarrels and arguments,' which had broken out during a visit of Vincent to Paris, makes you alert. As amicably as the legend [the guardian of the estate, Jo] would like you to believe....*"
>
> —(*ibid.*)

For Arnold, the letter is an additional piece of evidence in a circumstantial network that gives a changing view of Vincent van Gogh's conflicts and his relationship with his dear brother:

> "*It was not easy for Theo to have had an ingenious brother, especially when Theo was the one who encouraged Vincent to do art from Paris, and shared*

his apartment with Vincent from March 1886 to February 1888. However, an indicator of underlying malcontent would often manifest when Theo complained to their sister Wilhelmina 'that we have so little sympathy for each other.' Vincent misses 'no opportunity to remark that he despises me,' he is quarrelsome and seeks opportunity for conflict, 'dirty and sloppy,' 'his own enemy,' and 'as split into two people' where 'the one [is] wonderfully gifted, sensitive and gentle, the other selfish/egotistical and heartless.'"

—(ibid.)

The Written Clues About Marguerite, "*The Lover*"

Arnold also presented his thoughts on the significance of Marguerite to Vincent and what Madame Liberge, her best girlfriend, knew about their love affair and marriage plans. Again, from the *Der Spiegel* article:

"In his report on the garden picture and the first reference to Marguerite (probably with erroneous date 'May 25, 90'), during a possible portrait session, he lets the thoughts flow, Jo would 'make friends quickly' with the doctor's daughter. Does he fantasize Marguerite into a familial constellation in which the two brothers correspond to two harmonizing companions? More conspicuously, Theo, always sensitive to Vincent's messages, praises the consolation of the marriage in a solemn letter on July 1, and expresses the hope that his brother will 'one day have a wife' to pour his heart into. Then, in the same breath, he writes: 'Your portrait of Miss Gachet must be wonderful.' Vincent answers promptly, 'I do not think I'll ever have a wife. I'm afraid that, let's say, when I'm 40—but let's prefer to just say nothing. I'll explain that I'm whole, and I do not even know what turn it can take with me again.'"

—(ibid.)

How Much Did Vincent Openly Share about His Deepest, Most Heartfelt Feelings with Theo?

It is important to realize that Vincent was often very calculating in what he said about himself, his real, personal feelings, and his relationships. He often would opt to say nothing, like "*but let's prefer to just say nothing*." Often what was not said, what was read between the lines, was more important than what he openly stated. However, his art was a different story. He exuded feelings and descriptions to all about art in general and in his letters specifically. But personal information to Theo, about his personal life and loves,

was purposely withheld, at least in his correspondence. Most likely their dialogue in face-to-face private moments told a quite different story, but that information was sadly buried with the brothers. Mme Bergamon is an example: we do not know what the two brothers shared in their private conversations, but Vincent does not write directly about his affair with her or her strychnine suicide attempt. That kind of provocative information was initially kept to himself. But I am satisfied that he did not talk to Theo much about what was really happening between him and Marguerite, at least in their letters.

The Reported Relationship between Vincent, Paul Gauguin, and Dr. Paul-Ferdinand Gachet

Arnold also brings to the forefront some intriguing possibilities regarding these three characters that the Van Gogh Museum and Vincent Willem may have been sitting on:

> " '...the relationship between [Vincent, my] uncle and Gachet —as with Gauguin—has not yet been discussed to the last word.' Did the heir have special trusted knowledge as a confidant of his mother Jo? "
>
> —(*ibid.*)

What last word and missing information is being withheld? Why Gauguin? Further insight into Dr. Gachet and his son, too, would be extremely helpful to have now to fully understand what really happened on the day van Gogh was fatally wounded. We also need additional insights into the van Gogh–Gauguin relationship, which still needs to be openly discussed. What is missing from the true account of the ear-amputation episode in Arles? What did Vincent's nephew, his namesake, know about these characters that has yet to be elaborated and shared with Vincent's adoring public?

The Intriguing Conversation between Paul Gachet Jr. and Friedrich Karl Gotsch

Juergen Hohmeyer, the editor of the Der Spiegel article, noted:

> "Arnold came across another source. Paul Gachet Jr., the son of the doctor, has been questioned by Tralbaut on this subject without conclusive results. But already by 1927 [Tralbaut] had visited the German painter Friedrich Karl Gotsch (1900 to 1984), and in 1954 he reported in a cultural almanac with the ornate title 'Schri, kunst, schri' about his conversation; the almost hidden publication remained without an echo [so it was not widely known]."
>
> —(*ibid.*)

Apparently, the gist of what Paul Gachet Jr. told Gotsch is this quote that Arnold uncovered:

> *"We have not yet told anyone that 'it was my sister that caused Vincent to shoot himself. Oh, basically he did not want to kill himself, he was just so desperate, so headless. Vincent was not a pleasant guest in the house. He was loud and rude.Vincent wanted to paint Marguerite, but apparently frightened her, not only with his unusual and unkempt looks and damaged ear, but also with his direct talking to her about love making, which ultimately led to a conversation between Vincent and her father. From this explosive conversation, a significant wedge was driven into Vincent and her fathers' friendship, fracturing it beyond repair."*
>
> *—(ibid.)*

That is certainly a distinctly different story than what Madame Liberge told to her daughter, Giselle Baize, who then conveyed it to both Tralbalt (1969) and Wilkie (1978). Arnold believes that a rejection suggested by Paul Gachet would have had "*disastrous repercussions,*" as believed by Fell (2004):

> *"The closeness of the woman to whom he was attracted was denied him, and that by his friend and doctor. And if he turned against him in such a way, how sincere was his enthusiasm for the artworks and his trust regarding van Gogh's illness? After 2 July 1890, the Gachets' name no longer appears in the painter's letters. Already this affair alone would have been reason enough for disastrous depression [or repercussions]."*
>
> *—(ibid.)*

Arnold also noted that family tensions were increasing:

> *"In addition, significant tensions of Vincent van Gogh's relationship with Theo and his family intensified"*
>
> *—(ibid.)*

He said that Vincent's family visit in Paris ended abruptly, on the same day Vincent traveled back to Auvers:

> *"There has been a dense schedule, encounters with colleagues and works of art, the Portrait of a Lady At The Piano [Figure 125, Chapter 15], which was motif-related to the image of Marguerite Gachet and 'moved him very much' [and apparently reminded Vincent so much of Marguerite, he got up and left for Auvers]. The short letter could have crossed with an apparently equally appeasing letter to Jo, whom Vincent then perceives as 'a gospel,' but who himself has not become known to the public until today."*
>
> *—(ibid.)*

Other Interesting Comments Noted
by Mattathias Arnold

Arnold raised the question, posed by Jo, of whether Vincent's *"seizures"* (attacks of vertigo) were the cause of his suicide, but she believed him to be of sound mind with *"mental clarity"* until the end:

> *"Everything speaks for mental clarity until the end. Hardly (and by no means alone) 'the fear of the newly imminent illness or the seizure [vertigo] itself,' as sister-in-law Jo represents, drove van Gogh to his death. Already more than five months, a longer time than any other in the year and a half before, had passed without seizure. That should have made the haunted individual optimistic."*
>
> *—(ibid.)*

Arnold also speculates on all misinformation and spin surrounding the suicide story and where the gun came from:

> *"There are too many unverifiable anecdotes circulating, often late, hearsay, and without proof of source. It is already puzzling where Van Gogh got the weapon from. Sometimes it is said, by Dr. Gachet, sometimes a group of young marauders had entrusted a gun to him. Quite convincing is a report by the landlord Adeline Ravoux, that was published in 1953 by the French art critic Maximilien Gauthier. After that, the painter left that Sunday as usual as in the morning after lunch. That he did not return home at the usual time for the evening meal was unusual and 'disturbing' to the innkeepers. Daughter Adeline continued: 'We stood at the front door of the house to get a little fresh air when we finally saw him coming, wordlessly, like a shadow, he passed us by. With big steps he made his way through the dining room and into his room upstairs....' Mrs. [Louise] Ravoux had noticed that their strange guest was holding his side and sent her husband to look after him. Van Gogh showed his wound. Mr. Ravoux wanted to bring in a practicing physician in the village, but he did not contact him and it fell on Gachet. 'When he came, we had the impression that Mr. Vincent and he absolutely did not know each other.' When asked, Adeline Ravoux confirms to the interviewer her father's claim that the two 'did not exchange words.' Gachet concluded there was 'nothing to do' except to inform police and relatives."*
>
> *—(ibid.)*

Arnold suggests that the reason for not disclosing this missing letter may have been connected to the *"incomprehensible"* letter from Vincent. What exactly was so incomprehensible? What story, what facts needed to be censored or deleted from public

awareness that might be a blight on the van Gogh name, or worse, puncture the air out of the always unbelievably loving Theo-Vincent relationship.

> *"It is quite possible that Jo saw reasons for not disclosing the 'incomprehensible' letter in which Vincent spoke of it. It was as if by an ironic fateful direction that Jo van Gogh was then called to direct the fame of her brother-in-law—along with Doctor Gachet, who perhaps even had to attribute an element of contributory negligence to the death of the artist— in the Van Gogh 'cult' about which she reports could have had a guilty conscience."*
>
> —*(ibid.)*

Matthias Arnold next describes Vincent's funeral and the removal of many of his canvases by the Gachets. He estimates that they took the artwork because, as Adeline Ravoux acknowledged, Gachet's daughter was now *"compromised"*—a euphemism for *"no longer a virgin,"* meaning she was unsuitable for marriage in Victorian times. This in effect explained what most of the other villagers already knew about the lovers. This would explain why *"discretion"* was so important to Paul Gachet Jr. that Marguerite could not show up at the funeral, for fear she might say something, or be the focus of mean-spirited gossip. As Arnold said:

> *"The funeral took place on July 30 in the cemetery between the church of Auvers and the cornfields, two of Van Gogh's motifs. After the ceremony, according to the memory of Adeline Ravoux, Theo van Gogh came with Gachet and son back to the inn. He first asked the landlord to select the posthumous pictures. But he already had two and was content with it. Gachet, on the other hand, 'did not ask for long, and with the help of his son he rolled up one canvas after another.'"*

Significantly, Adeline Ravoux noted that: *"'It is quite possible that the generous gift, while barely having any market value, also compensated Gachet for seeing his daughter compromised. Marguerite had not appeared for the funeral, as discretion was indicated.'"* (ibid.).

What did it mean that Marguerite was *"compromised"*? Was her being compromised by Vincent the reason that Vincent was murdered...an honor killing of sorts?

Overview and Summary Regarding
This Crucial Missing Letter

Finding letter T41a quite by accident has revealed several important new directions to explore or add weight to pre-existing information. This may be helpful in unraveling what really happened on that hot, muggy day in July 1890, 128 years ago.

This discovery has revealed several important tidbits in an unfortunately challenging article to comprehend, that has nevertheless provided both new insights and also new questions. These new insights and questions have apparently stirred up quite a controversy in Amsterdam. The investigative reporters are searching now for further answers from the author and editor, and the discoverer of the letter. Are investigators now onto something that might cause a notable disruption to the public's perception of the old suicide myth, or worse, shed expository light onto the unbelievable legend of the Theo-Vincent fraternal relationship?

The controversies regarding what letters have been released and why, and what letters may have been held back has been simmering for many years. What are we still missing and why? Certainly, Matthias Arnold has raised some important questions with a deeper look into the brothers' fraternal relationship and underlying levels of conflict. It is amazing that this letter was found so recently—what other letters may still be unknown, missing, or purposely withheld? Why? If there are more missing letters for whatever reason, what secrets might they contain? What stories and truths could they reveal? Can they all be made readily available to those who love Vincent and his truths?

What has happened to Matthias Arnold; an investigative reporter is searching for this van Gogh art historian and researcher, who *"seems to have fallen off the grid?"* Is he still available to answer some questions? What about his *Der Spiegel* editor? Why have they been silenced?

Arnold's interpretations of the love affair between Vincent and Marguerite, and the awareness of Marguerite's compromised situation by Adeline Ravoux add weight to the old rumors and gossip from Madame Liberge and her daughter, Giselle Baize. The intriguing conversation documented between Paul Gachet Jr. and Friedrich Karl Gotsch certainly gives a totally different perspective on the relationship of Vincent and Marguerite than Madame Liberge or Adeline Ravoux had held. It was apparently well known throughout the village and town gossip that Marguerite was *"compromised"*?

What did the nephew, Vincent's namesake, know from his mother and from his unfettered access to all the letters held by the family, the museum, and the foundation that he was able to say, in effect, there is more to the relationship and the stories of Vincent, Gauguin, Theo, and Dr. Gachet than is widely known? That is very provocative! What else are we missing? If there are more missing letters for whatever reason, what secrets might they contain? What stories and truths could they reveal? Can they all be made readily available to those who love Vincent and his missing truths?

Part VI

Wrapping it all Up!

Chapter Twenty-Two

New Forensics Bolster Our Homicide Investigation

Now that we've looked at "*all*" possible crime scenes, possible murder weapons, and the individuals who had opportunity and reason to harm Vincent van Gogh, is there anything left that I can do to get you closer to the truth about his death and eliminate the myth of suicide? Will these new forensic truths convince you of the impossibility of Vincent committing suicide? The final piece of the puzzle, for me, is to try to physically, medically, and ballistically reconstruct how Vincent received his fatal abdominal wound and give you convincing visual, reproducible, hard evidence that meet 21st century forensic standards (Chapter 27). I will then present you with what I consider the most likely scenario of what happened on July 27, 1890 (Chapter 23).

All the minimally available information on Vincent's mortal wound has been forensically based on the description given years later by Paul Gachet Jr. This sole description of the wound—relayed to Paul Jr. by both Dr. Paul-Ferdinand Gachet and the illusory "Dr. Jean Mazery"—only came to light in an interview (1926), after both doctors had already died in 1909 and 1916 respectively. We thus have only the most basic information on the fatal wound, so little information, in fact, that we don't even know if it was caused by gunshot or knife! Moreover, this very limited wound information comes to us from a key suspect and person of interest in this case who has no residual credibility.

Fortunately, expert opinions and modern ballistic reconstructions might be able to amplify the bare-bones information we have about Vincent's wound, using the known description of the injury to extrapolate how far away and at what angle the fatal shot was dealt, and the likelihood of whether the wound could have been self-inflicted. As it turns out, when played out in a forensic reconstruction, this one simple piece of information becomes crucial in casting significant doubt on the suicide myth.

Background

I follow in the footsteps of a 2013 forensic analysis by Dr. Vincent J. M. Di Maio that convincingly concludes that Vincent did not commit suicide within a reasonable degree of medical probability, or greater than 50% (2013). Dr. Di Maio's conclusions were corroborated by two independent homicide detectives (R. Relf, 2018, M. Brandt, 2018; see letters in Chapter 28 in the Appendix). All three individuals are experts in determining whether a person's death is the result of suicide, an accident, foul play, or murder. All three are adamant that no 21st century detective would find a person alive or dead today with a suspected bullet hole in their belly and declare the case closed. Particularly when there's no lethal weapon in evidence, no exit wound, no powder burns or stippling around the entry wound, no autopsy, no suicide note, no crime scene, no bullet, and no witnesses.

They agree that they would not rely on any statements made by the victim on his deathbed as any such statements, unless they connect indisputably well to the evident facts, are not considered significant or meaningful. This would be true even if, in Vincent's case, one of his friends, his brother, his doctor, an innkeeper, another artist, or a policeman said he made a direct statement to them. Such statements could have been made under duress or coercion with questionable motivation, or to push out a false, modified statement of what Vincent might have actually said. It would all be hearsay evidence, without a corroborating witness or any supporting, contemporaneous written statements or reports. Furthermore, if the individual was in great pain, was going into shock, had poor blood flow to the brain, and was on the brink of dying, they would not accept these statements as having been made in sound mind, and certainly they would not let such statements override the evidence and the available facts. None of the criteria for a reliable investigation or credible deathbed statements were met at the time of Vincent's death, and it is up to us to do what we can today to sort out this confusion or purposeful obfuscation.

I have attempted a rough reconstruction of the 19th century crime to help enhance, or at least corroborate, the limited forensic evidence that was originally observed and reported in 1890, and then first stated 36 years later. The following forensic analysis is the same as the one provided to Dr. Di Maio by Naifeh (2011), and our extensive study is based on these same accepted "*wound facts*."

These "*facts*" can first be tested via a simple photographic simulation and documentation of the anatomic positions necessary to recreate the gunshot that may have wounded Vincent. In the following photographic simulations, I have attempted to match the description and trajectory of the wound as reported by Paul Gachet Jr. (Doiteau, 1928). Is it possible for Vincent to have placed the muzzle of the gun where the entry wound was supposedly located, pulled the trigger himself, and caused the "*magic*" bullet trajectory that ended near his spine and great vessels—all with no exit wound, and most importantly,

with no black powder burn? You decide! This is the crux of the case against a self-inflicted wound by a gun. These simulations are only directed to answer the possibility of Vincent logistically getting into any difficult position and shooting himself.

Figure 146 (The A>B>C Drawing) demonstrates the details of the wound centered at the bullet's entry point of impact (A), the trajectory of the bullet (upward B, downward D (as indicated by arrows)). Presumably a bullet travels in a straight line between a point of entry (A) and where the bullet comes to rest at the end point (C upward or E downward). Point C is supposedly near the midline of Vincent's body, next to the spine and great vessels, and is the alleged reason given for not trying remove the bullet or move Vincent to Paris. Alternatively, it could have traveled downwards (E).

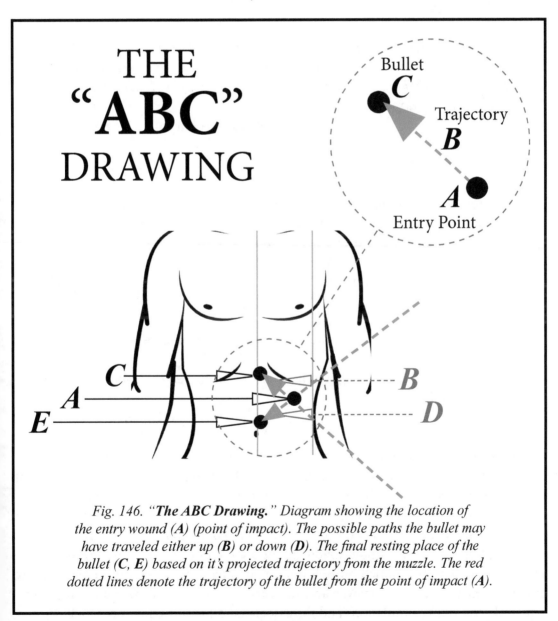

Fig. 146. "***The ABC Drawing.***" *Diagram showing the location of the entry wound (**A**) (point of impact). The possible paths the bullet may have traveled either up (**B**) or down (**D**). The final resting place of the bullet (**C, E**) based on it's projected trajectory from the muzzle. The red dotted lines denote the trajectory of the bullet from the point of impact (**A**).*

Dr. Di Maio's Forensic Report, With Analysis and Comments

Dr. Di Maio, a world-renowned forensic expert, made a report in 2013 to Steven Naifeh and White Smith that concluded that suicide was not at all likely (see the full report in the Appendix). His report has been an essential first step in overturning the "*blasphemy*" of the unverified story that Vincent killed himself. It is interesting to compare Dr. Di Maio's analysis to the medical report supposedly left by "Dr. Mazery" shortly before Vincent died.

Wound Description:

> "*In your book you state that: The first physician to see Van Gogh was Dr. Mazery. He described the wound as just below the ribs, about the size of a large pea, with a dark red margin and surrounded by a blue halo. The wound path was apparently downward.*"
>
> —(Letter to Naifeh from Di Maio, 2013)

Wound Confirmation:

> "*The Burlington Magazine article states, in the footnotes on page 459, that the wound was examined 'on the spot' by Dr. Paul Gachet and a local doctor, presumably Dr. Mazery. Then, allegedly based on their findings, which were 'probably written down but later lost,' Victor Doiteau and Edgar Leroy described the wound in their book published in 1928. They described the wound as being 'along the side of the left ribs, a little before the axillary line.'*"
>
> —(Dr. Di Maio, *ibid.*, 2013)

> "*There are two distinctly different trajectories 'observed and reported.' Both are considered.*"
>
> —(Dr. Di Maio, 2013)

The alleged rationale behind failing to make any attempt to remove the bullet and drain the wound, or to move Vincent to a hospital in Paris, was because the trajectory of the gunshot wound and the bullet's final resting place was close to the spine and great vessels. If that is to be believed, the bullet would have had to have "*magically*" moved from the point of entry (A) toward the midline of the body to get close to the spine (C), and along trajectory (B), without following the laws of physics. If we are to believe that Vincent could have positioned himself to be able to have delivered this bullet pathway himself, then we have our answer and the case is closed. (Review the photographic logistical positioning simulations and the associated difficulties; Figures 148-153.)

The trajectory, however, is uncertain. Apparently, the confusion comes from the account of "Dr. Mazery" and another from Dr. Gachet as retold by Paul Jr. These variations regarding the bullet's path suggest the first "*magic*" bullet of historical significance, predating the "*pristine magic bullet*" of JFK fame. According to information provided to Dr. Di Maio, the entry wound was in the upper-left quadrant of the abdomen at an angle that was not noted; it could have been angled up or down. "Dr. Mazery," potentially

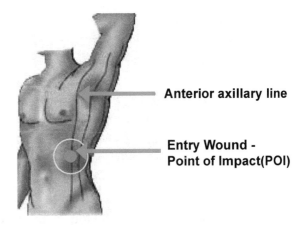

Anterior axillary line

Entry Wound - Point of Impact(POI)

*Fig. 147. Courtesy of Dr. Di Maio, See the Letter in the Appendix (Chapter 26). Red dot indicates entry wound "**point of impact**".*

an invention and "*straw man*" of Paul Jr.'s revisionist history, also described the wound trajectory as upward at an angle. Di Maio states that this is an impossible trajectory for a right-handed shooter to inflict on himself (*ibid.*).

In either case, the actual trajectory (B) was never confirmed and only comes from Paul Jr.'s description (Doiteau, 1928).

> "He [Dr. Mazery]...was a doctor from Paris, who may have been vacationing then in Auvers...[he] started the examination of the wounded person, searching to determine the internal trajectory of the projectile. The only indication of the course of the bullet was the patient's responses. No essential organ seemed to be immediately affected; no important external hemorrhaging. The bullet, ricocheting off the fifth rib, was likely descending (downward) into the region of the left groin."
>
> —(Gachet in La Folie, 1928)

The combination of factors needed for a bullet to end up near Vincent's spine in the midline—if the gun is presumably in the shooter's right hand and most likely aimed upward on the upper-left side of his own torso, and angled toward the center of his body—simply do not add up anatomically. Dr. Di Maio reported that the bullet's location and trajectory cannot possibly be the result of a self-inflicted wound. He concludes that the shot would have had to come from several feet or so away, likely from the ground pointing up to follow that trajectory. Additionally, the absence of the critical powder burn remains unexplained.

The report by "Dr. Mazery" also described a slight brown ring, or purplish discoloration concentrically around the wound, consistent with the bullet penetrating and bruising

the skin. As we now know, powder burns would have been quite noticeable by all, and expected in this case of a self-inflicted gunshot wound at any short distance. Dr. Di Maio noted that:

> *"black powder is extremely dirty—on burning, 56 percent of its mass is solid residue and not burned immediately upon the weapons discharge. Close-range inflicted wounds from black powder are messy to a degree that is impossible to ignore, compared to those of a modern, smokeless bullet"*
> —(Dr. Di Maio Letter, Appendix, Chapter 26, 2013)

"Dr. Mazery" also supplied a detailed description of the pea-sized entry wound and the colored concentric rings (red, purple, and tan-brown—but not black) around it. The observer who reported these details to such a careful degree would certainly have also noticed a black powder burn around the wound as well, if one existed. Dr. Di Maio emphasized the importance of the black powder burn to determine the closeness of the muzzle to the skin. The fact that no black powder burn was described at all strongly suggests that there simply wasn't one. Without a powder burn, the shot could not have been at very close range, an absolute necessity for Vincent to have been his own *"trigger man."* A greater distance away from the skin would indicate that someone else shot Vincent. This is the only possible explanation for a gunshot wound to have followed the described trajectory A>B>C. Thus, taking the simulations at face value, it would significantly reduce the likelihood to near zero that the wound was self-inflicted with a black powder bullet, by Vincent or anyone else.

Dr. Di Maio stated that:

> *"...the absence of grossly evident powder burns around the wound indicates the muzzle was more than a foot or two away (closer to two rather than one)."*
> —(ibid.)

With the type of pistols and black powder bullets available at the time, the only possible shooting condition that would have produced a wound with no powder burn would indeed be a shot fired from several feet away (or at least further away than the length of Vincent's own arm), as suggested by the investigating gendarme, Rigaumon. This is perhaps the most damning piece of evidence leading to the conclusion that Vincent was murdered. It was impossible for Vincent to have shot himself.

There was also no exit wound, which one might expect from a shot inflicted right up against or very close to the skin. A bullet exit wound is easily recognizable, since it is larger and often ragged in comparison to an entry wound, which is usually circular with a smooth border. Since no exit wound was reported, could the weapon have been a knife? An exit wound for a mortal knife wound is highly unusual unless the weapon was a sabre.

The Concept of a "*Magic*" Bullet

Was this some sort of "*magic*" bullet? Did it stop inside Vincent's body even if the gun was held right against his skin (Figure 148) but left no exit wound? Did it make a notable direction-changing turn inside of Vincent's belly to end where it was said to be, while defying the laws of physics (Figures 154, 155)? Does the resting position of this "*magic*" bullet make any attempted extraction impossible? Does this "*magic bullet,*" as critical evidence, exist in Vincent's coffin? Was the bullet ever there?

The concept of a "*magic*" bullet that follows no anticipated trajectory and defies the laws of physics was conveyed quite brilliantly in the film Loving Vincent by the "Dr. Mazery" character. Maybe it was the predecessor "*magic*" bullet to the pristine bullet found in President John F. Kennedy's gurney after he was assassinated—a bullet that was critical in the analysis of the assassination, portrayed so well in the Oliver Stone film *JFK* (1991). All you would have to find now is a similarly pristine 7mm, or possibly some other caliber bullet in Vincent's coffin, and you would have a monumental art history conspiracy theory to contend with.

The details of the wound—the bullet's entry, trajectory, and final resting place in Vincent's body—are critically important in assessing the validity of the suicide conclusion versus that of murder. It is important to re-emphasize here that the report by "Dr. Mazery" that Dr. Di Maio references in his findings was made by Paul Gachet Jr. I have thus put "Dr. Mazery" in quotes throughout this book because I believe everything attributed to him related to the death of Vincent is a purposeful fabrication of the Gachets, primarily Paul Gachet Jr. He carried on and enhanced the false suicide story started at Vincent's wounding at every opportunity.

Dr. Di Maio Concludes van Gogh Did Not Shoot Himself

He wrote:

> *"Based on this information, it is my opinion that, in all medical probability, the wound incurred by Van Gogh was not self-inflicted. In other words, he did not shoot himself."*
>
> —(Dr. Di Maio, *ibid.*)

Because Dr. Di Maio's analysis does not support the legendary, yet false suicide narrative, it has caused quite a stir and uproar in the academic art history world. Nonetheless, he drew his conclusions within a reasonable degree of medical probability (defined as greater than 50 percent certainty), that Vincent did not shoot himself. This expert opinion would stand up in a court of law today and be accepted as valid expert witness testimony.

Simulations of the "*Shot*" That Killed Vincent

In the following photo simulations, assuming a gun was the lethal weapon, I used the same gun model, the Lefaucheux, which the Van Gogh Museum credits as the lethal weapon. The Lefaucheux has a folding trigger; it's a pinfire 7mm revolver like the one found rusted in the wheatfield in Auvers-sur-Oise in the 1950s (see pencil sketch of this "*found*" gun, Figure 92). In the live-fire reenactments of these simulations, I also used the same type of vintage pinfire black powder ammunition that the shooter would have used, with that same model revolver. I have recreated several possible scenarios of how the "*shot*" may have been delivered on July 27, 1890, to recreate the penetrating abdominal wound as allegedly described by "Dr. Mazery," a.k.a. Paul Gachet Jr. and Dr. Paul-Ferdinand Gachet.

I have attempted a rough reconstruction of the crime mechanics to help enhance, or at least corroborate, Dr. Di Maio's findings and conclusion based on the limited forensic evidence that was originally observed and reported in 1890 and not written down until 36 years later. This can be achieved utilizing two modes of study.

The first is a photo simulation of the anatomic positions necessary to recreate the gunshot that may have wounded Vincent, and actually strike points A, B, and C (Figure 146). I have attempted to match the description and trajectory of the wound as reported by the Gachets and utilized by Dr. Di Maio. This is the first forensic challenge.

The second challenge is to carry this anatomic analysis forward utilizing reenactments with the same model antique gun and vintage black powder pinfire bullets that would have been used in 1890. I will attempt to definitively answer if it is possible for Vincent to have placed the muzzle of the gun on the target, "*point A*" (Figure 146), and pulled the trigger himself from some kind of unusual and difficult anatomic position, causing the bullet trajectory (Figure 146 (Line B)) to wind up near his spine and great vessels (Figure 146 (Point C))—all with no exit wound. This was, specifically, the excuse utilized "*to do nothing*" and to declare him "*too dangerous to move him [to Paris]*."

The purpose of these simulations, following the findings of Dr. Di Maio, is to prove how difficult it would have been physically for Vincent to get himself into the critical position necessary to line up A>B>C, thus confirming Di Maio's initial anatomic analysis and conclusion. His conclusion based on this type of analysis alone, was that it was not possible for Vincent to have shot himself.

The First Forensic Challenge

My first goal with these anatomic photo simulations was to confirm the conclusions of Dr. Di Maio. I used the unloaded Lefaucheux revolver to test the anatomic possibilities and physical limitations for Vincent to use this revolver to commit suicide, constructing a path from A to C via B.

Left-Handed Shooter Simulation

I first tested this with the gun in my left hand. I followed the guidance of Dr. Di Maio from a letter he wrote to Steven Naifeh on June 24, 2013:

> *"It would be extremely difficult to shoot oneself in this location [point of impact-entry wound 'A'] with the left hand. The easiest way would involve putting one's fingers around the back of the grip and using the thumb to fire the gun. One might grasp the gun with the right hand to steady it. In such a case, one would have 'powder burns' on the palm of the hand grasping the body of the gun."*
>
> —(*ibid.*)

*Fig. 148. Sketch of **Vincent van Gogh shooting himself with his left hand**. This scenario is highly unlikely as Vincent was right-handed. Art by Darrell Anderson.*

*Fig. 149. Demonstration of **the difficulty to shoot oneself from a distance** with the left hand without leaving a black powder burn. Photo by Edward Kobobel.*

*Fig. 150. **Shooting oneself in the belly at point-blank range left handed**. This method would leave a black powder burn on the body. Photo by Edward Kobobel.*

Right-Handed Shooter Simulation

Next, I tried simulating the shot with the revolver in my right hand. Even though Vincent was thought to be right-handed, a self-inflicted wound is still unlikely this way. As Dr. Di Maio said:

> *"Using one's right hand is even more absurd. You would have to put the right arm across the chest and again place one's fingers on the back of the grip and use the thumb to fire the gun. One might then grasp the gun with the left hand to steady it. In such a case, one would have 'powder burns' on the palm of the hand grasping the body of the gun."*

He stated further:

> "In both scenarios, the muzzle of the gun would have to be either in contact with the body or at most a few inches away."
>
> —(ibid.)

When I tried this myself, right-handed, I confirmed the extreme awkwardness of the position and angle (Figure 153). It is obvious that, unless Vincent was a contortionist, it was not physically possible for him to position the muzzle at point A and create a straight trajectory B that would allow the bullet to land at point C—regardless of which hand he used. It was not a "magic" bullet….or was it (Figures 154, 155)?

To accurately follow the trajectory from the perspective of a right-handed shooter—where the bullet enters at the point of impact (A) and ends up at rest near the midline (C) without hitting anything substantive to deflect it—the only straight shot that lines up with this trajectory (B) is a shot from low to high, at a distance of one or two feet or more, as first mentioned by Rigaumon.

Fig. 151. **Sketch of Van Gogh shooting himself** with his right hand. Based on the angle, this seems impossible to shoot oneself the trajectory demonstrated in the ABC Drawing (Figure 146). Art by Darrell Anderson.

Fig. 152. Dr. Arenberg demonstrates **the difficulty of shooting oneself from a distance** with the right hand. Photo by Edward Kobobel.

Fig. 153. Dr. Arenberg demonstrates **shooting oneself in the belly at point-blank range**. The angle is all wrong for this to shoot oneself and follow A>B>C trajectory and end point. The bullet would exit the left side (flank). Photo by Edward Kobobel.

The Mysterious, "Magic" Bullet Theory

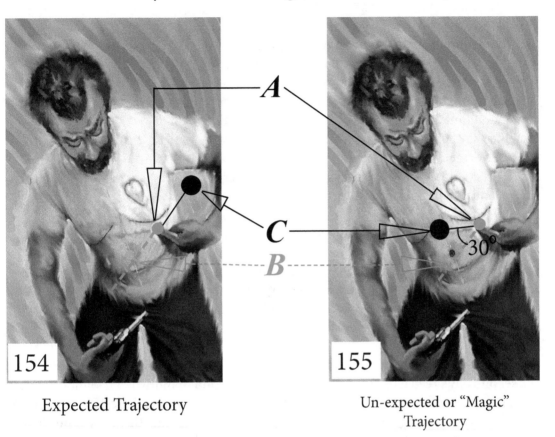

Expected Trajectory

Un-expected or "Magic" Trajectory

*Figs. 154, 155. Left image (154), shot to hit entry wound target(A), following trajectory (B), exiting from left side (C). Right image (155), bullet hits target (A), following trajectory (B), but takes a very strange turn back towards the midline of the body at a sharp "magic" angle (30 degrees) and rests at (C). Because of this strange angle, we have dubbed this the **mysterious, magic bullet theory.** Original Art by Darrell Anderson*

The Most Reasonable Option

If Vincent was indeed shot, the most plausible and likely scenario is that another person was the shooter, from several feet away. This matches the suggestion made by Rigaumon, the policeman at Vincent's deathbed, and is the only scenario that anatomically and logistically fits the crime as we now know it. To correctly line up the location of the accepted entry wound (A) and the end point where the bullet allegedly came to rest (C), the shooter had to be down near the ground and shooting upward to accomplish the necessary trajectory (B) between those two pointsww, as suggested by the Dr. Mazery character in *Loving Vincent*. In the absence of any known or described powder burns, this must be what happened, unless the weapon was a knife or other sharp instrument, or it was truly the first historical "*magic*" bullet.

The Second Forensic Challenge

Based on reviewing Dr. Di Maio's analysis and the simple anatomic simulations shown, I proceeded with a second set of forensic challenges: to recreate Vincent's wound and its trajectory with the same Lefaucheux revolver, but this time loaded and shot into a target made of FBI grade ballistic gel covered in a blue cotton shirt. These reenactment studies were performed live on a safe firing range, with a Range Safety officer, Matt Sebesta, present; images, videos, and details of this ballistic test follow.

The first day's reenactments utilized black powder, pinfire, vintage bullets in order to create the closest conditions possible to July 1890. Paper "Vincent" targets (Figures 148, 151) covered in cotton (to simulate his clothing) and backed with the highest grade of FBI ballistic gel were utilized in the first tests (Figure 156).

*Fig. 156. **Range setup for reenactment (Day 1)**, utilizing ballistic gel behind paper target, with blue cotton cloth over the ballistic gel behind the target. Photo by Edward Kobobel.*

The second day's reenactments allowed for the collection of more detailed forensic data and used the ballistic gel alone, covered by the blue cotton shirts. Tests were done at point-blank range (as if the muzzle of the gun were held against the body) and then at distances of six, 12, 18, and 24 inches away from the gel. Six inches or less is the most reasonable distance Vincent could have held the gun away from his body and still self-inflict the wound as forensically described; the other tests at 12, 18, and 24 inches are documented in detail as well for comparison and context. The further the gun was held from the gel (or body), the less noticeable the powder burn we expected to see, though some stippling and notable residue could still be present at 12-24 inches.

All these studies were documented with photos and videos taken from several vantage points, without any special lens or filter. I sought to capture the muzzle flash of the explosive round, the effects of the flash on the paper target, and the burns at the periphery of the bullet entry wound, both on the cotton clothes atop the targets and on the ballistic gel behind them. A self-inflicted gunshot wound at skin level would have been expected to produce some second-degree, possibly third-degree, burns. We made a video to record the slow burn of the cotton shirt and the red-hot burning powder fragments as they exploded toward the target at very high temperatures. This would confirm whether Vincent's shirt would have also partially burned and caught on fire from the proximity of a very red hot black powder explosion.

We also documented the bullet's path in the ballistic gel and the depth of the bullet penetration, along with single-frame "*muzzle flash flame*" shots to demonstrate what an

explosive round looks like up close as the bullet is discharged. It is basically an explosion directly against the skin, with intense heat, fire, and red-hot burning powder, as well as lots of unburned black powder residue. The website, www.KillingVincent.com/forensics, shows further video documentation of this phenomenon.

Results

A Glimpse of the Basic Results for the Cursory Reader

The following is meant to give the general reader a glimpse of the forensic and ballistics studies. For the serious investigator, please see Chapter 27 for all Day One and Day Two shooting and photo documentation at all distances organized from point blank to 24 inches, with three shots at each data point to control for variations in the old, vintage ammo. The best detail is in the video recordings which can be found on the website www.killingvincent.com/forensic/videos.

Figures 156 and 157 show the basic setup for Day One and Day Two reenactments respectively. The size of a powder burn at point blank range from the "*point of entry*" on the target is dramatic (Figure 159). This produced a very obvious four inch powder burn.

You can see the slow burn of the cotton shirt (Figures 162-167) best in the videos online.

The basic results of these studies were briefly presented here. For the more in-depth results, images, videos, and measurements, please refer to the Appendix, Chapter 27, and the website. For the enthusiast, you will enjoy the videos from which many of these single frames were taken. Any enthusiasts or "*gumshoes*" who wish to explore and study all of the available data collected may do so at their leisure. Some of the videos are

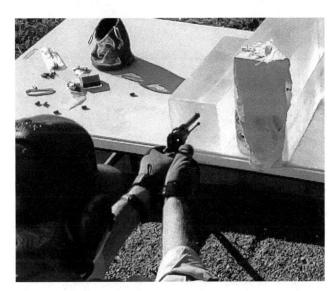

Fig. 157. **Re-enactment (Day 2)**, *utilizing ballistic gel with cotton cloth and without a paper target. Photograph by Matt Sebastian.*

intriguing, as you can see the bullet in flight, followed by the red-hot powder flying to the target and embedding in the gel after starting a slow burn of the cotton shirt. The images in this chapter and Chapter 27 only show you the burned hole in the shirt from the burning powder. The videos add another dimension.

Because of the extent of all the data collected in these reenactments—firings at point-blank, six, 12, 18, and 24 inches, in multiple sequences of three shots—only the most basic results are presented here in Chapter 22, in order to prove the significance of the powder burns in correlation with the distance from the skin/body. All of the data in its entirety have been collected in the Appendix, Chapter 27.

The Importance of the Powder Burn for Forensic Analysis

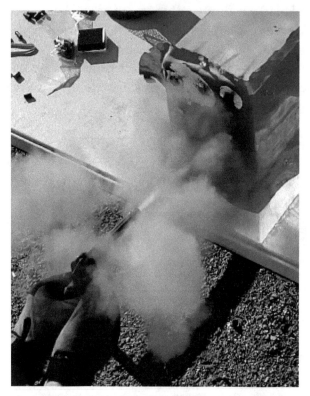

*Fig. 158. **Muzzle flash from black powder explosive.** Flame is quite evident. The "smoking gun" with pinfire black powder vintage bullets still produces a dramatic flash of a flame shooting out of the muzzle at six to eight inches away with a fire-flame, looking like an acetylene torch surrounded by smoke and red hot powder burning as it penetrates the shirt and ballistic gel.*

Given the way Vincent would have had to hold the gun in his left hand, it is clearly ridiculous for Vincent to have lined it up with point A, as Dr. Gachet said he did, but not end up with a significant powder burn on his hand and his belly—or catch his shirt on fire. The only way Vincent could have done this shot left-handed was to place the muzzle against or very close to his body through his shirt, but then he would have had a big powder burn (Figure 159).

Note that he would have had an even bigger powder burn if he lifted his shirt before he was shot. Otherwise, he would have had to move his arm far enough away from his body to minimize the possibility of a powder burn, but then he would have had to hold the revolver extremely unnaturally and depress the trigger with his thumb (Figure 149). I suggest that the reader try to do this with their hand held in the shape of the gun

(a *"finger gun"*). On top of the physical difficulty of shooting oneself in this way, scholars unanimously agree that Vincent was right-handed, not left-handed. For several reasons, I think it is impossible for Vincent to have shot himself with his left hand and still create a viable A>B>C path, so I concur with Dr. Di Maio.

Powder Burns - Day One

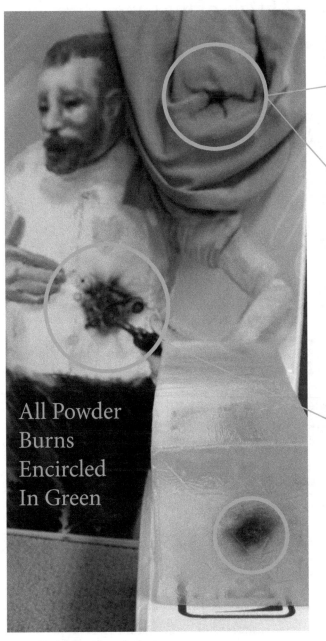

All Powder
Burns
Encircled
In Green

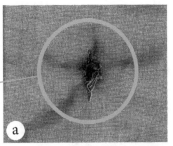

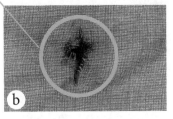

Fig. 160 a & b (above).
Same Shirt Powder Burn.
*Close up image of powder
burn as seen from the inside
of the same shirt. Photo by
Edward Kobobel*

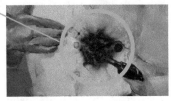

Fig. 161 (above). **Close
up image of black powder
burn** *on paper target.
Approximately 4 inches
away from muzzle.
Photo by Edward Kobobel*

Fig. 159 (left). **Powder on target, shirt, and balistic gel.** *Results from testing
Lefauchex 7mm pinfire gun. This is a paper target showing the powder burn
on the target (skin), the blue cotton shirt hole with spiraling powder (upper
right of photo) burn evident on the cotton shirt, and then the powder burns
on the ballistic gel (bottom right). at point blank range. *Note: Ballistic Gel
was fired at in a horizontal position on day one. Photo by Edward Kobobel*

Examples of Powder Burns at Various Distances From the Muzzle of the Gun

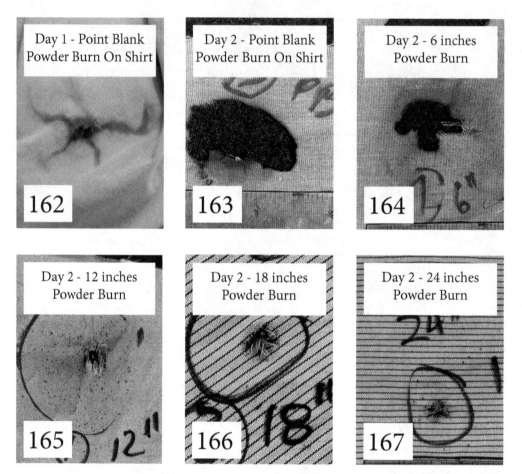

Figs. 162-167. **Results of firing the gun** *without a paper target at point blank range (162). The remaining five figures (163-167) were shot without a paper target. Results of firing gun from point blank(163), six (164) and 12 inches (165) away into ballistic gel covered by a cotton shirt. Compare these images to diminished powder burns and stippling at 18 (166) and 24 inches or greater(167).*

Results at Various Distances from the "*Skin*"

You can see that the greatest diameter powder burns result from a shot issued at six inches to point blank range. As the muzzle is moved further away, the amount of powder burn, black residue, and "*skin*" damage will diminish. You can still see the evidence of the dirty powder and stippling, even out to 24 inches, but the residue notably decreases with distance.

Unexpected Results Support the Knife Theory?

Note this bullet went through six inches of ballistic gel and exited creating an "exit wound" on the gel.

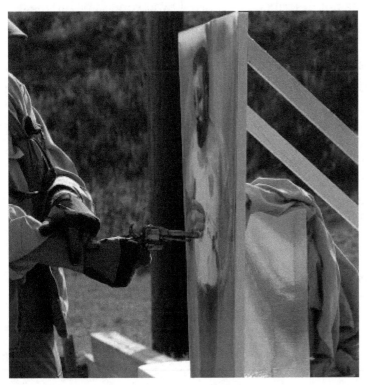

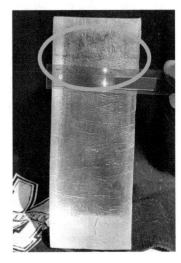

*Fig. 169. Unexpected result of **bullet passing all the way through the vertically positioned ballistic gel**. *Note: Circled in green, you can see the entry/exit points and the path of the bullet as it passed completely through the gel. Photo by Edward Kobobel*

*Fig. 168 Day One **shooting at paper target** from point blank range. *Note: Behind the paper target is a cotton shirt covering vertically positioned ballistic gel. Photo by Edward Kobobel*

*Figs. 170-172. Photos of **fired, empty casings** and unfired 7mm pinfire bullets. Also shows residual unburned powder in base of casing overlying the unbroken pin.*

The Alternative Knife Theory

In some tests at point-blank range and at six inches, in which the block of ballistic gel stood vertically, the bullet went all the way through the gel and no obvious exit wound was created. An exit wound was not described or reported by anyone as occurring on Vincent's body. This was a result that I did not expect, but it could be good news in terms of recovering a bullet still present in Vincent's remains or grave that could break open this case. Or, on the other hand, this could inform us that if a bullet, in these test conditions, did not exit the "*back*" of a simulated 150-pound male (consisting of ballistic gel that "*mimics human tissue perfectly*"), even from six inches away, then perhaps the wound was not caused by a gun at all. The theory discussed in Chapter 13, that Vincent was wounded by a knife, seems increasingly viable. The appearance of Vincent's entry wound, the absence of any powder burns or singed shirt or flesh, his comfortable and relatively calm demeanor after being wounded, and the several hours he survived in minimal distress all lead one away from the theory that Vincent was shot. Remember, Dr. Di Maio said that he could only tell that the entry wound was just that, an entrance wound effectively penetrating Vincent's abdomen.

Perhaps it was a "*pea-sized*" stab wound from a knife, a screwdriver, or an ice pick. To disprove the knife theory at this point would require someone to find and produce definitive proof of the existence of the missing "*magic*" bullet, found in Vincent's remains or in his coffin. Otherwise, until such evidence is produced, the knife theory is as likely as the gunshot wound theory.

But it is now safe to conclude, based on this extensive forensic analysis of simulations and recreations, that Vincent did not self-inflict this mortal penetrating abdominal wound. He was murdered. I can make that statement, as did Dr. Di Maio, to a reasonable degree of medical probability, that is greater than 50 percent. And that "*expert witness*" statement would hold up in any court.

My Conclusions: The "*Smoking Gun*" Theory

The simulation showed that for Vincent to have been shot with a gun but sustain no powder burns, and for there to have been no exit wound, he must have been shot from at least 18 to 24 inches away or even more. There is no way that the Lefaucheux 7mm gun and vintage black powder pinfire bullets could have resulted in a self-inflicted wound from six inches away or less without leaving an obvious and significant powder burn on both the skin and Vincent's shirt. Additionally, and clearly, there is no way that Vincent himself could have aimed the gun in the necessary position for the bullet to enter at point A and stop at point C—not to mention hold the gun 18–24 inches away from his own belly while self-administering such an amazing shot. It is simply impossible. I can

likewise state that, within a reasonable degree of medical probability, if Vincent was in fact shot with a black powder gun and bullet, he would have had to be shot at least 18 inches or more away from his belly to avoid the obvious signature powder burn, more likely at 24-36 inches or more. This is a feat Vincent could obviously not accomplish himself. Someone else had to pull the trigger, not Vincent! And whether he assisted his murderers by lifting his shirt is intriguing—a curious contention and zestful observation—but irrelevant to the presence or absence of the critical powder burn necessary for him to have shot himself. The *"lifting his shirt"* theory adds nothing of value to validate, support, or confirm the suicide, rather it does irrefutably confirm his murder.

Is There Any Forensic Support for the Old Suicide Theory?

Considering these forensic studies, what can anyone propose—or better yet demonstrate in the form of alternative forensics—to support the theory that Vincent killed himself? Multiple anatomical, physical, and logistical roadblocks would have prevented Vincent from placing the muzzle of the revolver in the position necessary to create the A>B>C pathways and avoid a powder burn.

I am stymied and look to you to pose viable suggestions, based on the limited information we all must work with, now 128 years later. What is the answer to this? Is there anything or anybody out there to offer other insights? I am sure we all want to know the truth, and I do not personally have an answer despite much *"noodling"* of this problem, and can offer no viable alternative theory.

I am open to discussing any reasonable thoughts or suggestions on the website forum. Can you overturn my conclusion that it was not a suicide, but a murder beyond a reasonable degree of medical/forensic probability. This is a conclusion that both Dr. Di Maio and I have both independently reached reviewing the same information and supported by two independent, retired homicide detectives very familiar with differentiation of foul play from a suicide attempt.

Chapter Twenty-Three

What Really Happened?

Now that you have just reviewed our new forensic studies to support Dr. Di Maio's findings (Chapter 22), hopefully you can accept that suicide was improbable and unlikely, even impossible. If you want even more confirmatory forensic data, please go to the Appendix (Chapter 27) and the Forensics tab on the KV website (www.killingvincent.com).

As we have already discussed, there are two competing stories about what happened the day Vincent was wounded, which are diametrically opposed (as described in Chapter 9). There are three accounts by Adeline Ravoux in the 1950s (1953, 1954, 1956), and then a final one with Tralbaut (1969). At that time, she was the only living person who met Vincent and knew what really happened after he was wounded. She was an eyewitness to everything that happened to Vincent at the Ravoux Inn in those few days as he was dying. She had no reason to fabricate or embellish her story. It is important to understand that she was only identified in the 1950s when everything about Vincent became so popular, and he became a cultural icon. As a result of all this van Gogh interest, and the movie *Lust for Life*, notices were placed in the newspapers to find anyone who knew Vincent, to maintain the "*buzz*." That was how the art world found the "*the lady in blue*." She was not seeking fame or notoriety; she just wanted to correct the false stories and misstatements she had heard about what happened in Auvers on the day Vincent was fatally injured and then died in her family's inn.

Adeline Ravoux's Accounts

It is intriguing that Adeline's first interview, with Maximillien Gaultier in 1953 on the 100th anniversary of Vincent's birth, may have been the most honest and believable recollection of events before others interfered to change her story to fit their familiar but twisted narrative. Adeline's first interview is the one I am most comfortable relying on. Her next interview was published in *Les Nouvelles Litteraires* in August 1954. It is apparent that after

this interview, Adeline felt some of her interviews and words were distorted, and thus she took it upon herself (with help and coaching?) to write a letter in 1956 to try to correct any misquotes. In the letter, she emphasized, *"I am without doubt the last surviving person who personally knew Vincent van Gogh in Auvers, and certainly the last living witness of his final days...It is possible that this true eyewitness memoir is contrary to certain now accepted legends"* (Ravoux-Carrie, 1956). Tralbaut (1969) interviewed Adeline himself even later, and because there are some different and contradictory statements that she offered to him after her previous interviews, I have copied her entire statement to Tralbaut below about what she remembered, so that you can digest her last recorded recounting of the death of Vincent van Gogh. Her several stories go from her honest remembrances to changes that clearly only support the old Gachet narrative.

I leave it to the scholars to sort through the discrepancies between what she first said and what major points she changed in her subsequent statements and why. I have kept her account intact for flavor and detail accuracy. It is almost like her final interview with Tralbaut was coached or coerced to fit the Gachet tale of a suicide. First, she repeats Vincent's statement of *"I am wounded,"* then later attributes to him a bizarre quote that he *"botched it."* In the first interview, she said *"there never was a Dr. Mazery present"* at Vincent's bedside. Then she tells Tralbaut her father sent for Dr. Mazery, but never said he came to the bedside. Interestingly, Tralbaut also relates, presumably from a later Adeline interview, that her father was quite upset that he did not at once remember that he had lent his pistol to Vincent, who said that he wanted it to scare away crows that came too close to his canvas when he was painting in the country. This pistol was never found (*ibid.*). Sounds to me like she was coached or coerced to change her original and honest remembrances to fit *"correctly"* with the Gachet's false suicide narrative.

The following quotes are taken from Adeline Ravoux's complete statement from her interview with Tralbaut (1969):

> *"A few hours later, the Gachets learned how Vincent returned to the Ravoux [Inn]. This is how Adeline described the occasion: 'Monsieur Vincent had lunch at midday, and then he went out at once. Nobody thought anything of it, for he came and went all the time, and neither my parents nor I had noticed anything odd about his behavior. But in the evening, he didn't come home as usual. Until then he had never been late to supper, for he liked to go to bed with the sun. Since he had been with us, he never failed to come to a meal. When they found that he didn't turn up, my parents finally decided to start supper without him. When we had finished, he still hadn't come home. The day had been very hot, and we were glad to take the air on the doorstep until closing time. My parents were becoming more and more anxious at not seeing M. Vincent, for his supper had been ready long ago. After a while, we saw him coming in the distance, but he was moving in a strange way... He was staggering along in big strides, with his head tilted a little towards*

*the side of his maimed ear. You might have thought that he had been drink-
ing. But though they have said M. Vincent was an alcoholic, I can swear he
never drank anything when he was with us. Night was falling.'"*

She continued,

*"'...and in the half-light only my mother noticed that M. Vincent was hold-
ing his belly and that he seemed to be limping. His jacket was buttoned
up. When he came near us, he passed like a shadow, without saying 'good
evening.' My mother said to him, 'Monsieur Vincent, we were worried at not
seeing you. What happened to you?' He leaned for a few moments against
the billiard table in order not to lose his balance and replied in a low voice,
'I am wounded.' Then he slowly climbed the 17 steps up to his little attic
room with whitewashed walls and its skylight looking up to heaven. We
wondered what he meant. Would he come down to supper or not? I was cu-
rious as any girl might be, and I went to the foot of the stairs to listen. There
I really heard him groan, and I told my parents at once. Then my mother
said to my father, 'You'd better go and see, Gustave. Perhaps M. Vincent
is not well.' My father went up. He also heard a faint groan. The door was
not locked, and my father went in and saw M. Vincent lying on his narrow
iron bedstead with his face turned to the wall. My father gently asked him
to come and eat downstairs. There was no answer. 'What is the matter with
you?' my father went on. Then M. Vincent turned carefully over toward my
father. Look...he began and taking his hand he showed him the place on his
body at the bottom of his chest where there was a small bleeding hole. Once
again, my father asked; 'But what have you done?' And this time M. Vin-
cent replied: 'I shot myself...I only hope I haven't botched it. My father was
alarmed and called my mother. He understood what was wrong, and that
he must get a doctor at once. They sent at once for the doctor who came to
Auvers twice a week and treated all the village. His name was Dr. Mazery.'"*

—(*ibid.*)

Tralbaut concludes, *"This was the story Adeline Ravoux told me"* (*ibid.* p. 326).

Germaine Ravoux's Remembrances

Although Germaine Ravoux was only two years old at the time of Vincent's murder,
she had heard all of the talk among her family about the eccentric, yet friendly artist
who used to draw pictures of her before bedtime. Hosting this now famous guest
at their family's modest inn was probably the most notable event in her family's
lifetime. Germaine was not an eyewitness, though she was in fact an ear witness to
the family stories of those momentous events. Apparently she was very upset when

she heard the broadcasts in the buildup to *Lust for Life*, all the media fuss about Vincent and his unusual "*suicide*," and the color that had embellished the story to make the Gachets look good and honest. Consequently, she was asked to review a manuscript by Pierre Leprohon in 1965 about Vincent.

She replied,

> "'You will not be surprised if I tell you that I rushed to read your chapter on dealing with the death of poor M. Vincent, and saw with satisfaction that you...doubt Dr. Gachet and his son...The father and son came to the burial and then the house [inn] to take away as many paintings as possible—Dr. Gachet taking them off the walls and handing them to his son...under the stupefied gaze of my father who thought their actions scandalous....Yet last night, listening to radio Luxembourg, I couldn't contain my indignation at hearing such lies.'"
>
> —(Fell, p. 233-234, 2004)

This a much more up to date and uncoached report from an ear witness within the Ravoux family that succinctly states that the villagers did not trust the Gachets or their intentions.

Tralbaut on the Certainty of Vincent's Suicide

Apparently, Tralbaut was quite "*certain*" about what happened to Vincent:

> "One thing is certain: Vincent attempted to kill himself. All the evidence is positive on this point. It is also certain that he used a pistol. But there is some doubt about the part of his body that he wounded. Some say that the bullet went into his belly, others that it was his chest. As the wound was mortal, wherever it was, this would be a quibbling point, if it were not for Vincent's passion for all things Japanese...a shot in the belly might indicate that he was following the ancient tradition of hara-kiri. Where the death took place is even more problematical."
>
> —(*ibid.*)

Unfortunately, I would have to quibble with Tralbaut about his certainty regarding the "*suicide*," the gun, and the wound location. I find it somewhat amusing that Tralbaut thought a belly wound with a bullet would have followed Japanese traditions. Hara-kiri was always done with the Samurai sword. Now, he may have been on the right track with a knife wound, if in fact no bullet is ever found in Vincent or his casket. But it was not Vincent inflicting either a knife or a bullet wound upon himself, as extensive modern forensic analysis has brought to our attention.

Paul Gachet Jr.'s Accounts

In 1969, Tralbaut reported an earlier interview with Paul Gachet Jr. This interview confirmed that on the day Vincent was wounded, there was a meeting between the artist and the Gachets. This interview, which has been virtually glossed over, is critical to determining what might really have happened. Tralbaut in fact did an in-person interview with Paul Jr. and Marguerite and reported it years later (1969). Tralbaut also did another interview with Adeline Ravoux as discussed above (1969). These interviews cannot be disregarded, even if we may not consider him to be completely reliable. At least Tralbaut looked these major players in the eye, person to person.

Tralbaut describes the timing of this interview with Paul Jr. and Marguerite Gachet as follows:

> *"On July 20, Theo had taken his wife and child to Holland, but he had to come back for a short period in Paris before he could join them for his annual holiday. Five days after he returned to Paris [July 25], he wrote to Jo: 'I have a letter from Vincent which seems quite incomprehensible; when will there come a happy time for him? He is so thoroughly good."'*
> —(Tralbaut, 1969)

Tralbaut further summarized his interview with Paul Jr. and Marguerite (though all information apparently came only from Paul Jr.):

> *"Two days later, towards the end of the afternoon of Sunday, July 27 [the day Vincent was shot], the Gachets watched Vincent leave. He seemed perfectly calm, but they nevertheless felt uneasy about him. Something was wrong. Vincent seemed to have some hidden intentions."*
> —(ibid.)

Paul Jr. also described to Tralbaut that:

> *"An earlier incident had begun to give Dr. Gachet some concern. One Sunday, when he was lunching with the Gachets, Vincent had suddenly thrown down his napkin and left in order to go back to his paints."*
> —(ibid.)

Now, we have all heard about the very loud arguments that Vincent had with Dr. Gachet; the fight heard on July 27 was attributed to Vincent's displeasure that the Gachets left a now famous nude painting by Guillaumin (Figure 173)—which might have inspired Vincent's most noted nude (Figure 174)—unframed on the floor.

Vincent was said to have threatened Dr. Gachet with a *"phantom"* gun by sticking his hand in his pocket (*ibid.*). Could this story only be a cover-up to prevent the villagers

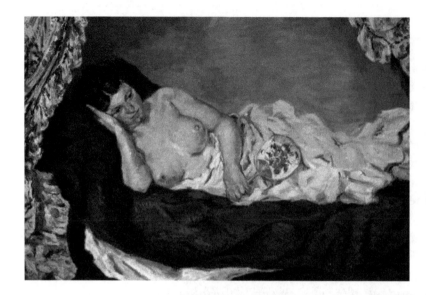

*Fig. 173. Armand Guillaumin, **Reclining Nude**, 1877. Oil on canvas, 49 x 65 cm, Musée d'Orsay, Paris.*

*Fig. 174. Vincent van Gogh, **Nude Woman Reclining**, 1887. Oil on canvas, 38 x 61 cm, Private Collection.*

who heard the arguments from knowing the real reason behind them? I believe that the accepted narrative explanation—that Vincent and Dr. Gachet merely fought over framing a painting and that Vincent threatened Gachet in any way with a gun or a knife—is very unlikely. Dr. Gachet, however, retold this story often to imply that Vincent was crazy and to deflect questions about what was really happening inside their strange and secretive household, and what was the real basis for their loud arguments. It also became the pretext for how a gun came to be in Vincent's possession prior to his presumed self-inflicted, gunshot wound. Paul Jr. continued telling the same story to drive the false narrative, and he somehow got away with it without any other evidence that Vincent ever carried around any gun in his pocket. For you are supposed to assume that with this story, Vincent had obtained a gun and was carrying it around in his pocket, so he already had the gun he supposedly used to shoot himself. A pretty *"convenient truth"* and amazing job of later planting false *"facts"* to fill in and cover up the details of a murder after his death. So this false narrative, repeated so often, was effectively able to deflect any curiosity away from anyone else, other than Vincent.

The Most Likely Scenario

What follows is a scenario that I believe most closely represents the actual events of July 27, 1890, when Vincent van Gogh was fatally wounded. This scenario, I believe, is best able to connect all the dots based on the *"facts"* as relayed to us years later by Adeline Ravoux's first account. When you add in the critically important fact supplied by Tralbaut (1969) that Vincent, Dr. Paul, Paul Jr., and Marguerite ALL were together on July 27, 1890 before Vincent was fatally injured, the stories form a compelling narrative that plays out in the following scenario.

My suggested scenario is confirmed by the extensive forensic evidence, making me certain his penetrating abdominal wound was not self-inflicted (Chapters 11, 12, 13, 22, 26, 27, and 28). It is my historical and medical opinion and conclusion, based on all of the facts and stories that I have pulled together, that Vincent did not shoot himself or fall on his own knife (hara-kiri) in an attempted suicide. He was murdered.

The Real Story

On Sunday July 27, 1890, Vincent and Marguerite met with Dr. Gachet and Paul Jr. together and professed their undying love for each other. They hoped to marry and wished to ask for the family's blessing. This story would explain why Vincent did not take his art equipment with him when he left the Ravoux Inn that day, and why there was no last painting from the day he was shot. He never took any of his art paraphernalia with him to paint, as he had this very important meeting to attend to with all the Gachets, confirmed by Tralbaut (1969). Painting was not on his agenda for that Sunday—but neither was being murdered.

Perhaps Vincent and Marguerite already viewed themselves as married in the eyes of God. Vincent had a painting of two people that could have commemorated them walking down the aisle, arm-in-arm at their marriage ceremony out in nature's church—he in a traditional groom's top hat, and she in a full-length gown(Figure 123, Chapter 15).

*Fig. 175. **Vincent and Marguerite profess their undying love** for each other and ask her father for permission to marry. This is the meeting that Tralbaut acknowledged occured before Vincent was mortally injured. Art by Darrell Anderson.*

Dr. Gachet's response to Vincent's request to marry his daughter was undoubtedly a burst of anger. An explosive argument ensued and was heard by all in earshot. Dr. Gachet forbade the lovers to see each other. Vincent was truly crushed initially, but he firmly resolved to challenge the decision of the Gachet men more emphatically, but with more self control, later that day. They agreed to meet at the barn up the road on the rue Boucher after lunch after some much needed cooling off time.

Vincent consoled Marguerite at her gate before departing and assured her that everything would work out and be alright. This was, sadly, their last loving hug and embrace. Following Vincent's departure, Marguerite was left to face her father and brother alone.

Fig. 176. ***The response from Dr. Gachet and Paul Jr. was dismay and anger.***
Art by Darrell Anderson.

The Gachets then told Marguerite, in no uncertain terms, that she was forbidden to see Vincent ever again, unless her father and/or brother were present! Most likely some threat to the well-being of her lover was made, as well as to her own safety. Distraught, young, and desperately in love, Marguerite sought comfort from her best friend, Madame Liberge, another 21-year-old in the village. Mme Liberge lived in one half of the old Daubigny villa that Vincent had painted twice while in Auvers (Figure 149). Poor Marguerite told Mme Liberge all about her predicament—she loved Vincent but greatly feared her weird father and, even more, her strange brother.

Meanwhile Paul Jr. offered his own consolation to his father, put his arm on his shoulder, and said, "*Don't worry, Father, we will soon finally settle this with Vincent in the barnyard.*" Dr. Gachet told his son to get his old service revolver out of the cabinet drawer near where the Guillaumin nude sat unframed on the floor (Figure 173). Certainly, the teenage Paul would know where the gun was kept. After its use as an officer's sidearm in the French military, would it now be put to a murderous use?

Fig. 177. **Paul Jr. consoles his father** *as Marguerite, saddened, looks to Vincent for help. Art by Darrell Anderson.*

Fig. 178. **The "final" solution to the Vincent problem is planned**, *but overheard, by the housekeeper's illegitimate daughter, Louise-Josephine—Marguerite's older half-sister and confidante. Art by D. Anderson.*

Fig. 179. **At the gate the two lovers bid each other adieu**, *not knowing that their destiny would make this their last embrace! Art by Darrell Anderson.*

Fig. 180. *Vincent van Gogh,* **Daubigny's Garden**, *1890. Oil on canvas, 51 x 51.2 cm, Van Gogh Museum, Amsterdam.*

Dr. Gachet and Paul Jr. continued their discussions on the "*Vincent problem*" and prepare to meet and enact the "*Final Solution.*" Their dastardly plan was fully overheard by the housekeeper's bastard daughter, Louise-Josephine, who was always like an unseen shadow, a ninja, drifting throughout the dark and creepy household. Louise-Josephine, who was Marguerite's good and only friend and confidante in this dysfunctional home, told Marguerite of her father and brother's murderous plans. Unfortunately, she was only able to tell Marguerite just as the two men were leaving to meet Vincent at the barn, leaving her no time or opportunity to warn Vincent of this evil plot. Louise-Josephine encouraged Marguerite to go to the barnyard and try to warn Vincent to stay away from entering the barn and this murder trap, for his own good and her future happiness.

Fig. 181. **The overheard plan is shared by Louise-Josephine with Marguerite**, *who encourages her to go to the barn and try to warn Vincent. The Guillaumin nude is sitting on the floor, still unframed. The cabinet drawer is opened after the Gachets take the old service revolver from its place. Art by Darrell Anderson.*

Fig. 182. *The barnyard scene of* **the final argument on the day Vincent was mortally injured**. *Unfortunately for us all, Marguerite arrived too late to prevent Vincent from engaging in this ill-fated meeting. She watches in great fear and trepidation as the discussion begins. Art by Darrell Anderson.*

As the Gachet men arrived at the barnyard on the Rue Boucher, nothing could stop their anger. Marguerite, tipped off by Louise-Josephine Chevalier (Gachet), followed quietly at a distance, trying to not be detected but hoping to intervene successfully. She was too late. Dr. Gachet and Paul Jr. were so incensed at Vincent's boldness and, even worse, at the fact that Vincent and Marguerite were adult lovers already. Rage erupted, and the argument flared. Threats and name calling ensued and appeared unstoppable. Vincent, who never backed down from an argument, probably threw out more insults and provoked the equally hot-blooded and very jealous Paul Jr. Given his history, though, Vincent was unlikely to accept yet another personal rejection, particularly since it was not his lover rejecting him but her father and brother.

Fig. 183. *As the arguments escalated and* **Paul Jr. was provoked, he pulled the old service revolver from his pocket**. *Art by Darrell Anderson.*

Paul Jr. pulled a gun (or, alternatively and equally as likely, a knife) as the argument escalated and threatened Vincent with the weapon. Vincent raised his hands in the universal sign to stop and not shoot. Everything happened so fast. Dr. Gachet stepped back as Marguerite ran rapidly toward Vincent, yelling *"STOP, STOP!"* to prevent her family's plan to eliminate her lover and her future happiness. Vincent reacted to some sort of verbal or nonverbal response from Paul Jr. and lunged at him to get to the gun (or knife), or deflect it away from him and from Marguerite who had now entered the fray.

*Fig. 184. **As Paul Jr. is rushed by Vincent, he is backed down to near the ground**. Marguerite is too late. Paul Jr. fires the lethal shot into Vincent from near the ground, upward into his belly as Marguerite rushes to the side of her lover. Art by Darrell Anderson.*

Vincent pushed Paul Jr. away to minimize the threat, but as Paul Jr. fell back in their tussle, his finger on the trigger, he purposely discharged his firearm. It was not an accident, but preplanned, yet poorly executed. However, he only shot Vincent in the stomach, not the heart or the head as intended. Dr. Gachet retreated further, as Marguerite frantically ran forward to try to stop what she feared most.

*Fig. 185. **Marguerite rushed to aid Vincent but was too late**. She sobs uncontrollably over Vincent's body as her brother, holding the smoking gun, and her father look on with some degree of satisfaction. Art by Darrell Anderson.*

Vincent had just sustained his mortal abdominal wound from either a bullet or a knife. Uncontrollably sobbing, Marguerite kneeled over the wounded Vincent, trying to help him and console him, while her brother and father looked at their actions with some satisfaction of a job well done, a family problem averted, and family honor preserved and protected, with this honor killing of Vincent. They thought Vincent was dead or soon would be.

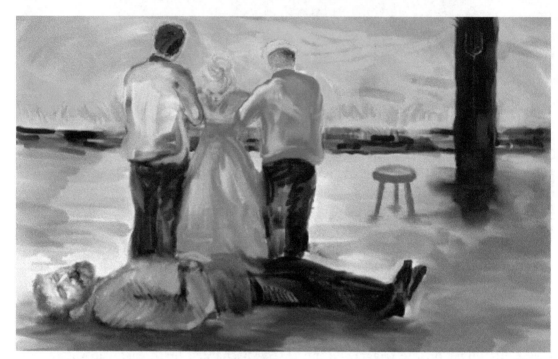

Fig. 186. ***The Gachets carry a distraught Marguerite, one with each arm, inconsolably*** ***sobbing, away from Vincent's body.*** *They bring her toward a stool to essentially read her the Riot Act about how this family's honor will be preserved at all costs, and to review the official story as it will be told. No one is ever to hear about the truth of what actually happened in that barn or how Vincent really was murdered to preserve her image and honor in their small village. Art by Darrell Anderson.*

Marguerite was led away by her father and brother to a stool in the barn, and Vincent was left behind—alone and wounded, presumed dead. Most likely, Dr. Gachet and Paul Jr. threatened Marguerite, read her the Riot Act, and took advantage of her unstable and vulnerable state by making her swear to never tell anyone about what she witnessed. She feared, with unequivocal certainty, that the same murder that befell her lover would befall her as well should she speak. Her brother was unbelievably cruel and evil, and she really hated them both, but what else was she to do now, at 21, with no Vincent and now no other prospects? Her worst fears were being realized. She feared for her life and her sanity, as she knew both men were crazy, one perhaps more so than the other. So, she was coerced into agreeing to maintain her silence or suffer the consequences. This would explain her deep and obvious depression, her forced spinsterhood, her life as a social shut-in, her significant reclusive behavior, her apparent muteness even with her best friend, and her regular visits to Vincent's grave

to bring flowers. Her lost youth, her lost marriage prospects, and her future life were now totally under the control of her unhinged family, and she lived in fear of losing her own life, miserable as it was. She was to become a prisoner in her family home, much the same as Louise-Josephine, relegated to very tight scrutiny and supervision in all situations for fear of what she might say, purposely or inadvertently.

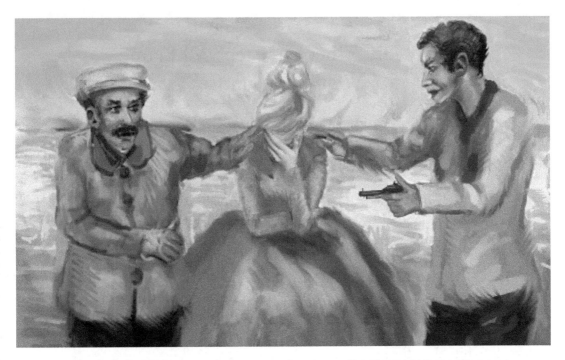

Fig. 187. As Paul Jr. points the gun at his sister, **they threaten her to forever maintainher silence about this honor killing** *event that was done in "her best interests," or she will die as well. Art by Darrell Anderson.*

According to this scenario, Vincent's fatal wounding occurred in the barn on the farm at the rue de Boucher, on the road to Chaponval, near Dr. Gachet's villa as well as the Secrétans' summer residence. It was not an accident and certainly not a suicide, as the legend would have one believe.

It was premeditated murder—an honor killing because Vincent took Marguerite's virginity and "*compromised*" her—even though a murder weapon was never found and no one except Giselle Baize's "*trusted*" grandfather came close to confirming a crime scene. This scenario would explain why Vincent did not take his art equipment with him when he left the Ravoux Inn that day, and why there was no last painting from the day he was shot. He never took any of his art paraphernalia with him to paint, as he had this very important meeting to attend to with all the Gachets, confirmed by Tralbaut (1969). Painting was not on his agenda for that Sunday—but neither was dying. It explains the "*rift*" and the arguments between Vincent and the Gachets that were heard by so many people, and it explains why poor Marguerite ended up so withdrawn, depressed, unmarried, and effectively silent; only when Vincent's name was brought up did she brighten up.

It would further explain why Marguerite was kept away from social activities, for fear she might slip up and say something, and why her father and brother controlled her so forcefully. As Paul Jr. told Gotsch, they were worried about what she may say in public. They maintained her lifetime of silence through fear and threats, and forced her to part with the only treasure she had from Vincent other than memories—his portrait of her at the piano.

Why Did Vincent Accept All Blame for "*Wounding Himself*?"

Most importantly, this scenario completely explains why Vincent wanted to take full blame for shooting himself: he wanted to protect his beloved Marguerite's reputation from the scorn of the townspeople, even more so if he feared that she may yet have been pregnant with his child. There is no good reason he would want to protect Dr. Gachet or his son from their murderous act, and certainly not the Secrétans if they were remotely involved—only his Marguerite. It would further explain why Adeline Ravoux described Dr. Gachet at Vincent's bedside saying nothing, as the two men glared at each other.

Although his art was clearly paramount in his life, even more important than his brother Theo, Vincent's final and most magnanimous deed involved neither of these passions. On his deathbed, he faced something so much more essential to him, something he had always missed in his barren, emotional life: love and acceptance. Nothing was more important to him than the love of his life, Marguerite.

Chapter Twenty-Four

Closing Arguments: To The Court Of Public Opinion

In closing, I want to thank you all for participating in this preliminary hearing to determine the cause of death of Vincent van Gogh. Your objective now is to conclusively determine whether Vincent van Gogh purposely killed himself, as told in the old 19th century stories, or was murdered. As we have learned, the suicide narrative is missing contemporaneous notes, reports, or supporting and definitive corroborating evidence. Would such a narrative, lacking any substantive evidence, be accepted as adequate in any 21st century coroner's inquest or a court of law? I believe that would be extremely unlikely, so I have attempted to upgrade my evaluation of this key question—suicide or murder?—for you with new forensic studies to bolster the original studies. These new studies will hopefully help you to determine the validity of the old narrative and question which theory best fulfills acceptable modern standards of meaningful scrutiny.

I am trying to represent the interests and good name of Vincent van Gogh in this preliminary matter before the world court of public opinion. I hope you will seriously look upon this argument of a murder as an alternative to suicide with a completely open mind.

If, after giving serious consideration to all the new evidence presented to you, you cannot make that determination of suicide with greater than 50 percent certainty (a reasonable degree of medical probability), then this case is closed.

If, alternatively, you believe after reviewing all this new evidence presented at this preliminary hearing that Vincent did not commit suicide, but rather was murdered (realizing the only possible alternative conclusion to suicide is murder), then we must push to reopen this 128-year-old cold case as a homicide investigation. This will help to determine who murdered Vincent and why such a murder happened in the placid village of Auvers-sur-Oise that hot summer Sunday in July.

Your verdict of not-suicide, by necessity, becomes a conclusion of unsolved murder. This verdict would allow the court of public opinion to be able to fully exonerate Vincent from

the historical crime of suicide, clear his name historically, and expunge this false narrative of suicide from all accounts, his death certificate, other records, and biographies.

If you conclude murder within a reasonable degree of medical probability, then the next step is to determine who murdered Vincent van Gogh, and why? You now have all this new data to support the murder contention. We must then proceed to who committed the act. If he did not do it himself, then whoever created his fatal penetrating abdominal wound was the murderer.

The Suicide Argument

Everyone was told from the very beginning that Vincent killed himself as a martyr for his art. He was the "*mad*," depressed artist who cut off his own ear—an unstable, sickly nutjob, whose suicide ultimately reinforced that notion. When he was alive, he could not even give away his paintings, and he was totally dependent on the good will of his younger brother for his generous monthly stipend. This pathetic version of Vincent is just what the suicide legend preyed upon.

In reality, Vincent was at his best in Auvers at the time he was wounded. There was no suicide note found because he never wrote one. Are there any other alternative, scientifically valid questions that would yet challenge the murder theory? The key question in the case of the suicide theory's relevance would be whether Vincent could have possibly shot himself with either hand at the distance of a foot or less without sustaining significant, noticeable, and distinctive powder burns that would be obvious to even the most casual observer. We've answered that question in our re-enactments.[4]

It is decidedly not possible for Vincent to have placed the muzzle of the gun where the entry wound was supposedly located, pulled the trigger himself, and caused the "*magic*" bullet trajectory so that the bullet ended near his spine and great vessels—all with no exit wound, and most importantly, with no black powder burn. In the absence of any such description of a black powder burn, one would have to conclude that there was no powder burn. Therefore, Vincent was shot at a greater distance away from his belly than he could remotely stretch to self-fire any gun.

Moreover, the policeman on Vincent's case, Rigauman, reportedly confirmed that Vincent was seemingly "*shot at several feet away*," but unfortunately no written police record has survived, if it ever existed. As both Rigaumon and our forensic studies concluded, the distance needed to fire a shot without leaving a powder burn needs to be from "*several feet away*." This is the real crux of the case against a self-inflicted wound by a gun.

[4]Granted, my tests did not conclusively prove what weapon was utilized—that cannot be done until a bullet is found (or not), and proves the murderer used a gun. In the absence of a bullet, the murderer could have equally and alternatively used a knife. Either way, suicide seems out of the question, and in fact impossible.

If Rigaumon said Vincent was shot from several feet away, the forensic study presented in this book of the powder burns and stippling produced at various short distances (point blank, six inches, 12 inches, 18 inches, and 24 inches)[5] from "*Vincent's belly*" confirms this observation. I have corroborated both Rigaumon's and Dr. Vincent J.M. Di Maio's statements and conclusions.

The simulations presented in previous chapters are meant to respond to the remote possibility of Vincent being able to position himself in such a way that he could have fired the mortal shot into himself, without creating the required powder burn as expected. This is both extremely difficult, even for a contortionist, and extremely unlikely.

If you still support the suicide narrative, absent any powder burns and after reviewing the new forensics provided, then please have your defense counsel elaborate your additional insights and supporting evidence to this court.

The Murder Argument

You now have two complementary conclusions independently based on forensic data assessed by two medical doctors (Di Maio and myself) that both state within a reasonable degree of medical probability (i.e., greater than 50%) that it was not possible for Vincent van Gogh to have self-inflicted his fatal wound. Therefore, he did not commit suicide!

In addition to Rigaumon and these two medical forensic analysts, there are the opinions of two retired homicide detectives (Ron Relf and Marvin Brandt) with extensive experience with both suicides and murders, both attempted and successful. They are experts in assessing foul play and criminal intent. They have also independently agreed, based on this limited information, that suicide was unlikely, and that an appropriate, in-depth investigation was needed to rule out foul play and murder.

Their analysis was also based on the limited available data from 128 years ago, only put on paper 36 years after Vincent's death. These few and sketchy details are all that is available to any forensic investigator today. Realizing the limitations of such basic forensic information related to the entry wound is an important limitation to any modern analysis, but it is still a promising place to start.

Without any new evidence to support the suicide theory, the likelihood of murder only becomes clearer! In fact, the strongest case for murder is the elimination of any

[5]This new forensics study demonstrates how there can be both powder burns and stippling at 18 inches and even out to 24 inches, further confirming the necessity of reporting powder burns for a self inflicted wound back in the day.

possibility that Vincent committed suicide. The most efficient and undeniable way to accomplish that was through a definitive analysis, using modern forensics and ballistics, which has now been presented to you.

Conclusion of the Preliminary Hearing to Determine the Cause of Death of Vincent Van Gogh

Dr. Di Maio has stated, and I fully agree, that Vincent did not shoot himself or commit suicide. You, the reader, must tell me what additional forensic evidence you need to be convinced that Vincent did not create his mortal wound.

This is indeed one heck of a cold case that concerns probably the most iconic artist and cultural treasure of the western world, Vincent van Gogh. Again, thank you for your participation in this preliminary hearing to determine if Vincent van Gogh committed suicide with a self-inflicted gunshot wound, or if there are enough concerns and grounds to reopen this 128-year-old cold case as a homicide investigation. We can then together expunge Vincent van Gogh's record of suicide and correct all the misinformation out there in books, articles, biographies, movies, and other places where Vincent has been incorrectly declared a suicide victim.

Who do you think murdered Vincent? Please contact me with your additional suggestions for further forensic studies or alternative analysis (ika@killingvincent.com). We have established an ongoing forum for all aspects related to Killing Vincent and look forward to your comments, critiques, and suggestions for future studies. (www.killingvincent.com/forum)

Part VII

Epilogue

Chapter Twenty-Five

Is It Yet Possible to Resolve This Cold Case?

The case of the murder of Vincent van Gogh can only be advanced to a definitive resolution if the questionable possibility of a self-inflicted wound and a suicide is ruled out once and for all. Given the parameters outlined by the forensic reconstructions I performed, could Vincent have gotten into a contorted position and self-inflicted his wound without a described and duly noted powder burn? If that is doubtful, then finding the missing bullet and verifying its existence would at least confirm that a gun was involved in the death of Vincent van Gogh…and even possibly to whom the gun belonged…or, as importantly, who may have pulled the trigger?

Then, the biggest remaining forensic challenge if a bullet is found in van Gogh's body or casket is to determine the caliber. A 7mm bullet in Vincent's casket, or any bullet of any caliber, would be very important additional evidence. This "*magic*" bullet, if it exists or ever existed, holds the answer to many questions that can potentially eliminate a person or two of interest. If found, will this bullet match the old 7mm caliber revolver found rusted in the field 60 years after Vincent's death?

Scientifically, ground-penetrating radar with spectrophotometric capabilities could potentially ascertain the presence or absence of this mysterious, still missing, and critically important lead bullet from the crime lab forensic bag of evidence. Taking this equipment to respectfully hover over and look down into Vincent's grave to determine whether there is a lead bullet would be extremely important. If a bullet is present, that would eliminate the knife theory completely.

If the equipment could determine the size and caliber of the lead metal fragment and confirm it was a 7mm bullet, then it would be possible to confirm that it could fit the old rusted revolver that the Van Gogh Museum claims is the gun that was used in Vincent's death. Though even if it is a correct fit, that still does not confirm whose gun it was for certain and, most importantly, who used it to shoot Vincent! What is the way forward here? Basically, someone needs to reexamine the body and the gravesite, and finally find this mysterious and still missing bullet.

End Game Forensics to Find and Analyze
The Missing, "*Magic*" Bullet

If necessary, a long, flexible endoscope could be respectfully snaked down through Vincent's burial site and into his coffin to find out what secrets he really took to his grave. Then the missing bullet could be measured, photographed, or even extracted for detailed analysis. If it is not a 7mm bullet, what caliber is it?

If it is .380 caliber (9mm short round), as René Secrétan confessed to owning in his last interview, then maybe the gun used was indeed the .380 pea-shooter that was "*borrowed*" from his hunting bag. That information would eliminate the old rusted Lefaucheux revolver. Was Secrétan telling the truth about Vincent taking his missing "*pea shooter*" gun?

We must also remember that Dr. Paul-Ferdinand Gachet retained his military service sidearm. So what gun did he choose to carry? What caliber was his sidearm? Did he have more than one gun, possibly? His son would most likely also have had access to his revolver. Of course, someone else could have bought an inexpensive "*varmint*" gun, readily available at hardware stores back then for five francs. The low-power .22 round would be the most likely to enter Vincent's body without creating an exit wound. Will putting the missing bullet into the crime lab's forensic evidence bag, if one exists, help us to eliminate any person of interest? Yes, possibly.

What If No Bullet, "*Magic*" or Otherwise, Is Ever Found?

If there is no bullet found, did the Gachet father-son team remove it and discard it at the time of the 1905 disinterment, when they moved Vincent's remains to his present location? Why would they remove the bullet—for a souvenir, guilt, or maybe because it was incriminating evidence? Maybe Johanna instructed Dr. Gachet to get rid of any evidence of foul play. It was too important to the legend of Vincent, the martyr for art, that the suicide myth be maintained at all costs.

But, if no bullet is found, maybe it was a knife thrust that eventually killed Vincent. Was it only a knife wound after all these years, and everyone assumed and suspected a gunshot wound because of the false narrative propelled by the murderer? Anyone could have easily committed this murder with a knife! It would have taken only a simple, single thrust into Vincent's gut, and the killer could let infection, peritonitis, and sepsis painfully finish him off. Using a knife to kill Vincent but blaming a gun for the fatal wound was a brilliant misdirection, sending the police and everyone else looking for that gun.

Exhumation, if undertaken now, would be able to analyze the size, condition, and caliber of any existing bullet. An additional advantage of exhumation would be a

modern necropsy analysis of Vincent's remains for an accurate assessment of his wound, depending on the condition of the remains. Paleo-anthropology-archeologists have developed extensive experience and expertise in analyzing those long dead, with limited residual satisfactory material. Also, a DNA sample may be useful for family tree analysis or confirmation of lineage and ownership rights to Vincent's stolen art.

What If a Bullet Is Found in Vincent's Remains or in the Casket?

If the Bullet Found Is a 7mm Caliber Bullet

The Belgian Lefaucheux folding trigger revolver, stated by the museum to be a 7.65mm caliber found in a wheatfield by a farmer many years after Vincent's murder, could be the murder weapon. A 7mm caliber bullet would confirm whether this is true.[6]

If the Bullet Found Is a .380/9mm Short Caliber Bullet

If a .380 caliber round is found, then that would increase the likelihood that Naifeh's analysis of René Secrétan as the shooter was correct.

If the Bullet Found Is Any Other Caliber Bullet

Or, if the bullet is found to be some other caliber, not a 7mm or .380 bullet, then we might have to suspect it would have had to come out of Gachet's gun. The police never checked that gun to see if it had been recently fired, because Dr. Gachet told them Vincent's case was a "*suicide*," and they accepted that fake narrative about the mad artist who cut off his ear from his doctor without serious investigation.

Now Where Is the "*Magic*" Bullet? Does It Exist?

If the Gachet team removed the bullet in 1905, that would raise questions and be very incriminating evidence against the black-hearted and evil Team. Did they do that? It is hard to know unless the search is properly made for that missing bullet.

To make a step in the direction of determining which gun was used to murder Vincent van Gogh, the bullet would have to be retrieved from his coffin and examined to determine its caliber and trajectory. Once that is confirmed, then finding a matching gun, if possible, will be huge step forward in resolving this case.

[6]There was no such round available in 1890 as a "7.65mm round black powder pin fire cartridge," though 7mm rounds were the equivalent.

At least for now, no analysis of caliber is possible. Maybe the bullet remains in the casket and the decomposed body, and the bullet that killed Vincent may yet remain undisturbed and available for analysis. How likely is that? Could it be retrieved, and the caliber determined?

What If There Was Never A Bullet Present?

Since a test bullet did come out the backside of the ballistic gel fired at point blank range, simulating an exit wound, then a knife wound is still a very viable possibility clinically and forensically. We may yet find a more plausible and acceptable ending to the saga of the final days of Vincent van Gogh. Or maybe not! To make any further progress, we really need to find that mysterious, missing, "*magic*" bullet if it exists in Vincent's grave to prove a gunshot wound was the lethal event. If no bullet is found, refocusing on the knife theory becomes paramount, and we should conclude tha the penetrating, mortal abdominal wound was created by a right-handed assailant plunging a short-bladed knife into the belly (right upper quadrant) of Vincent van Gogh.

An Archeological Autopsy

What if an archeological and anthropological autopsy is respectfully and carefully performed on Vincent's remains?

1. The importance of any bullet being present- or absent- has already been discussed.
2. The condition of his clothes, if he was buried in the clothes he was wearing when mortally wounded, is unknown. Was there a bullet hole? Was there any evidence of black powder on his clothes?
3. The skin, if present, even if terribly dried and/or discolored, would still confirm the exact point of the entry wound. If possible, and most importantly, the belly skin would confirm the presence or absence of any black powder residue impregnated in the skin. The black carbon tattoo will still be present on the residual skin unless the skin has fully decomposed.
4. If a bullet is present, is it still inside Vincent or just rattling around in his coffin free of his body? If present inside, can the forensic paleoanthropologist reconstruct anything useful to better understand Vincent's fatal wound.
5. If the bullet is outside of the remains, can the left ribs all be examined for any fractures, chips, or evidence of a bullet impact, as allegedly described which deflected the bullet trajectory downward?

Author's Alert: Another New Scenario

At the end of the day, there is still another compelling suspect for the van Gogh murder that has never been publicly voiced but soon will be. The argument for this suspect is being made by William Arnold (personal communications, July 2018), a veteran journalist and author of several bestselling novels who got hooked on the mystery in Auvers after being hired to write a screenplay for a Dutch van Gogh biopic that was planned to be released on the 100th anniversary of Vincent's death in 1990. That film was never made, but Arnold's research soon convinced him the suicide was a murder. He would spend a good deal of the next 30 years investigating every aspect of the crime and its cover-up.

The death scenario Arnold now embraces largely parallels and supports the case against the Gachets, but then takes the inquiry into a whole new and mind-boggling dimension. The result of his long journey will soon be on view in *Exile in the Light* (in press, 2019), an epic mystery-thriller set not in Vincent's time, but in 1955 Paris during the controversy over the Gachet donations, the filming of *Lust for Life*, and the surprise appearance of the last witness to the Auvers death scene. Described by one early reviewer as *"the Da Vinci Code of Vincent van Gogh,"* the book weaves its body of authentic new evidence into a fictional detective story about the hunt for, and impact of, an explosive last van Gogh letter that Arnold contends really came to light during this period in the mid-50s and was ruthlessly suppressed by the French Government (*ibid.*). To back up and give credibility to his novel, Arnold is also publishing a nonfiction companion book, A Death in Auvers: The Strange Suicide of Vincent van Gogh (forthcoming early 2019). In three parts, it tells the real story behind his novel as journalism, as personal memoir, and as recorded via interviews and transcripts with former French intelligence agents.

My Review and Comments on *Exile In The Light* and *A Death In Auvers: The Strange Suicide Of Vincent Van Gogh*

It's not fair to comment on books that have not yet been published (or to reveal the climax of a story that is basically a whodunit), but I have read an early version of the novel that was briefly on Amazon as a *"test run,"* and I've also read excerpts of some of the interviews that were posted on Arnold's website. I had the pleasure of discussing this most intriguing alternative path to Killing Vincent with William Arnold himself (*ibid.*). I can say his book was an exciting page-turner of a murder mystery, with lots of unanticipated twists. It is apparently based on critical interviews with surviving French Secret Service agents many years later that tell an amazing follow-up to the death of Vincent van Gogh.

Never-Ending Mysteries Continue to Surround Vincent van Gogh into the 21st Century

Continued From Page x. The unusual photo is of great interest to all van Gogh lovers, as one would definitely love to know what Vincent really looked like. The organizations PetaPixel and Hyperalllergic believe the image is, *"still of significant historical value and only time will tell if experts reach a consensus in the identities of everyone depicted."* Use the URL below to view the image...

https://hyperallergic.com/216134/newly-discovered-photo-offers-a-glimpse-of-van-gogh-gauguin-and-other-drunk-artists/

The Van Gogh Museum Photo Expert's Conclusions:

1. It can't be the artist *"because it simply does not look like him."*
2. Vincent abhorred photography and adamantly avoided having his picture taken.
3. Van Gogh didn't mention the gathering in his letters from the time period.

My thoughts:

1. Based on these images, the person in the photo does not look like either of the Vincents in the two most realistic portraits, unless Vincent notably added weight, particularly to his face. In both of these portraits (Figures 5 & 6, Chapter 1) Vincent's face is long and thin face with a bony structure much like an ectomorph, but in the photo his face is full, too squared off, and has the bony structure of a mesomorph. It just does not look like Vincent.

2. Vincent viewed photography almost like cheating. The fact that the photo shows a man comfortably leaning back in his chair smoking is another big negative to the validity of the unsubstantiated claim that this photo includes Vincent.

3. Though Vincent didn't mention the gathering in his letters, it is improbable that he would have written about this event to anyone other than Theo, who he was living with at the time. Theo who would have cared about this meeting, but probably would have heard about that evening directly from Vincent.

4. Vincent was accepted as right-handed, so the fact that Vincent is holding his pipe in his left hand while his right hand is tucked inside his coat, Napoleon-like, when one typically holds his pipe in his dominant hand also seeks to discredit the legitimacy of the photo.

5. One could expend considerable effort to do facial recognition analysis on all three *"photo-images"* to determine the correlation among these various images and determine a percentage probability of a *"match"* or not.

6. Are there any notes from the photographer or the gallery where these artists were exhibiting and hanging their art? **I don't believe this is a photo of Vincent van Gogh**!

Part VIII

Appendix
Supporting Evidence and Related Documents

Chapter Twenty-Six

Forensic Expert, Vincent J.M. Di Maio MD, Letter To Steven Naifeh, June 24, 2013

VINCENT J.M. DI MAIO, M.D.
CONSULTANT IN FORENSIC PATHOLOGY
10 CARRIAGE HILLS
SAN ANTONIO, TEXAS 78257
(210) 698-1400
FAX (210) 698- 3809
Email: vincent_dimaio@yahoo.com

June 24, 2013

Steven Naifeh
Woodward/White
237 Park Avenue, SW, First Floor
Aiken, SC 29801,

Re: Death of Vincent Van Gogh

Dear Mr. Naifeh:

As requested, I have reviewed the following materials in regard to the death of Vincent Van Gogh:

1. Your book, specifically Chapter 43 and the Appendix
2. the article The Life and Death of Vincent van Gogh by Louis Van Tilborgh and Teio Meedendorp (translated from the Dutch by Michael Hoyle) published in The Burlington Magazine • CLV July 2013

You have also informed me that the general consensus is that Van Gogh was right handed.

In your book you state that: The first physician to see Van Gogh was Dr. Mazery. He descried the wound as just below the ribs, about the size of a large pea, with a dark red margin and surrounded by a blue halo. The wound path was apparently downward.

The Burlington Magazine article states, in the footnotes on page 459, that the wound was examined "on the spot" by Dr. Paul Gachet and a local doctor, presumably Dr. Mazery. Then, allegedly based on their findings, which were "probably written down but later lost", Victor Doiteau and Edgar Leroy described the wound in a book published in 1928. They described the wound as being "along the side of the left ribs, a little before the axillary line'.

Based on this information, it is my opinion that, in all medical probability, the wound incurred by Van Gogh was not self-inflicted. In other words, he did not shoot himself.

There are a number of reasons for my opinion:

The first is the general location of the wound. If you accept the description of Dr. Mazery, the wound was in the abdomen, just below the ribs. Based on a review of 797 suicides using

handguns by Molina and DiMaio (Handgun Wounds: A Review of Wound Location, Range of Fire and Manner of Death, in press), 1.3 % of self-inflicted handgun wounds were in the abdomen.

If you accept the description in the article by Louis Van Tilborgh and Teio Meedendorp that the wound was of the left chest then the article by Monina and Di Maio states that suicidal gunshot wounds of the chest with handguns accounts for only 12.7 % of cases.

Thus, in both scenarios, the general location of the entrance wound is unlikely.

Second is the precise location of the entrance. The reference by Van Tilborgh and Meedendorp states that the wound was "a little before" the axillary line on the left side. Please note in Figure 1 the location of the anterior axillary line . It would be extremely difficult to shoot oneself in this location with the left hand. The easiest way would involve putting one's fingers around the back of the grip and using the thumb to fire the gun. One might grasp the gun with the right hand to steady it. In such a case, one would have "powder burns" of the palm of the hand grasping the body of the gun.

Using one's right hand is even more absurd. You would have to put the right arm across the chest and again place one's fingers on the back of the grip and use the thumb to fire the gun. One might then grasp the gun with the left hand to steady it. In such a case, one would have "powder burns" of the palm of the hand grasping the body of the gun.

Anterior axillary line

Middle axillary line

Figure 1

In both scenarios, the muzzle of the gun would have to be either in contact with the body or at

most a few inches away.

This brings me to the other, and most important, reason the wound was not self- inflicted

Mention is made of a small wound with a red to brown margin and a purple ring around the wound. The purplish ring is said to be due to bullet impact. In fact, this is subcutaneous

bleeding from vessels cut by the bullet and is usually seen in individuals who live awhile. Its' presence or absence means nothing. The brown rim or dark red margin around the entrance is an abrasion ring and seen around virtually all entrance wounds. It just indicates an entrance.

The most important aspect of the entrance is what is not there. Handgun cartridges at this time (1890) were loaded with black powder. Smokeless powder had only recently been developed (1884) and was used in only a few military rifles. Black powder is extremely dirty. On burning 56% of its mass is solid residue. Close range wounds from black powder are extremely dirty (Figure 2). If he shot himself, Van Gogh would have held the muzzle of the revolver at most a few inches away, most probably it would be in contact with the body. This is due to the location of the wound. In such a case, there would have been soot, powder tattooing and searing of the skin around the entrance. These would have been grossly evident. None of this is described. This indicates the muzzle was more than a foot or two away (closer to two rather than one).

As to statistics on range in suicidal gunshot wounds, 96% are contact and 2.5% intermediate (show evidence of powder tattooing but are not contact).

Figure 2: Range 6 inches. Shot On left
black powder; on right smokeless power

In summary, based on the medical description of the wound, it is my opinion that, in all medical probability, Van Gogh did not shoot himself.

Sincerely,

VINCENT J.M. DI MAIO, M.D.

Chapter Twenty-Seven

Additional Forensic Evidence to Support the Dr. Di Maio Conclusion that Van Gogh Did Not Commit Suicide

The Forensics Study Details

Objective: This study was designed to confirm the conclusions previously stated by Dr. Di Maio and Dr. Arenberg in previous chapters.

Materials: Lefaucheux 7mm Folding Trigger Revolver. This revolver is the same model as the gun implicated in Vincent's death by the Van Gogh museum. A 7mm Lefaucheux folding trigger gun with a rifled barrel utilizes 7mm pinfire black powder bullets (see Chapter 11 for more details about the pistol).

The Bullets: Pinfire, Black Powder, 7mm Vintage Bullets Approximately 100–150 Years Old, various manufacturers. (See Chapter 12 for more details about the bullets and powder burns from up close and personal weapon discharge near to the skin).

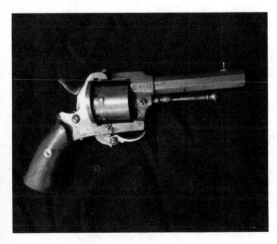

Fig. 188. 1850's **Lefaucheux Revolver**

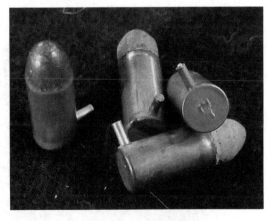

Fig. 189. **7mm pinfire bullets**,
Note: headstamp 7

The Range Of 7mm Pinfire Bullets Available In Late 19Th Century

Ref #	Size	Power Grain	Bullet Weight	Head-stamp	Manu-facturer	Notes
2951	7mm	5.4	48.7	BB	Bruan & Bloem	ball
2384	7mm	6.4	47.7	BB 7	Bruan & Bloem	ball
12302	7mm	6	53.6	7 SB	Sellier & Bellot	ball
569	7mm	4.7	60	CF	Charles Fusnot	ball
2406	7mm	5	55	BB 7	Bruan & Bloem	ball
1045	7mm	4	65.1	7 Eley	Eley	ball
3936	7mm	5.2	63.6	Kynoch 7m/m	Kynoch	ball

Ballistic Gel: FBI Forensic-Grade Clear Ballistic Gel, Manufactured By www. ClearBallistics.com, In Slabs Of 6 x 6 x 24 inches *"The Clear Ballistics gel is a modern-day ballistic gel, is 100% synthetic, and contains no organic materials. It is as perfectly clear as glass and mimics human tissue perfectly."*

Cotton Material: 100% Blue Cotton Shirts

Paper Targets: (Vincent van Gogh trying to shoot himself) Artist-Rendered

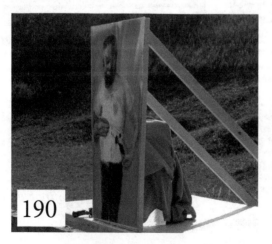

Figs. 190, 191. **Artist rendered paper target** *used for forensic tests. Art by Darrell Anderson.*

Methods

Day One: I test fired the vintage bullets at custom targets made to look like Vincent, which were marked with all the known forensic data (Figure 160). I fired again at the paper target over the ballistic gel blocks, with a cotton shirt over the gel to simulate what Vincent may have been wearing on the day he was wounded. By placing these targets on a safe firing range at several reasonable distances, and with a range safety officer present, I was able to perform the several live fire studies without incident or malfunction even though both the revolver and the bullets laid dormant for well over 100 years.

Day Two: Similar to day one—I took multiple shots in sets of three at the same gel target covered with cotton at point blank range, six inches, 12 inches, 18 inches, and 24 inches away (the paper target was not used on day 2).

Observations, Results, and Analysis

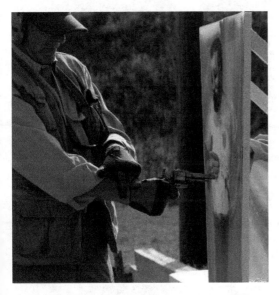

*Fig. 193. **Point Blank - Day 2**. These blue shirts were used to simulate Vincent's clothing. They were placed over the point of impact, or bullseye, on the ballistics gel laid flat/horizontal. The depths of penetration can be easily measured this way in the horizontal gel as the bullet remains entrapped in the gel. Only a much more powerful (military), modern bullet could be expected to exit this set up.*

*Fig. 192. **Point Blank -Day 1**. Shooting the paper target with cotton shirt covering FBI ballistic gel. Note the gel block is stood vertically. When the revolver was test fired, the 7mm bullet went all the way through the gel; creating an unexpected exit wound. (Would the bullet have gone all the way through Vincent if he was shot point blank?)*

Footnote: The range of variation in power and weight, even by the same manufacturers, confirms there were no accepted standards at that time. All 7mm bullets were equivalent, and any 7mm pinfire bullet would fit in this same gun.

Analysis and observation of each sequence (photos/videos) and visual pertinent comments of the cotton fabric and the gel itself can be viewed in unedited detailed videos on website.

Also, measurements of the length of penetration into the gel, for each of 3 firings including point blank, six inches, 12 inches, 18 inches, 24 inches away.

The Point Blank Reenactment

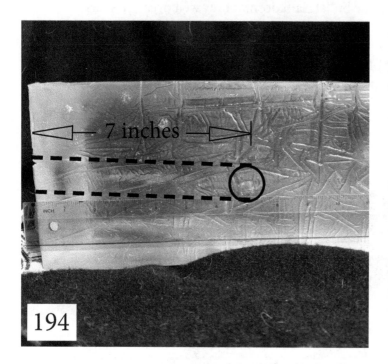 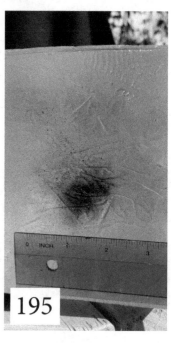

*Figs. 194, 195. **7mm pinfire bullet path in ballistic gel**. Dotted lines show the trajectory. The circle is the resting location of the bullet; 7 inches away from the impact point (194). The facing edge of the ballistics gel showing the entrance wound and the powder burn (195). Photos by Edward Kobobel.*

 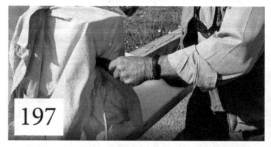

*Figs. 196, 197. The above images **demononstrate a simulation of the knife thrust into the same setup** as the gunshot. Both the point blank results and the possibilty of the pea-sized wound being a knife wound is 50/50 until a bullet is produced. There were no witnesses, no gunshot was heard, and no bullet has ever been recovered. Photos by Matt Sebesta.*

Point Blank Shots

Day 2 - Shot 1 Sequence (Figs. 198-203)

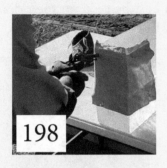
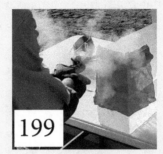
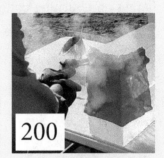

Day 2 - Shot 3 Sequence (Figs. 204-209)

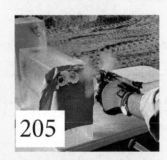
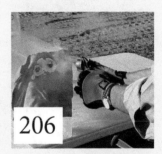

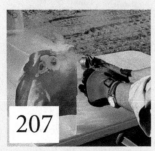
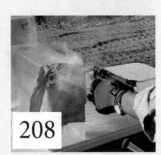

Details of the Burn Damage to the Cotton Shirts and Ballistic Gel at Point Blank Range

Note the burning of the cotton shirt from the over 100-year-old vintage black powder bullets that may have lost some explosive fire power, but worked just fine for these tests. Red flames and burning cotton at point blank range can best be seen on the original videos at www.killingvincent.com/forensics (See Figures 210-215).

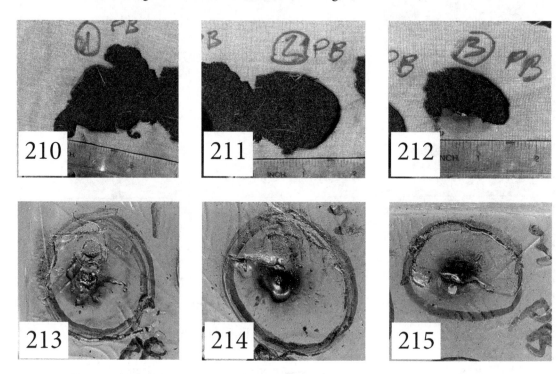

All shots in ballistic gel thru the cotton shirt—you can easily see the residual powder burn.

The Six-Inch Reenactment

Fig. 216(A,B). **Image from Video at six inches away (Day 1) shows an overview of the setup.** *Note the flame from the explosion of the gunpowder.*

6-Inch Shots

Day 2 - Shot 1 Sequence (Figs. 217-222)

Day 2 - Shot 2 Sequence (Figs. 223-228)

Day 2 - Shot 3 Sequence (229-234)

Details of the Burn Damage to the Cotton Shirts and Ballistic Gel at Six-Inch Range

At six inches away, we saw a powder burn that was four inches in diameter, and the cloth was noticeably singed. You can view the video online (Figs. 235-240).

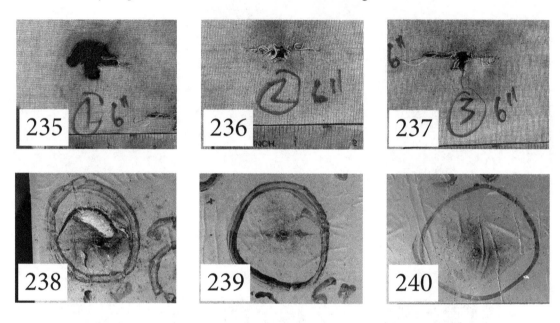

The 12-Inch Reenactment

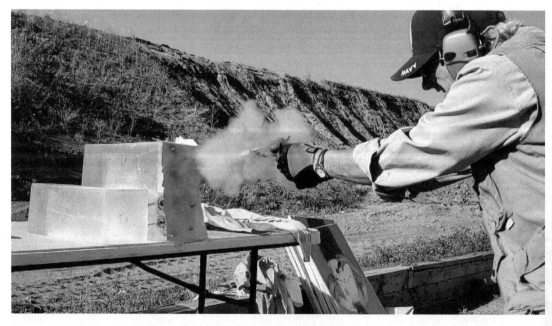

*Fig. 241. **Reenactment of 12-inch setup and firing** 7mm Lefauchex Revolver.*

12-Inch Shots

Day 2 - Shot 1 Sequence (Figs. 242-247)

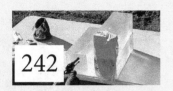 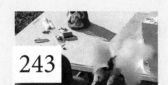 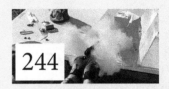

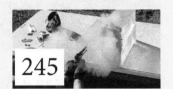 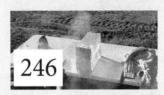 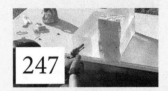

Day 2 - Shot 2 Sequence (Figs. 248-253)

Day 2 - Shot 3 Sequence (Figs. 254-259)

Details of the Burn Damage to the Cotton Shirts and Ballistic Gel at 12-Inch Range

At 12 inches away, we saw much less damage; hardly any black powder comes in contact with the cloth. You can view the video online (Figs. 260-265).

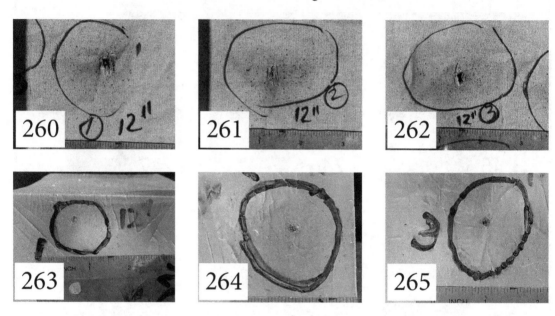

The 18-Inch Reenactment

Day 2 - Shot 1 Sequence (Figs. 266-271) During this test fire, the bullet hit the target but then bounced off and did not penetrate the shirt or ballistic gel.

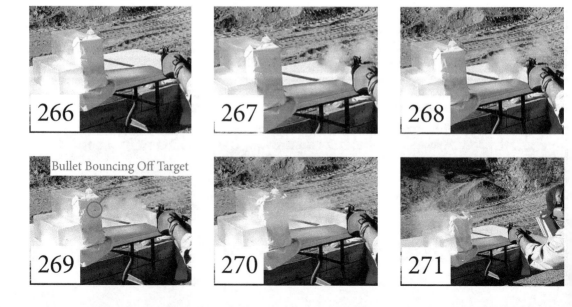

18-Inch Shots

Day 2 - Shot 2 Sequence (Figs. 272-277)

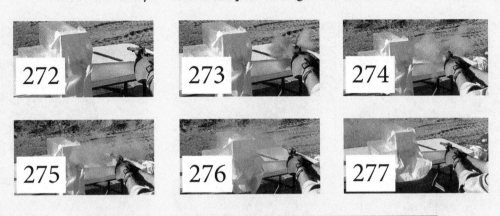

Day 2 - Shot 3 Sequence (Figs. 278-283)

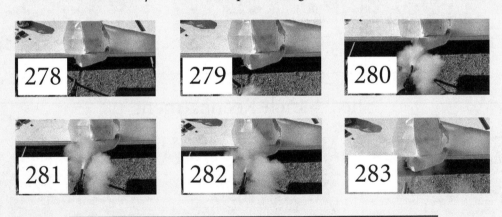

Day 2 - Shot 4 Sequence (Figs. 284-289)

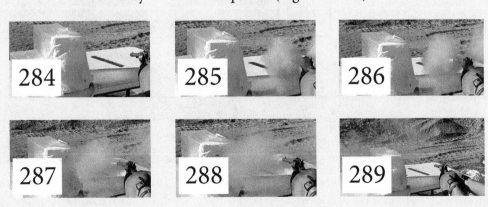

Details of the Burn Damage to the Cotton Shirts and Ballistic Gel at 18-Inch Range

Minimal, but still present evidence of a powder burn, suggesting the Vincent's murderer had to be more than 18 inches from him when the revolver was discharged.

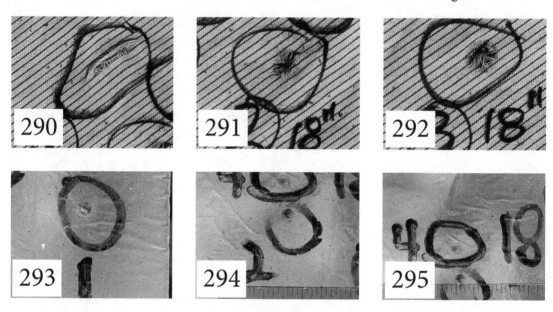

The 24-Inch Reenactment

Figs. 296-299. **Reenactment:** *First the setup, two feet away (296). Then the actual firing at two feet away (297). A small bullet hole in cotton cloth and spread-out black powder, or stippling (298). Shot at two feet away, the shirt moved (see video at www.killingvincent.com/videos) (299).*

24-Inch Shots

Day 2 - Shot 1 Sequence (Figs. 300-305)

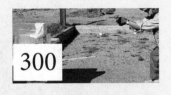
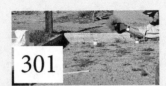

Day 2 - Shot 2 Sequence (Figs. 306-311)

Day 2 - Shot 3 Sequence (Figs. 312-317)

Details of the Burn Damage to the Cotton Shirts and Ballistic Gel at 24-Inch Range

Even at 24 inches, there is still some dirty powder residue on the cotton shirt. This strongly suggests that the murderer was two feet or more from Vincent's belly.

Discussion

You can see that, at both point blank range and six inches away, the powder burn is most evident. As one goes further away, the amount of powder burn and skin damage will diminish. You can still see the evidence of the dirty powder even out to 24 inches, but its presence notably decreases. Now you are starting to see stippling.

This chapter provided supplemental forensic evidence to Chapter 22 as an important portion of the data available to support Dr. Di Maio's conclusion that "*within a reasonable degree of medical probability, Vincent van Gogh did not commit suicide.*" I hope this extensive data is sufficient to satisfy you, the jury in the court of public opinion, that it is virtually impossible for Vincent to have positioned the muzzle of the gun close enough to the accepted entry wound and actually fire the weapon himself, so that the bullet ended up near his spine and great vessels. This provided Dr. Gachet an "*excuse*" to not try to remove the bullet, if there was one, or move him expeditiously to a Paris hospital with war trained surgeons available, who might have been able to save his life from his non-lethal wound.

If Vincent was able to succeed in such an extremely challenging physical act, he absolutely would have sustained a notable powder burn on his skin that even the most casual observer could not have missed reporting. If you need additional forensic evidence, the

website www.killingvincent.com has an extensive group of videos from which we pulled some single frames for this chapter. All of this video footage and photo imaging data can be found under the "*Videos*" and "*Forensics*" tab, so any enthusiasts or "*gumshoes*" who wish to explore and study all of the available data collected may do so at their leisure. There are some very intriguing videos of reenactments at several distances where you can see the bullets in flight, the explosive flames, the powder burning the cotton shirt, and other unique observations that are much more definitive than the single frames/ out-takes shown in this book.

Chapter Twenty-Eight

Corroborating Expert Statements In Support Of Dr.
Di Maio's "Beyond Reasonable" Doubt Statement.

Homicide Detectives, Ron Relf (Ret) January 10, 2018.
Cold Case Investigator. Marv Brandt (Ret) March 13, 2018

DENVER POLICE DEPARTMENT
CITY AND COUNTY OF DENVER

Detective Ronald Relf 82069 (ret)
Assault/Homicide

Police Administration Building
1331 Cherokee Street
Denver, CO 80204
(303) 640-3541 / Pager (303) 860-5752

Metro/SWAT Bureau
550 East Iliff Ave
Denver, CO 80210
(303) 871-8888

January 10, 2018

Dr. Arenberg,

Thank you for the opportunity to review the facts regarding the death of Vincent van Gogh as to whether it was suicide or murder. The forensic analysis provided by Dr. Di Miao demonstrates that it was very unlikely that van Gogh shot himself. If suicide is not a probable conclusion, then murder, whether accidental or intentional, must be considered.

Because of the limited forensic information, and the unlikelihood of new forensic evidence coming forward, it is reasonable to consider that there are many other un-answered questions surrounding van Gogh's death and I would not be comfortable writing this case off as a suicide. Therefore, it is reasonable and prudent to recommend this investigation remain open solely as an academic historical cold case.

This is particularly true since no gun was in van Gogh's possession, and no gun was discovered at any potential crime scenes. Until a deeper investigation of all persons of interest surrounding van Gogh's death has been fully completed, this academic and historic cold case should remain open.

If the bullet was recovered from van Gogh's body, it could help in determining if the old rusted gun discovered in a Auvers Wheatfield, in the 1950s, was the gun that killed van Gogh.

Detective, Ronald Relf (retired)

March 13, 2018

Scottie: Since I am retiring tomorrow, I really don't want to be working on this case, I am going to be busy doing retirement things. If you contact him, you can tell him the following:

 1- After reading this case and from the information I gathered, this appears to be an accidental shooting. Someone shot him from a short distance, not close enough to leave powder burns, or gunshot residue. I can only assume someone was pointing a gun at him playing some type of game and thinking the weapon did not have ammo, fired the weapon. My reason for believing this is if someone wanted to kill van Gogh they would have shot him more than once and made sure he was dead, so he could not tell authorities who shot him. Even if there was only one bullet available, I am sure other means of death were available. The person who shot him simply ran off.

 2- It was not a suicide because of the location of the entrance wound, lack of stippling, or lack of residue or powder burns. The fact that van Gogh was right handed, and the location of the wound was in such an odd area makes it very difficult shoot one's self without leaving these markings. You don't normally shoot yourself in the stomach or side if you were committing suicide.

 3- There was no note, no gun found, he did not have access to a gun. No crime scene was located. I am sure the van Gogh knew who it was that shot him but because he probably thought it was an accident didn't wish to report that person. Likewise, the person who shot him was scared and afraid he was going to get into trouble, so therefore if there were no witnesses, evidence, etc., this person kept his mouth shut'

Scottie, I believe this is what happened, not because I was there but because the evidence or lack of evidence shows that is what happened.

Marv Brandt
Investigator Cold Case Unit
Investigation Services
13101 E. Broncos Parkway
Centennial, CO 80112

Part IX

Afterword

Chapter Twenty-Nine

Often-Asked Questions About My Fascination With Vincent: My Homage To Vincent Van Gogh

This "*homage*" to Vincent van Gogh hopefully answers your questions and establishes my personal appreciation for and connection to the famous artist over the years. As both a fan and an early investigator attempting to solve the puzzle of van Gogh's misdiagnosis as well as the unlikeliness of his commiting suicide, this book is my tribute to Vincent's genius and his art, and reinforcement to his legacy.

I had the pleasure of sharing a dinner with a sweet six-year-old granddaughter of a dear old friend this past spring, and she had already learned about Vincent in her first-grade art class. When asked what she had learned in school that week, she told us excitedly, without any prompting, that she had learned about van Gogh from her art teacher. Vincent would no doubt be thrilled to find that he and his art are so widely loved and studied now, over a century after his unfortunate death. However, he may not be thrilled to learn about the untrue narrative of his suicide that has been passed down to the new generations.

This was basically the simplified story told to me by this very savvy and articulate first-grader:

> *"Vincent van Gogh was a very strange Dutch painter that suffered from fits. This drove him into a state of madness. He was crazy and cut off his own ear. He put himself into a funny farm. When he got out, he shot himself."*

While understandably brief and simple, this is a typical example of the common (mis) understanding of Vincent's life and death by so many.

In this book I present alternative possibilities for you to consider, in the hope that I can convince you, the readers, that at least one of these scenarios is a realistic alternative to suicide. I tried to play devil's advocate as I explored each of these

different possibilities, no matter how unlikely they may seem, and despite my inherent bias. My goal is to ultimately exonerate poor Vincent from the stigma—going against his character, his beliefs, and his religion—that he committed suicide, which was a known crime in his day should he have survived.

Over the years, since van Gogh first captured my interest in my youth, I have made many pilgrimages all over the world to see exhibitions of his work in museums and special curated shows. I was even lucky to catch one in Tokyo in December 1985, when I was there giving an unrelated lecture. I also enjoyed a recent exhibition in my home city of Denver, at the *Denver Art Museum*, titled *Becoming van Gogh*. The show, curated by Timothy Standring and Louis van Tilborg, was particularly brilliant, not only because of the selection of Vincent's earlier art but also because of how the work was displayed and discussed in the exhibition catalogue, focusing on the evolution of the artist's skills and technique (2012). I hope to see much more of Vincent's work here in Denver.

Fig. 324. **The young author** *and his first face to face homage with Vincent, 1966*

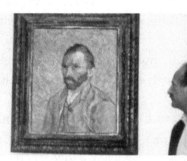

Fig. 325. **Another visit and sustained homage,** *1990*

Fig. 326. *The* **author paying homage to Vincent** *at the Musee d'Orsay, Paris, on one of his many such tribute visits over the years, (1966, 1972, 1973, 1975, 1982, 1985, 1990, 1996, 2001, etc)*

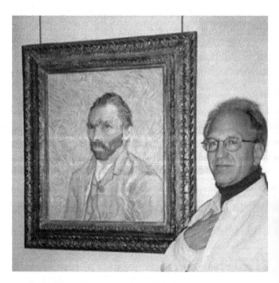

Fig. 327. **The author paying homage to Vincent** *at the Musee d'Orsay, Paris, on one of his many such tribute visits over the years, circa 2001.*

I have many photos documenting the homage I pay to Vincent whenever I have an opportunity. In truth, I have long been fascinated by his life story and his art, but I was also always fascinated by his death and the accepted story that he committed suicide as a martyr for his art. Something about the suicide narrative just *"smelled funny"* and did not fit together easily for me. I never personally believed that he committed suicide.

In the late 1980s, when I delved deep into Vincent's history, I decided to help van Gogh and his legacy, at least to have the benefit of a modern and correct diagnosis. I was limited, when I made the diagnosis of Meniere's disease in 1990, to only three pages to address the correct clinical diagnosis, and to override the longstanding but incorrect diagnosis of epilepsy. This article was published as the cover story and *"Special Communication"* in the prestigious *Journal of the American Medical Association*, a peer-reviewed medical journal (*JAMA*, July 25, 1990), on the 100 year anniversary of Vincent's death. On the day of the publication of this *JAMA* article, I was invited to New York for a live interview with Paula Zahn on *CBS This Morning* (July 25, 1990).

Fig. 328. Vincent van Gogh's diagnosis of Meniere's disease and not epilepsy
as the basis for his violent attacks in his last few years was discussed on the day
the article was published in the Journal of the American Medical Association (JAMA), 1990.
I. Kaufman Arenberg interviews with Paula Zahn, CBS This Morning,
July 25, 1990. (*www.killingvincent.com/videos*)

Now, having corrected one of his medical diagnoses explaining his *"attacks"* and hallucinations as the result of an inner ear disorder and not epilepsy, I can now try to focus on exonerating him from that mistaken concept of death by suicide with a new perspective and forensic analysis of his death as an unsolved homicide; an honor killing and premeditated murder.

Part X

Selected Bibliography

Additional Author's Note

Fig. 329. **Dr. Arenberg in front of his library** *accumulated over many years of late 19th century to early 20th century art with a major focus on Vincent and his colleagues.*

Much of this list of references in this selected bibliography is drawn from my extensive personal art history library, which I have accumulated over many years and consulted frequently over those many years as I pursued my fascination with and research on Vincent van Gogh and the art of the late 19th century. Much of the information for this book was found in the standard sources listed below. The below list encompasses more than the sources referenced specifically in this book. Consider the titles below as previously consulted, but not necessarily cited. Much of the information in this book appears in many sources and has entered widespread public knowledge. Those readily accepted facts about van Gogh's life have therefore not been cited within the text.

I have cited only specific references when I believe it is necessary to better explain where a concept or a quote came from, to drive home a significant point that has not been as strongly emphasized in the past, or to supply additional clarification. Previous scholarship has been used to confirm or add greater depth to certain aspects of my non-fiction historical analysis of the mysterious death of Vincent van Gogh.

The present effort on understanding these mysterious circumstances surrounding his death, as you will see, has very little value derived from Vincent's letters. None of his letters actually apply to his last few days alive in Auvers-sur-Oise, France, or shed light directly on his death. There is nothing specific to the circumstances surrounding his unexplained death that can be gleaned from his many available letters, unless there are missing letters that we are not privy to (Chapter 21).

The secondary sources most relied upon, are marked with an asterisk (*). I apologize for any errors or omissions and in the next printing will correct any errors brought to my attention (ika@killingvincent.com). I thank you in advance for your indulgences.

Van Gogh's Letters

*Johanna van Gogh-Bonger, (Introduction) *The Complete Letters of Vincent van Gogh, Volumes I, II, III*, The New York Graphic Society (Greenwich, CN), approved English Edition with reproductions of all the drawings in the correspondence, 1958. (NOTE: Citations in the text are indicated by the assigned number of the letter and the month and year of the letter when vailable.)

The Complete Letters of Vincent Van Gogh: Volume 1-3. New York: New York Graphic Society, 1953.

*van Gogh, V., *Letters of Vincent van Gogh 1886-1890, A facsimile edition I and II*, Scholars Press, London, 1977.

De Leeuw, Ronald editor. *The Letters of Vincent Van Gogh*. Translated by Arnold Pomerans. London: Penguin Books Ltd, 1996.

Jansen, Leo, Luijten, Hans, Bakker, Nienke, *Vincent van Gogh-The Letters; The Complete Illustrated and Annotated Edition*, Thames and Hudson, Volumes 1-6, 2009. (Author's note: This is not an easy system to identify the old letters by their prior, earlier designations in these new translations, so I continued to use the old numbering system).

Lord, Douglas, *Vincent Van Gogh Letters to Emile Bernard*. the Museum of Modern Art, New York, (1938), The Chiswick Press LTD. Great Britain, 1937.

*Van Gogh, Theo, Bonger, Jo, Van Gogh, and Crimpen, Han (Introduction) *Brief Happiness, The Correspondence of Theo Van Gogh and Jo Bonger*, Waanders Publishers, Zwolle, 1999.

Art Exhibitions and Catalogues

*Barr, Alfred H. (Jr.), *Vincent van Gogh, The Museum of Modern Art*, New York, Spiral Press, New York, 1935.

Cachin, F. Welsh-Ovcharov, B., *Van Gogh a Paris, Editions de la Reunion*, Paris, 1988.

*Distel, Anne, Stein, Susan Alyson, *Cezanne to Van Gogh, The Collection of Doctor Gachet, Exhibited at the Metropolitan Museum of Art*, May 1999, Harry N. Abrams, New York, 1999.

*Kendall, Richard, Van Gogh's *Masterpieces from the van Gogh Museum Amsterdam*, National Gallery of Art, Washington, Harry N. Abrams, Inc., New York, 1998-1999.

*Leeuw, Ronald de, *Van Gogh at the Van Gogh Museum*, Waanders Drukkers, Zwolle, 1994.

Marceau, Jo, (editor), *Van Gogh, A Profound and Tormented Genius*, Leonardo Arte, s.r.l. Milan, 1998.

*Mayekawa, S., *Vincent Van Gogh Exhibition*, National Museum of Western Art, Tokyo, 1985.

*Pickvance, Ronald, *Van Gogh in Arles*, The Metropolitan Museum of Art, Harry N. Abrams, Inc, Publishers, New York, 1984.

*Pickvance, Ronald, *Van Gogh In Saint-Rémy And Auvers*. The Metropolitan Museum of Art, Harry N. Abrams, Inc, Publishers, New York, 1986.

*Standring, Timothy J, van Tilborgh Louis, editors. *Becoming Van Gogh*. Denver Art Museum: Yale University Press, London, 2012.

van Tilborgh, Louis, Sale, Marie-Pierre, *Millet-Van Gogh, Musee d'Orsay*, 1998-1999. Ed. Reunion, Paris, 1998.

….Vincent van Gogh; *Detailed catalogue Kroller-Mueller National Museum*, 1980.

van Uitert, E., van Tilborgh, L., *Vincent van Gogh; Drawings*, Rijksmuseum Vincent van Gogh, Amsterdam, March 3th-July 29th, 1990, Arnoldo Mondadori Arte, 1990.

Historical Narratives and Fiction

*Arnold, William, *Exile in the Light*, in Press, 2019.

*Cooperstein, Claire. *Johanna: A Novel of The van Gogh Family*. Scribner, New York, 1995.

*Fell, Derek. *Van Gogh's Women: His Love Affairs and Journey Into Madness*. Robson Books, Ltd., London, 2005.

*Richman, Alyson, *The Last van Gogh*, Berkley Books, New York, 2006.

*Saltzman, Cynthia, *Portrait of Dr. Gachet*, Penguin Books, New York, 1998.

*Stone, Irving, *Lust for Life*, a novel about Van Gogh, Longmans, Green and Co, New York, 1934.

*Stone, Irving, *Dear Theo: The Autobiography of Vincent Van Gogh*. Doubleday & Company, New York, 1937.

-----*Dear Theo, The Autobiography of Vincent Van Gogh*, Signet Book, New York, 1969.
----- *Lust for Life, 50th Anniversary Edition*, New American Library, New York, 1984.
----- *Lust for Life*, Pocket Books, New York, 1972.
----- *Lust for Life*. Doubleday and Company, Inc., New York, 1961.
----- *Lust for Life: A Novel About van Gogh*. The Heritage Reprints, New York, 1953.

*Wallace, Carol, *Leaving Van Gogh*, Amazon Kindle, 2011.

Articles

*Aurier, Albert-Gustave, "*The Isolated Ones*" **Mercure de France**, V.1,1890.

*Bell, Bob Boze, *A Murder of Crows. Vincent van Gogh vs Rene Secretan. July 27, 1890 in Classic Gunfights*, **True West Archives**, p. 32. 2011.

*Carrie-Ravoux, Adeline, *Letter from Adeline Ravoux to {those} in Auvers-sur-Oise, 1956, Memoirs of Vincent van Gogh's stay in Auvers-sur-Oise*, **Les cahiers de Vincent van Gogh**, no. I, p. 7-17, 1956.

*Doiteau, V. "*La Curieuse figure du Der. Gachet*", **AESCALAPE**, August 1923.

*Doiteau, V, Deux *"copains" de Van Gogh, inconnus, les frères Gaston and Rene' Secretan, Vincent, tel qu'ils l'ont vu {Two "friends" of van Gogh, unknown, the brothers Gaston and Rene' Secretan, Vincent, such as they saw him}*, **AESCALAPE**, 40, p. 39-54, March 1957.

*Gachet, Paul, *Les médecins de Théodore et de Vincent van Gogh {The doctor of Theodore and Vincent van Gogh}*, **AESCALAPE**, 40, p. 52, March 1957.

Gastault, Henri, *La Maladie de Vincent van Gogh Envisagée a la Lumière des Conception Nouvelles sur l'epilepsie Psychomotrice*, **Ann Med-Psych**, 114, p.196-238, February 1956.

*Gauthier, Maximilien, *La Femme en bleu nous parle d l'homme 'a l'oreille coupée*, **Les Nouvelles Littéraires Artistique et Scientifiques**, 16, p. 1-6, April 1953.

*Hohmeyer, Jürgen {after interviewing Mattathias Arnold from Munich, the finder of the missing letter T41a}, *Ruhe im Zusammenbruch, (Calm in Collapse)*, **Der Spiegel**, 4: p. 168-181, January 22, 1990.

*Lacayo, Richard, *The Stranger; A New Look at van Gogh's life--and death.* **TIME**, v.178, (17), p. 63-66, October 31, 2011.

*Mothe, Alain, *The Last Summer of van Gogh, The Painters at Auvers*, **Beaux Arts magazine**, p. 36-57, April 1994.

*Nickell, Joe, *The Murder of Vincent van Gogh*, **Skeptical Inquirer**, October, 2012.

*Runyan, W.K., *Why did van Gogh cut off his ear? The problem of alternative explanations in psychobiography.* **J.Personal soc Psychol**, 40, 1070-1077, 1981.

*Sweetman, David, *Who Killed Van Gogh? The Doctor Did It.* **Connoisseur**, vol. 220, #941, p. 88–92, June 1990.

*Tilborgh, Louis van, Meedendorp, Teio, *The life and Death of Vincent van Gogh*, **The Burlington magazine**, CLV, p. 456-462, July 2013.

*White Smith, G. and Naifeh, S., NCIS : *Provence; The van Gogh Mystery*, **Vanity Fair**, December 2014.

Van Gogh: Topical and Focused Treatises

Alexander, Jenny. *The Strange and Lonely Life of Vincent Van Gogh. Illustrated by Olivia Bown.* HarperCollins Publishers, London, 1996.

Arnold, W.N., *Vincent van Gogh; Chemicals, Crises, and Creativity,* Birkhauser, Boston, 1992.

*Artaud, d'Antonin. *Van Gogh- Le Suicide De La Societe.* Skira Publishing, Paris, 2014.

Auden, W. H. *Van Gogh: A Self Portrait – Letters Revealing His Life as A Painter.* Paragon House, New York, 1989.

*Bailey, Martin, *Starry Night, van Gogh at the Asylum,* White Lion Publishing, London, 2018.

*Bailey, Martin, *Studio of the South; Van Gogh in Provence,* Frances Lincoln, London, 2016.

Bailey, Martin, *The Sunflowers are Mine: The Story of van Gogh's Masterpiece,*White Lion Publishing, London, 2013.

Bailey, Martin, *Vincent van Gogh; Letters from Provence,* Collins and Brown, London, 1990.

*Bakker, Nienke, Louis van Tilborgh, and Laura Prins. *On the Verge of Insanity: Van Gogh And His Illness*. Yale University Press, London, 2016.

Barnes, Rachel, *Van Gogh by Vincent, Artists by themselves*. Alfred A. Knoph, 1990.

Bernard, Bruce, *VINCENT by Himself, A Selection of van Gogh's Painting and Drawings together with Extracts from his Letters*, A New York Graphic Society Book, Little Brown and Company, Boston, 1985.

*Bonafoux, Pascal, *Van Gogh; The Passionate Eye*, Gallimard, Editoriale Libraria, Trieste, 1995.

*Bonafoux, Pascal, *Van Gogh: Self Portraits with Accompanying Letters from Vincent To His Brother Theo*. Paris: Éditions Denoël, TABARD PRESS, 1989.

De Leeuw, Ronald. *Van Gogh at the Van Gogh Museum. 6th Edition*. Zwolle: Waanders Uitgevers, 1996.

*Doiteau, V., Leroy, E., *La Folie de Vincent van Gogh, Preface by Paul Gachet Jr. (1926)*, Paris, 1928.

Edwards, Cliff. *Van Gogh and God: A Creative Spiritual Quest*. Loyola University Press, Chicago, 1989.

*Faille, J.B. de la, *The Works of Vincent van Gogh, His Paintings and Drawings*, Reynal and Co., Paris, 1928 and Meulenhoff International, Amsterdam, William Morrow and Company, 3rd edition, New York, 1970.

Feaver, William. *Van Gogh*. Longmeadow Press, Stamford, (1990) 1992.

*Gachet, Paul Jr., (Comments; Alain Mothe), *Les 70 jours de van Gogh a Auvers*, Valhermeil, Val-d-'Oise, 1994 (1959).

*Gayford, Martin, Jo Van Gogh-Bonger, *A Memoir of Vincent van Gogh*, Getty Publications, Los Angeles, 2015.

*Gayford, Martin. *The Yellow House: Van Gogh, Gauguin, And Nine Turbulent Weeks in Provence*. Fig Tree, Penguin Group, London, 2006.

Goldscheider, L. Uhde, W. *Van Gogh.*, Phaidon Press Ltd., Oxford, 1945.

Graetz, H.R. *The Symbolic Language of Vincent Van Gogh*. McGraw-Hill Book Company, New York, 1963.

Greenberg, Jan, Jordan, Sandra, *Vincent van Gogh; Portrait of an artist*, A Dell Yearling book, New York, 2001.

Gruyter, Jos de, *The World of van Gogh*, Uitgeverij Bert Bakker. Amsterdam, 1990.

Hammacher, A.M. *Van Gogh; 48 plates in color*, Hamlyn, London, 1961.

Hammacher, A. M., Hammacher, R. *Van Gogh a Documentary Biography*. Thames and Hudson Ltd, London, 1982.

Hammacher, A.M., *Van Gogh-25 Masterworks*, Harry N. Abrams, New York, 1984.

*Heenk, L. *Secrets of Van Gogh; Van Gogh's Inner Struggles*, Kindle, 2016.

*Heiligman, Deborah, *Vincent and Theo, The Van Gogh Brothers*, Goodwin Books, New York, 2017.

Huyghe, Rene, *Van Gogh*, Crown Publishers, Inc,, New York, 1958.

*Hulsker, Jan. *The Complete van Gogh*. Meulenhoff International, Amsterdam, 1977, 1980, 1985.

*Hulsker, Jan. *Vincent And Theo Van Gogh: A Dual Biography*. (Holland, 1985), James M. Miller, editor, Fuller Publications, Ann Arbor 1990.

Guillaud, Jacqueline and Maurice. *Van Gogh: Vertigo Of Light*. New York: Clarkson N. Potter, Inc. 1990.

Janson, H.W. editor. *Van Gogh in Perspective*. Edited by Bogomila Welsh-Ovcharov. Prentice-Hall, Inc., Englewood Cliffs, 1974.

Lubin, Albert J. *Stranger on the Earth; A Psychological Biography of Vincent van Gogh*, Henry Holt and Company, New York, 1972.

Meier-Graefe, Julius. *Vincent Van Gogh: A Biographical Study. Translated by John Holroyd-Reece*. The Literary Guild of America, New York, 1933.

Milner, Frank. *Van Gogh*. Promotional Book Company, Inc., New York, 1991.

*Miralles, Francesc. *Van Gogh: His Life and Complete Works, With an Illustrated Comprehensive Catalog*. Todtri Productions Limited, New York, 1995.

*Mothe, Alain, *Vincent van Gogh, an Auvers-sur-Oise*, Paris, 1987.

*Murphy, B. *Van Gogh's Ear*, Farrar, Straus, and Giroux, New York, 2016.

*Naifeh, Steven, White Smith, Gregory, *Van Gogh: The Life*. Random House Publishing Group, New York, 2011.

*Panter, B. M. et al, *Creativity and Madness, Psychological Studies of Art and Artists*. AIMED Press, Burbank, 1995.

*Piérard, Louis. *The Tragic Life of Vincent van Gogh. Translated by Herbert Garland*. Houghton Mifflin Company, Boston and New York: p. 112-115, p. 313-315, 1925.

*Schama, Simon, *Power of Art, (BBC Productions), "Van Gogh, Painting From Inside The Head*, BBC Books and Harper-Collins, London and New York, p. 296-351, 2006.

*Schapiro, Meyer. *Van Gogh*. Harry N. Abrams, Inc. (1983), 1952, Second printing of the third edition. The Museum of Modern Art, New York, 1978.

Schneede, Uwe M. *Van Gogh in St. Remy and Auvers*; Gemalde 1889/1890, Schirmer/Mosel, 1989.

*Stein, Susan Alyson, editor. *Van Gogh: A Retrospective*. Hugh Lauter Levin Associates, Inc. Fairfield, and Beaux Arts Edition, Crown Publishers, New York, 1986.

*Sweetman, David. *Van Gogh: His Life and His Art*. Crown Publisher, Inc., New York, 1990.

*Tralbaut, M. E. *Vincent Van Gogh. Translated by Edita Lausanne*. The Viking Press, Inc., New York, 1969.

*Tromp, Henk, A Real Van Gogh; *How the art world struggles with truth*, Amsterdam University Press, Amsterdam, 2010.

*Van Der Leek, Nick, *The Murder of Vincent van Gogh*. Shakedown, Irvine, (May), 2018.

van Uitert, Evert, Louis van Tilborgh, Sjraar van Heugten, editors. *Vincent Van Gogh: Paintings*. Arnoldo Mondadori Editore, S.p.A., Italy, 1990.

van Uitert, Evert, *Van Gogh Drawings*, The Overlook Press, Woodstock, 1978.

*Van Der Veen, W.,Knapp, P. editors. *Van Gogh In Auvers: His Last Days*. The Monacelli Press. New York, 2010.

van der Wolk, J., Pickvance, R., Pey, E.B.F., *Vincent van Gogh ; Drawings*, Rijksmuseum Kroller-Müller, Otterlo, March 3th-July 29th, 1990, Arnoldo Mondadori Editore Arte, S.p.A., Italy, 1990.

Van der Wolk, Johannes. *The Seven Sketchbooks of Vincent van Gogh, A Facsimile Edition*. Translated by Claudia Swan.: Harry N. Abrams, Inc., New York, 1987.

Wallace, R.,*The World of Van Gogh*, 1853-1890, Time-Life Books, New York, 1969.

*Walther, Ingo, F.,Metzger, Rainer, Van Gogh, *The Complete Paintings, Volume I, Etten, April 1881--Paris, February 1888, Translated by Michael Hulse*. Benedikt Taschen Verlag, Köln, 1990.

*Walther, Ingo F. Metzger, Rainer, Van Gogh, *The Complete Paintings,Volume II, Arles, February 1888--Auvers-sur-Oise, July 1890, Translated by Michael Hulse*. Benedikt Taschen Verlag, Köln, 1990.

*Walther, Ingo F., *Vincent Van Gogh, Vision and Reality*, Barnes and Noble Books, New York, 2004.

*Wilkie, Ken:
---- *The Van Gogh Assignment*, Paddington Press, New York, 1978.
---- *The Van Gogh File, A Journey of Discovery*, Souvenir Press, London, 1978, 1990.
---- *In Search Of van Gogh: A Journalist's Revealing New Findings About the Artist's Life and Death*. Prima Publishing, Rocklin, 1991.
---- *The Van Gogh File, The Myth and the Man*, Souvenir Press, London, 2004.

Woodford, Michael,Vincent Van Gogh, *A Vincent van Gogh Biography*, 2017.

…. *Van Gogh's Van Goghs*. Harry N. Abrams, New York, 1999.

…. *The Color Library of Art. van Gogh: 48 plates in full colour*. The Hamlyn Publishing Group Limited, New York, 1961.

Period References

Bailey, C.B., Rishel, J.J., Rosenthal, M., *The Annenberg Collection: Masterpieces of Impressionism & Post-Impressionism*, Harry N. Abrams, Inc., New York, 1989.

Bessonova, Marina, Williams, Wm, J., *Impressionism and Post-Impressionism. The Hermitage, Leningrad, The Pushkin Museum of Fine Arts, and the National Gallery of Art*. Macmillan Publishing Company, New York, 1986.

Herbert, Robert L. *Impressionism: Art, Leisure, & Parisian Society*. Yale University Press, London, 1988.

Janson, H. W. *History of Art. Second Edition*. Harry N. Abrams, New York, 1977.

*Malkova, Alla, *French Painting from the Hermitage Leningrad: Mid-19th to Early 20th Century*. Fourth Edition. Aurora Art Publishers, Leningrad, 1987.

Raynal, Maurice. *The History of Modern Painting: From Baudelaire to Bonnard. The Birth of a New Vision*. Translated by Stuart Gilbert. Albert Skira, Geneva, 1949.

Pool, Phoebe, *Impressionism*, Frederick A. Praeger, New York, 1967.

*Rewald, John. *The History of Impressionism*. The Museum of Modern Art, New York, 1946 (1st), 1955 (2nd), 1961 (3rd), 1973 (4th).

*Rewald, John, *Post-Impressionism-From van Gogh to Gauguin*. MOMA, Harry N. Abrams, Inc., New York, 1978.

*Rosenblum, Robert. *Paintings in The Musee D'Orsay*. Stewart, Tabori & Chang, Inc., New York, 1989.

Rothenstein, Sir John, *The Moderns and Their World*, Phoenix House, London, 1957.

Walker, John, editor. *The Armand Hammer Collection*. Harry N. Abrams, Inc., New York, 1980.

Zafran E. M., *Masters of French Painting 1290-1920 at the Wadsworth Atheneum Museum of Art*, D. Giles Limited, London, 2012.

Other Related Artists and Topics

Barskaya, A. Bessonova, M., Kantor-Gukovskaya, A. *Paul Gauguin In Soviet Museums*. Aurora Art Publishers, Leningrad, 1988.

Boudaille, Georges, *GAUGUIN, His Life and Work*, Tudor Publishing Company, 1964.

*Cate, Philip Dennis, editor. *Toulouse-Lautrec And La Vie Moderne, Paris 1880-1910*. Art Services International, Alexandria, 2013.

Denvir, Bernard, *Paul Gauguin-The search for Paradise. Letters from Brittany and the South Seas*, Collins and Brown, London, 1992.

Feinblatt, E., Davis, B., *Toulouse-Lautrec And His Contemporaries: Posters of the Belle Epoque from the Wagner Collection. Belgium*: Los Angeles County Museum of Art, Offset-Printing Van Den Bossche, Los Angeles, 1985.

Forge, Andrew, *Degas*. Harry N. Abrams, Inc., New York, 1988.

*Gauguin, Paul, *The Intimate Journals of Paul Gauguin*, KPI, London, 1923.

*Guerin, D. *The Writings of a Savage Paul Gauguin*, Viking Press, New York, 1974.

Huisman, O. Dortu, M.G. *Lautrec by Lautrec*, Viking Press, New York, 1964.

Huttinger, E. *DEGAS*, Crown Publishers, New York, 1967.

Negri, R. *Toulouse Lautrec*, Avenel Books, New York,1979.

*Prather, Marla Stuckey, Charles F., editor. *Gauguin: A Retrospective*. Macmillan Publishing Company, New York, 1987.

Seitz, W.C. *Monet*, Harry N. Abrams, Inc, New York, 1960.

Thomson, Belinda, *GAUGUIN*, Thames and Hudson, London, 1987.

White, Barbara Ehrlich. *Renoir: His Life, Art, and Letters*. New York: Harry N. Abrams, Inc., 1984.

Cinema, Theatre, Media

*Stone, Irving, Screenplay, **Lust for Life**, (Biopic; Vincent Van Gogh), MGM Studios, Vincente Minnelli, Director, John Houseman, Producer, Starring Kirk Douglas as Vincent and Anthony Quinn as Gauguin), 1956.

*Nimoy, Leonard, **VINCENT**, a one-man theatre production, Leonard Nimoy as Theo van Gogh, Guthrie Theater, Minneapolis, Magnum and Paramount Productions, 1981.

*Mitchell, Julian, (Screenwriter), Altman, Robert (Director), **VINCENT & THEO** (Tim Roth and Paul Rhys), Orion Productions, 1990.

*Schama, Simon, "**Power of Art,Part 3; Van Gogh, Painting From Inside The Head**, (BBC Productions), London and New York, 2006.

*Scorsese, Martin, in Akira Kurosawa, **Dreams, (Van Gogh Fantasy)**, Warner Brothers, 1990.

*Pialat, Maurice, *Van Gogh*, (Jacques Dutronc), Under the Milky Way and Monument Pictures, Gaumont and ABC Distribution, 1991.

*Safer, Morley (correspondent), (David Browning, producer) *60 Minutes, The Life and Death of Vincent van Gogh*, CBS News, October 16, 2011.

*Kobiela, Dorita, Welchman, Hugh. Dehnel, Jacek, **LOVING VINCENT** (Robert Gulaczyk, "*Vincent*", Douglas Booth- "Armand Roulin"), Breakthru Films, RBF Productions, 2017.

*Schnabel, Julian (director), written by Jean-Claude Carriere, Julian Schnabel, Louise Kugelberg, *At Eternity's Gate,* (Willem Dafoe as Vincent), CBS Films, 2018.

Vintage Ammo, Antique Guns, and Forensics

*Newcomer, Aaron, *The Pinfire Page*, Excerpts from the **International Ammunition Association Journal**, V. 1-5, July 2013-May 2018.

*Rohan, Alain, *Vincent van Gogh, Aurait-retrouvé; l'arme du suicide?* Paris, 2012(cited from von Tilborgh, 2013).

Dougherty, M.J., *Small Arms; From the Civil War to the Present Day*. Metro Books, New York, 2005.

*Walter, J. Handguns; *The Definitive Guide to Pistols and Revolvers*, Quercus, London, 2013.

Meniere's Disease

Meniere, P. *Gazette Medicale de Paris*, 1861, translated by Atkinson, M. "*Meniere's Original Papers*", Acta Otolaryngol, suppl 162, 1961.

Trousseau, A. *De la congestion cerebrale appoplectiform, dans ses rapports avec l'epilepsie*, Gazette Medicale Paris, v. 16, p. 51-52, 1861.

Charcot, J.M. *Lectures on Diseases of the Nervous System*. Facsimile of London, 1881, New York Academy of Medicine, Hafner Publishing company, 1962.

Arenberg, I.K., *A clinical analysis of Prosper Meniere's original cases*. Am. J. Otol. v. 10, p. 314-326, 1987.

Arenberg, I.K. (ed), *Inner Ear Surgery*, Kugler Publications, Amsterdam, 1991.

Arenberg, I.K. (ed), *Dizziness and Balance Disorders*, Kugler Publications, Amsterdam, 1993.

Arenberg, I.K. (ed), *Meniere's Disease Symposium, Otolaryngologic Clinics of North America*, W.B. Saunders, Philadelphia, November 1980.

Arenberg, I.K. (ed), *Inner Ear Surgery, Otolaryngologic Clinics of North America*, W.B. Saunders, Philadelphia, February 1983.

Arenberg, I.K. and Graham, M.D. (ed) *Endolymphatic Sac Surgery; Treatment Options for Meniere's Disease*, Singular Press, San Diego, 1998.

Arenberg, I.K. and Smith, Don B., (ed) *Diagnostic Neurotology, Neurologic Clinics*, W.B. Saunders, Philadelphia, May, 1990.

Arenberg, I.K., *Overview of inner Ear Disease*, Am J. Otol. v. 8, 189-194, 1987.

Arenberg, I.K., Marovitz, W.F. Shambaugh, G.E. Jr. *The Role of the Endolymphatic Sac in the Pathogenesis of the Endolymphatic Hydrops in Man*, Acta Otolaryngologica, (Uppsala) suppl 275, 1970.

*Stahle, J. Stahle, C. Arenberg, I.K., *The Incidence of Meniere's disease*, Arch Otolaryngol, 104, 99-102, 1978.

*Arenberg, I.K. et. al., *The Incidence and Prevalence of Meniere's Disease, A Statistical Analysis of Limits*. Symposium on Meniere's Disease, Otolaryngologic Clinics North America, p. 597-601,1980.

*Prins, Laura, *Van Gogh's physical and mental health; a chronology*. On the Verge of Insanity: Van Gogh And His Illness. London: Yale University Press, 2016.

*Arenberg, I.K., Countryman, L.F., Bernstein, L.H. Shambaugh, G.E. Jr. *Van Gogh had Meniere's disease and not epilepsy*, JAMA 264, (4) 491-493, July 25, 1990 (Note; purposely published on the 100th anniversary of his death to the week)

*Arenberg, I.K., Countryman, L.F., Bernstein, L.H., and Shambaugh, G. E. Jr, *Vincent's Violent Vertigo; an analysis of the original diagnosis of Epilepsy vs. the current diagnosis of Meniere's Disease*, Acta Otolaryngologica (Stockholm) suppl. 485, 84-103, 1991.

Acknowledgments

This book is the product of several years of work, and it would never have come to be without the support of so many amazing people in my personal and professional lifes. First and foremost, I wish to acknowledge and thank my children, Dan, Mike, and Julie, and my seven grandchildren—Zachary, Joel, Mitchell, Jacob, Nickolas, Alison, and Nathan—for their acceptance of my decreased availability as "*Grandpa.*" Now I am back.

My extended family and old friends have also been incredibly supportive throughout this endeavor, which turned out to be more challenging than I expected. I am especially grateful to Nina Marie, my old sidekick and muse.

I give thanks to my many patients with Meniere's disease over the last 50 years, who motivated me and inspired me to correct the misdiagnosis of Vincent van Gogh's "*attacks.*" It is because of them that I was able to determine that Vincent had Meniere's disease and not epilepsy. That discovery began my 30-year adventure of trying to solve the enigma of Vincent's mysterious death, which I never accepted as a suicide.

My research and writing team have been a huge help as I've worked on this project. My research associate, Edward Kobobel, has provided vital support in his many areas of expertise. The depth and breadth of his experience, his common sense, his logical savvy, and his understanding of this extensive project are all greatly appreciated. He is truly a computer whiz who helped me by laying out the interior of the book as well as designing the cover. He was also a research associate in general and helped with executing the forensic studies and analysis.

I am indebted to Timothy Standring, the Gates Foundation Curator of Painting and Sculpture at the Denver Art Museum and a curator-editor of *Becoming van Gogh*, who generously wrote the unbiased foreword for the publication, as well as kindly directed me to an excellent editor. That editor, Madeline Kloss Johnson, has done an outstanding job organizing and editing this book, and she put up with a novice in this field, since I come from the medical field and an entirely different writing background. This is my first non-medical, non-fiction effort. She made amazing improvements to the manuscript organization and successfully navigated its more challenging topics and put them into a more easily readable form.

In addition, Cindy Brovsky, my "*beta*" editor and final reader, was very helpful. Rebekah Woolverton, an assistant, aided me with organizing my initial and extensive research notes into a very rough working draft, and she assisted with the German translations. Sandy Levine served as the French translator, and Wesley Mysinger helped with the French research, translations, and securing some difficult older articles and books to work with.

For the second printing, Kimberly Damone, a young editor with a fresh perspective, has done a magnificent job refining the additional material and resolving the residual glitches. The book is now so much more organized, and the reader has a clear pathway to transcend the preconceived notion that van Gogh committed suicide. I am very proud of all my team, and it goes without saying, they are all wonderful and a pleasure to work with, and it could not have been done without their help and patience with my eclectic style.

I had invaluable help with the aspects of this book concerning forensics, antique firearms, and vintage ammunition. The major kudos go to Steven Naifeh for noting that the suicide narrative just did not fit together, for pursuing this concern, and for presenting the very limited wound information to a world-renowned forensic expert, Dr. Vincent J. M. Di Maio. I thank Di Maio for his groundbreaking report and giving permission to use his report in this book, which concluded that Vincent van Gogh did not shoot himself. My detailed forensic studies are designed to prove his findings correct.

Thanks also goes to my old friend Matt Sebesta, the director of *The Family Shooting Center*, http://www.familyshootingcenter.com, located in the Cherry Creek State Park. Matt is a certified Range Safety Officer who oversaw all of the simulations and reenactments using live, vintage black powder ammo. Matt provided his expertise in firearms and made available wide access of the shooting range for the testing and re-creation of Vincent's fatal wound before analysis. He also helped be recording videos of all the test fires.

Bart Miller, the gunsmith from www.legacyarms.com at Centennial Gun Club, helped with the design and analysis of the materials and methods in my simulations. He also helped analyze all aspects of these forensic studies, double-checked the results, and made a 125-year-old antique firearm safe and serviceable.

Aaron Newcomer, from www.freemycollection.com, shared his extensive research on pinfire guns and ammos, provided an available supply of the 7mm caliber vintage pinfire ammunition needed for the reenactment studies, and allowed me to use some photos from his website in this book. Logan Borland also helped with some of the black powder bullet research and helped me find a source for the vintage 7mm bullets used. Scott Schilb and Daniel McCune at *Antique Arms* found me the same Lefaucheux 7mm model matching the one found rusted in a field in Auvers.

Ron Relf, an old friend and retired US Navy Seal and retired homicide detective from the Denver Police Department, also reviewed these forensic studies and assessed and confirmed the likelihood that Vincent's death was not a suicide. Marvin Brandt, another retired homicide detective, from the Arapahoe County Sheriff's Office concurred that suicide was unlikely.

This book has been both a challenge and a joy to work on, especially in that it allowed me to collaborate and discuss my ideas with so many wonderful people. I could not have brought *Killing Vincent* to fruition without their patience, aid, support, and encouragement.

CPSIA information can be obtained
at www.ICGtesting.com
Printed in the USA
LVHW050516080319
609919LV00002B/2/P